Abandoned Cinemas of the World

A photographic study by
SIMON EDELSTEIN

Preface by **FRANCIS LACLOCHE**

JONGLEZ PUBLISHING

For Elisabeth, my steadfast collaborator in this photographic adventure

Preface

Over a period of fourteen years, Simon Edelstein has visited more than thirty countries around the world, scouring countless remote city suburbs, on the lookout for forgotten cinema façades worn by the ravages of time, but with telltale signs that testify to former grandeur.

Edelstein's passion for cinemas was first aroused in Geneva, a sober city where such fanaticism is not immediately apparent. In order to satisfy his enthusiasm, he had to delve into areas of cities where these deserted treasures – with histories often going back more than a century – have come to rest.

The earliest film shows in France, England, and elsewhere in Europe and the United States were set up in travelling sideshows. Later they would be found in music halls and cafés-concerts, and finally in theatres. Their success was driven by great public demand, which in turn accelerated their development. This did not, however, change the shows' original purpose, and for many years they continued to share billing with live performing artists.

Simon Edelstein's pictures show that while many theatres have not fared well, others have been put to new use for commercial, sports or even religious purposes, or else converted into homes.

Movie theatre proprietors have left a magnificent legacy to cinematography. As these photographs demonstrate, owners across the globe would frequently turn their properties into cathedrals dedicated to Hollywood, taking design cues from the surrounding environment. Some would come to resemble great cruise ships in the middle of popular city districts; others radiated like little jewels in French villages or the sun-drenched urban expanses of Texas and California.

But as winters go by and these cinemas continue to quietly crumble, it is mostly memories that remain. Edelstein has cast a tender eye over the ruins and decay, its lighting reflecting the end of an era, seemingly created for the sole purpose of serving his art and delivering magnificent pictures to us. Undaunted by obstacles, regulations or warnings, he has entered

faded shrines that now resemble the set of some tragédie lyrique in order to realise in his magnificent pictures the determination of these places to survive. Driven by an insatiable curiosity, he has boldly explored a world that remains immune to the digital age.

The pages of this book are testament to all the elements that were for decades integral to the cinema experience: beautiful signage, grandiose canopies, magnificent entrance foyers with ticket desks ranging from the modest to the highly ornate; confectionary counters that once offered all manner of delights; and finally the corridors leading into the theatre itself. Some have survived intact, others are in varying stages of dilapidation – all are irresistibly photogenic. When Edelstein returned to Geneva he had a roll of film crammed with images of magnificent old picture houses from across the United States, Europe, and even India. His photographs magically preserved the very essence of their past glories.

When night falls, cinemas shine brightly, illuminated by a thousand neon tubes. The towers are transformed into luminous beacons that can be seen from far away. But all too soon, the lights go out, the neon tubes darken and signs flicker into sleep. An imposing silence descends. Simon Edelstein captures that silence, the beauty, and the palpable sadness left when an area is deprived of its theatre.

Some cinemas have been given a reprieve. Destined for recycling, they have escaped the diggers' voracious jaws and have been given a second chance. As churches, restaurants, gaming rooms, sports venues or housing, the spacious halls of many former cinemas now host a variety of new occupants. And the old signs, canopies, illuminated stages and ornate trappings are the magnets that draw people in.

Although the Saturday night crowd has long ceased to converge on these buildings, what remains of them as they lie sleeping under years of dust has been revived by Edelstein's lens. He offers a final glimpse of decaying façades, once glittering foyers, and vast auditoriums, populated only by the ghosts of happier times.

So now, let the show begin.

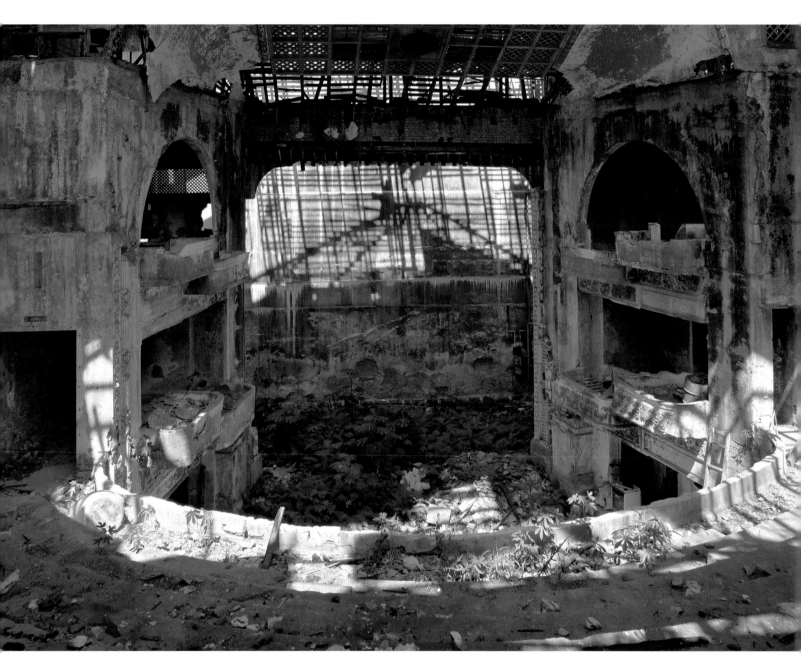

Havana – Cuba – Campoamor – 2013

Abandoned cinemas

Cinemas are ephemeral. Once abandoned, they are swept away in much the same way as the fallen autumn leaves that blanket the parks of our cities. But the decline of movie theatres is not confined to a particular season, and they are becoming a rare feature of the urban landscape. Either through apathy or influenced by market forces, authorities generally refuse to designate old theatres as listed buildings. They offer no support for the continued use of properties that have become troublesome and costly. With restoration far from certain, former cinemas get forgotten, and the public grows indifferent to their slow disappearance. But for lovers of these dream palaces, the disintegration of their bold architecture is a visual nightmare.

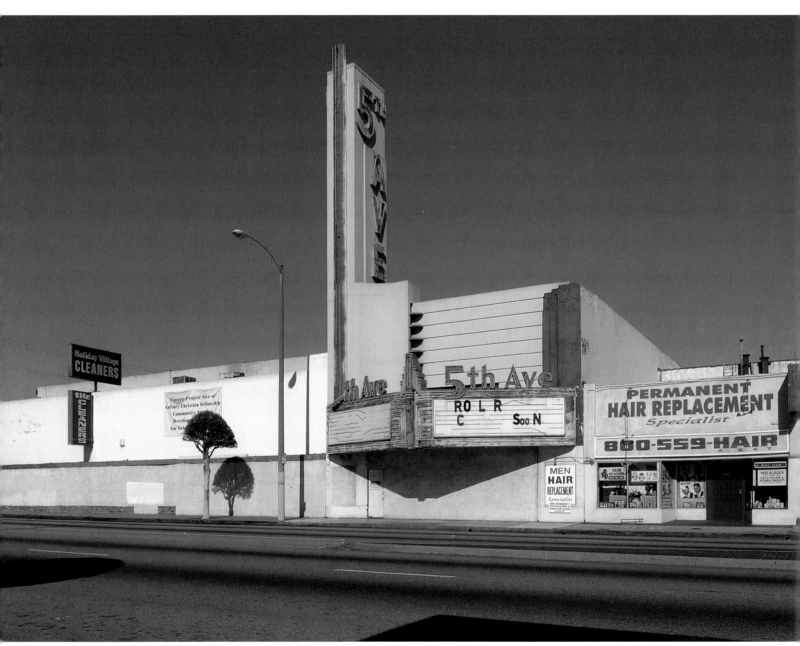

Inglewood, California – USA – 5th Avenue – 2011

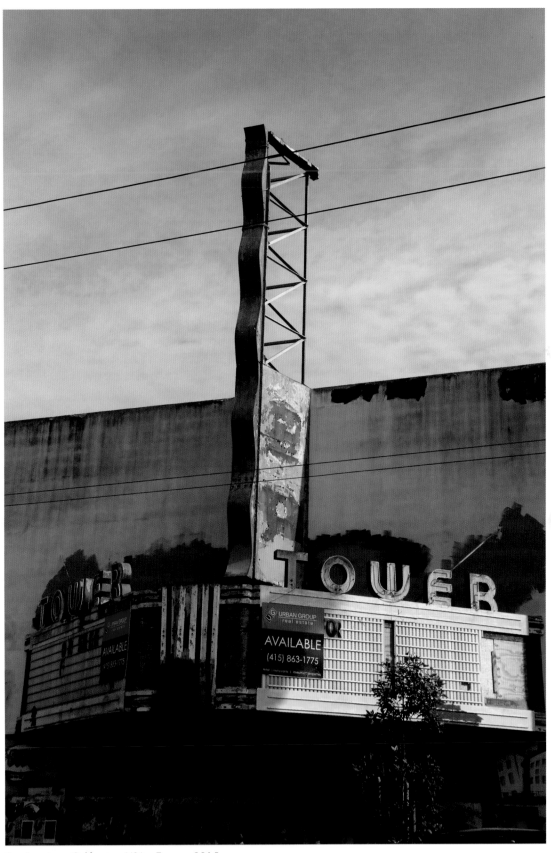

San Francisco, California – USA – Tower – 2015

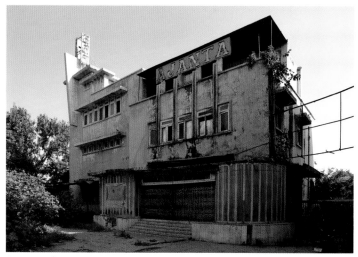

Ajmer – India – Ajanta – 2016

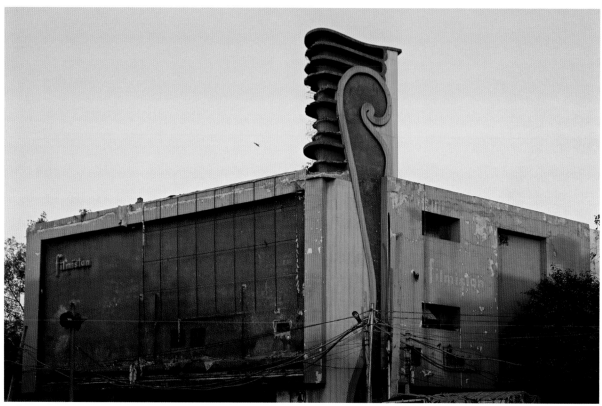

Delhi – India – Filmistan – 2015

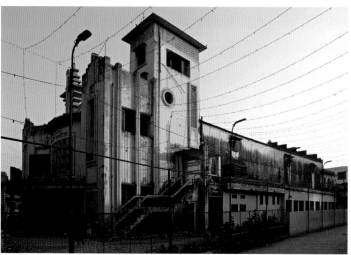

Allahabad – India – Lakshmi Talkies – 2017

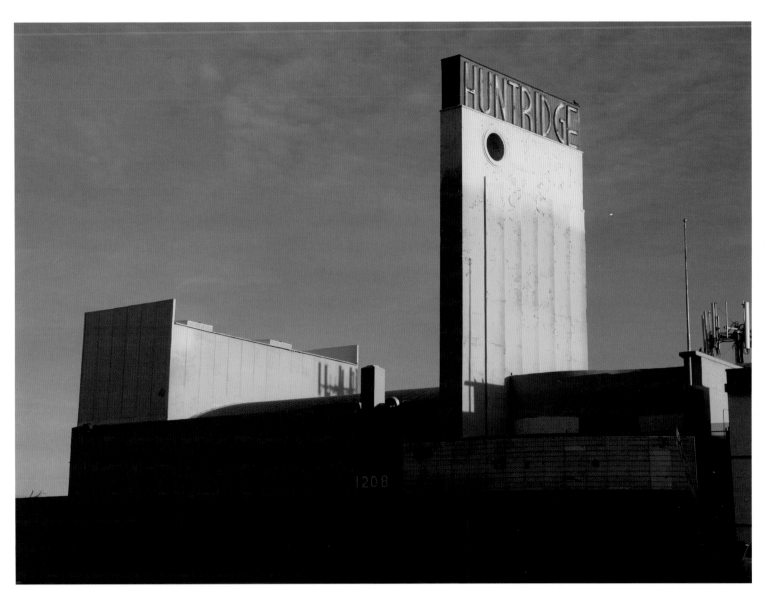

Las Vegas, Nevada – USA – Huntridge – 2011

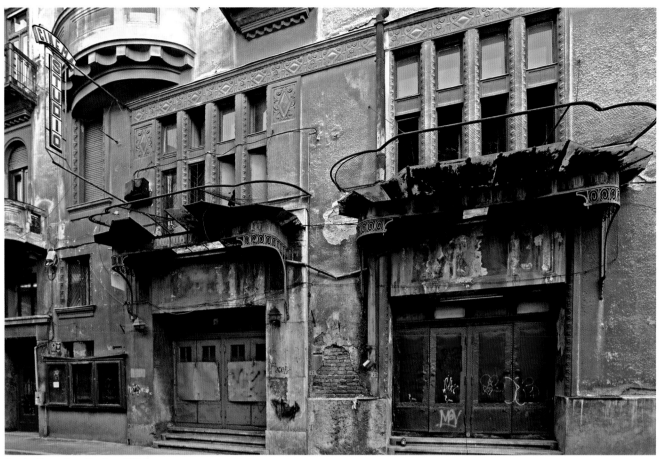

Arad – Romania – Studio – 2016

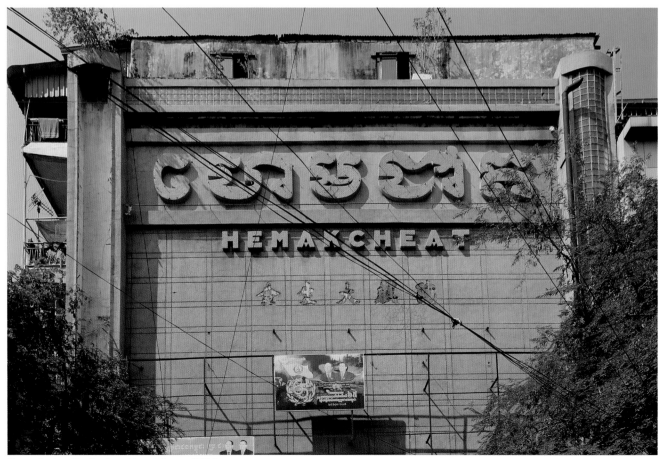

Phnom Penh – Cambodia – Hemakcheat – 2019

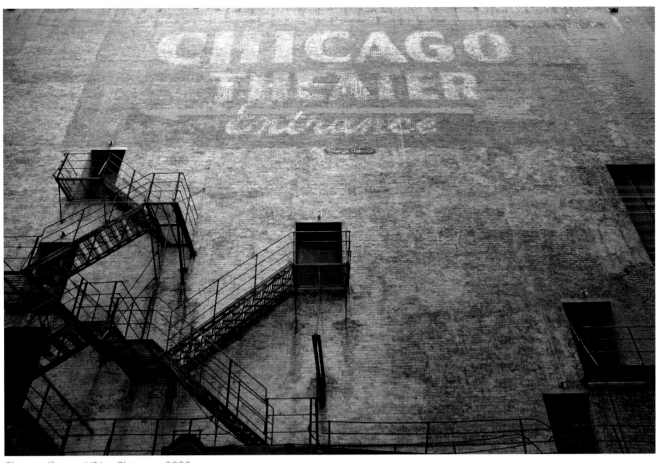

Chicago, Illinois – USA – Chicago – 2008

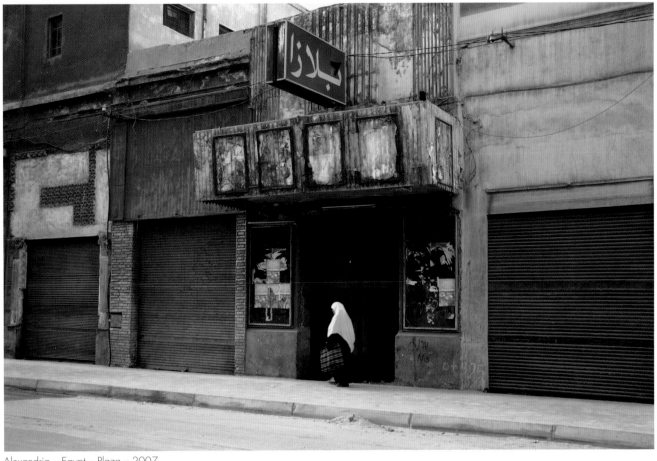

Alexandria – Egypt – Plaza – 2007

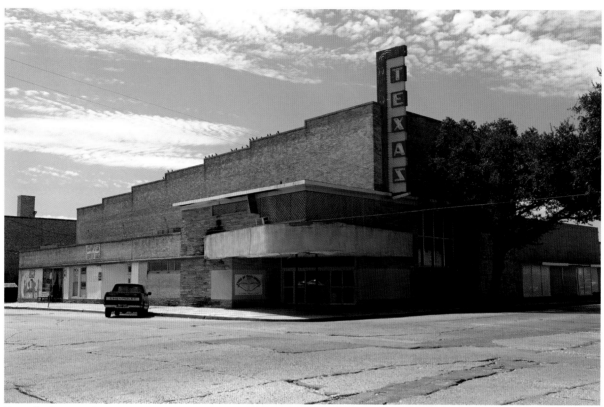

Kingsville, Texas – USA – Texas – 2011

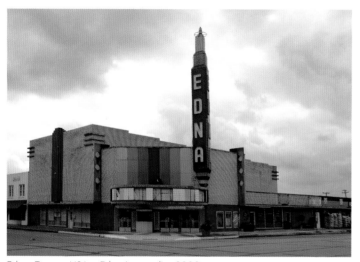

Edna, Texas – USA – Edna (restored) – 2008

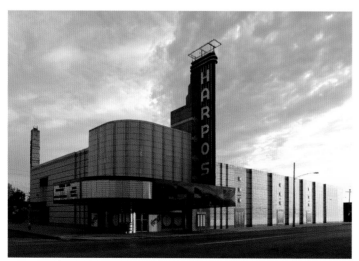

Detroit, Michigan – USA – Harpos – 2010

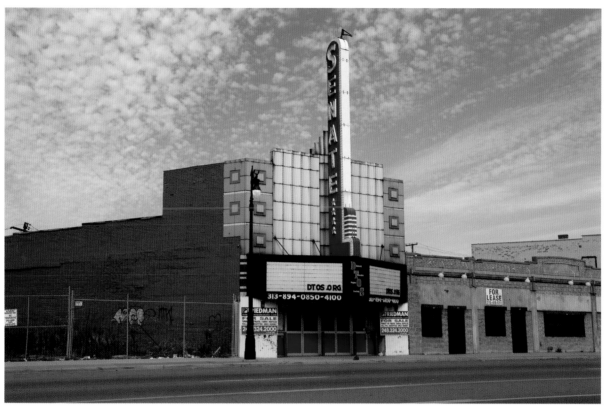

Detroit, Michigan – USA – Senate – 2010

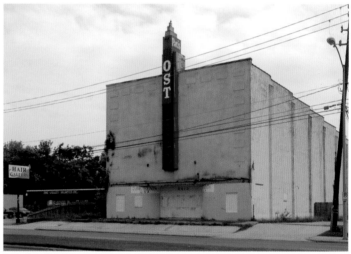

Houston, Texas – USA – Ost – 2008

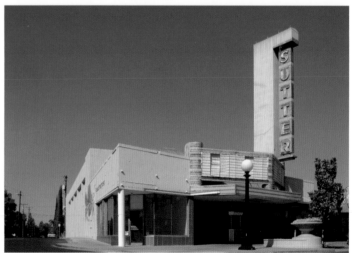

Yuba City, California – USA – Sutter – 2009

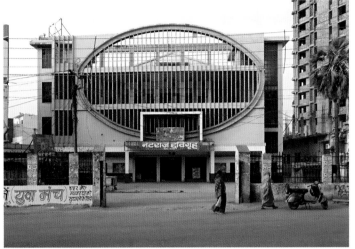

Varanasi – India – Natraj – 2012

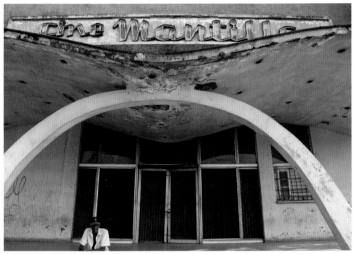

Havana – Cuba – Mantilla – 2013

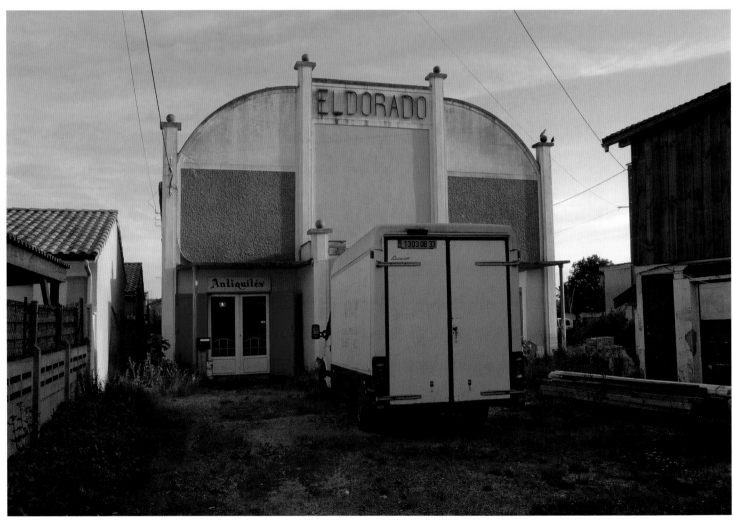

Gujan-Mestras – France – Eldorado – 2013

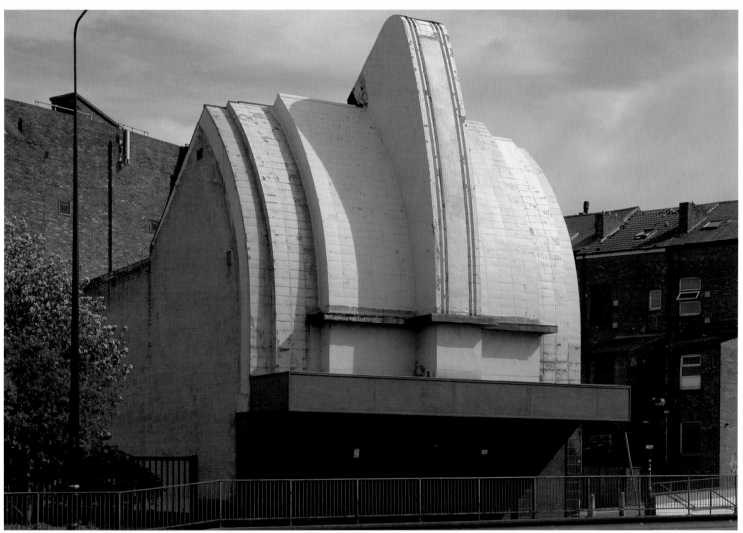

Stretford – England – Essoldo – 2006

In India there is a different attitude to the decline of cinemas. Thirty million Indians go there every day. And for many, the cinema offers a place to dream, an escape from poverty, or simply a cool place to sleep – fans are provided, though they are often noisy and ineffective. These once splendid places, with their sagging seats and out-of-focus projections, continue to resist property developers. India is currently undergoing rapid change. There is an increasingly large middle class that is now turning its back on the cinema, especially since the rise of satellite television. Such audiences demand state-of-the-art convenience and luxury. As a result, some beautiful Art Deco cinema halls have been demolished and replaced by shopping malls.

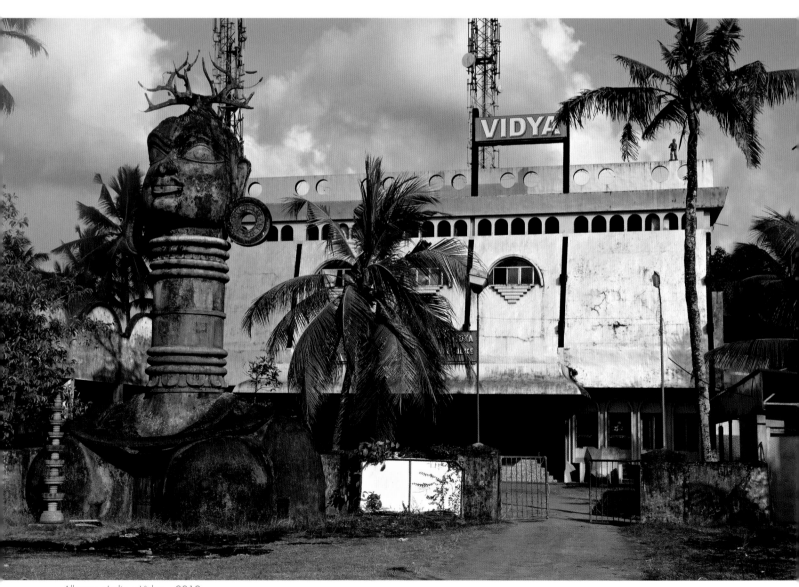

Allepey – India – Vidya – 2012

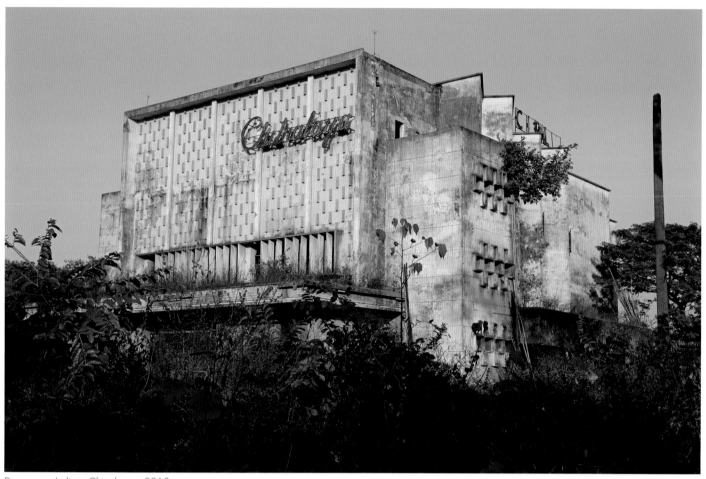

Durgapur – India – Chitralaya – 2018

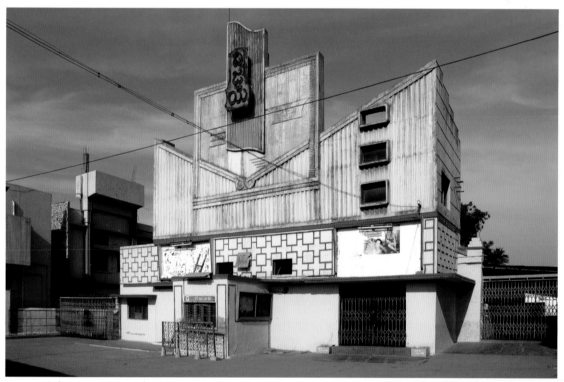

Hospet – India – Vijaya Karnataka – 2007

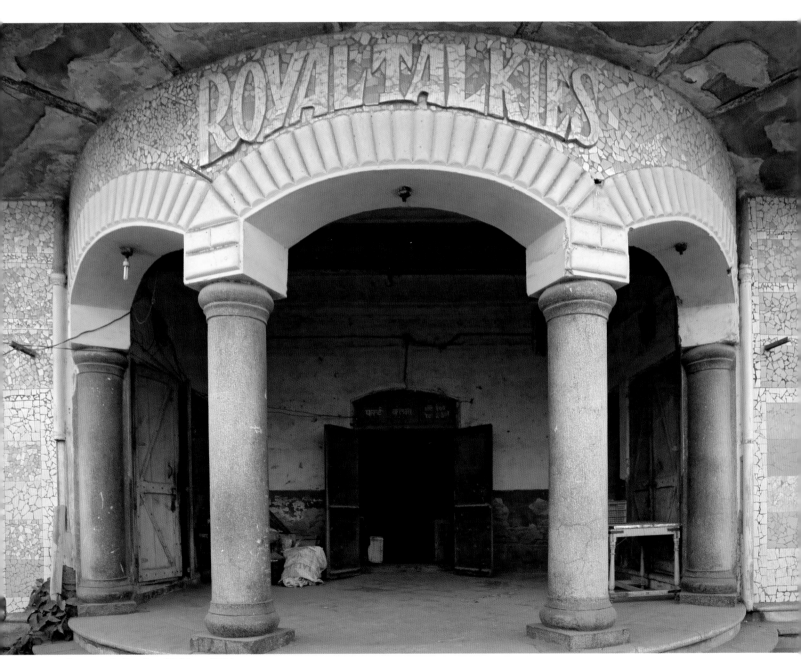

Beawar – India – Royal Talkies – 2016

20

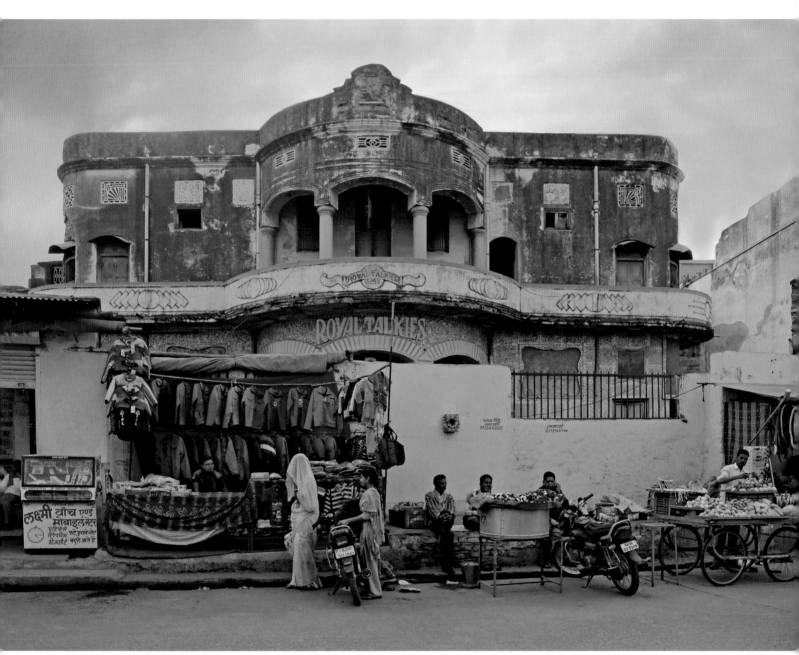

Beawar – India – Royal Talkies – 2016

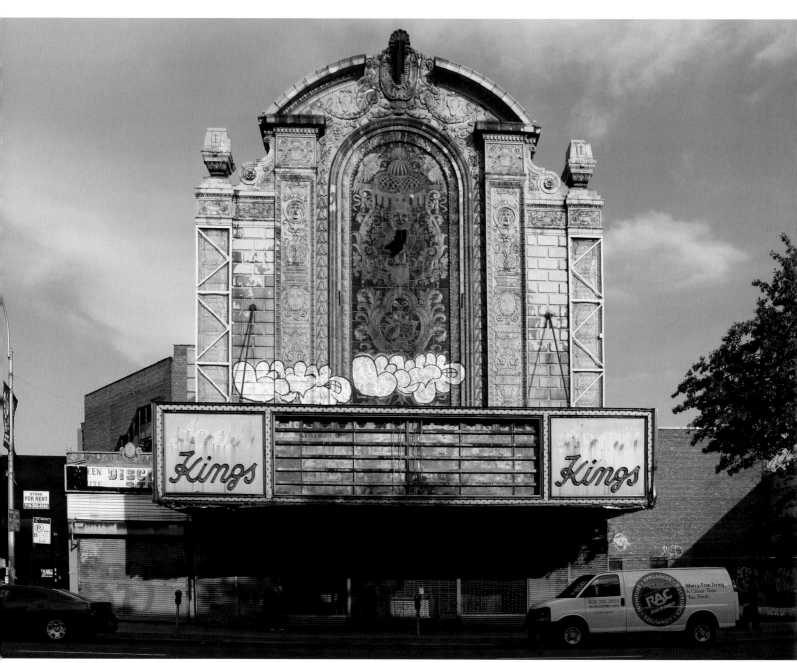

Brooklyn, New York – USA – Loew's Kings (restored) – 2010

Opened in 1929, the Loew's Kings boasted a façade richly decorated with terra cotta. Inside, the 3,676 seats inhabited a luxurious realm of crystal chandeliers, mahogany panelling and Art Deco light fittings. It was the perfect embodiment of the golden age of American cinema. The same company built four other cinemas in the New York area, all of them opening in that year. Miraculously, they are still standing, although not a single one is still a cinema. The Loew's Kings even had a gymnasium and a basketball court in its basement purely for the use of its employees.

Audience numbers declined in the mid 1950s, and the Loew's Kings closed its doors for the last time on 29 August 1977. Over time, a combination of rainwater damage and vandalism led to the deterioration of the building. In spite of this, having lain empty for 35 years, the Loew's Kings underwent a renovation and opened its doors once again on 3 February 2015 for a Diana Ross concert.

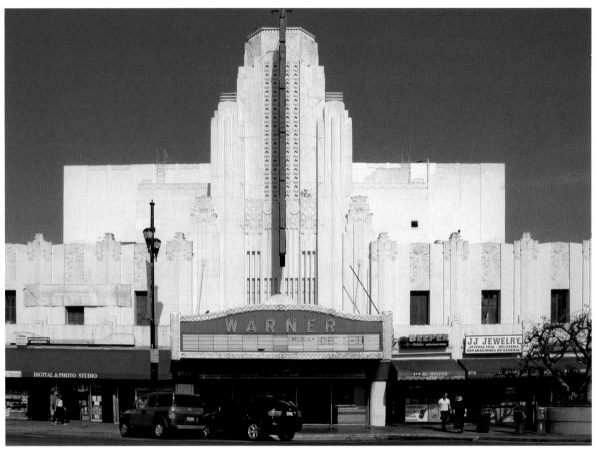

Los Angeles, California – USA – Huntington Park Warner – 2008

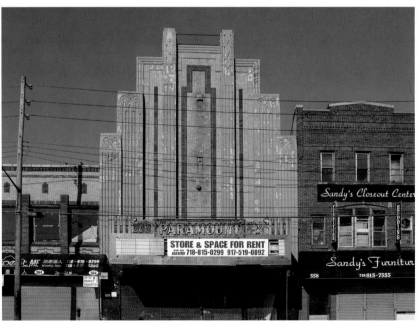

Staten Island, New York – USA – Paramount – 2007

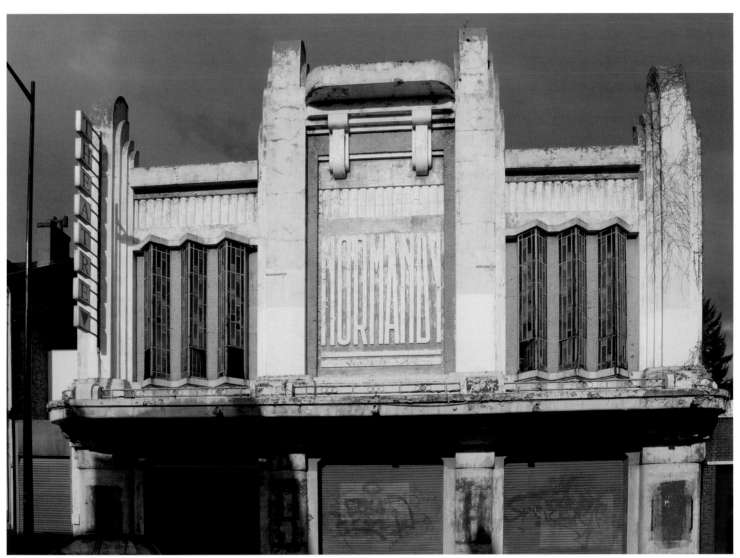

Le Havre – France – Normandy – 2012

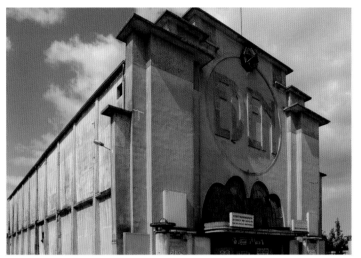

Saint-Jean-d'Angely – France – Eden (burnt down and rebuilt) – 2009

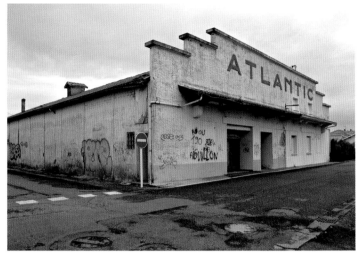

Biscarosse Plage – France – Atlantic (demolished) – 2008

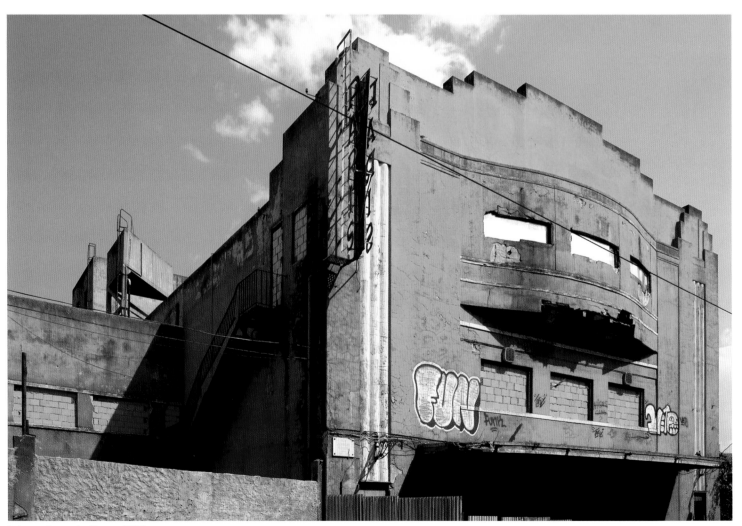

Lisbon – Portugal – Paris – 2011

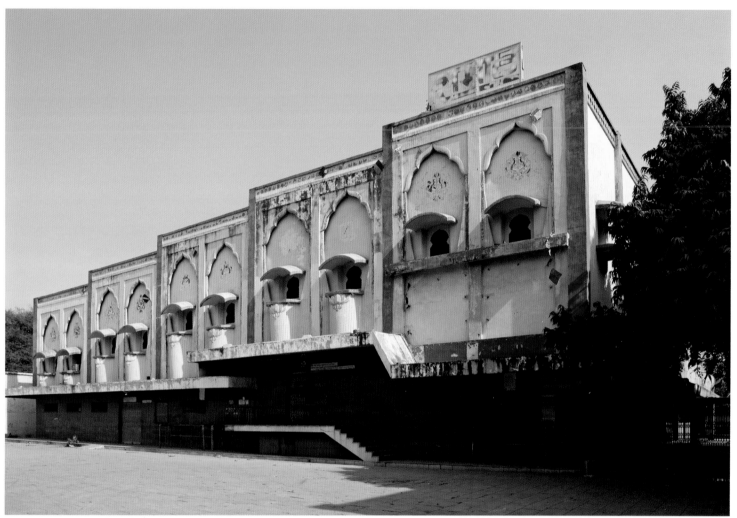

Jaipur – India – Samrat – 2014

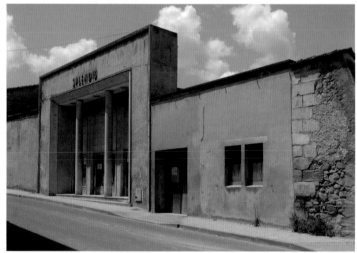

Langoiran – France – Splendid – 2008

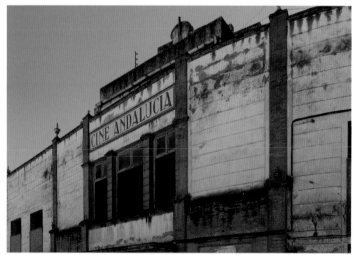

Alcala de los Gazules – Spain – Andalucia – 2015

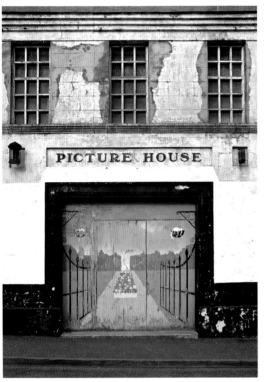
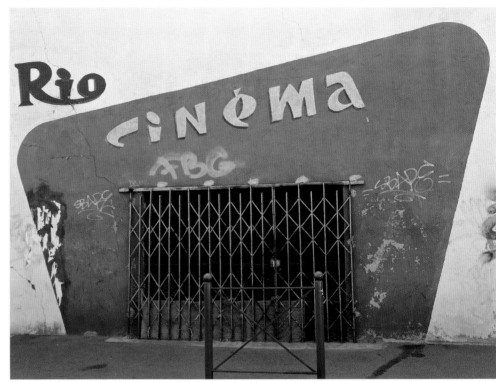

Blairgowrie – Scotland – Picture House – 2007

Sète – France – Rio – 2015

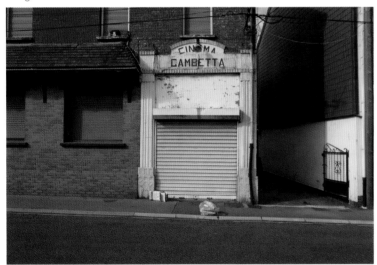
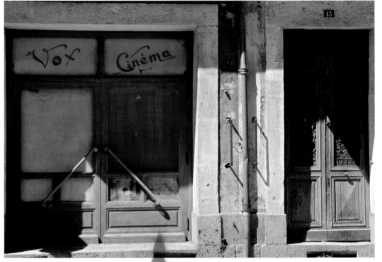

Marles-les-Mines – France – Gambetta – 2013

Brassai – France – Vox – 2017

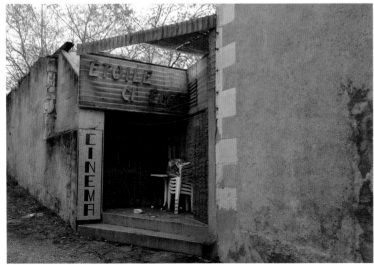
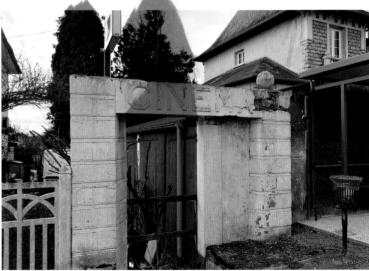

Imphy – France – Étoile – 2018

Premery – France – Royal – 2018

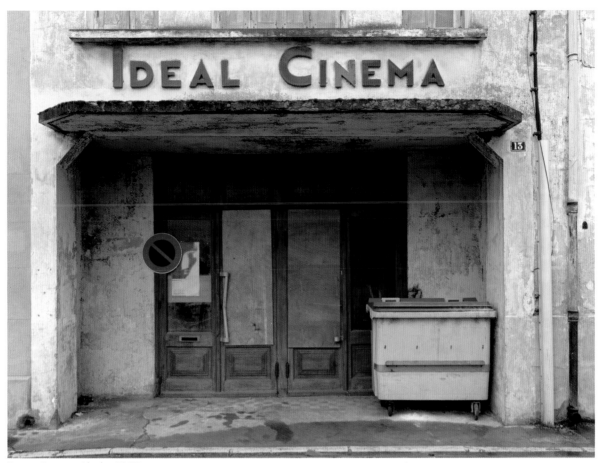

Bram – France – Idéal – 2010

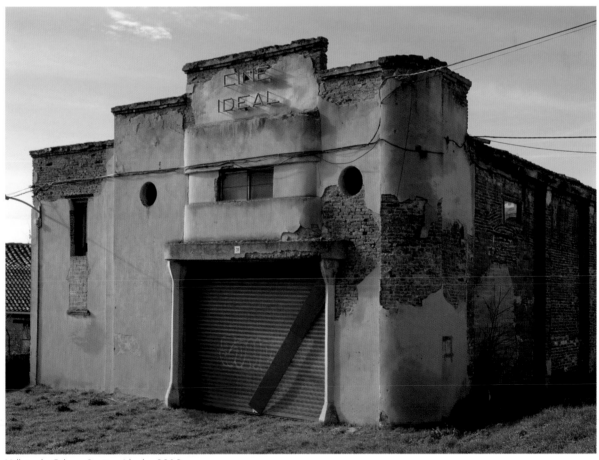

Vallejo de Orbo – Spain – Ideal – 2018

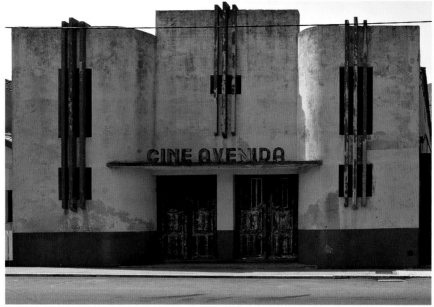

Costa Nova (Porto) – Portugal – Avenida (demolished) – 2006

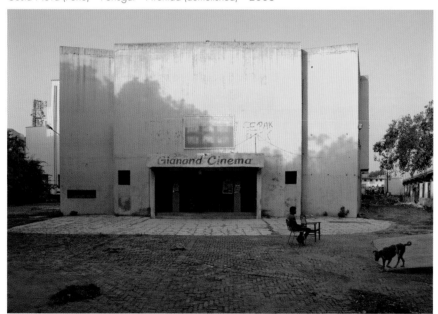

Delhi – India – Gianand – 2014

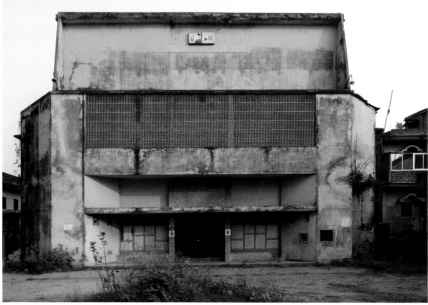

Gaya – India – Sudha – 2017

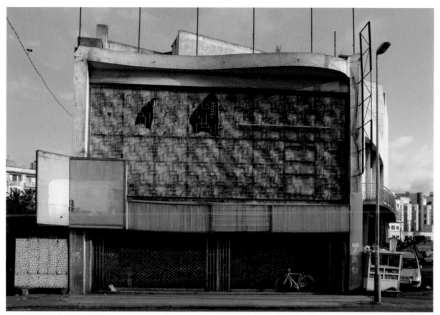

Casablanca – Morocco – Opéra – 2009

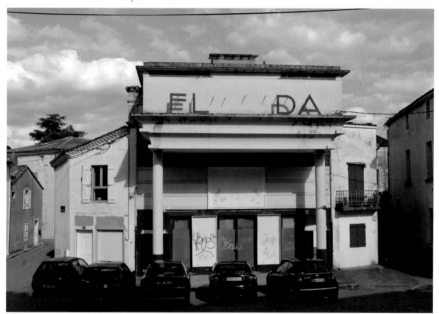

Langon – France – Florida – 2008

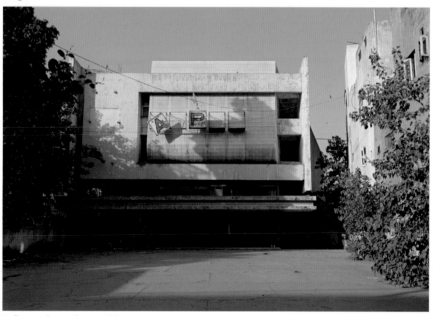

Delhi – India – Alpna – 2014

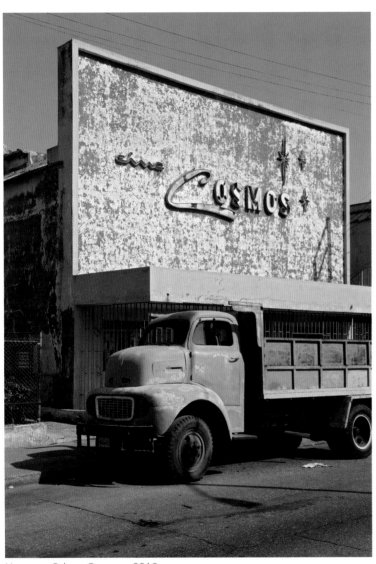

Havana – Cuba – Cosmos – 2010

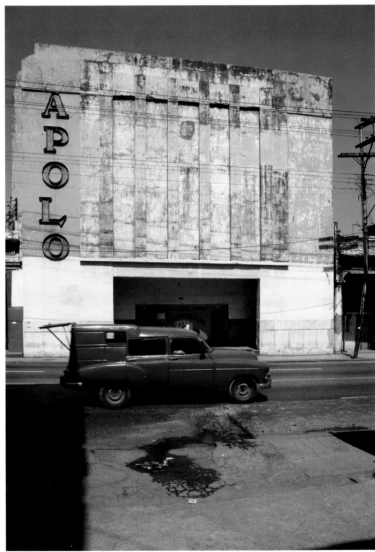

Havana – Cuba – Apolo – 2013

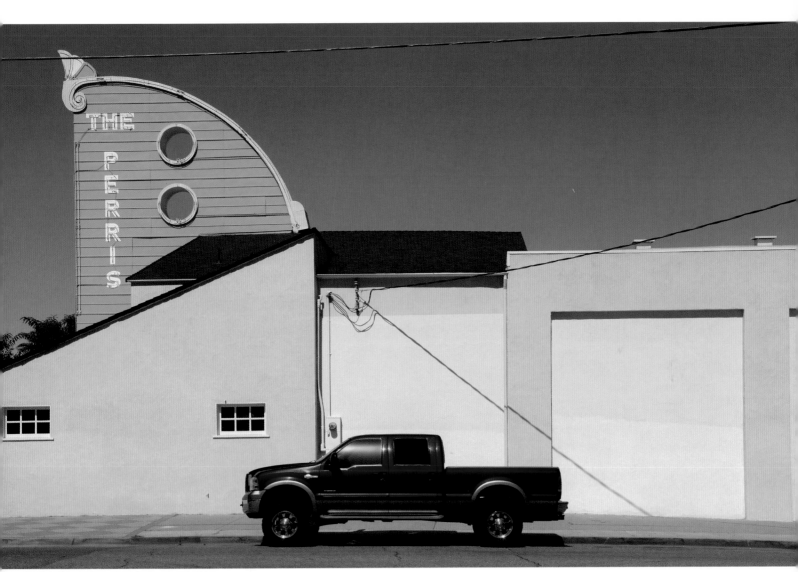

Perris, California – USA – The Perris – 2011

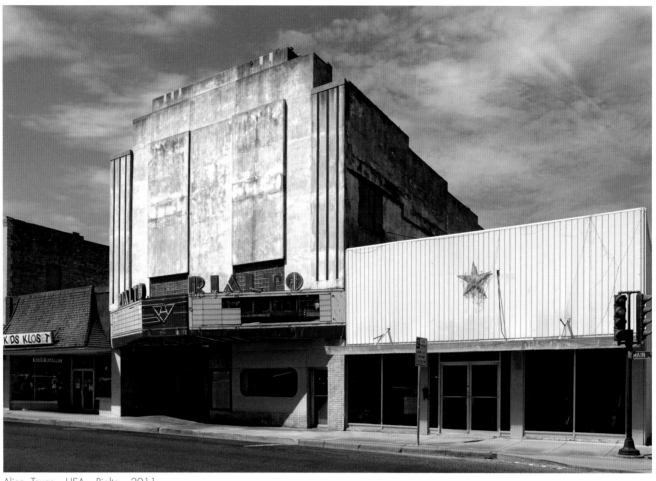

Alice, Texas – USA – Rialto – 2011

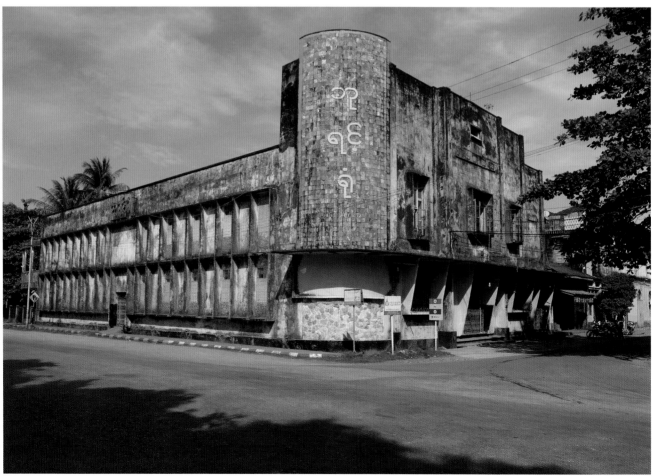

Mawlamyine – Myanmar – Bayint (restored) – 2017

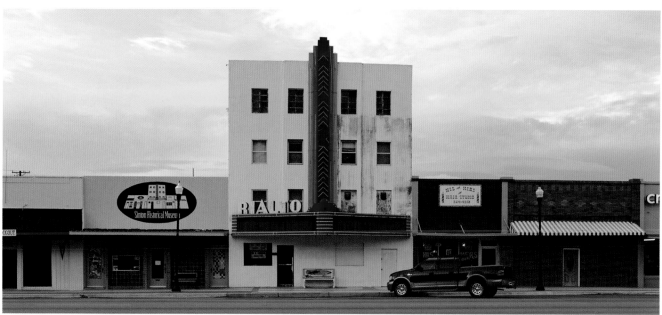

Beeville, Texas – USA – Rialto – 2011

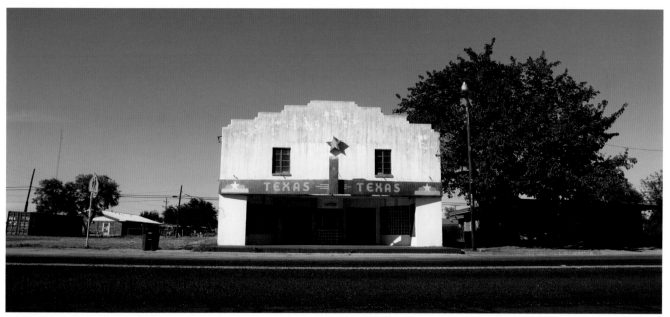

Bronte, Texas – USA – Texas – 2011

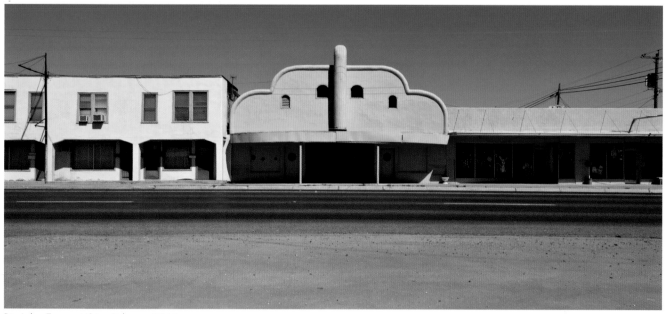

Big Lake, Texas – USA – Palace – 2011

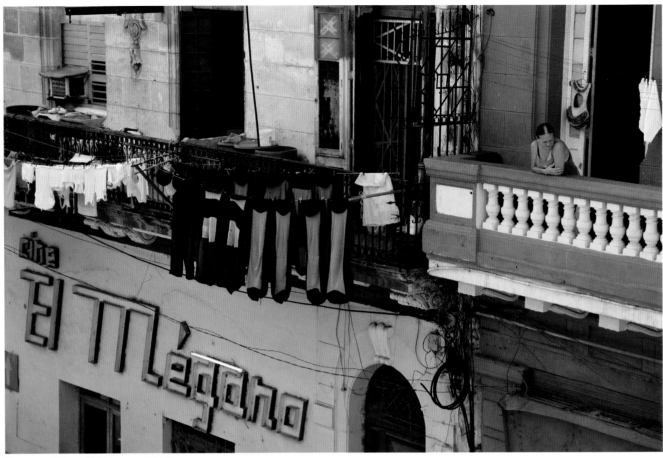

Havana – Cuba – El Mégano – 2013

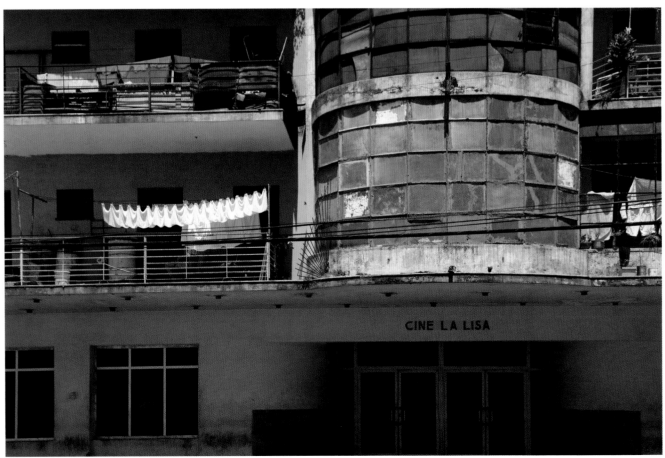

Havana – Cuba – La Lisa – 2010

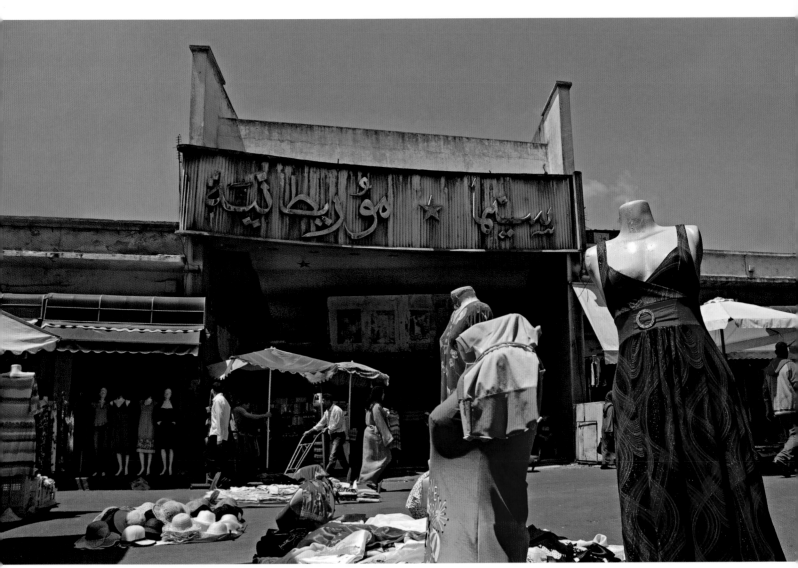

Casablanca – Morocco – Mauritania – 2009

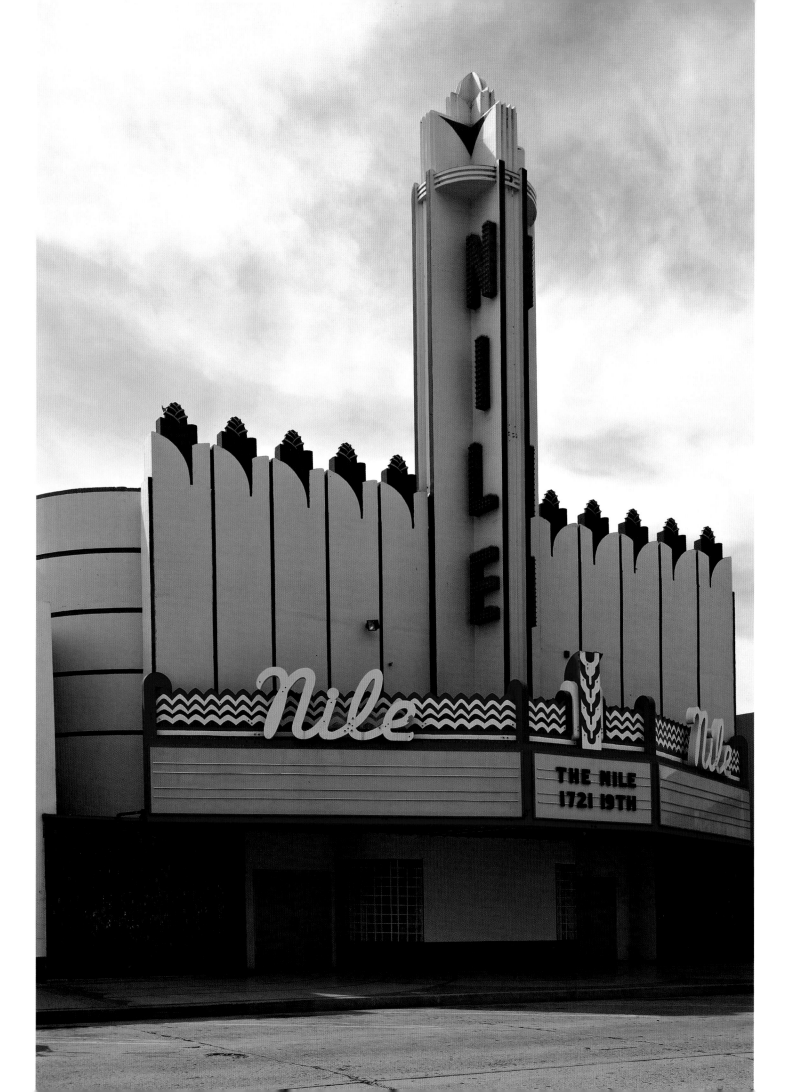

Examples of cinemas resisting decline can take a variety of strange forms. In some cases, if showing films is no longer possible, a new owner or occupier will still retain the original frontage, maybe even giving it a facelift, perhaps in the hope that one day it will rise again from the ashes.

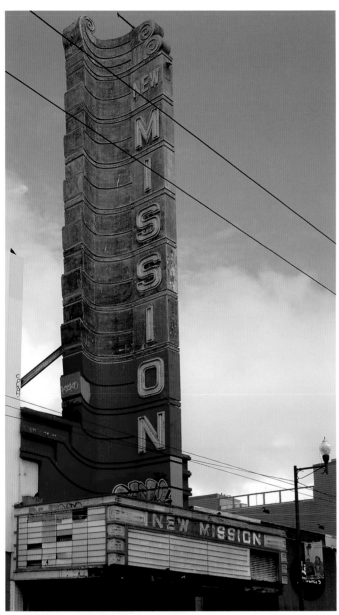

San Francisco, California – USA – New Mission (restored) – 2007

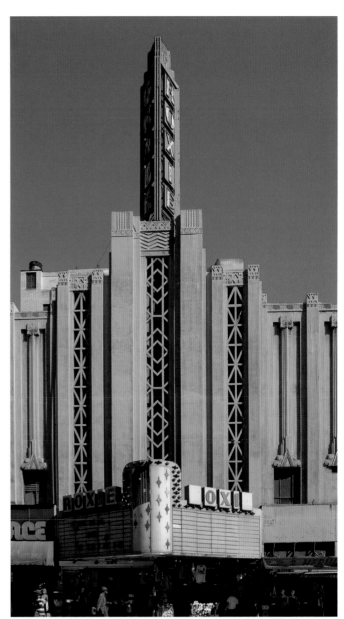

Los Angeles, California – USA – Roxie – 2008

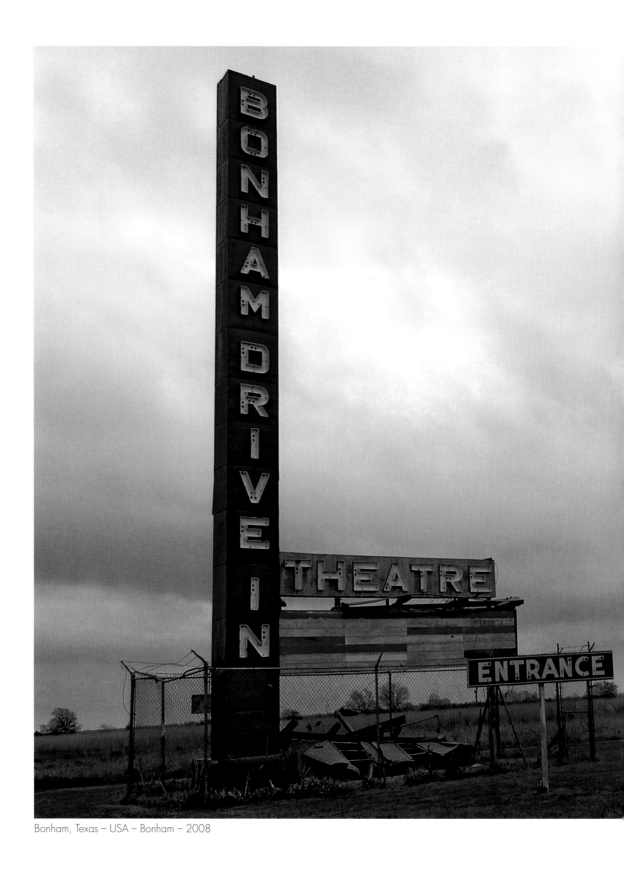

Bonham, Texas – USA – Bonham – 2008

Drive-ins are an iconic feature of modern American history. They evoke a time of easy living coupled with a lust for life: chrome cars as long as ocean liners; the excitement in the back seat while films such as John Ford's western *Stagecoach* played on the screen. The first drive-ins appeared in the early 1940s, a time when Americans were inseparable from their cars and hooked on movies. Inside your car you could do anything: watch together with friends or family, talk through an entire film, or even eat a full meal. By

the 1950s there were as many as 4,600 drive-ins across the United States — though in Quebec, in order to preserve public decency, they were banned until the mid 1960s. Even if today their popularity has significantly dwindled, several hundred drive-ins still remain. But they are now combined with other facilities, such as cafeterias, children's day-care centres and play areas. Since all you pay for is a parking space, this remains a low-cost form of entertainment, so they are more widely used by less affluent sectors of American society.

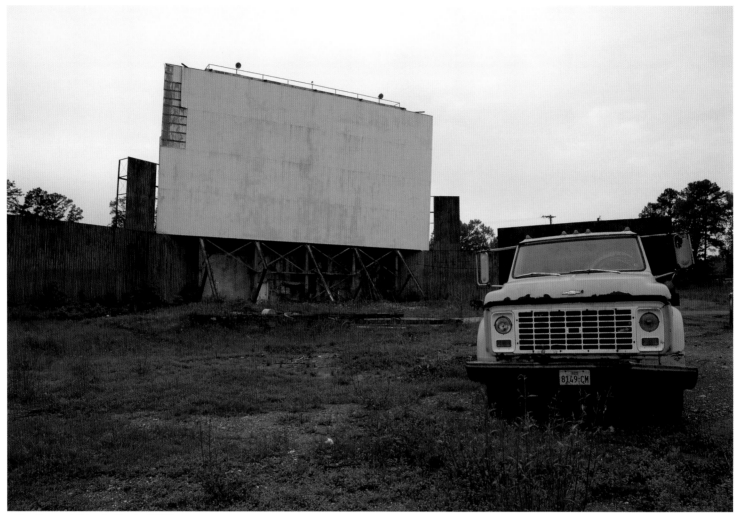

Lufkin, Texas – USA – Redland – 2008

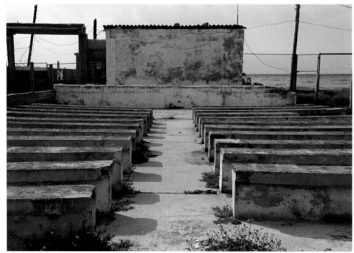

Havana – Cuba – Baracoa open air – 2013

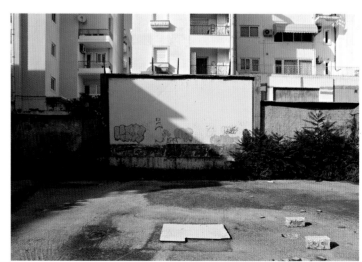

Athens – Greece – Arian – 2017

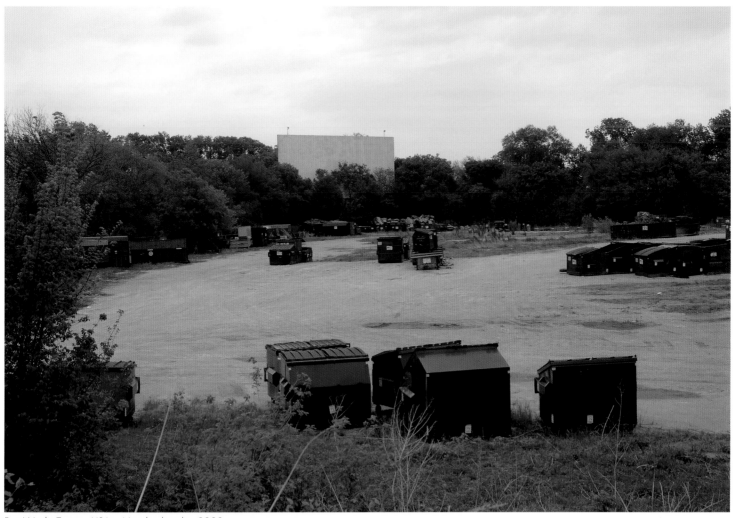

Fort Worth, Texas – USA – Meadowbrook – 2008

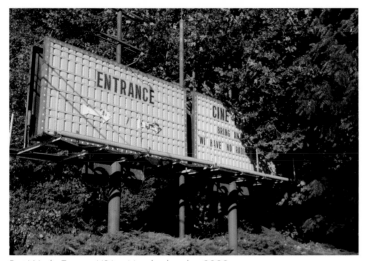

Fort Worth, Texas – USA – Meadowbrook – 2008

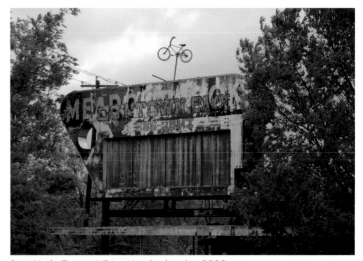

Fort Worth, Texas – USA – Meadowbrook – 2008

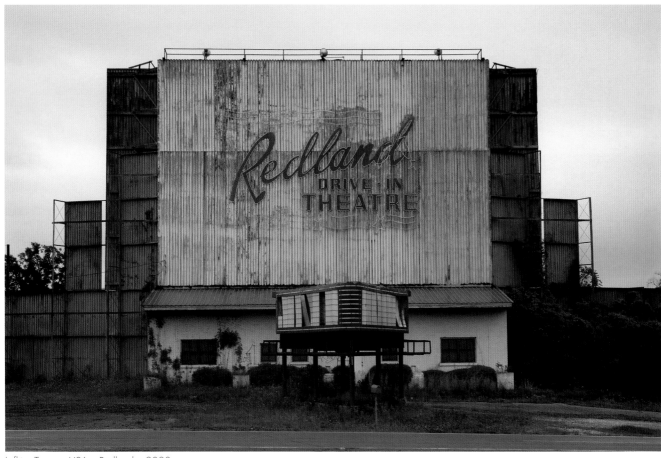

Lufkin, Texas – USA – Redland – 2008

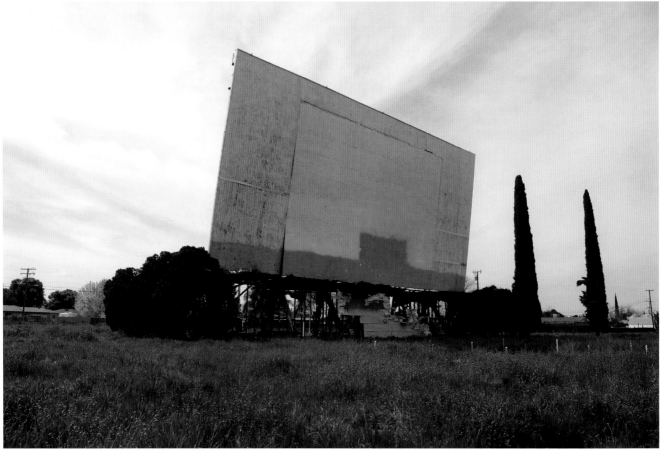

Porterville, California – USA – Porterville – 2011

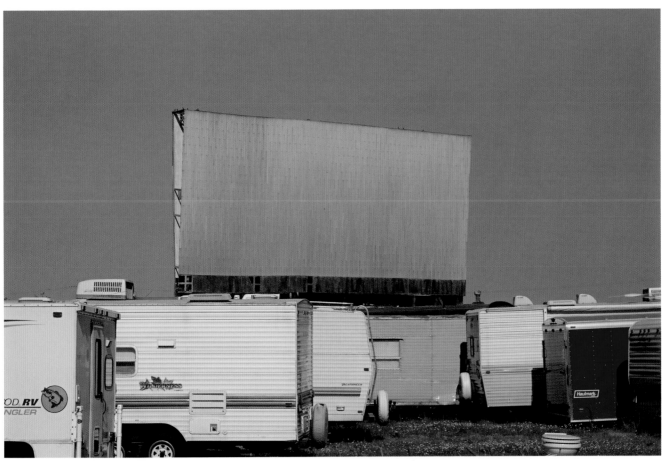

Eureka, California – USA – Midway – 2009

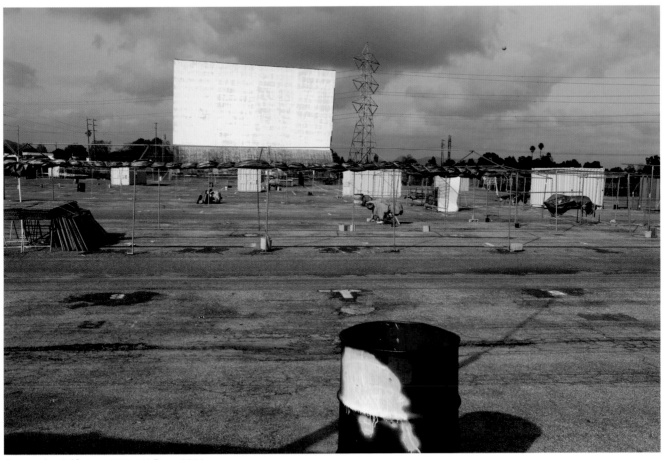

Oceanside, California – USA – Valley – 2011

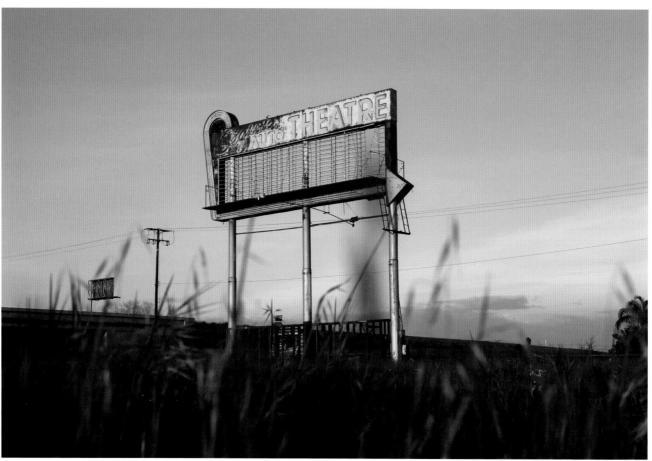

Visalia, California – USA – Fox – 2011

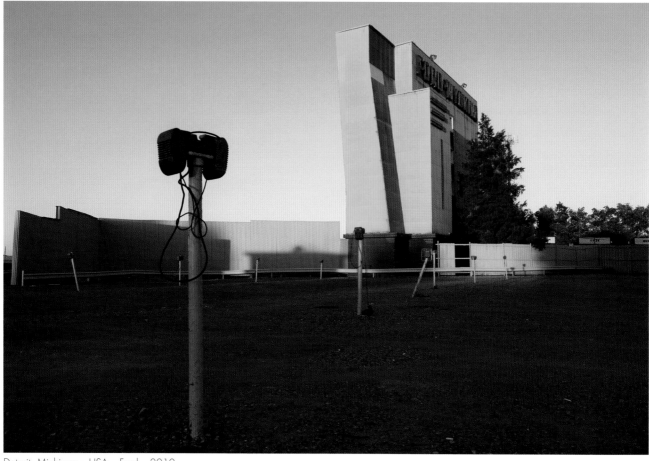

Detroit, Michigan – USA – Ford – 2010

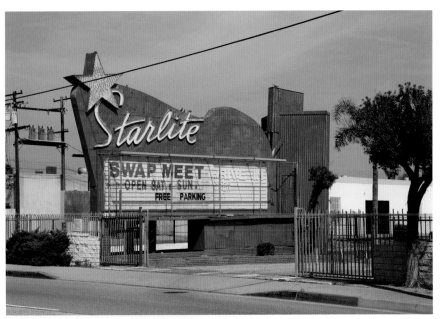

South El Monte, California – USA – Starlite – 2011

Leipzig – Germany – Luru–Kino – 2015

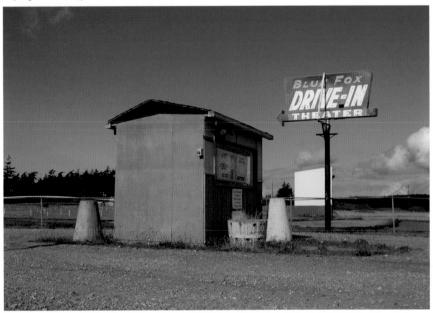

Seattle, Washington – USA – Blue Fox – 2009

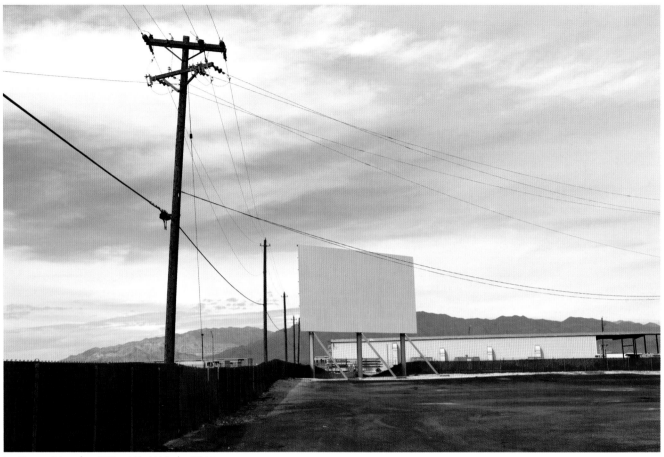

Las Vegas, Nevada – USA – West Wind – 2011

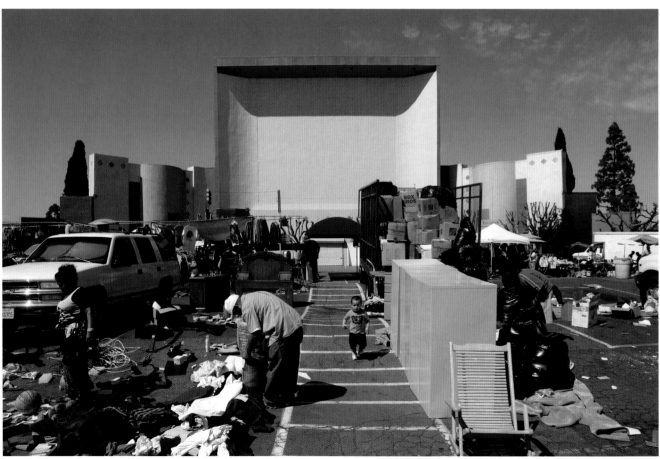

Torrance, California – USA – Roadium – 2011

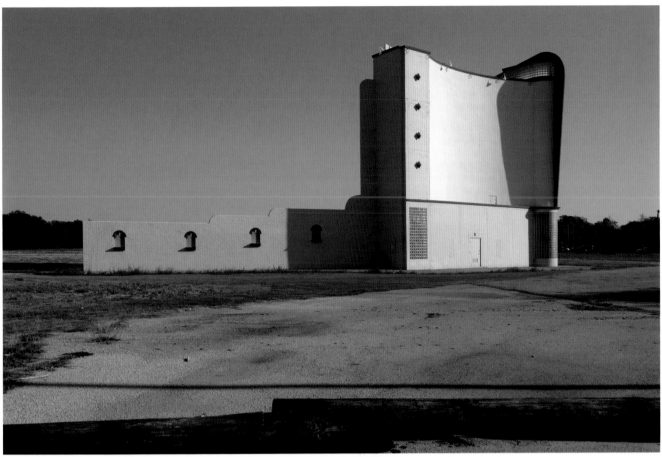

San Antonio, Texas – USA – Mission 4 – 2011

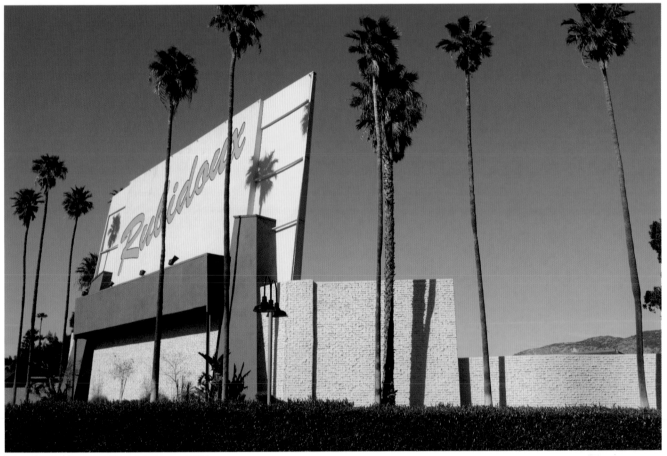

Riverside, California – USA – Rubidoux – 2011

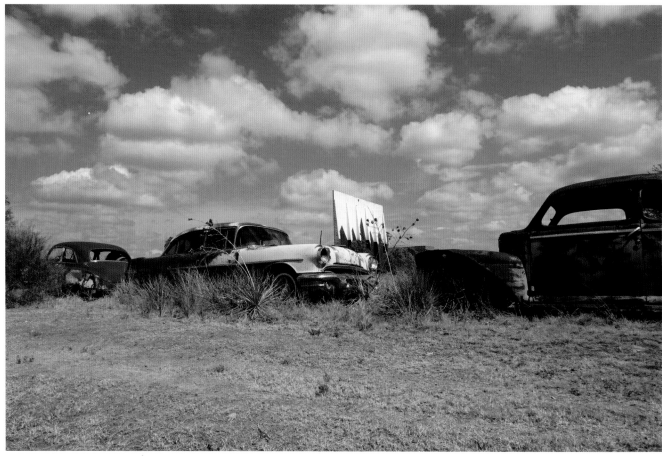

Sweetwater, Texas – USA – Midway – 2011

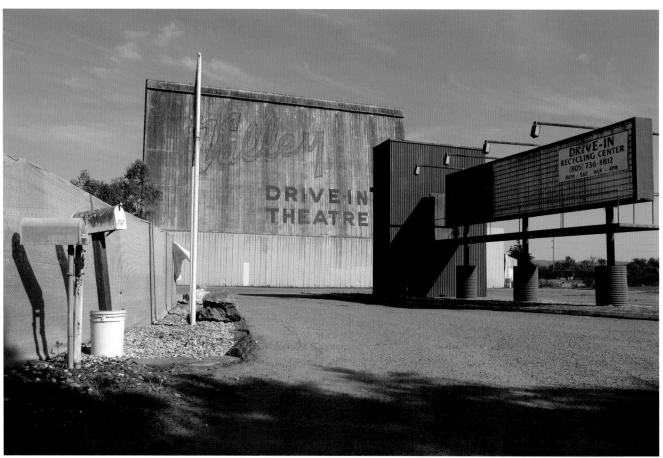

Lompoc, California – USA – Valley – 2011

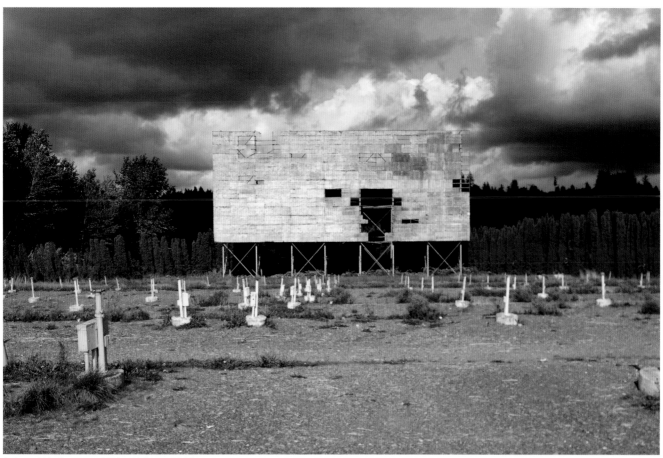

Auburn, Washington – USA – Valley – 2009

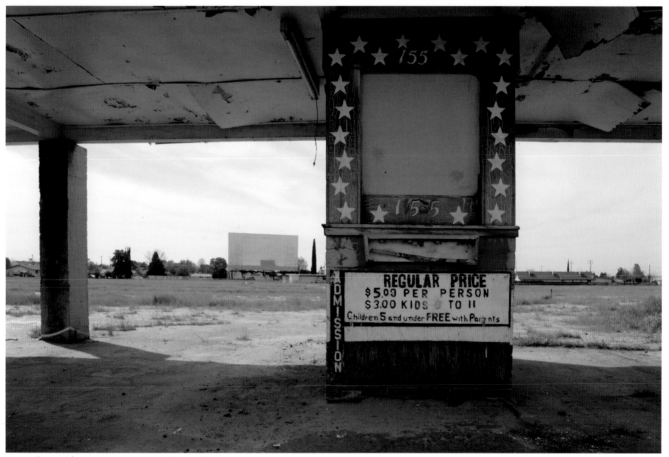

Porterville, California – USA – Porterville – 2011

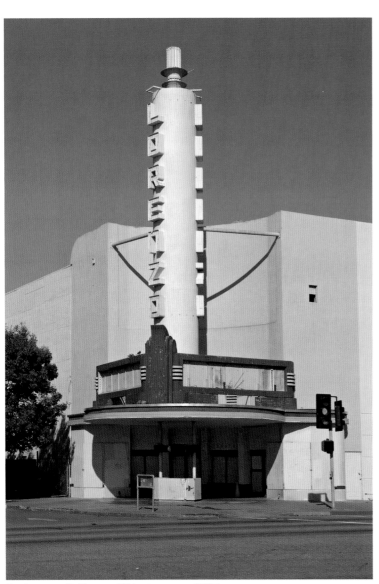

San Lorenzo, California – USA – Lorenzo – 2007

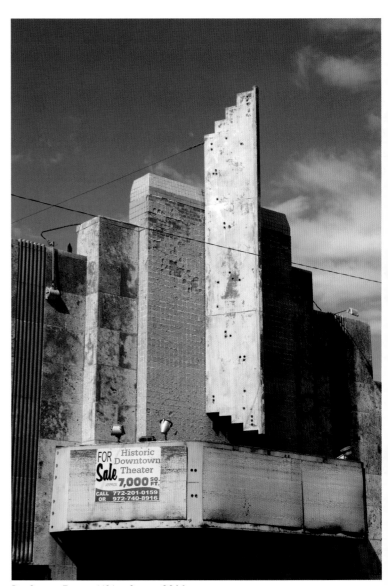

Big Spring, Texas – USA – State – 2011

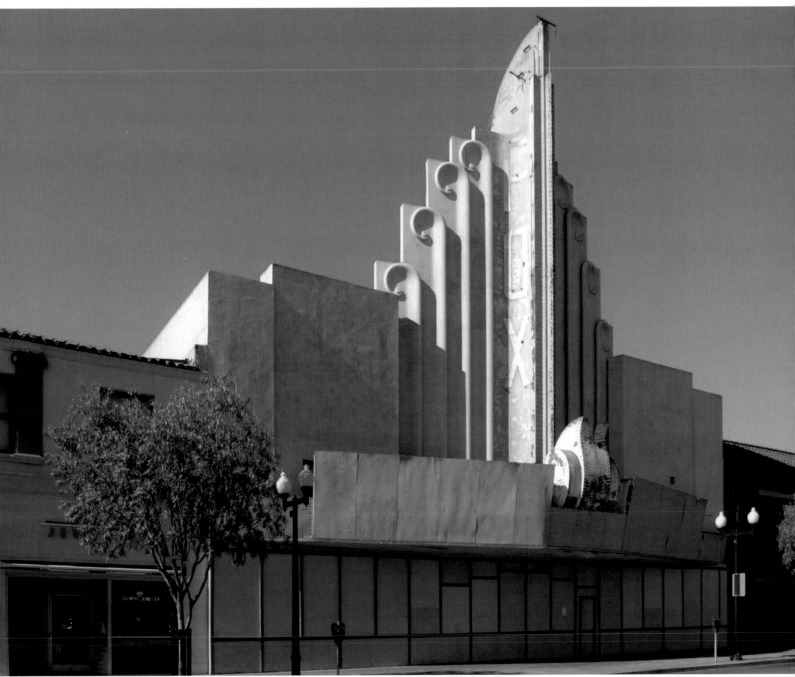

Inglewood, California – USA – Fox – 2011

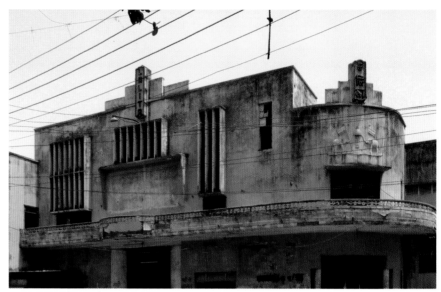

Varanasi – India – Lalita – 2012

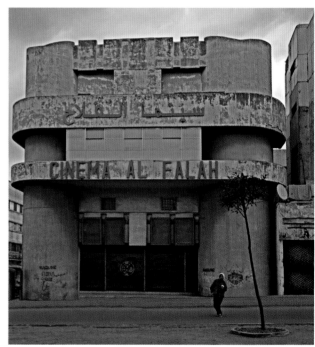

Casablanca – Morocco – Al Falah – 2017

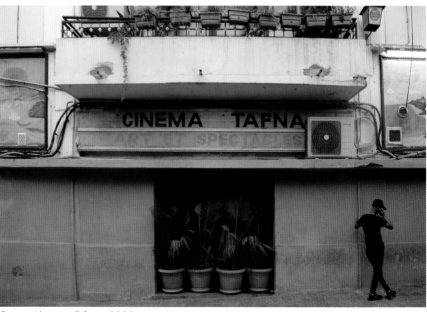

Oran – Algeria – Tafna – 2018

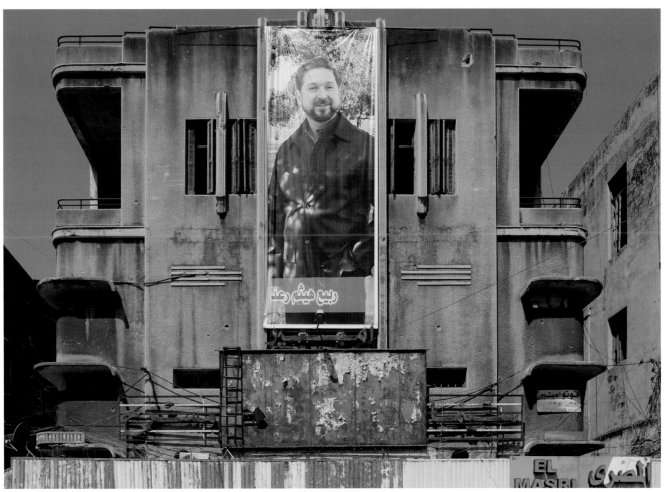

Tripoli – Lebanon – Empire – 2018

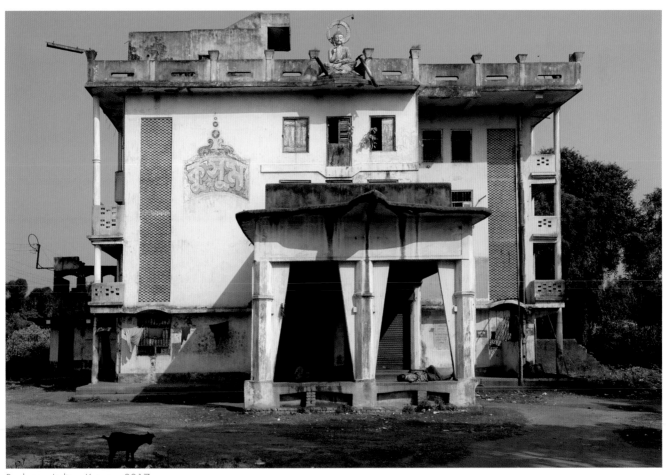

Bankura – India – Kusum – 2017

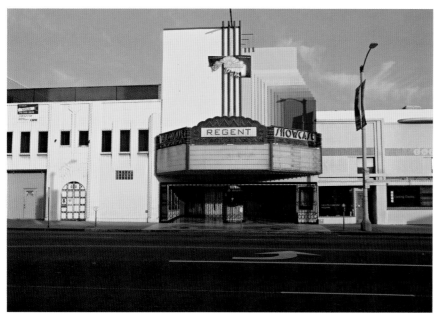

Hollywood, California – USA – Regent – 2015

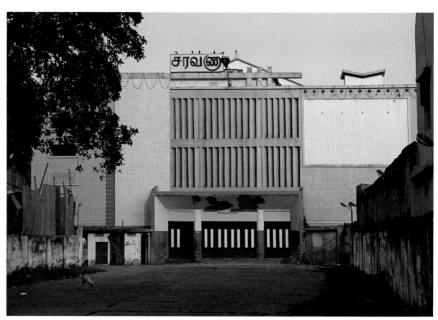

Chennai – India – Nishat – 2012

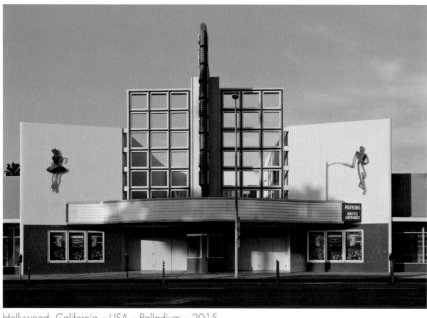

Hollywood, California – USA – Palladium – 2015

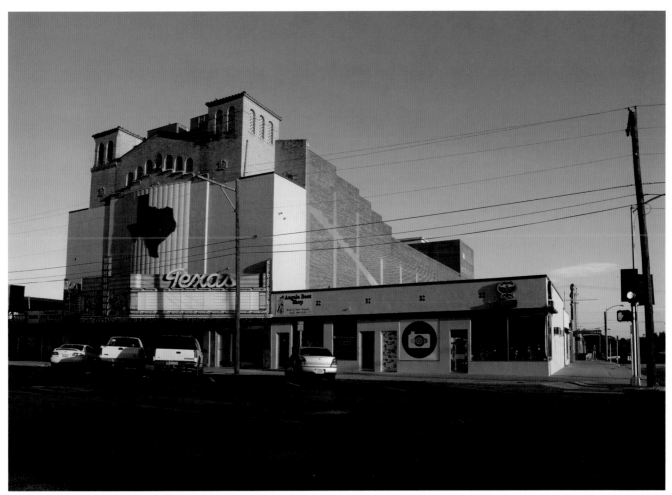

San Angelo, Texas – USA – Texas – 2011

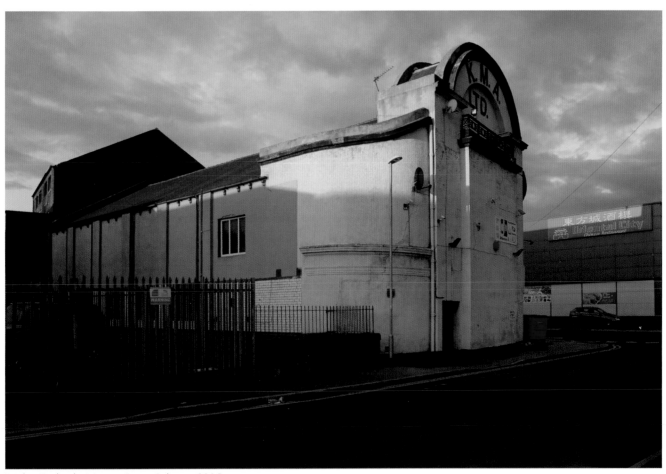

Leeds – England – Newton Picture Palace – 2015

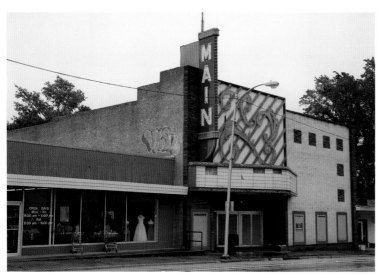

Nacogdoches, Texas – USA – Main – 2008

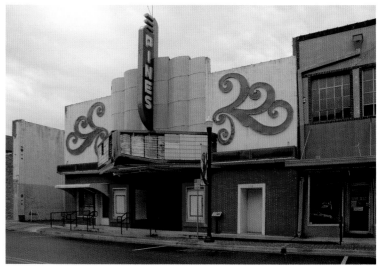

Lufkin, Texas – USA – Pines – 2008

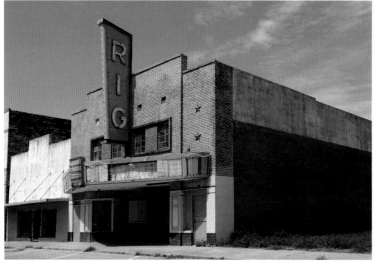

Premont, Texas – USA – Rig – 2011

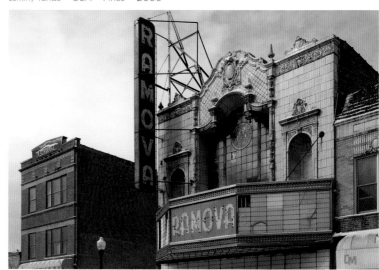

Chicago, Illinois – USA – Ramova – 2008

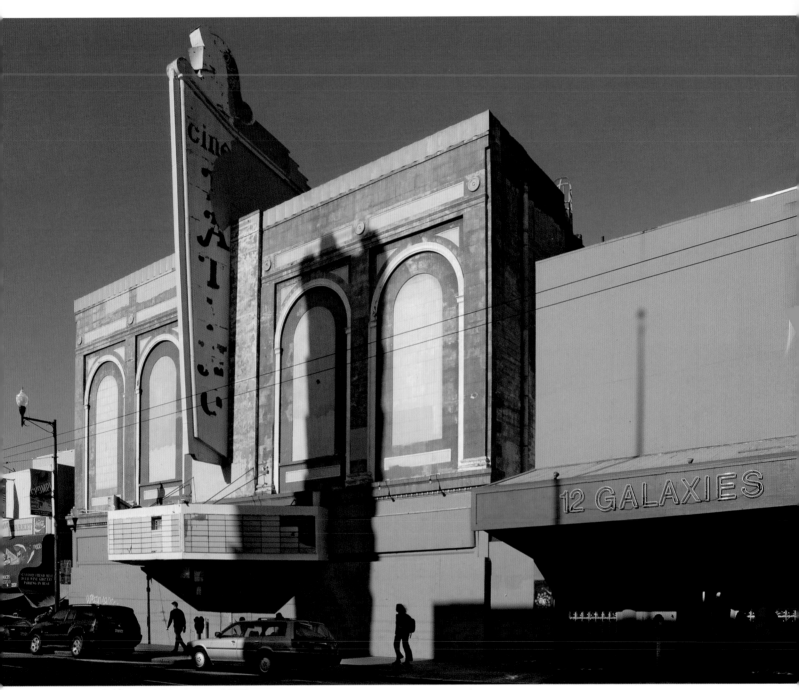

San Francisco, California – USA – Latino – 2007

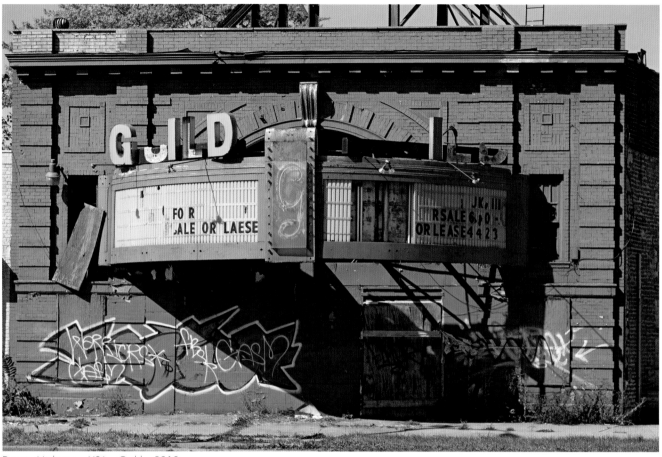

Detroit, Michigan – USA – Guild – 2010

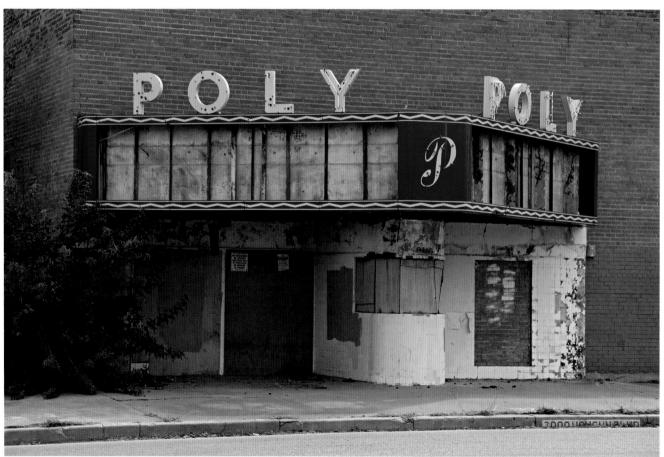

Fort Worth, Texas – USA – Poly – 2011

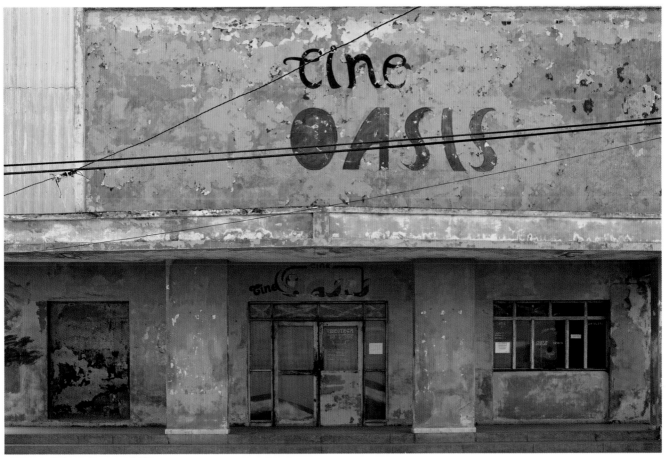

Havana – Cuba – Oasis – 2010

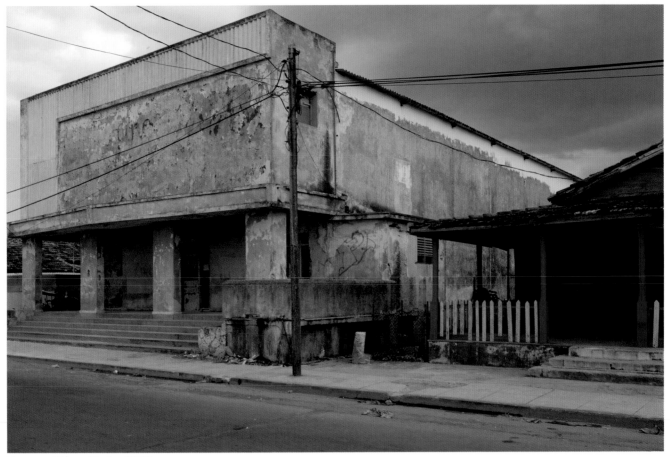

Havana – Cuba – Oasis – 2013

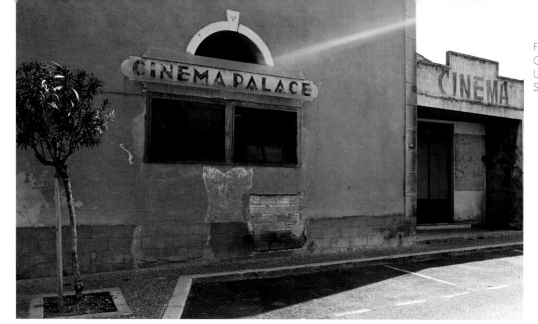

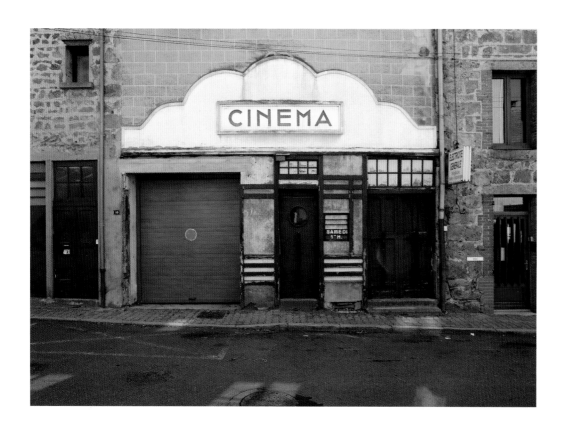

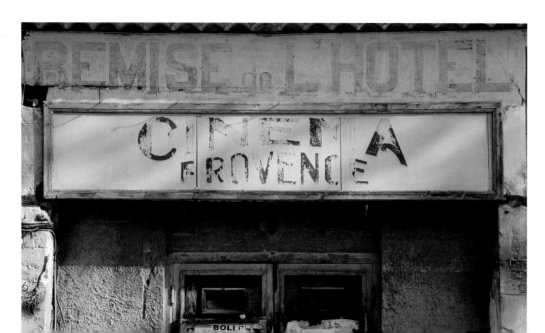

From top to bottom:
Cessenon-sur-Orb – France – Palace – 2015
Usson-en-Forez – France – Cinema – 2015
Saint-Paul-Trois-Châteaux – France – Provence – 20

Right page:
Ubrique – Spain – Alcazar – 2015

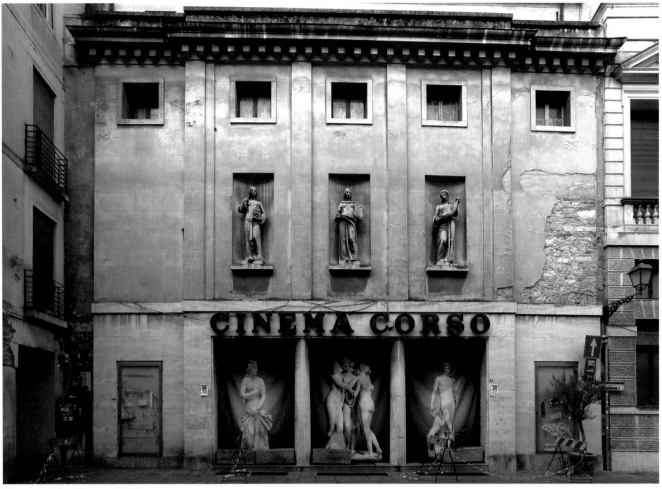

Vicenza – Italy – Corso – 2016

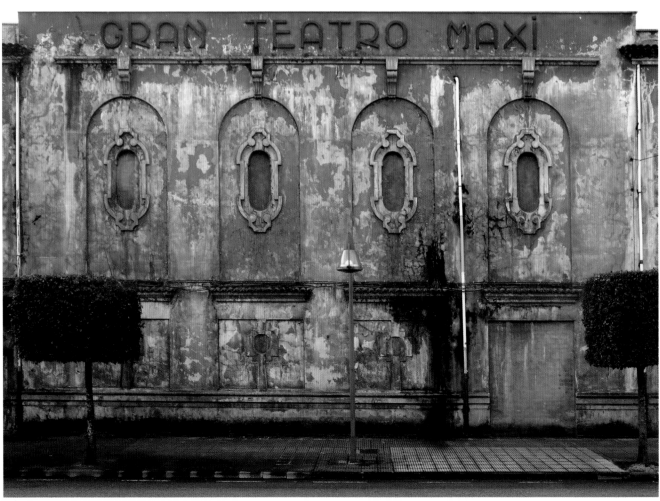

Pola de Laviana – Spain – Gran Teatro Maxi – 2018

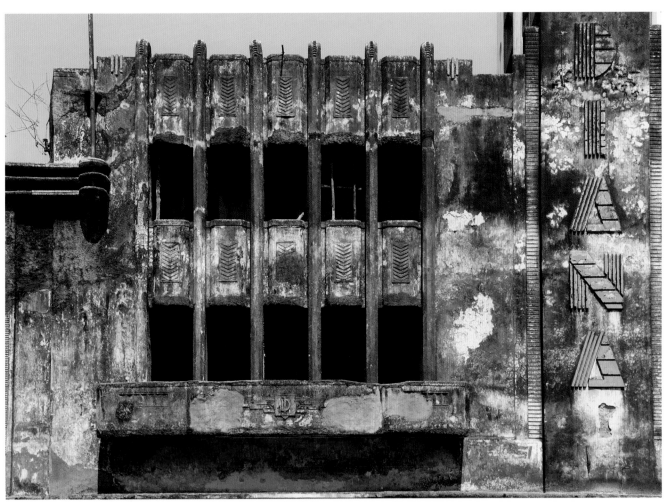

Mumbai – India – Diana – 2012

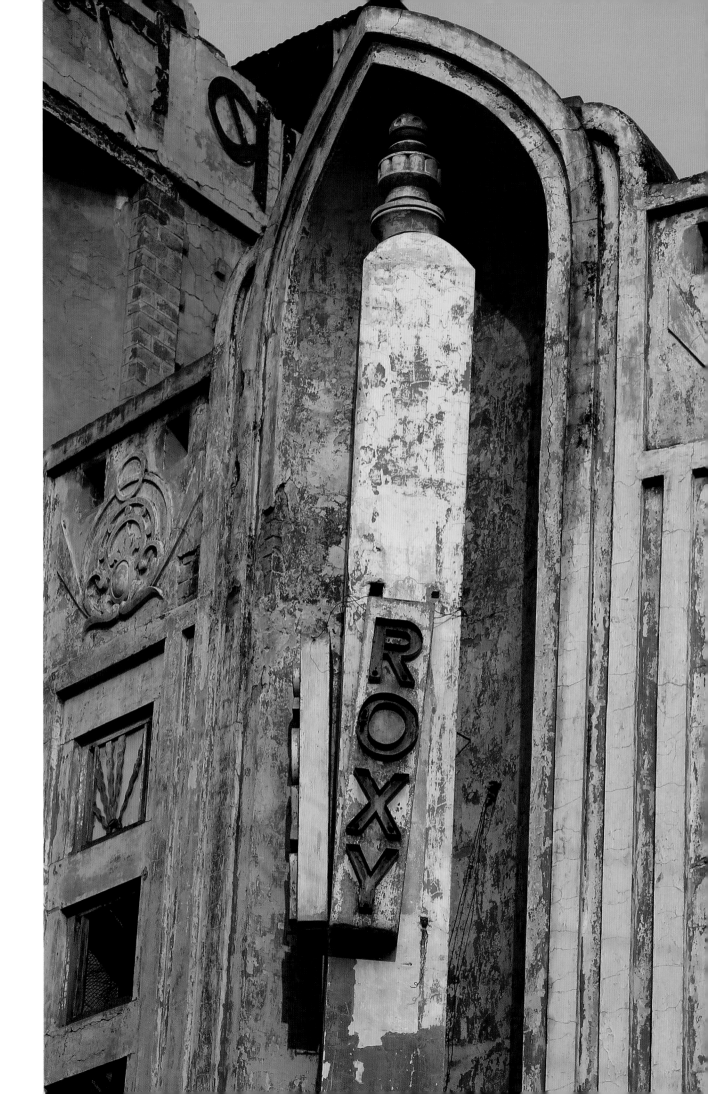

Today even the state of disrepair of the signs does not succeed in overshadowing the typographical skills of the people who created them in an age before a kind of gangrenous conformity had spread across the world.

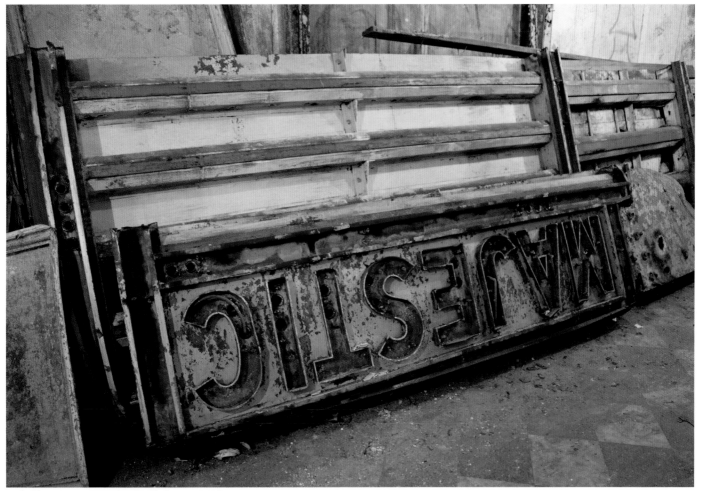

Bridgeport, Connecticut – USA – Majestic – 2010

Beirut – Lebanon – Colisée – 2018

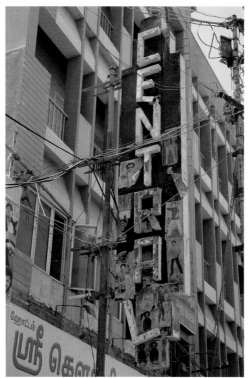

Madurai – India – Central – 2006

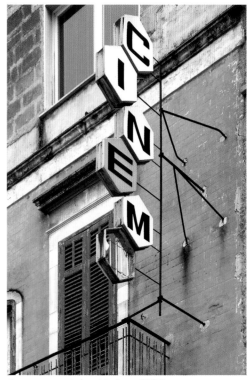

Conversano – Italy – Norba – 2008

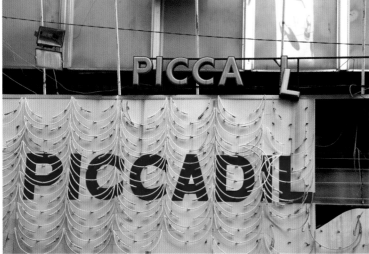

Beirut – Lebanon – Piccadilly – 2018

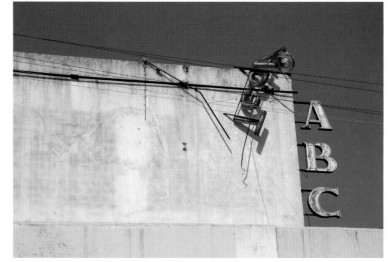

Porto – Portugal – ABC – 2008

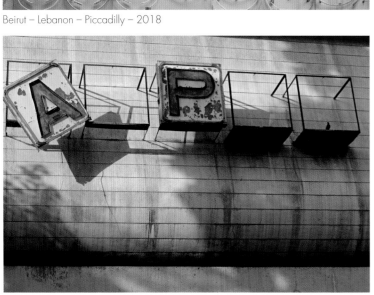

Delhi – India – Alpna – 2014

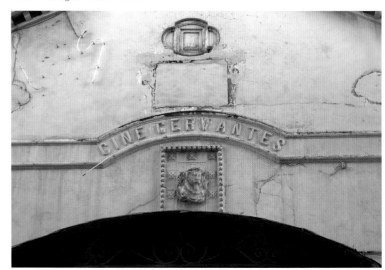

Torrent – Spain – Cervantes – 2016

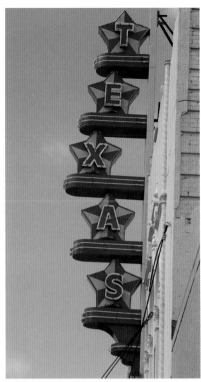

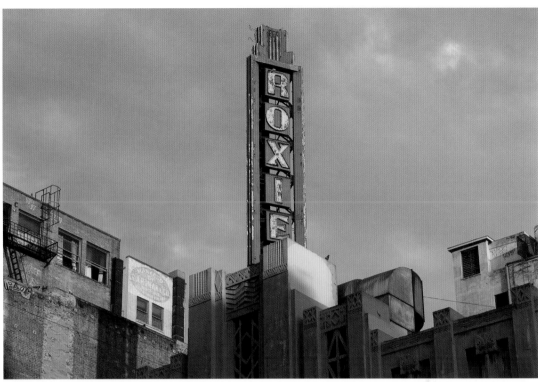

Dallas, Texas – USA – Texas – 2011 Los Angeles, California – USA – Roxie – 2015

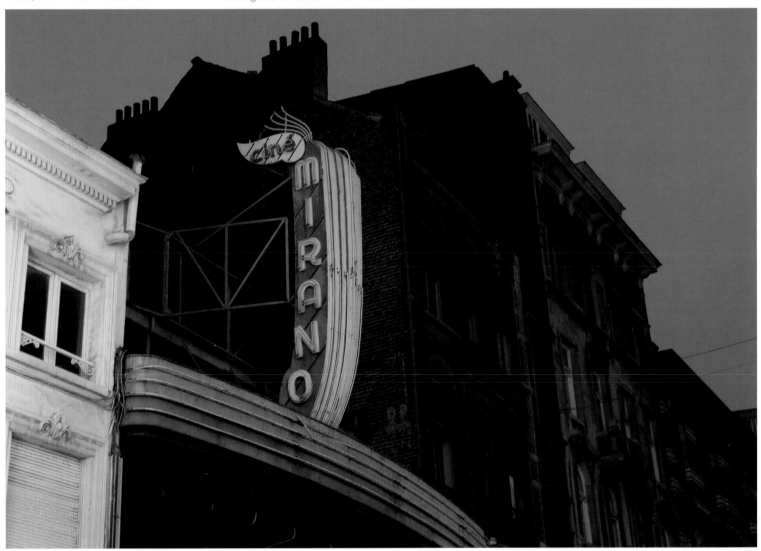

Brussels – Belgium – Mirano – 2011

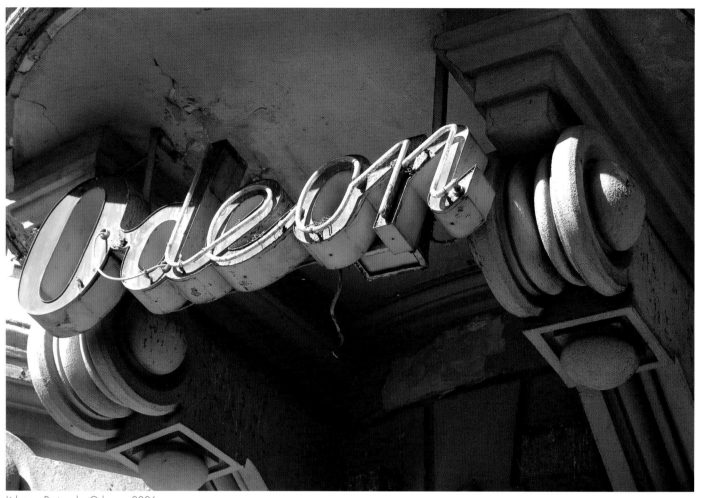

Lisbon – Portugal – Odeon – 2006

Right page:
Catania – Sicily – Tiffany – 2017

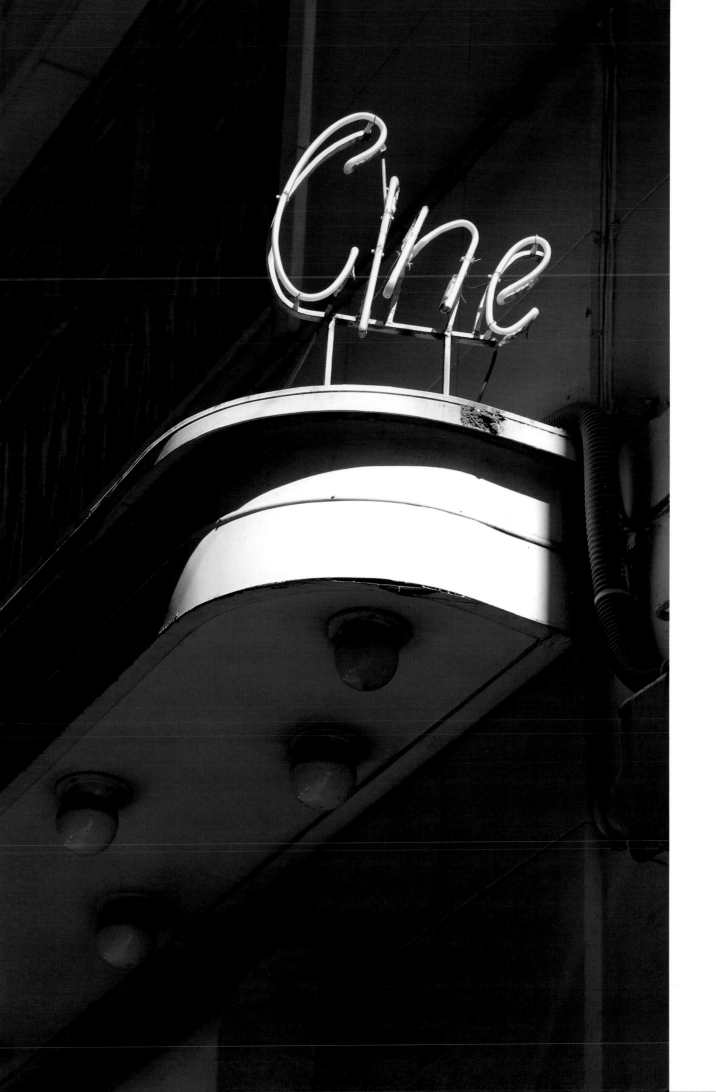

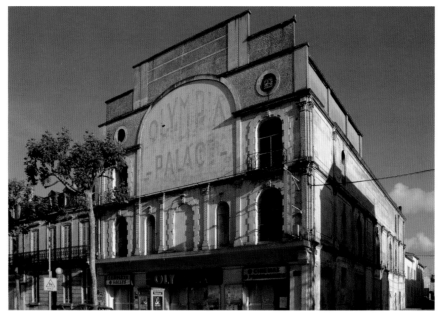

Saintes – France – Olympia – 2008

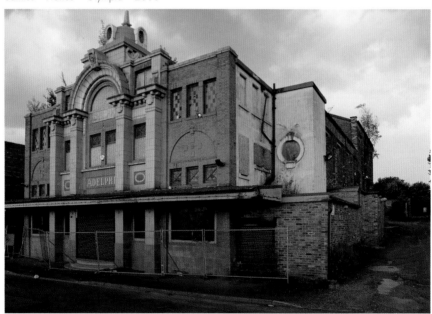

Sheffield – England – Adelphi – 2015

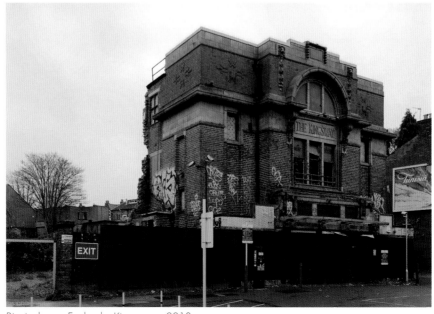

Birmingham – England – Kingsway – 2018

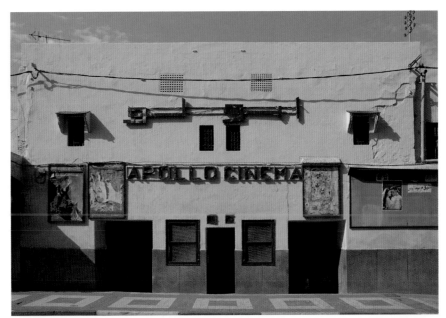

Meknes – Morocco – Apollo – 2009

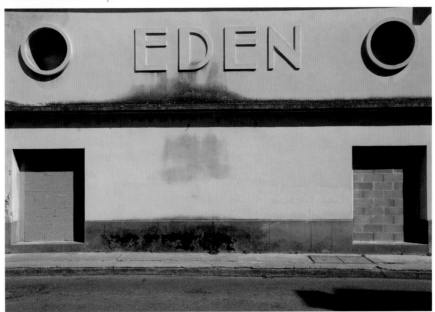

Ganges – France – Eden – 2016

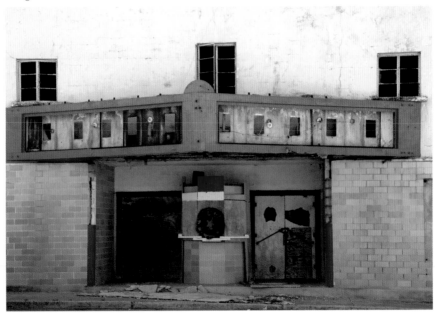

Freer, Texas – USA – Rialto – 2011

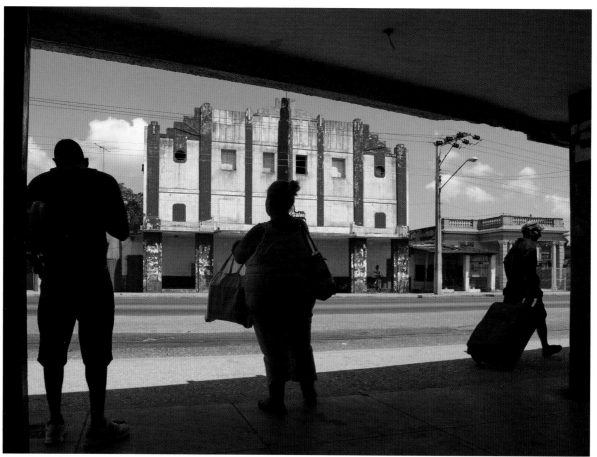

Havana – Cuba – Palma – 2013

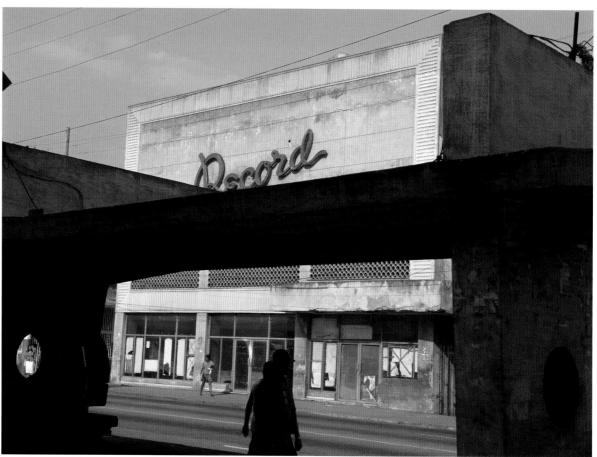

Havana – Cuba – Record – 2013

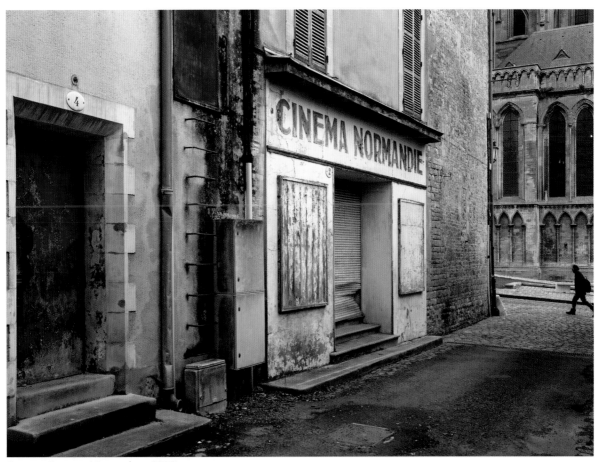

Bayeux – France – Normandie – 2013

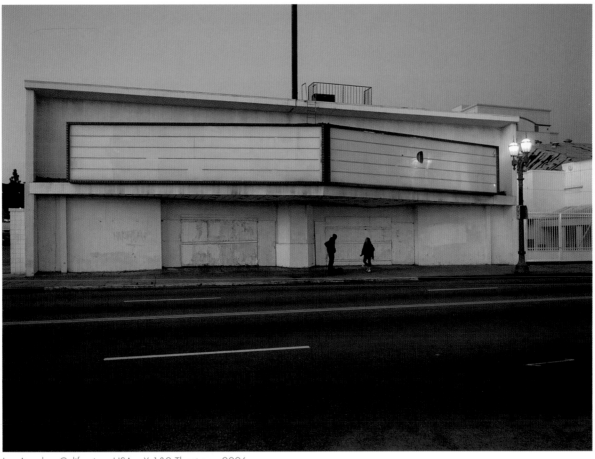

Los Angeles, California – USA – X 1&2 Theatres – 2006

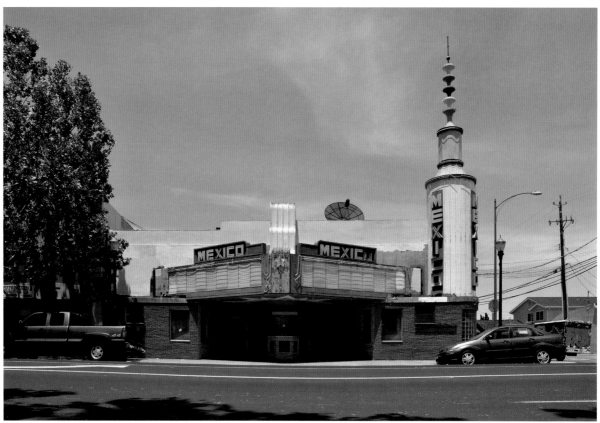

San Jose, California – USA – Mexico – 2007

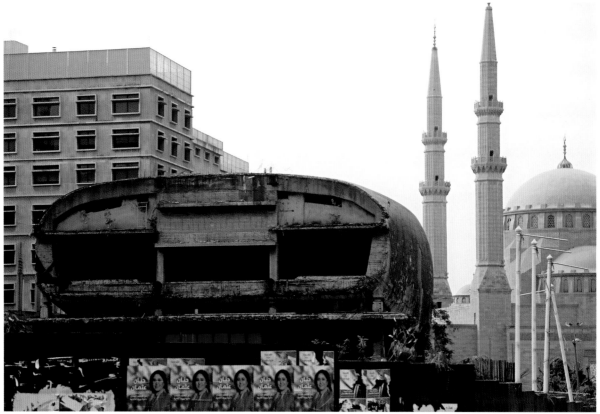

Beirut – Lebanon – Dôme (The "egg") – 2018

Bearing all the hallmarks of a Lebanese folly, the Dôme Cinema – often referred to as "The Egg" – was never completed. Inspired by the World Trade Center, it was supposed to be flanked by two imposing towers. It is one of history's ironies that the New York towers were destroyed, while those in Beirut were never built, because civil war in Lebanon prevented the completion of the project.

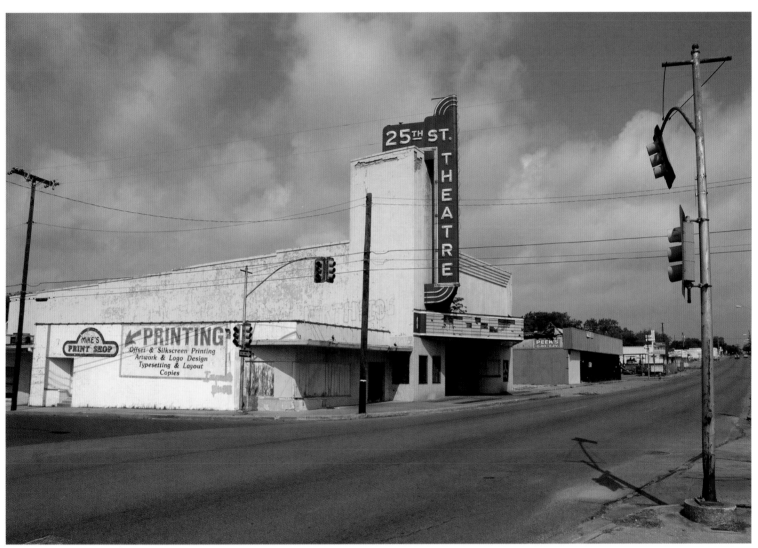

Waco, Texas – USA – 25th Street Theater – 2008

Bryan, Texas – USA – Queen – 2008

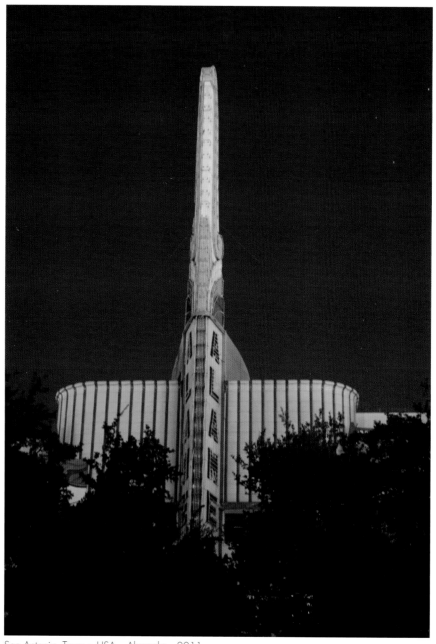

San Antonio, Texas – USA – Alameda – 2011

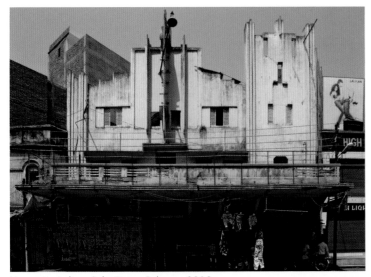

Varanasi – India – Sahu Picture Palace – 2012

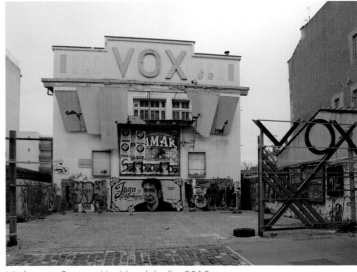

Narbonne – France – Vox (demolished) – 2015

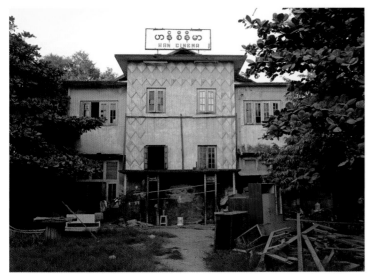

Kyaukse – Myanmar – Han – 2016

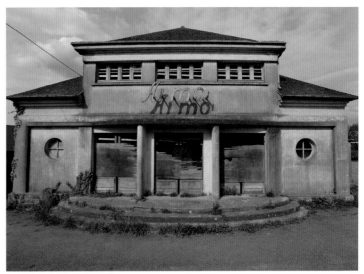

Montreuil-sur-Ille – France – Armor – 2015

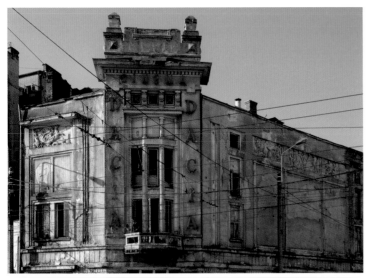

Bucharest – Romania – Dacia – 2008

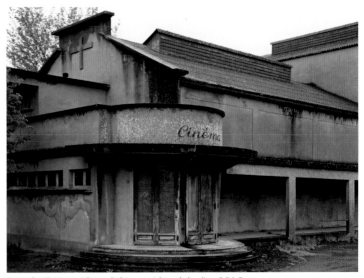

Derval – France – Saint Sébastien (demolished) – 2015

Sometimes disused cinemas are simply absorbed into the surrounding urban landscape. With the passage of time their frontages are slowly but surely eroded, until even the authorities and property developers seem oblivious to their presence. They remain where they are, ignored by the world, overlooked remains of a bygone age.

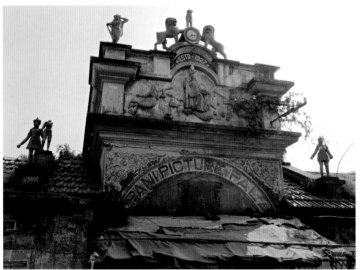
Bankura – India – Binapani – 2018

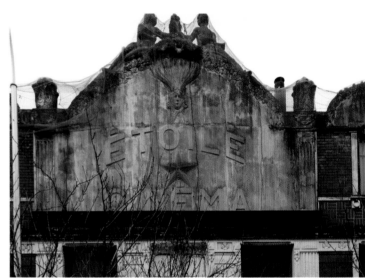
La Courneuve – France – Étoile – 2012

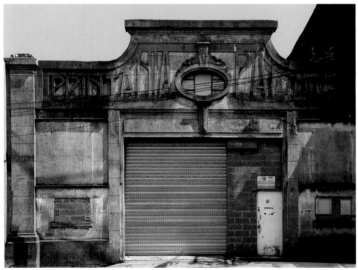
Auchel – France – Printania – 2013

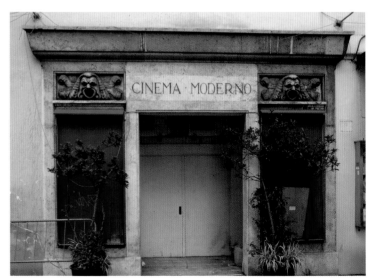
Rome – Italy – Moderno – 2006

Havana – Cuba – Santos Suarez – 2013

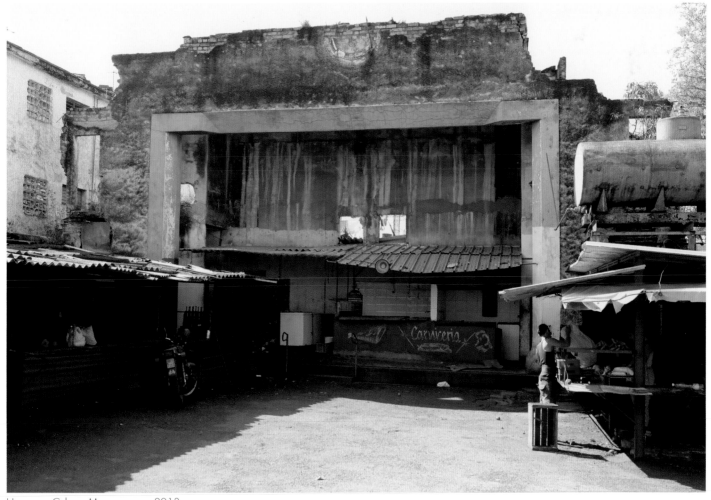

Havana – Cuba – Manzanares – 2013

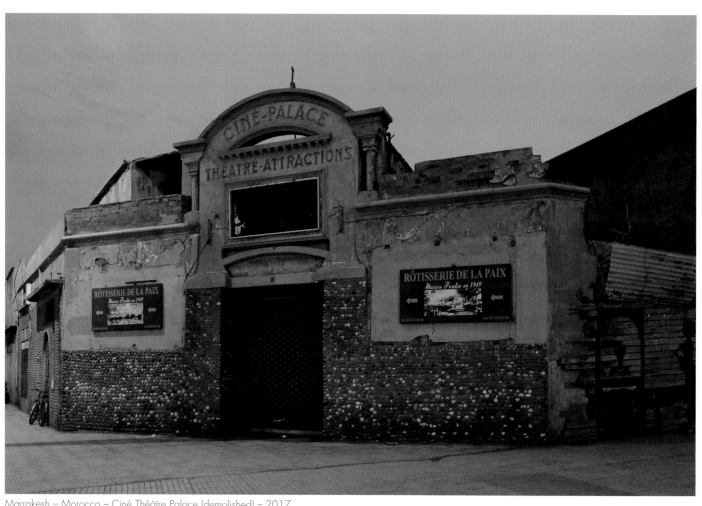

Marrakesh – Morocco – Ciné Théâtre Palace (demolished) – 2017

The Ciné Théâtre Palace was built in 1926, modelled on the Lumière brothers' Eden Theatre. Its Art Deco frontage, which long resisted the elements, was an architectural jewel. Originally, the cinema also had an open-air theatre and a dance floor. Nat King Cole appeared here, and Rita Hayworth once lightly swung her hips as she crossed the auditorium to present *Gilda*. Founded in 2007, the "Save Cinemas in Morocco" association arranged regular visits and tried to breathe new life into the Ciné Théâtre. But in spite of continued support, the cinema was destroyed in October 2018.

Thirty years ago there were 280 cinemas in Morocco, frequented by 50 million cinemagoers. But by 2017 only 27 cinemas remained for its 1.6 million viewers. The most beautiful movie theatres have been turned into supermarkets or car parks, now primarily used by couples seeking privacy in a country where public displays of love can have severe consequences.

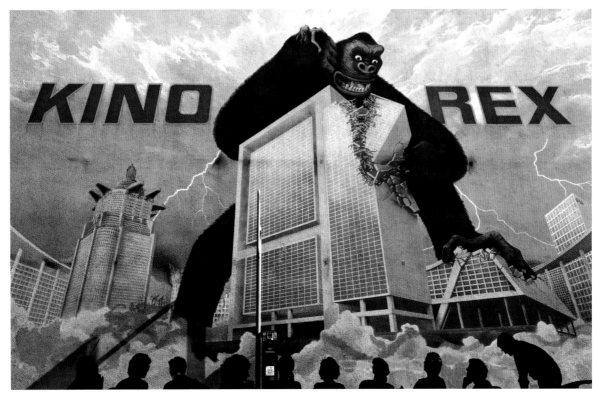

Bienne – Switzerland – Rex – 2011

Cinema names have to be easy to remember – short and catchy. They need to hint at what is on offer inside: The Familia (with its wholesome choice of showings), The Palace (a place of dreams), The Modern, The Central and The Coliseum. In later years, cinemas were named on the whim of their new management, or based on a recent event, such as The Concorde (a tribute to aviation). Some names caught on more quickly than others; while there are 300 theatres called The Odeon in England and the United States, similarly-named cinemas have remained quite rare in other countries.

Some picture houses have names based on their cinematographic past; The Méliès and The Lumière, in tribute to those pioneers of cinema, can be found all over the world. At a more local level, cinema canopies might bear names such as Lubitsch, Gabin, Arletty or Renoir. Other names are chosen to remind us of great cinematic works, such as the Les Enfants du Paradis in Chartres.

Curiously, many iconic cinema names end with an 'x' – The Lux, The Pax, The Vox. There are few cities that don't boast a Rex! The letter 'x' also slips quietly into other theatre names – The Excelsior or The Roxy, for example. How could one forget the Roxy Theatre in New York City, built in 1927 with the capacity to seat an audience of 5,920? It was the biggest in the world at the time, opening with *The Love of Sunya*, produced by and starring Gloria Swanson. The legendary film star would return in 1960 to the ruins of the Roxy, visibly distressed as she stood before the site of the demolished theatre. The Golden Age of Hollywood was coming to an end and the demolition of these temples, which had once seemed eternal, was just beginning. It continues to this day. Fashionable modern brands stand poised in the wings, eyeing up the undamaged façades of these buildings, eager to impose new names that promise to make different dreams come true:

Nike, Mango, Zara.

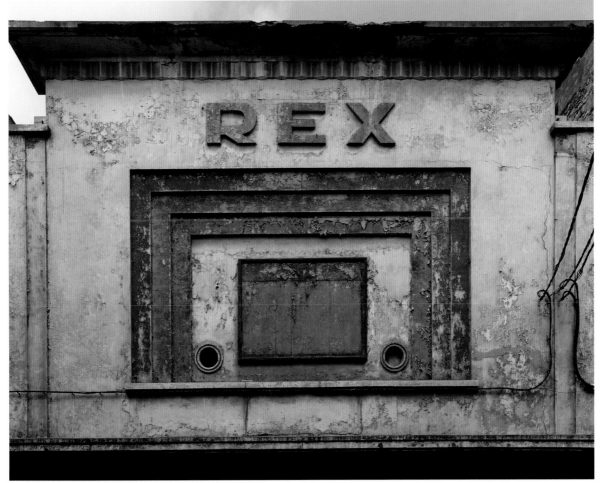

Oran – Algeria – Rex – 2018

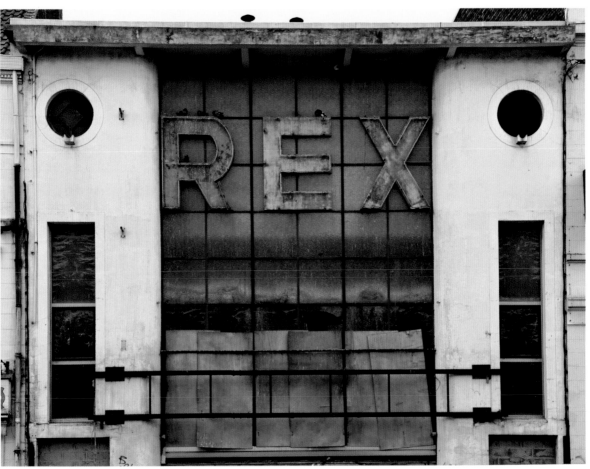

Armentières – France – Rex – 2011

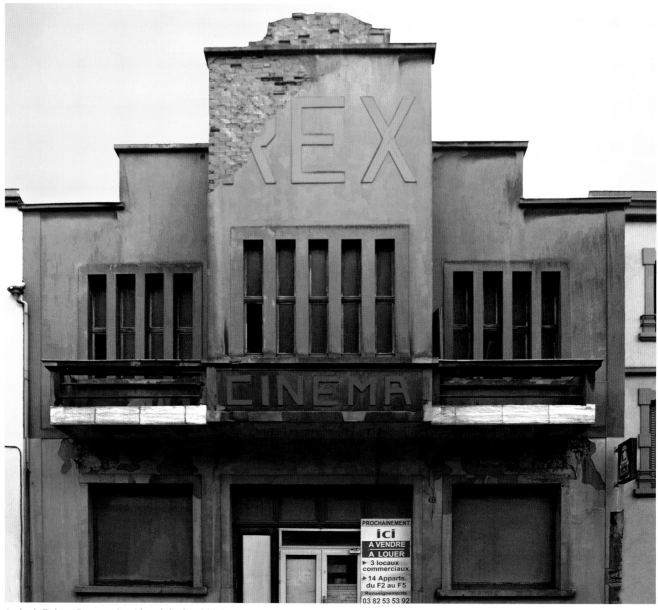

Audun-le-Tiche – France – Rex (demolished) – 2014

Right page:
Champagnole – France – Rex – 2018

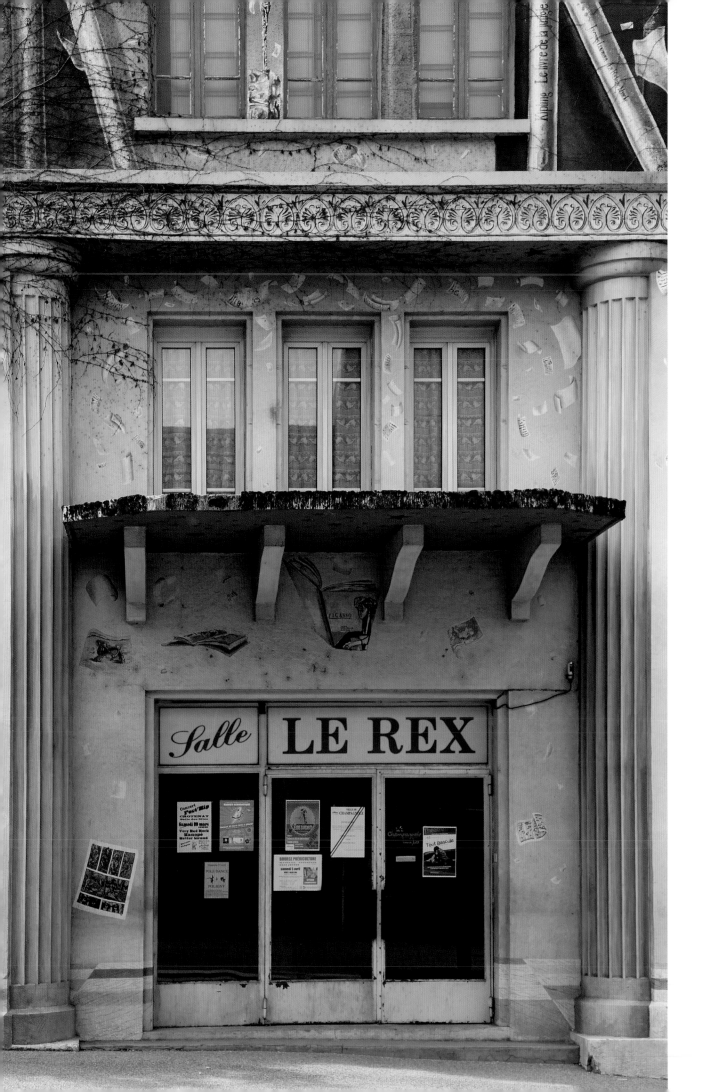

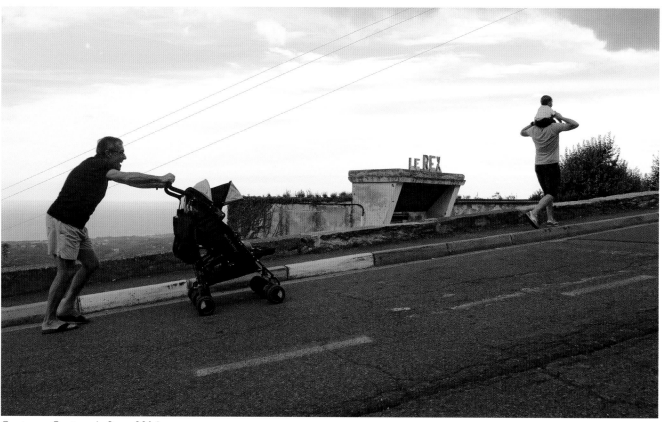

Cervione – Corsica – Le Rex – 2014

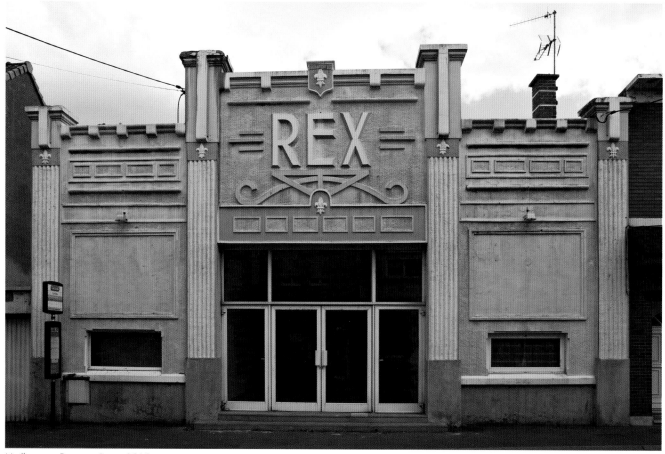

Haillicourt – France – Rex – 2012

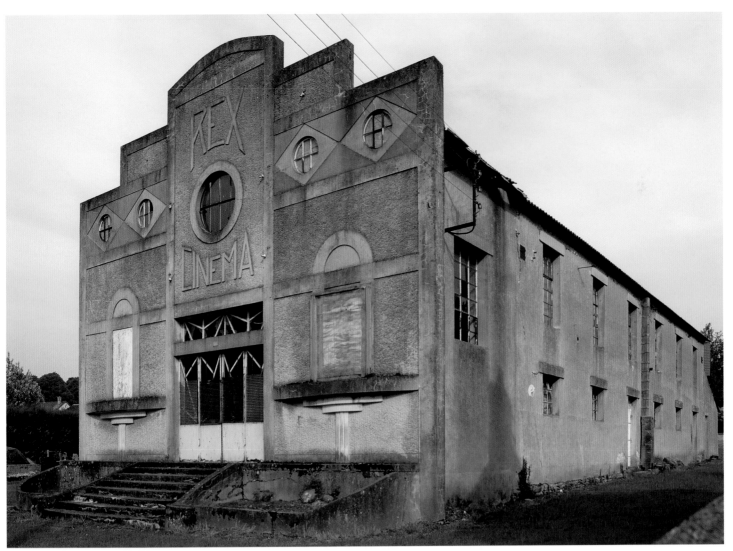

Guérigny – France – Rex – 2008

A clothes shop in an uninspiring street. At the door sits a Chinese man eating lunch. He continues eating as he watches us approach. Apparently, the door conceals two cinemas, one above the other, a double-decker with a total of about four thousand seats. It seems barely credible. The man nods; a hundred dollars changes hands; and the next minute, we slip along a magnificent corridor, now used as a jeans store with an emphasis on discontinued lines. Dim lighting fades into total darkness. We switch on our pocket torches to reveal seats with gaping upholstery and screens in shreds. The RKO Proctor's in Newark, New Jersey, is nothing more than a ghost of its former self, destined to be forgotten. Few seem aware that a cinema ever stood here ... a fate shared by so many thousands of other auditoriums around the world.

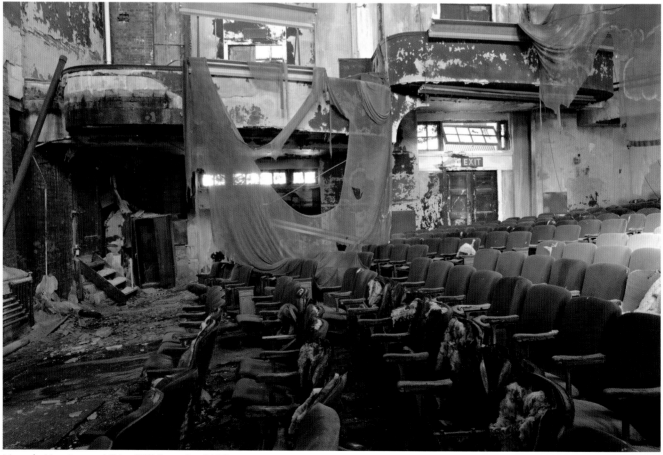

Newark, New Jersey – USA – RKO Proctor's – 2010

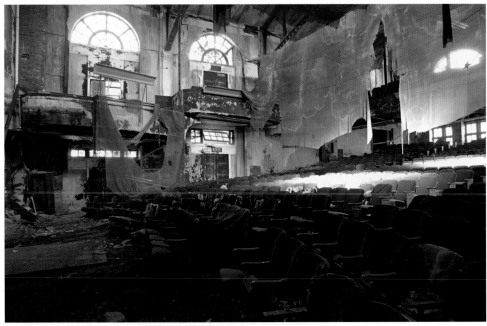

Newark, New Jersey – USA – RKO Proctor's – 2010

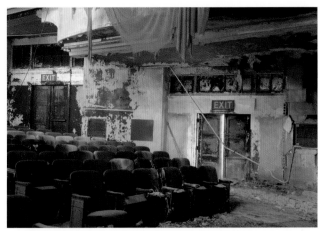

Newark, New Jersey – USA – RKO Proctor's – 2010

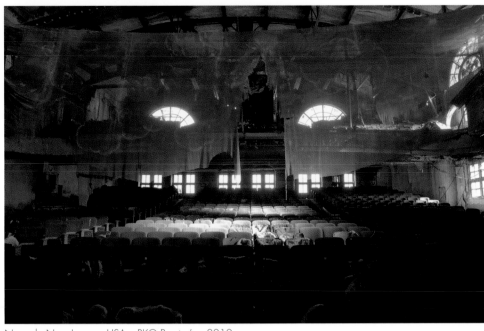

Newark, New Jersey – USA – RKO Proctor's – 2010

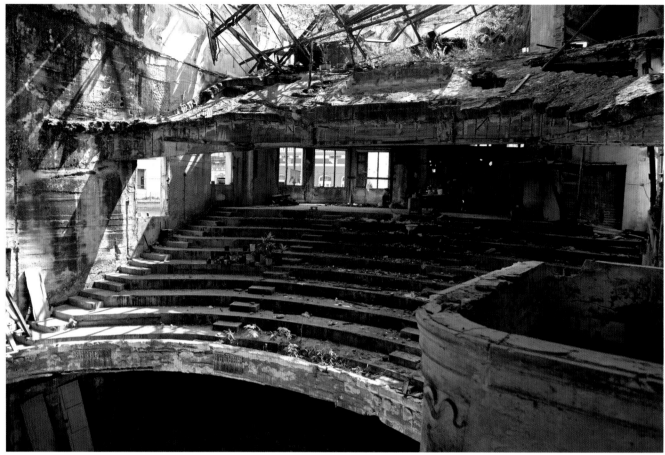

Havana – Cuba – Campoamor – 2013

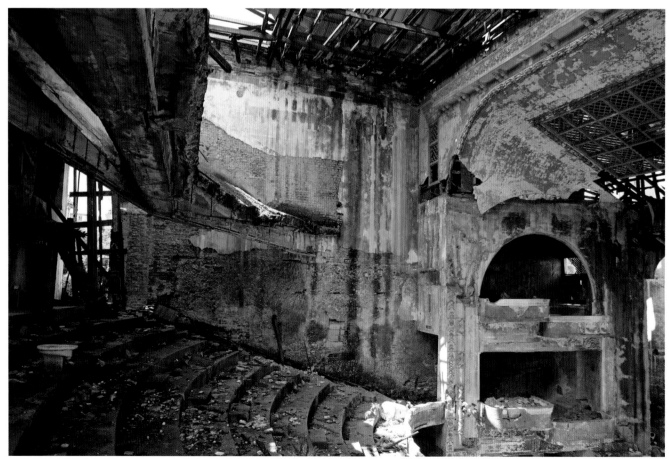

Havana – Cuba – Campoamor – 2013

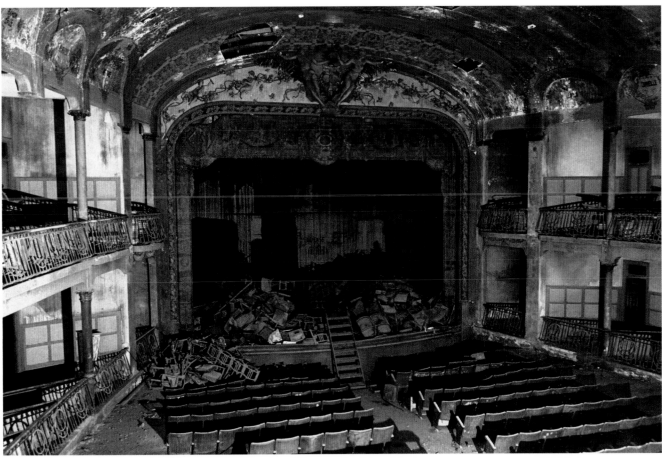

Tangier – Morocco – Cervantes – 2011

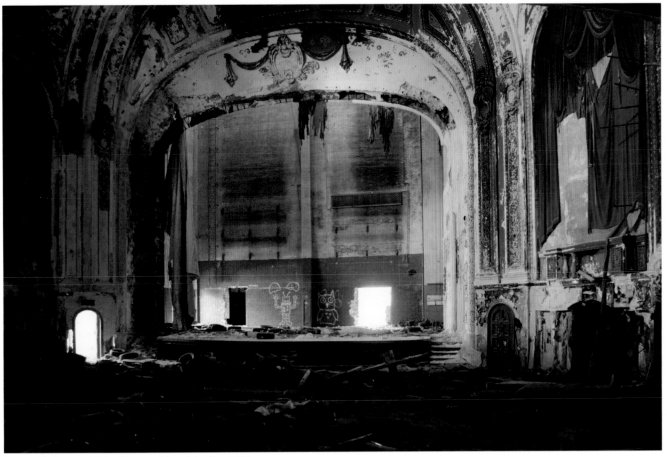

Detroit, Michigan – USA – Eastown (demolished) – 2010

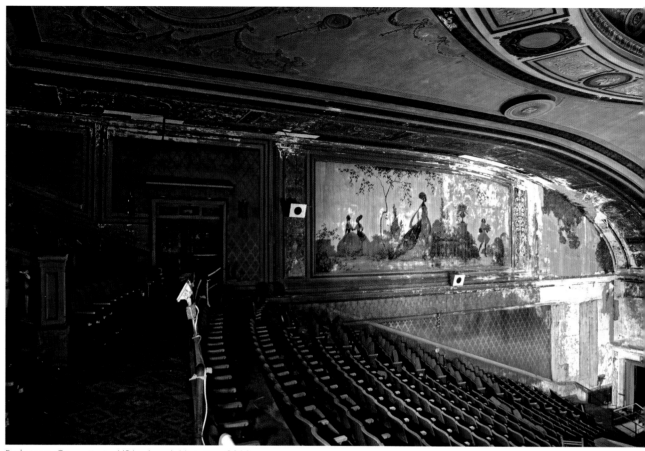

Bridgeport, Connecticut – USA – Loew's Majestic – 2011

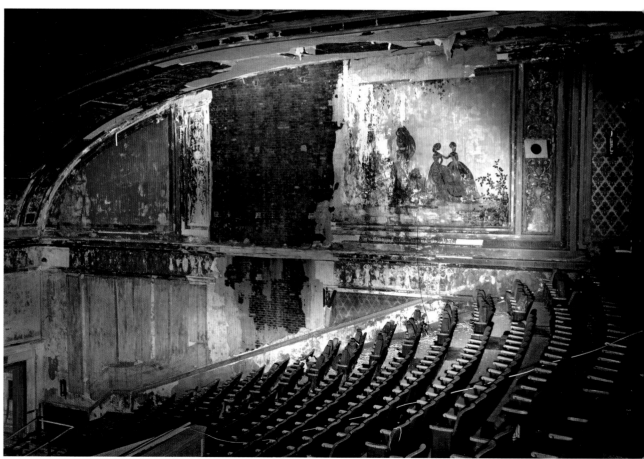

Bridgeport, Connecticut – USA – Loew's Majestic – 2011

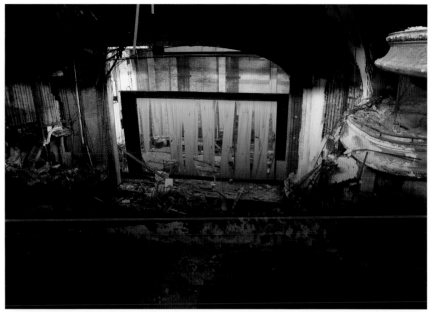

Newark, New Jersey – USA – RKO Proctor's – 2010

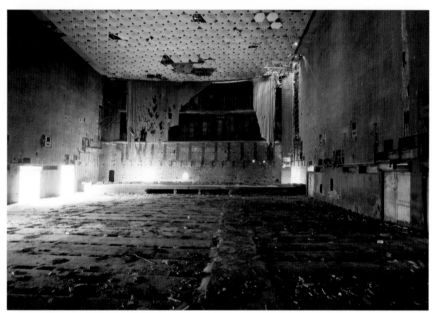

Delhi – India – Chand – 2016

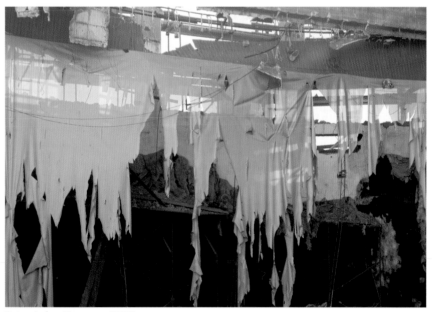

Turin – Italy – Fiamma – 2008

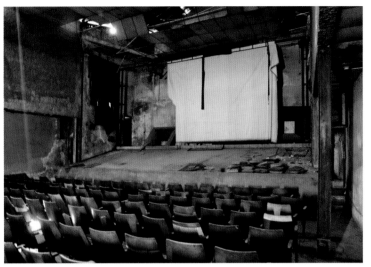

Havana – Cuba – Cervantes – 2013

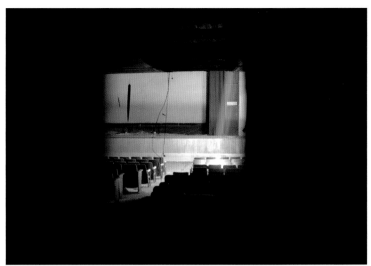

Rabat – Morocco – Mauritania (demolished) – 2009

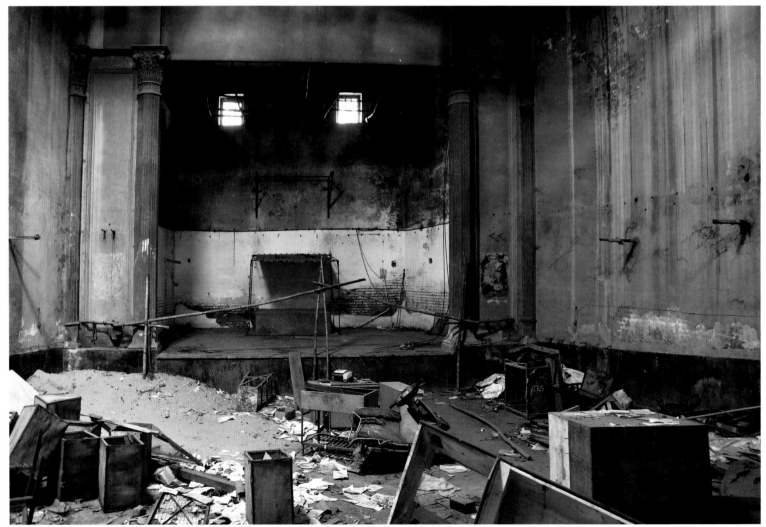

Beawar – India – Royal – 2016

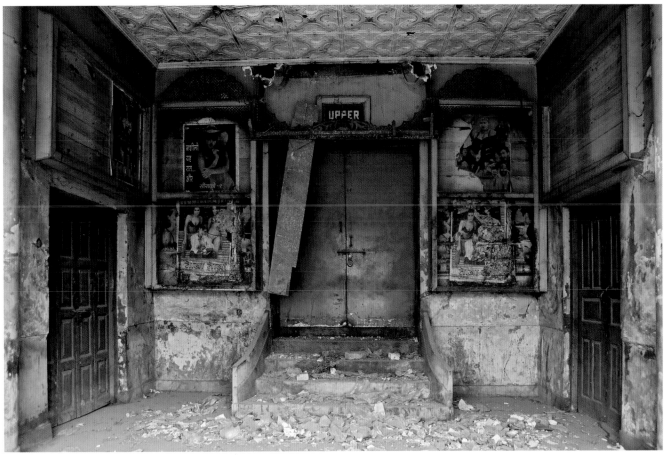

Ambala – India – Nishat – 2017

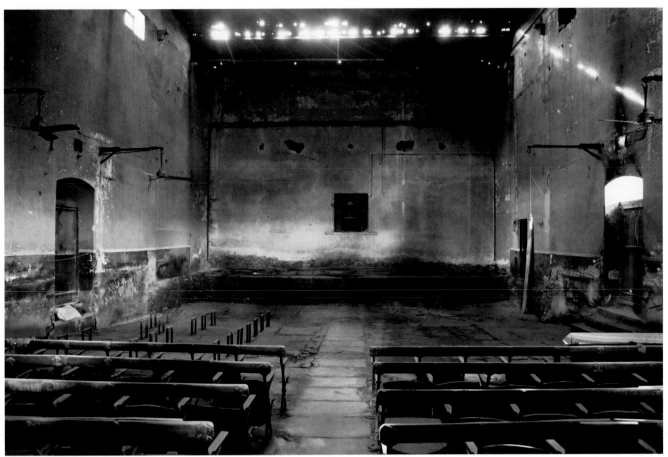

Allahabad – India – Rupbani – 2017

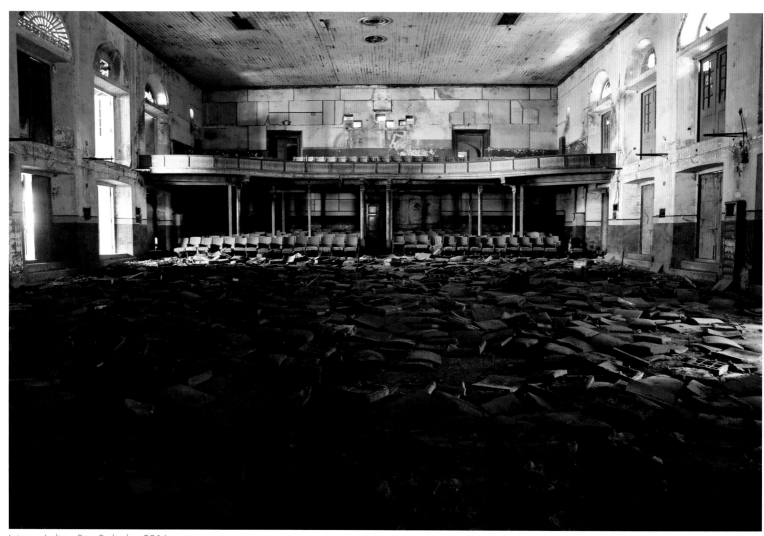

Jaipur – India – Ram Prakash – 2016

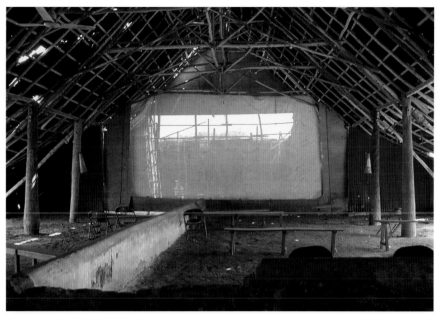

Karaikudi – India – name not known – 2006

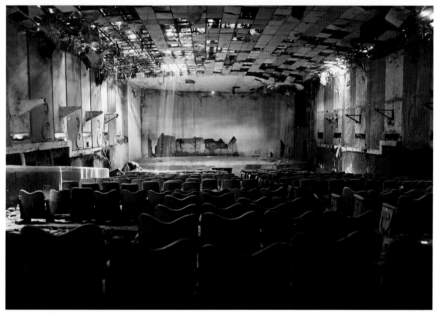

Delhi – India – Jagat – 2012

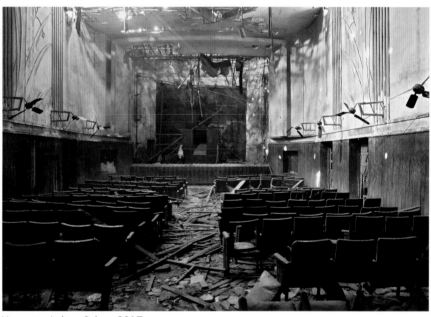

Varanasi – India – Sahu – 2017

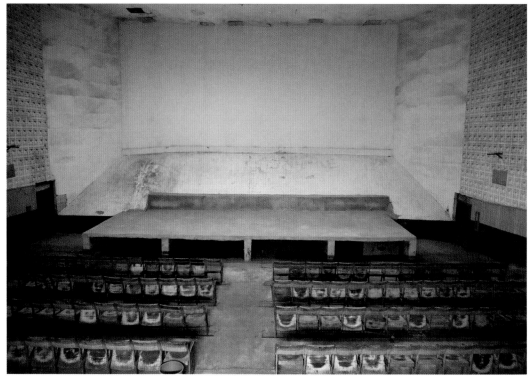

Jaisalmer – India – Ramesh – 2016

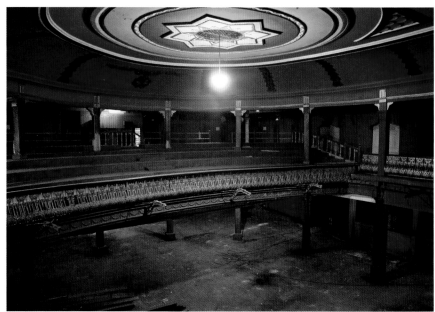

Mumbai – India – Capitol – 2012

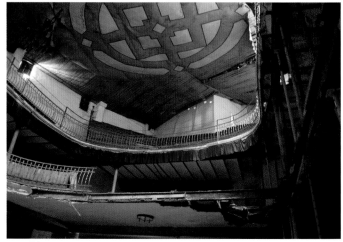

Sa Pobla – Majorca, Spain – Can Guixa – 2013

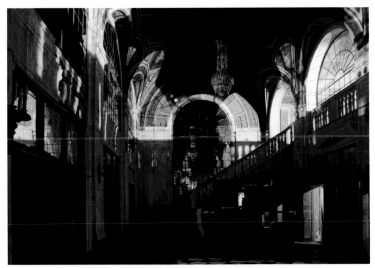

Bridgeport, Connecticut – USA – Loew's Majestic – 2011

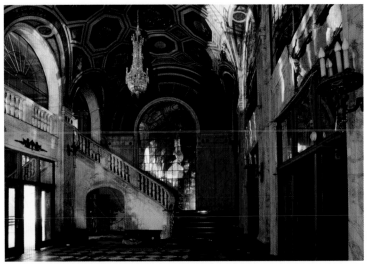

Bridgeport, Connecticut – USA – Loew's Majestic – 2011

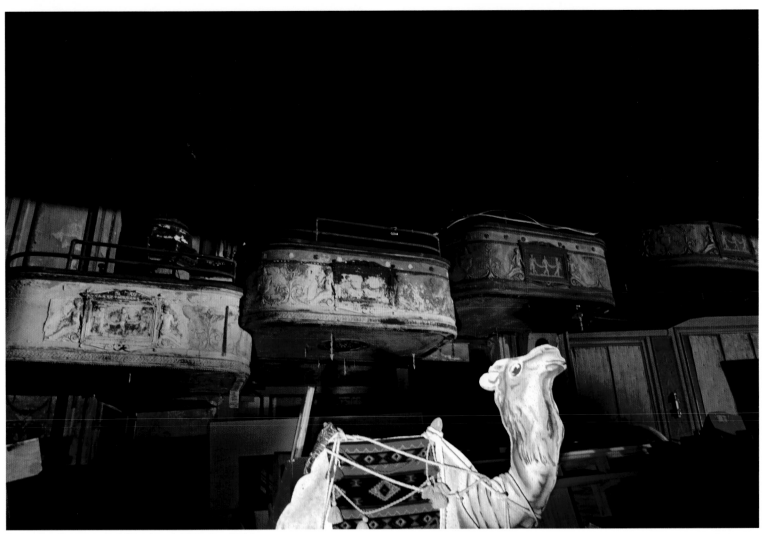

Bridgeport, Connecticut – USA – Loew's Majestic – 2011

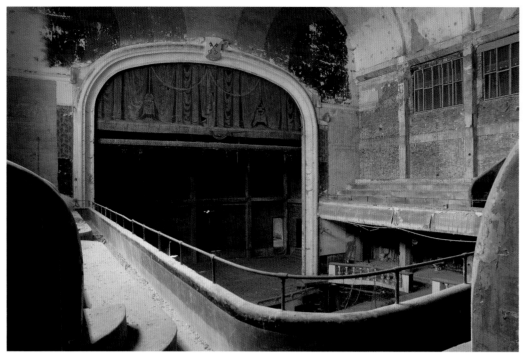

Charleroi – Belgium – Varia – 2009

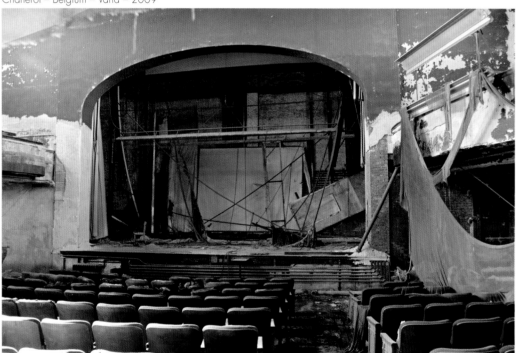

Newark, New Jersey – USA – RKO Proctor's – 2010

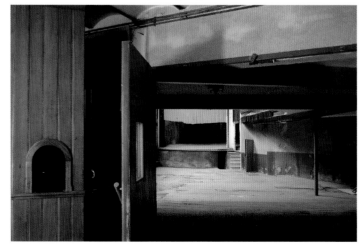

Sa Pobla – Majorca, Spain – Can Guixa – 2013

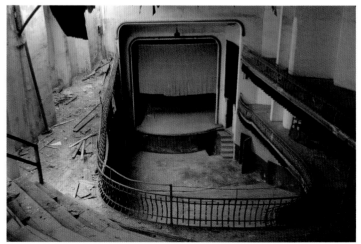

Sa Pobla – Majorca, Spain – Can Guixa – 2013

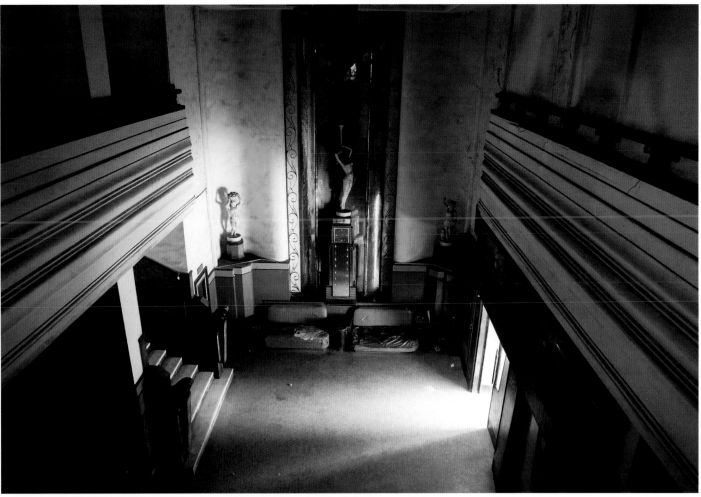

Mumbai – India – Naaz – 2012

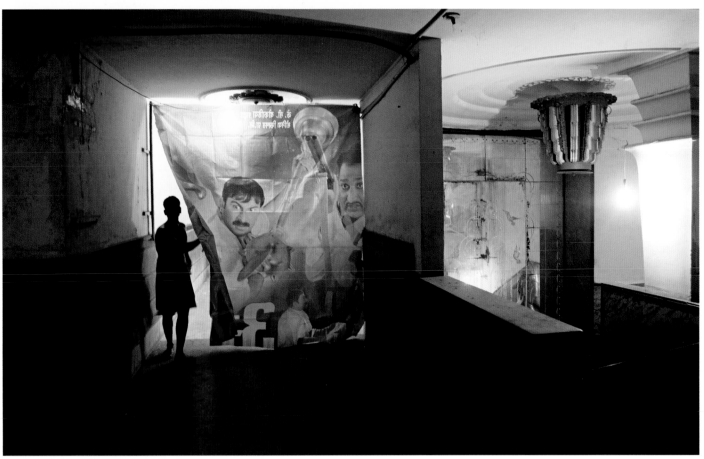

Mumbai – India – Naaz – 2012

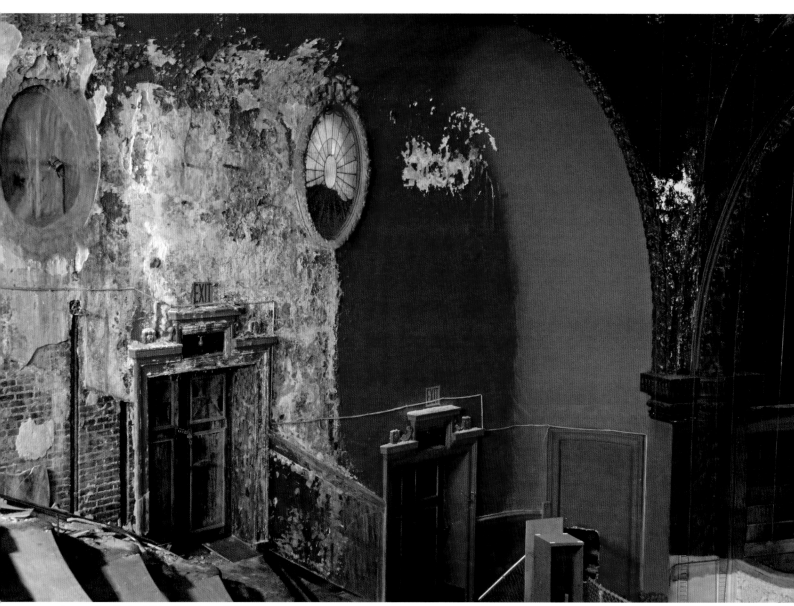

Bronx, New York – USA – Paradise – 2009

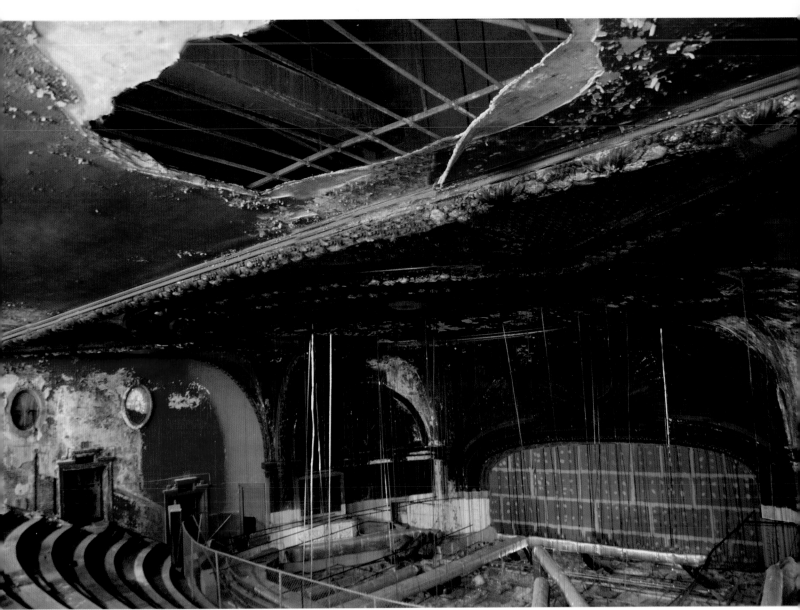

Bronx, New York – USA – Paradise – 2009

Tripoli – Lebanon – Commodore – 2018

Casablanca – Morocco – Opéra – 2015

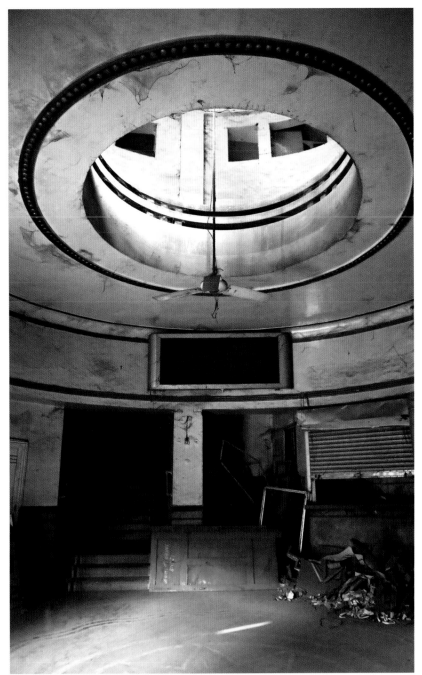

Allahabad – India – Niranjan – 2017

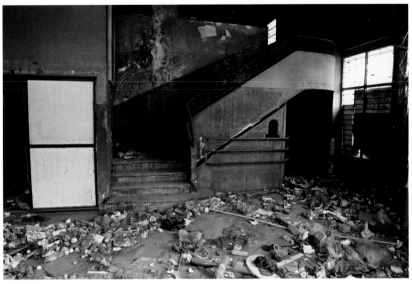

Casablanca – Morocco – L'Arc – 2009

Newark, New Jersey – USA – RKO Proctor's – 2010

Mysore – India – Chantala – 2014

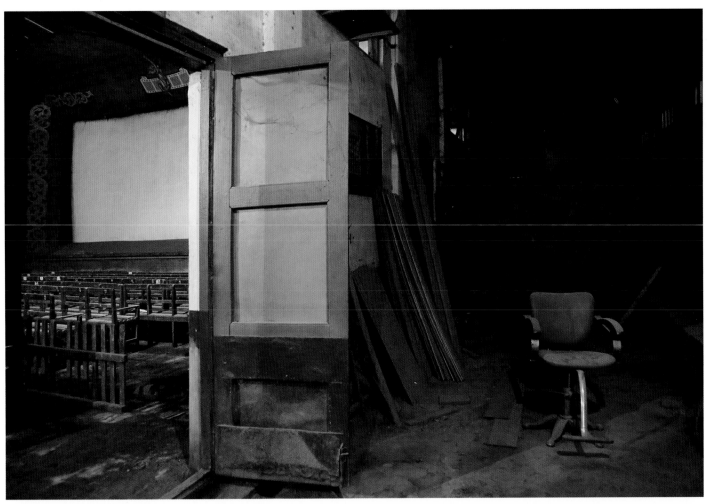

Kyaukse – Myanmar – Han – 2016

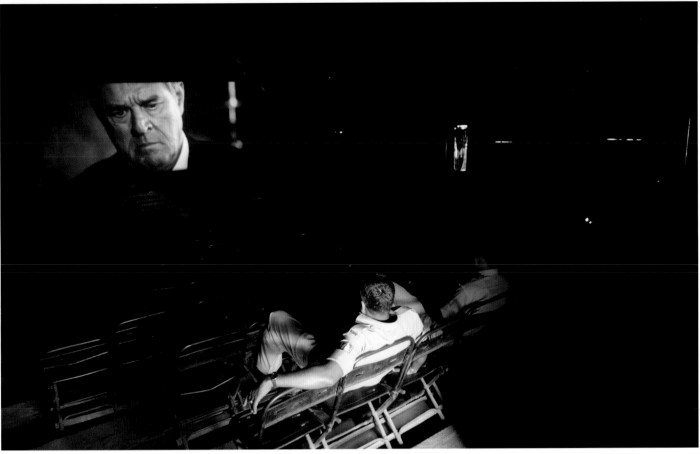

Mysore – India – Viantani – 2013

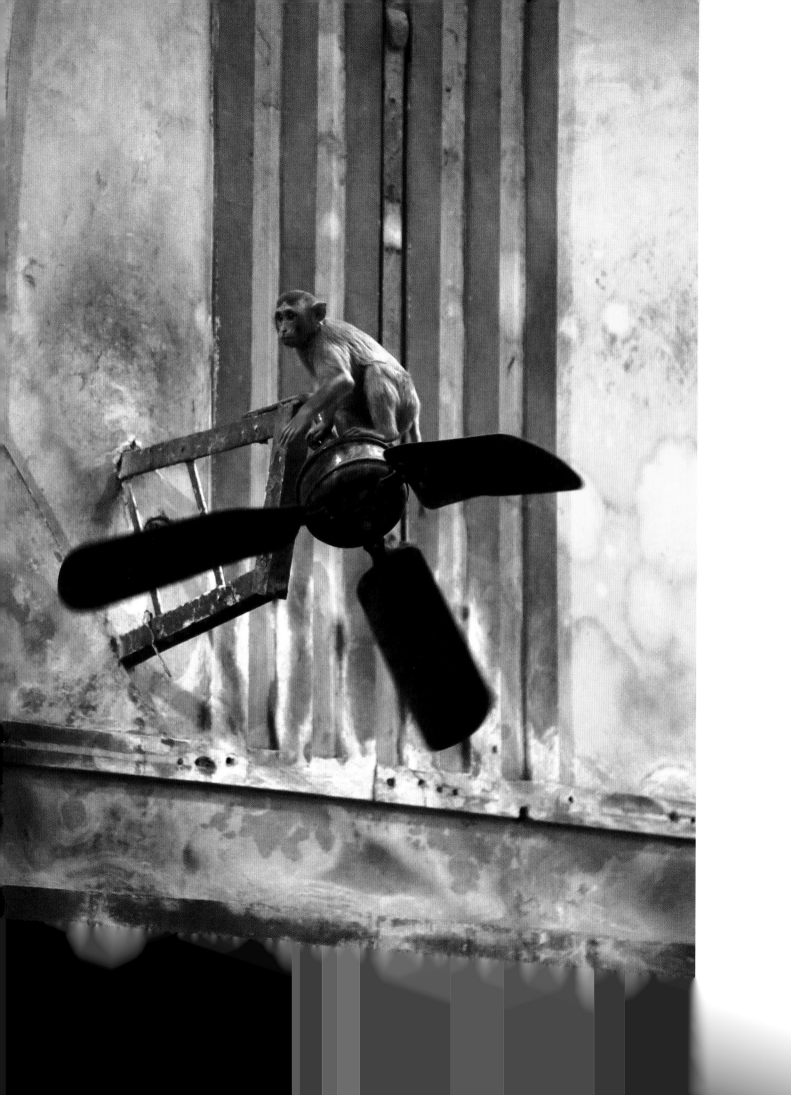

The abandoned cinema exudes decay. It stands before us, all access points blocked, barriers in place to discourage visitors. We take a walk around and find a door; it barely resists our attempt to gain entry into the dark interior. As we switch on our pocket light, we freeze for a moment, startled by some monkeys watching us. There are rickety seats, and remnants of film litter the floor. Moving through, we find the projector, asleep, and a long-forgotten radio. A sound. The machinery comes to life, the screen lights up and the cinema comes alive again. Shadows move, settle into their seats. Alas, it is only the monkeys; they are the only audience now.

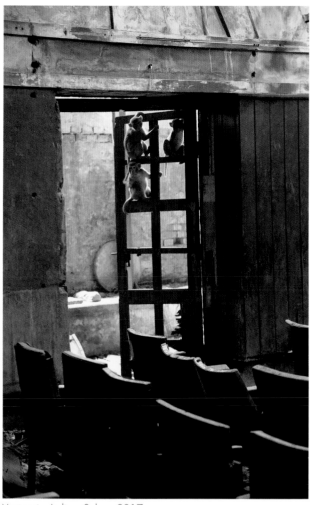

Varanasi – India – Sahu – 2017

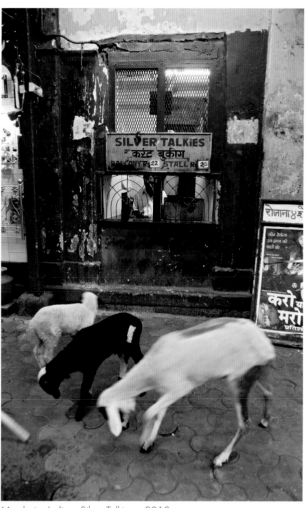

Mumbai – India – Silver Talkies – 2012

Left page:
Varanasi – India – Sahu – 2017

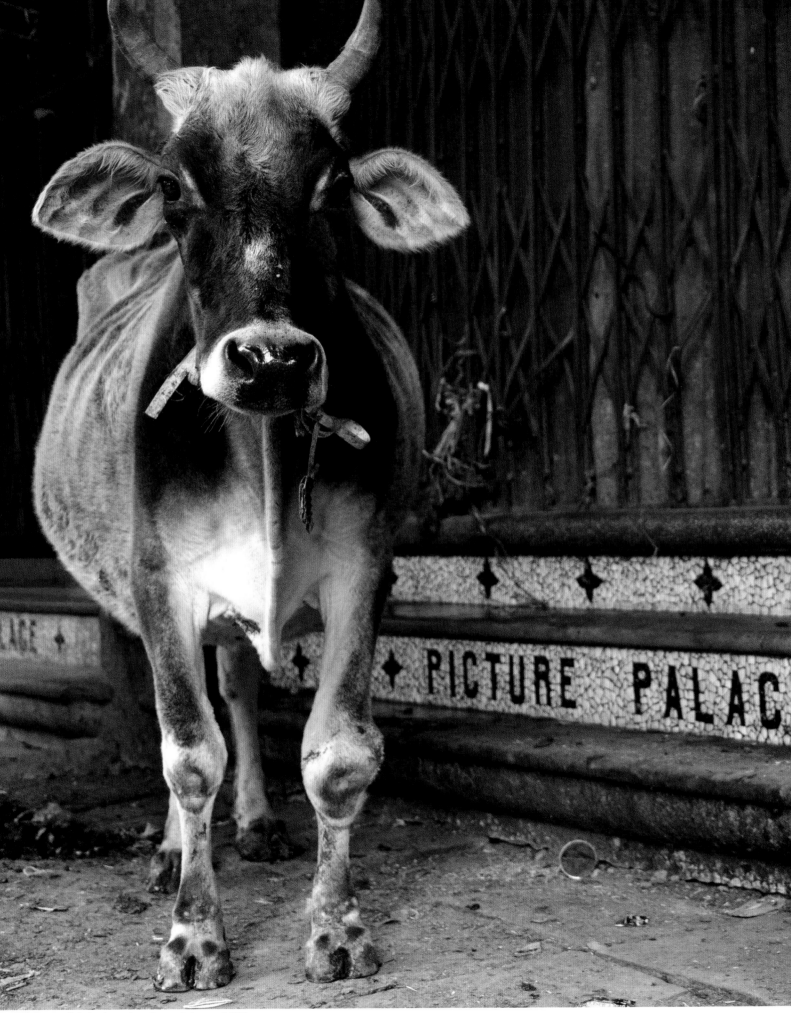

Allahabad – India – Picture Palace – 2017

Madurai – India – Aravind – 2012

At one time, seats were not just comfortable, they were luxurious. Audiences were in awe of their magnificent surroundings. In the days of silent films, folk would frequently visit in winter because the theatres were much warmer than their own homes. As they entered these flamboyant palaces, they felt elevated to the lofty social level of the producers and their stars. The entertainment began even before the lights went out and the film started. An environment of unimaginable splendour, attentive service, music that moved the soul; all these things combined to make each visit an unforgettable experience.

Right page:
Varanasi – India – Sahu – 2017

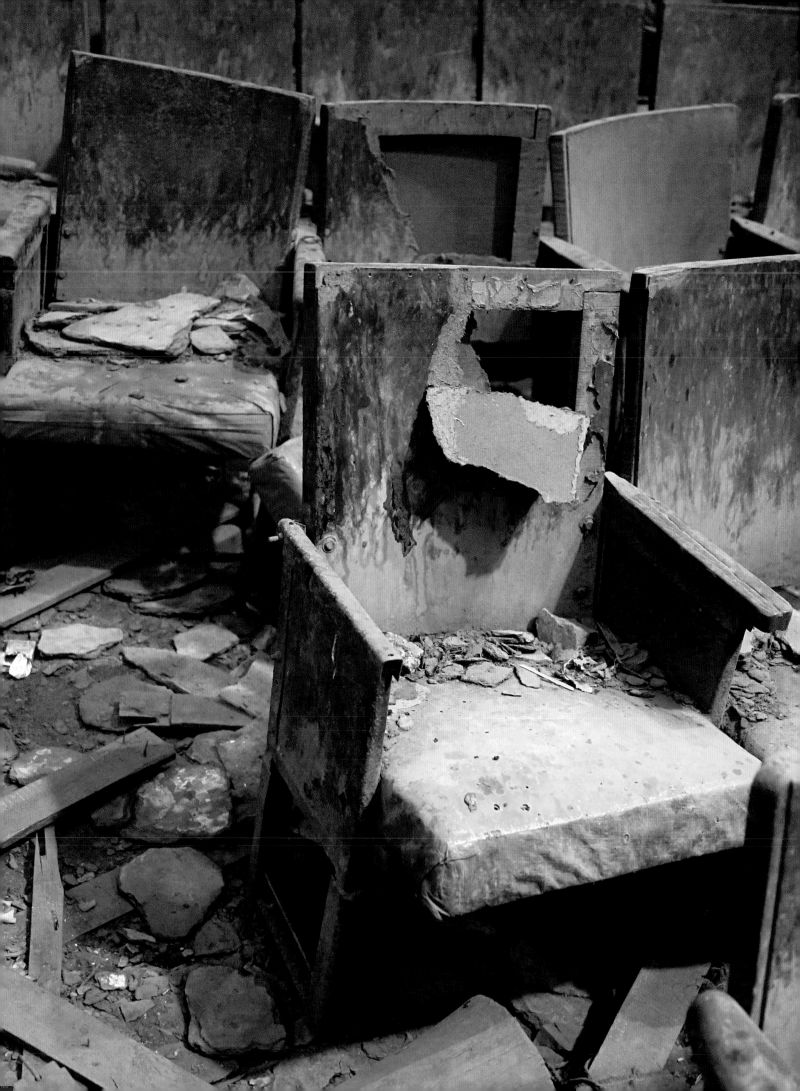

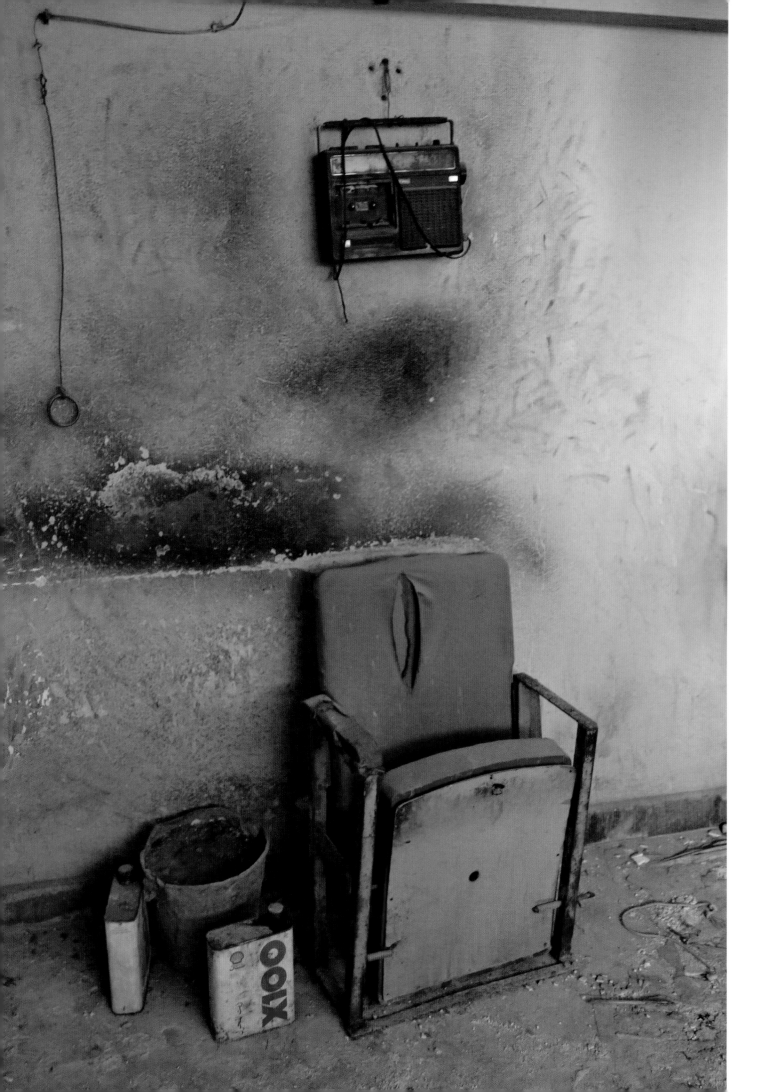

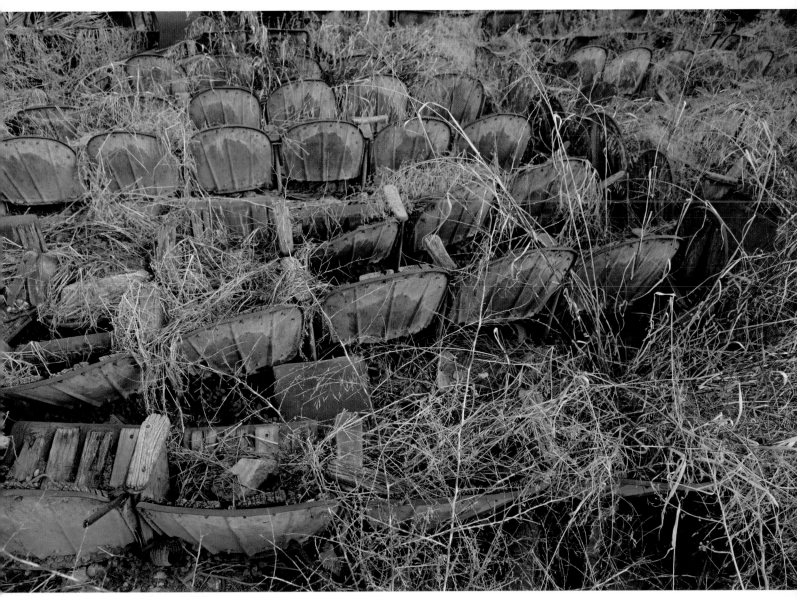

Marrakesh – Morocco – Zhora – 2009

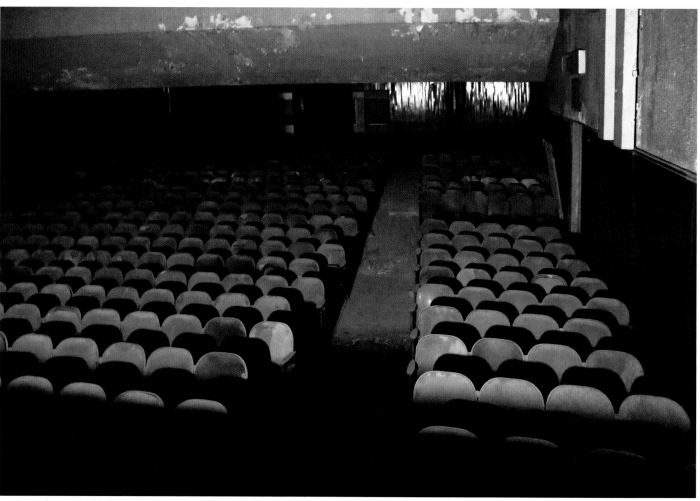

Saïda – Lebanon – Hilton – 2018

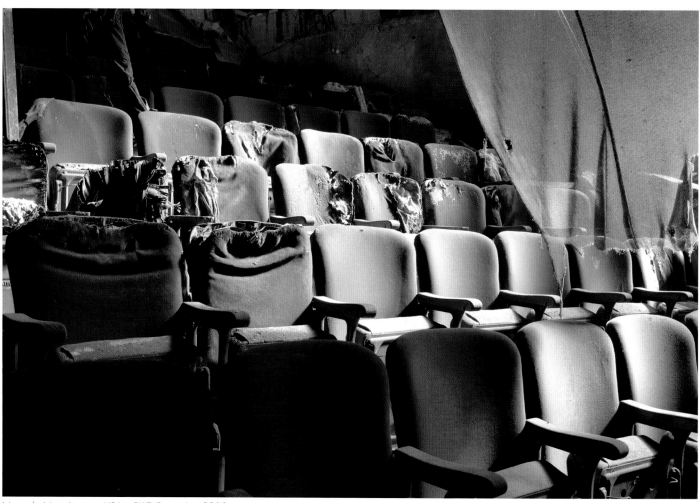

Newark, New Jersey – USA – RKO Proctor's – 2010

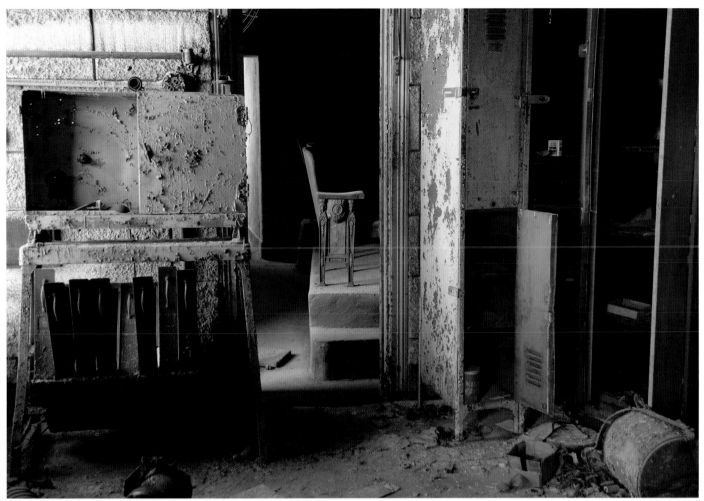

Newark, New Jersey – USA – RKO Proctor's – 2010

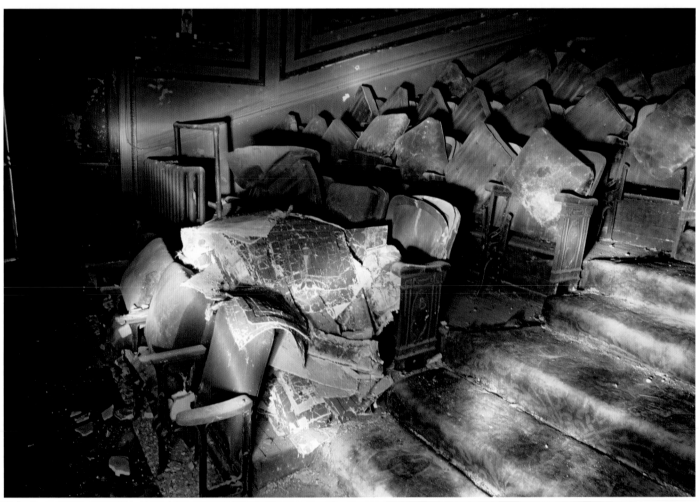

Bridgeport, Connecticut – USA – Loew's Majestic – 2011

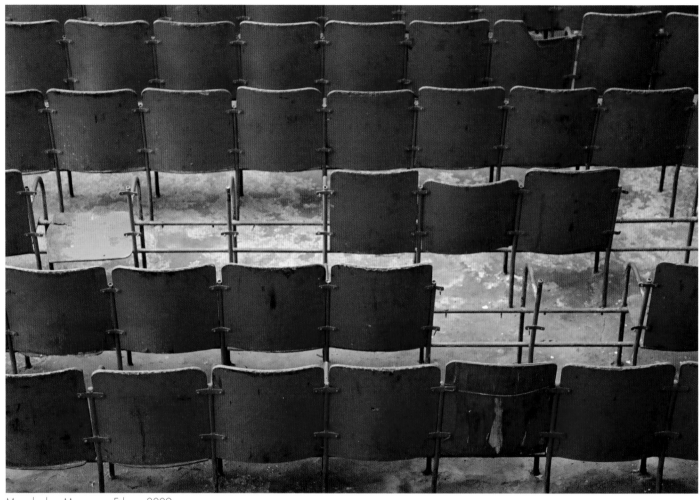

Marrakesh – Morocco – Eden – 2009

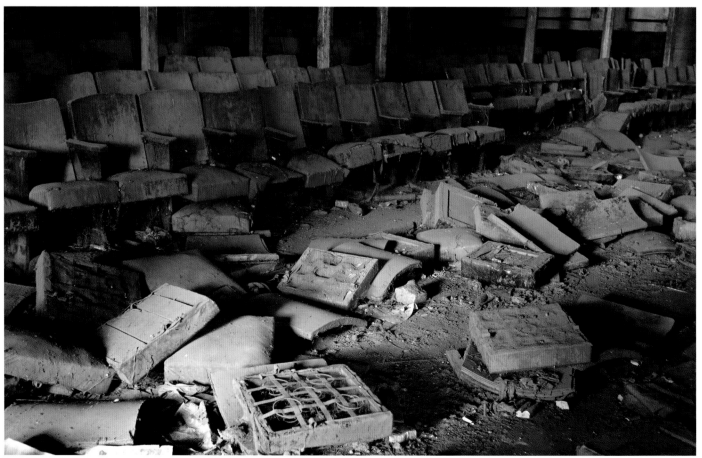

Jaipur – India – Ram Prakash – 2016

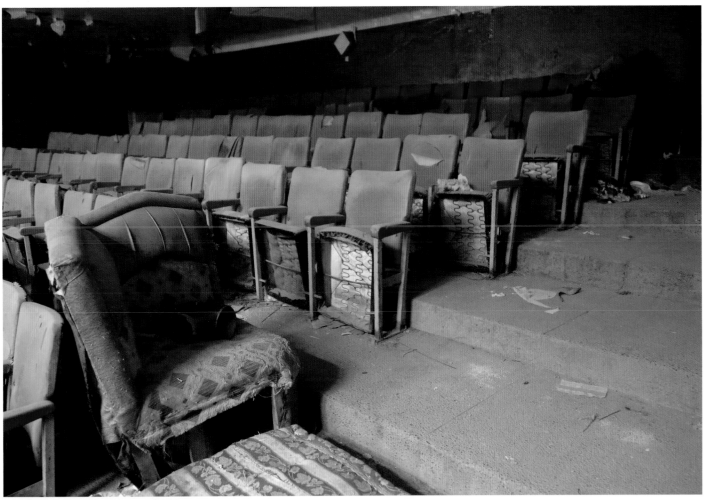

Marrakesh – Morocco – Hamra – 2015

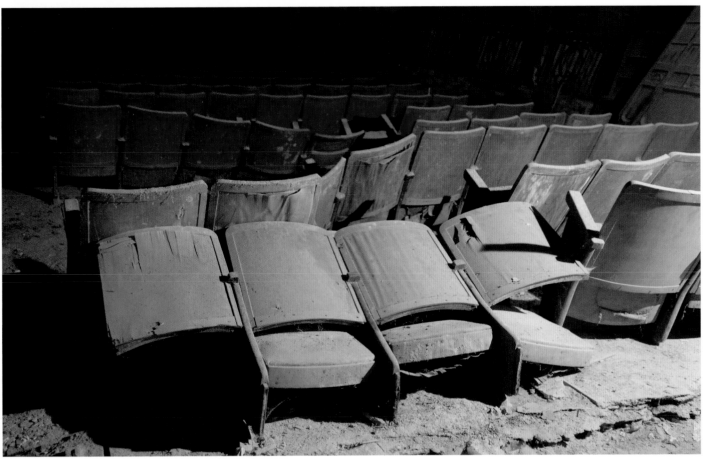

Tangier – Morocco – Cervantes – 2011

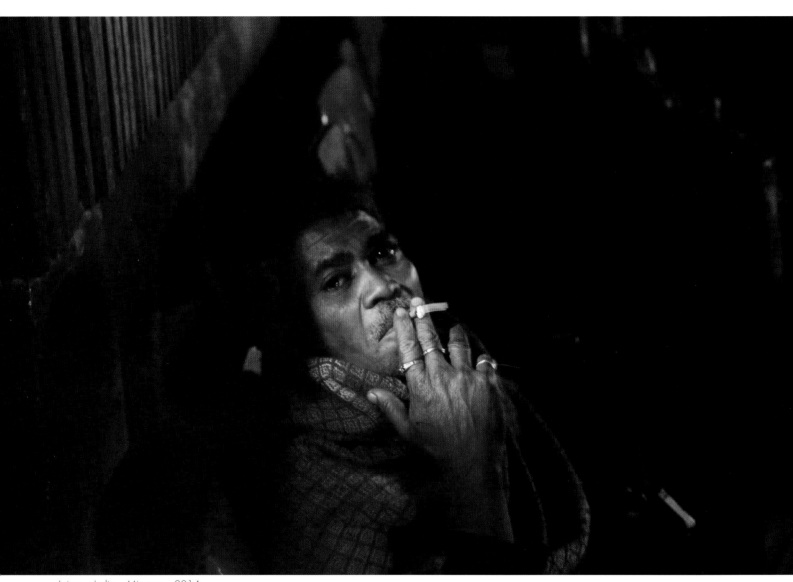

Jaipur – India – Minerva – 2014

Hubs of entertainment that refuse to give up

Despite the fact that more and more cinemas are shutting down, we certainly haven't heard the last word from these temples of the seventh art. Film theatres valiantly struggle against the threat of being consigned to perpetual darkness. In the face of imminent closure, screens around the world continue to light up, thanks to the undying spark of passion in the hearts of filmgoers. A smiling face behind the ticket window, pleasantries exchanged at the refreshment stall, the familiar creak of a seat as it is folded down, the intense concentration on the face of the projectionist; life continues to pulse through the arteries of these gentle giants, which owe so much of their magic not only to the multi-coloured dreams projected onto the white canvas screen, but also to the thousand and one stories of the people who bring them to life every day.

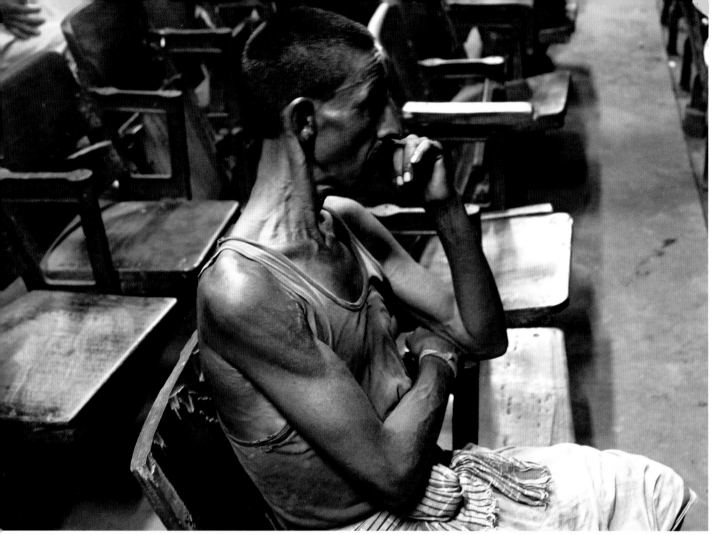

Kolkata – India – Orient – 2012

Kolkata – India – Orient – 2012

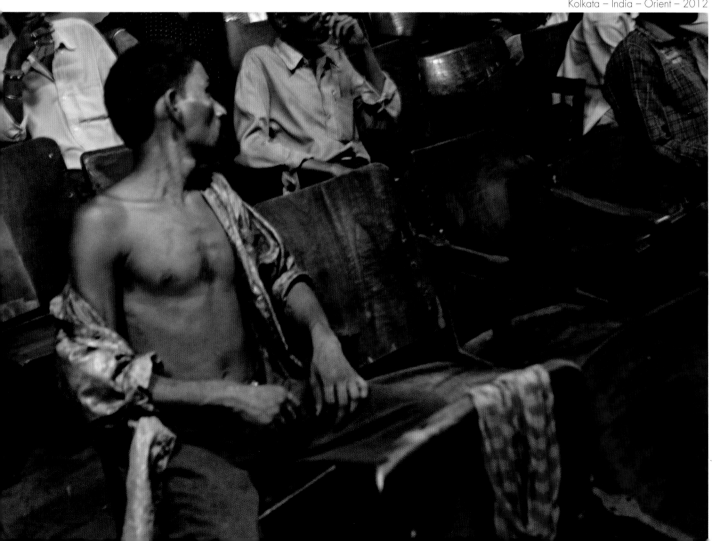

Pune – India – Jaihind – 2014

Chennai – India – Jayanthi – 2012

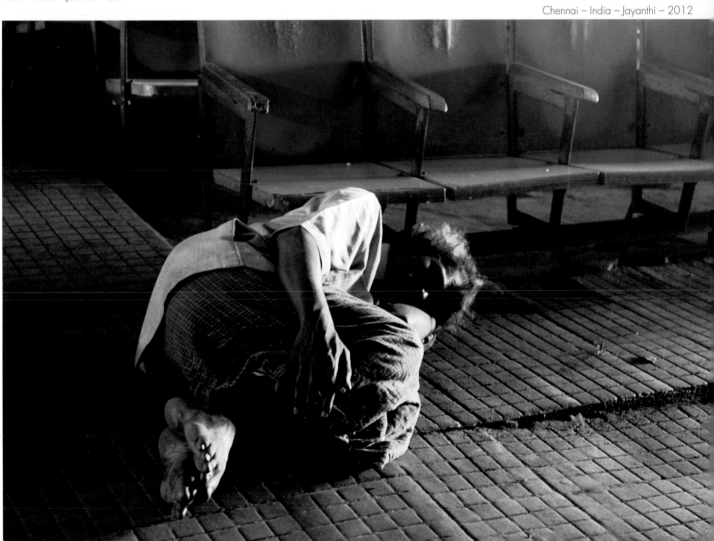

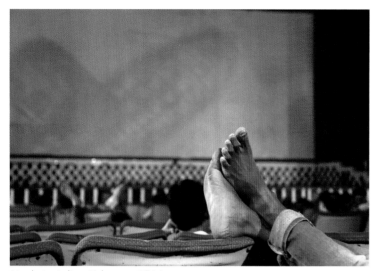

Mumbai – India – Kalpana – 2014

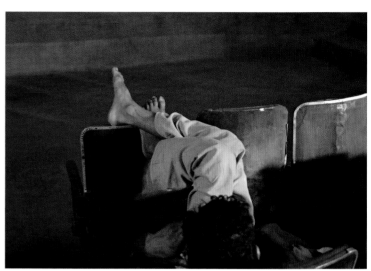

Delhi – India – Supreme – 2014

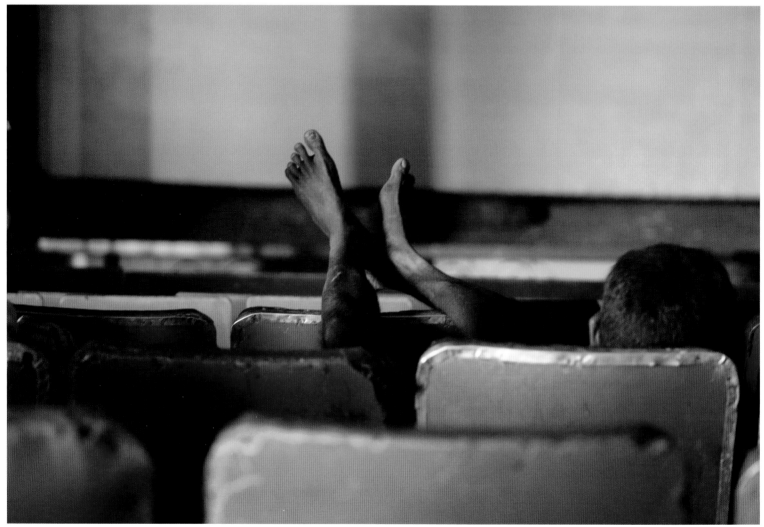

Madurai – India – Vellaikannu – 2012

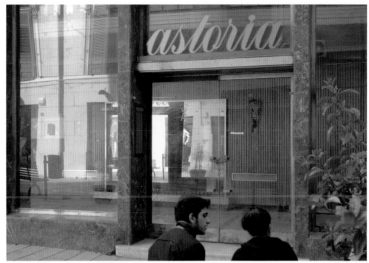

Palermo – Sicily – Astoria – 2009

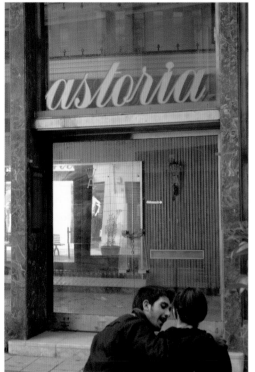

Palermo – Sicily – Astoria – 2009

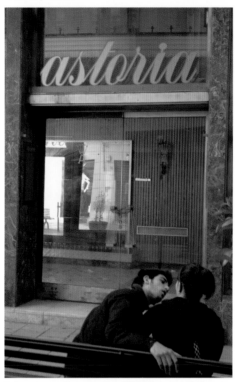

Palermo – Sicily – Astoria – 2009

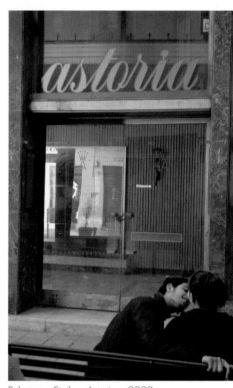

Palermo – Sicily – Astoria – 2009

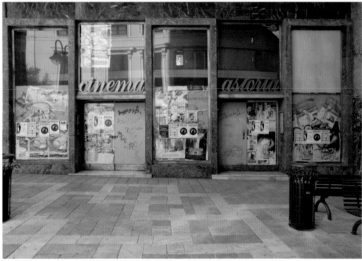

Palermo – Sicily – Astoria – 2017

Nowadays, hard disks have replaced reels of film. Projectionists often find themselves behind a counter selling popcorn or issuing tickets, their previous work carried out by a cashier simply clicking a button. Back in the days of 35mm film, reels were occasionally wound back to front, producing some rather surprising results on the screen. Some projectionists would cut some of the more risqué pictures from films for their private collections. Since films were circulated around numerous picture houses – where other projectionists might share the same hobby – the heavily edited film would elicit frustration bordering on despair. In some countries, projectionists were required to perform the role of censors, masking shots of an innocent kiss on the orders of a government ministry. Later, cinemas impoverished by falling audience numbers made do with a single projectionist covering several theatres. He would rush from one to the other on his bicycle. If his bike broke down, the audience could face quite a lengthy wait in the dark! Many projectionists treated their machines as living entities, each complete with body and soul. They would give them girls' names and speak of them in loving terms: "She does as she is told, she's a sweet, reliable machine." Today, film projection is invariably perfect; no more blurred images, no more scratched copies … just a hard disk to connect.

Right page:
Sa Pobla – Majorca, Spain – Can Guixa – 2013

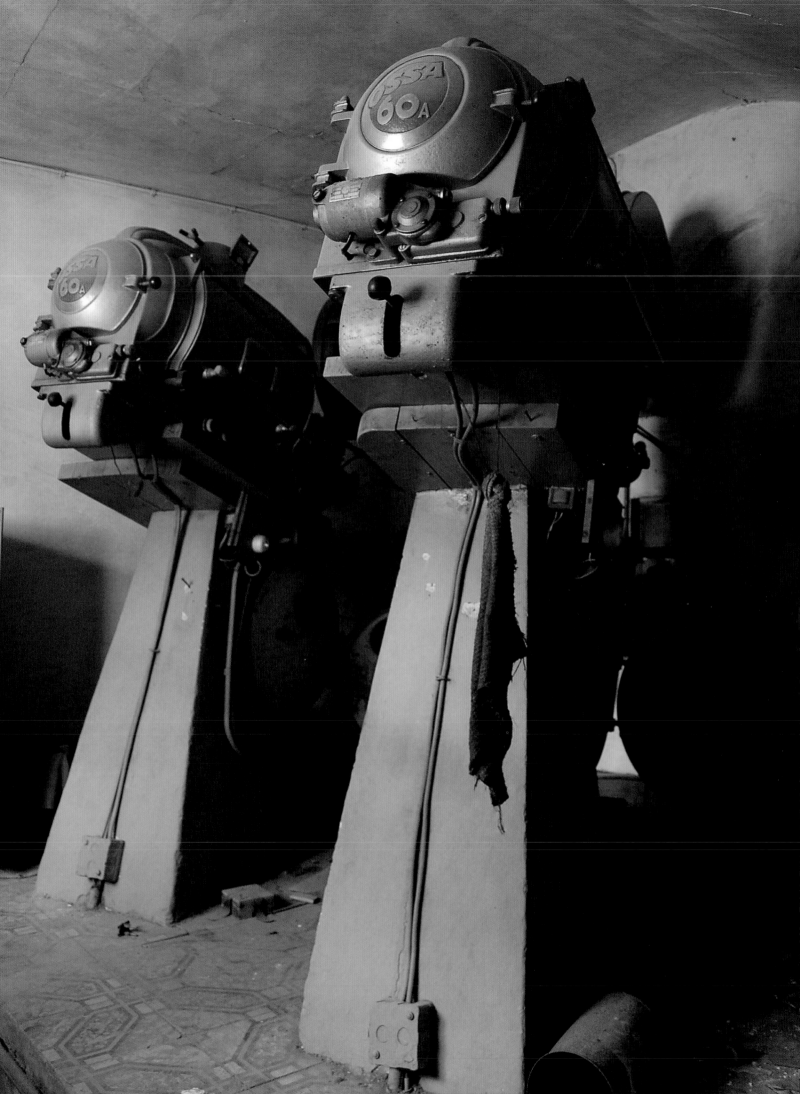

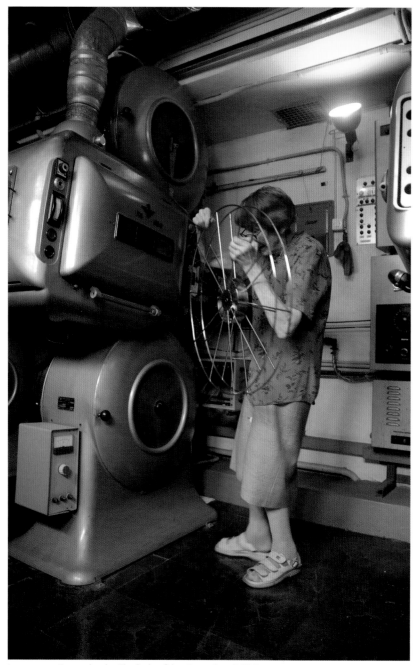

Lausanne – Switzerland – The lady of the Capitole – 2009

Kathmandu – Nepal – Ranjana (demolished) – 2006

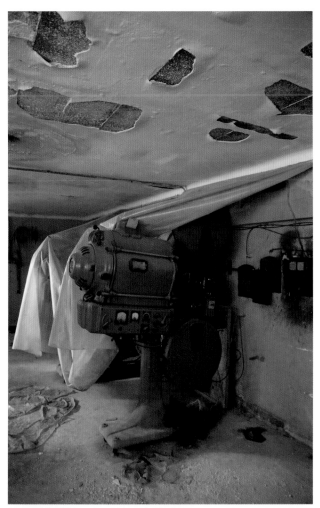

Marrakesh – Morocco – Hamra – 2015

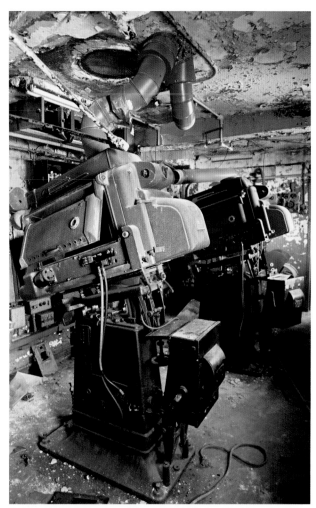

Bridgeport, Connecticut – USA – Loew's Majestic – 2011

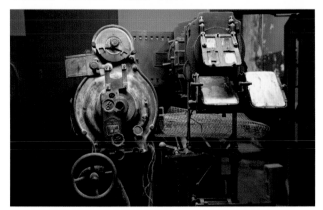

Jersey City, New Jersey – USA – Jersey's Loew's – 2008

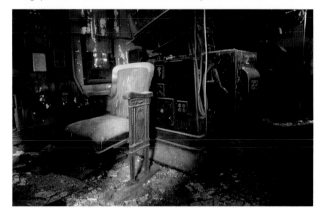

Bridgeport, Connecticut – USA – Loew's Majestic – 2011

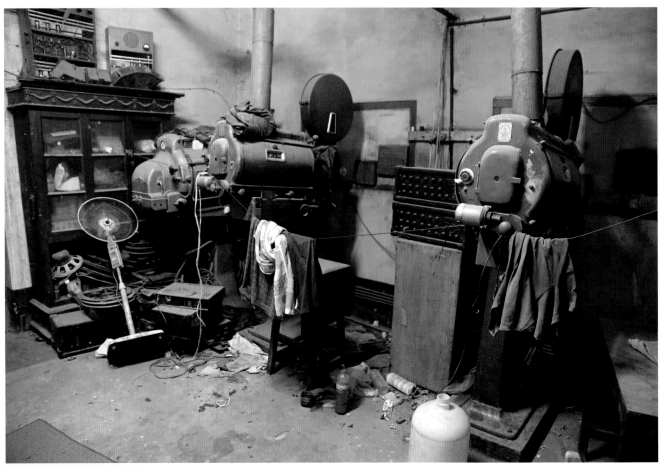

Kyaukse – Myanmar – Han – 2016

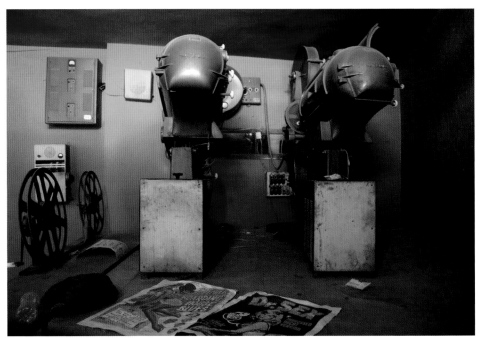

Chekka – Lebanon – Picadilly – 2018

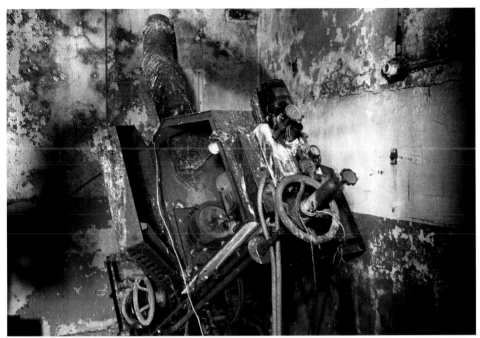

Bridgeport, Connecticut – USA – Loew's Palace – 2011

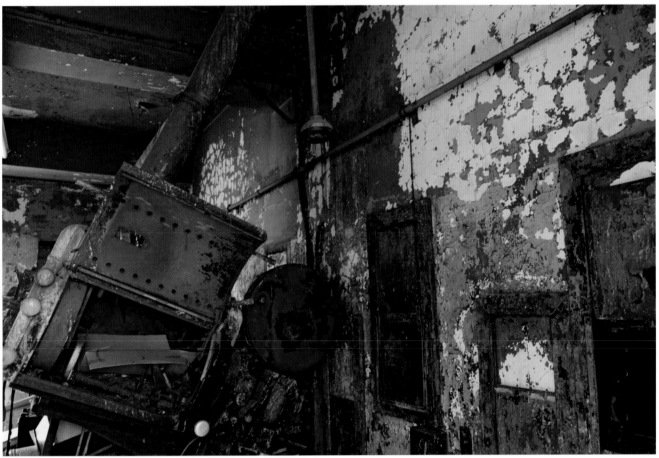

New York, New York – USA – Eagle – 2010

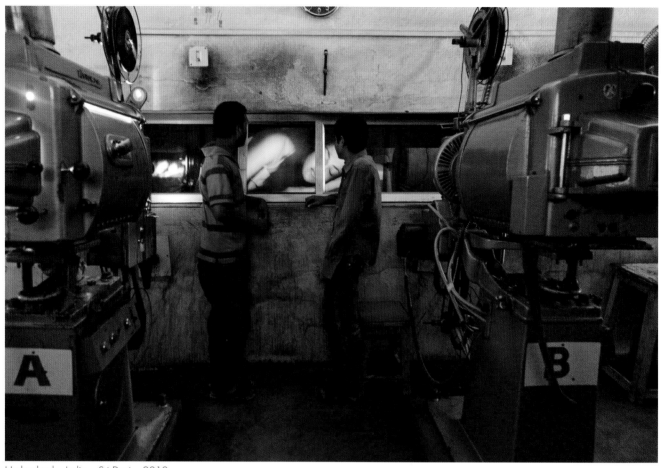

Hyderabad – India – Sri Devi – 2012

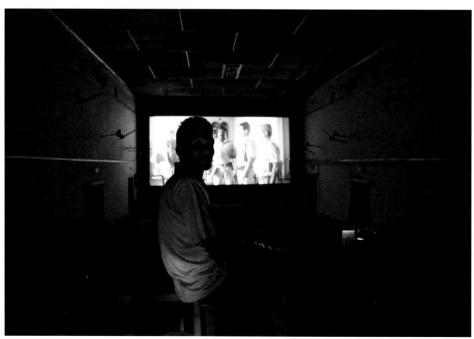

Banera – India – Subhakamana – 2015

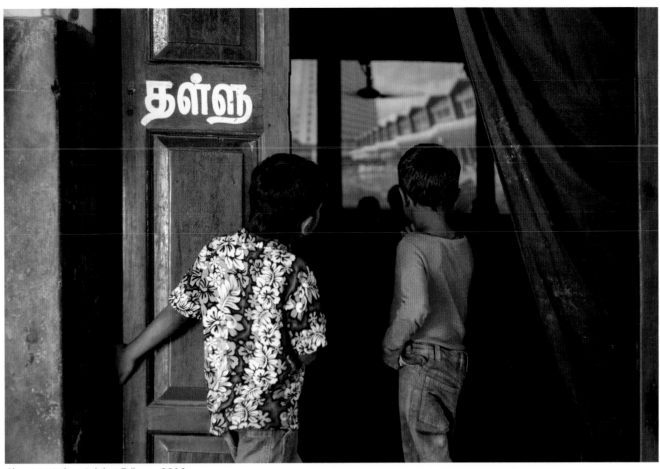

Chennai – India – Lakshmi Talkies – 2012

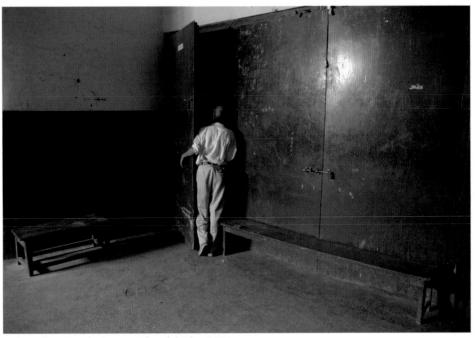

Kathmandu – Nepal – Ranjana (demolished) – 2011

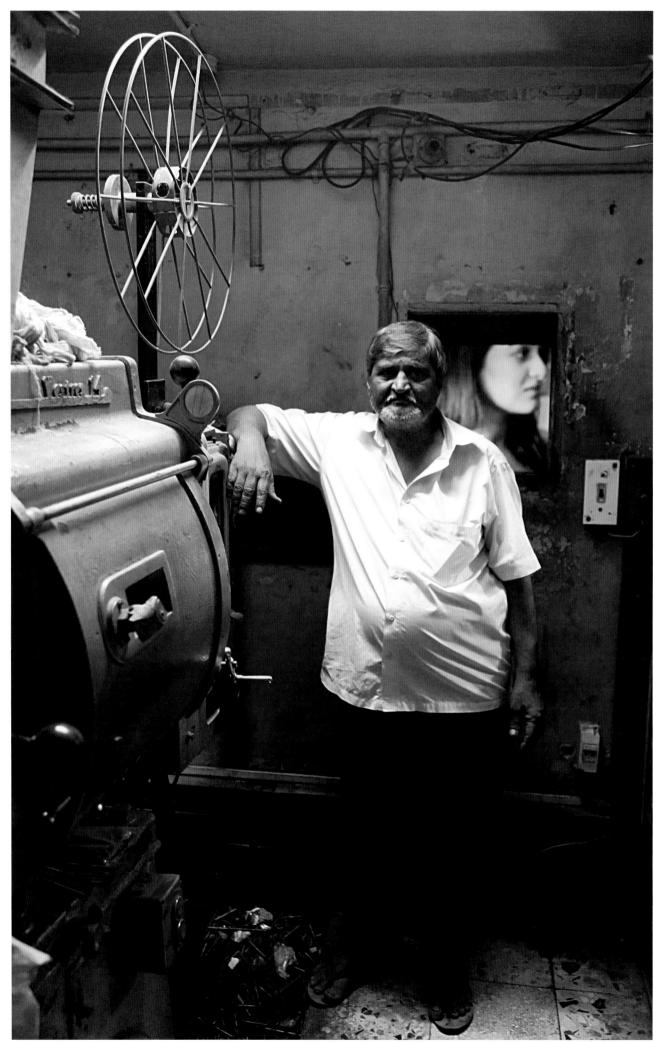

Mumbai – India – Kalpana – 2014

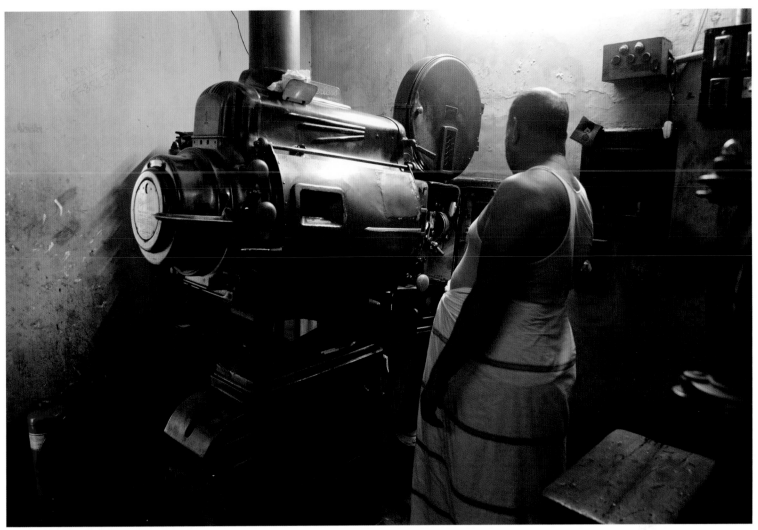

Chittagong – Bangladesh – Palace – 2012

Confined, noisy, and often overheated boxes bathed in a strange half-light, cinema projection rooms have much in common with the command post of a ship. The antediluvian projectors are usually left behind, huge dust-covered insects looming from the gloom, the last vestiges of some infernal machine that terrorised the stars of a science fiction movie. They are of little value and extremely heavy, so they can be sure of a long wait before better days come around.

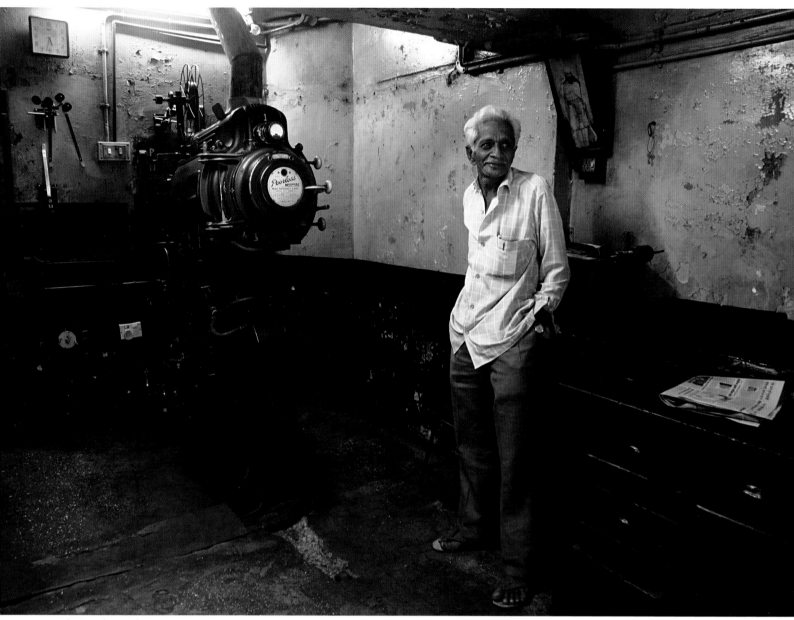

Mumbai – India – Palace – 2012

138

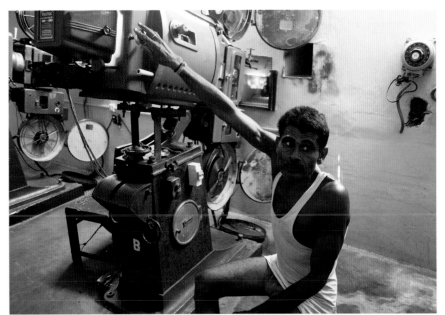

Varanasi – India – Abhay – 2012

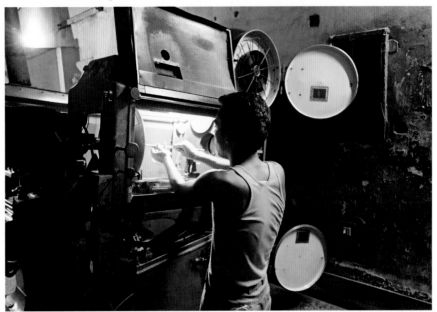

Dacca – Bangladesh – Purmina – 2012

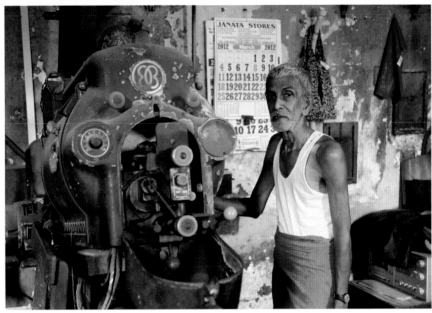

Mumbai – India – Naaz – 2012

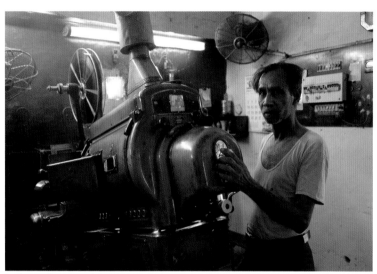

Delhi – India – Excelsior – 2012

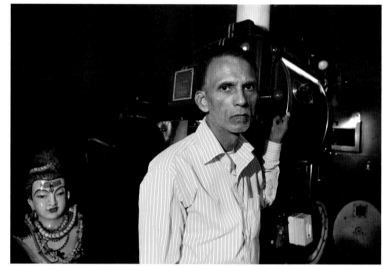

Varanasi – India – Anand Mandir – 2012

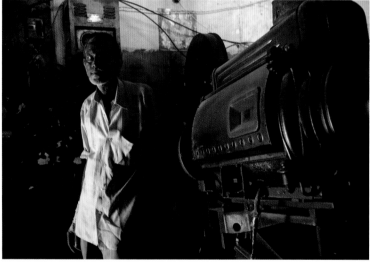

Agra – India – Roxy – 2014

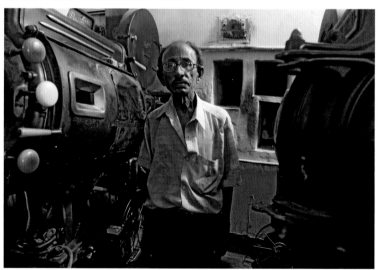

Kolkata – India – Talkie Show House – 2012

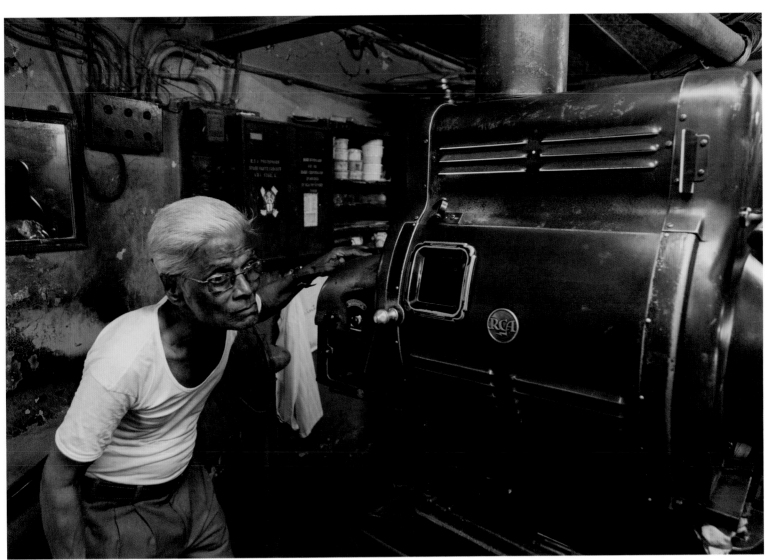

Mumbai – India – Bharatmata – 2012

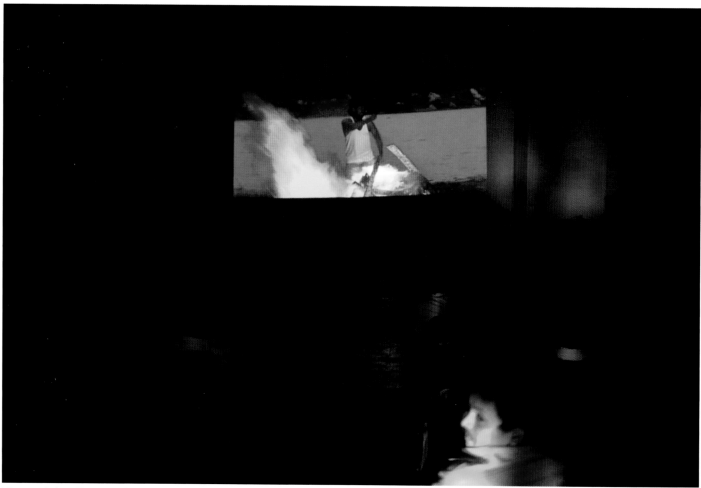

Mysore – India – Viantani – 2015

Kyaukse – Myanmar – Han – 2016

Vallauris – France – Pigalle – 2010

Mumbai – India – Naaz – 2014

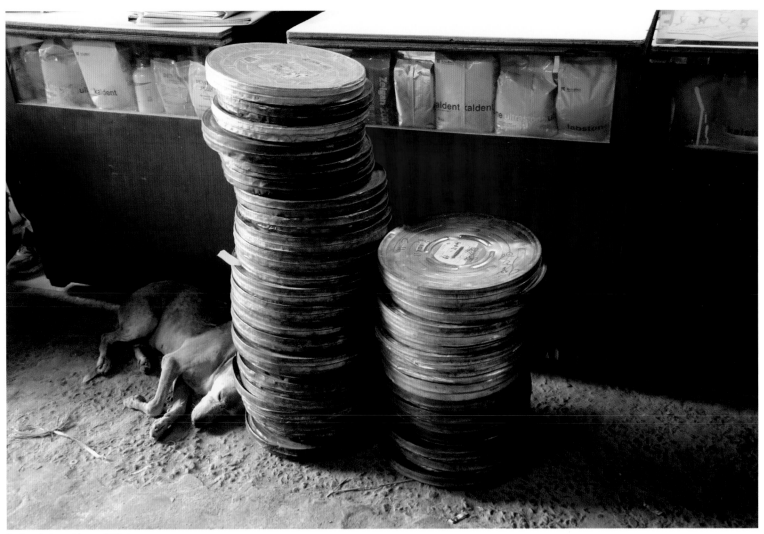

Delhi – India – Moti – 2014

Marrakesh – Morocco – Atlas – 2009

Time drags for this cashier as she sits in her "cage" facing the street, checking her iPhone as people pass by. Queues for tickets are rare — automatic ticket dispensers are destined to replace human contact. The days of film-loving cashiers recommending a film to you will soon be gone forever. But in India, the passion survives. Cashiers, often with iron bars for protection, still sell tickets at a frantic rate to avid customers excited at the prospect of discovering a new story.

Right page:
Tangier – Morocco – Roxy – 2009

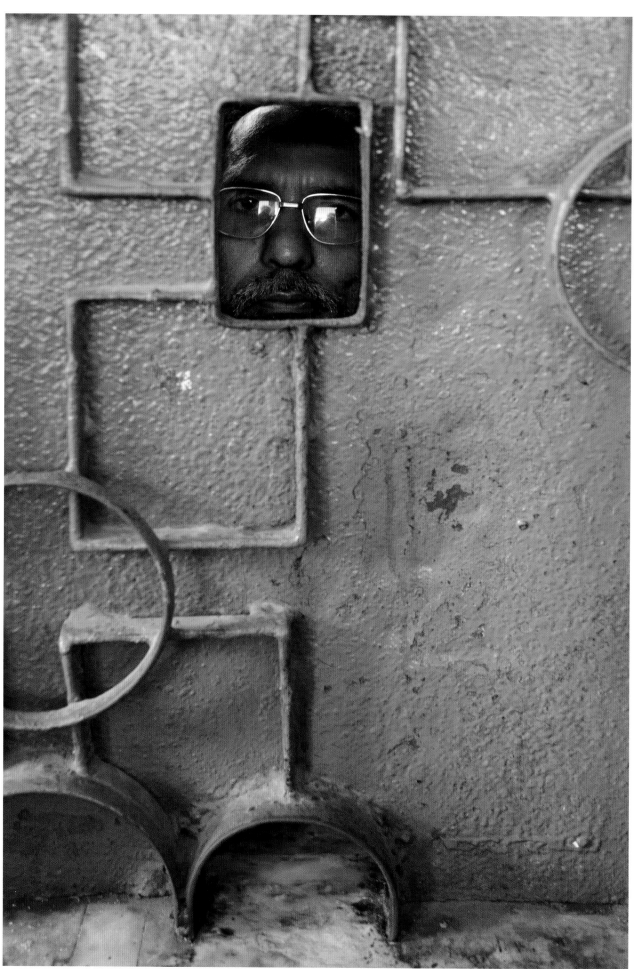

Dacca – Bangladesh – Anand – 2012

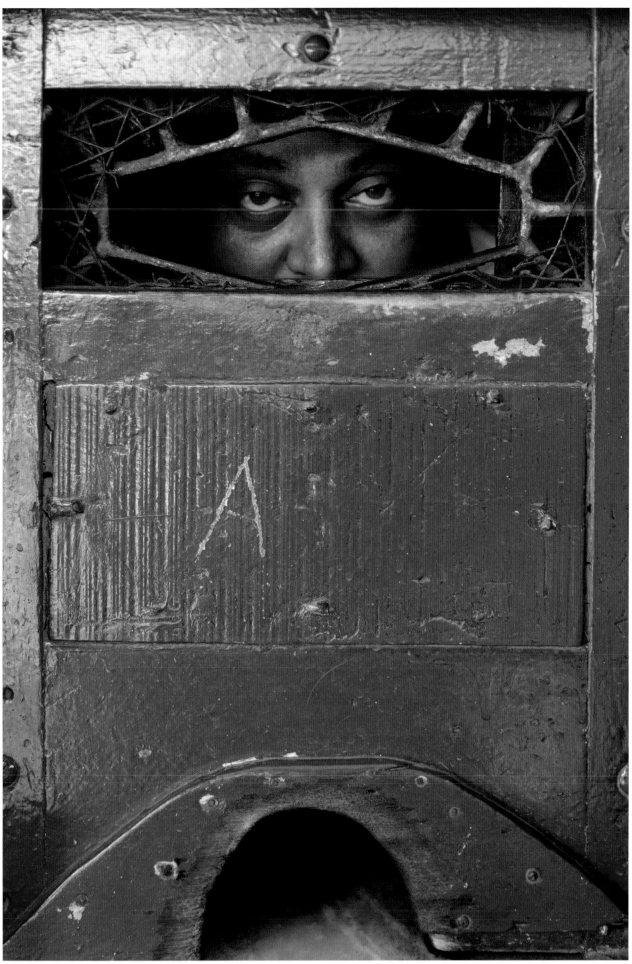

Chittagong – Bangladesh – Almas – 2012

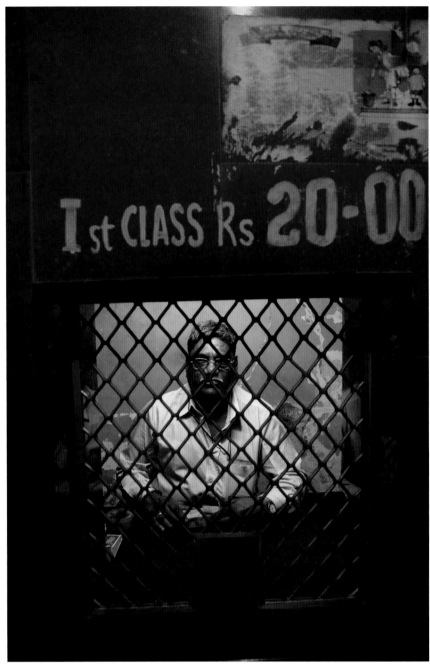

Mumbai – India – Nishat – 2012

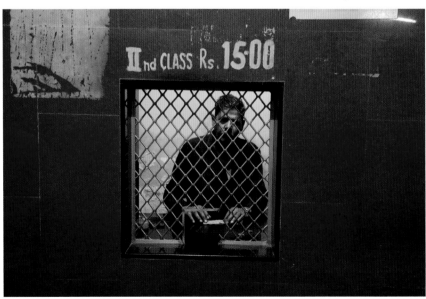

Mumbai – India – Nishat – 2012

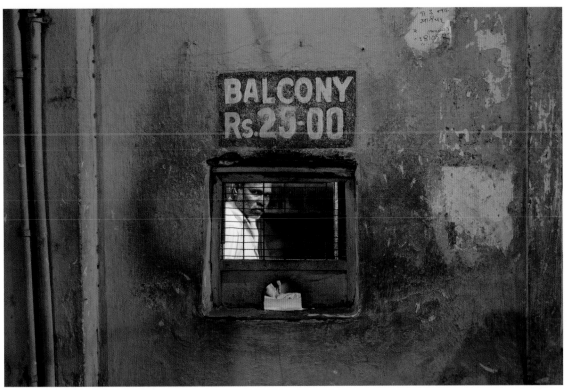

Mumbai – India – Nishat – 2012

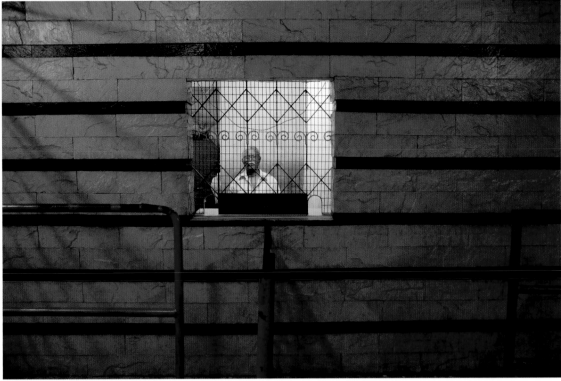

Chennai – India – Vijaia – 2012

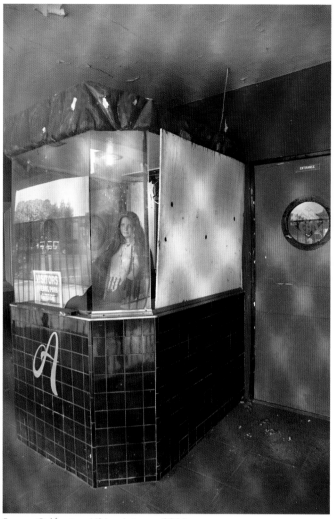

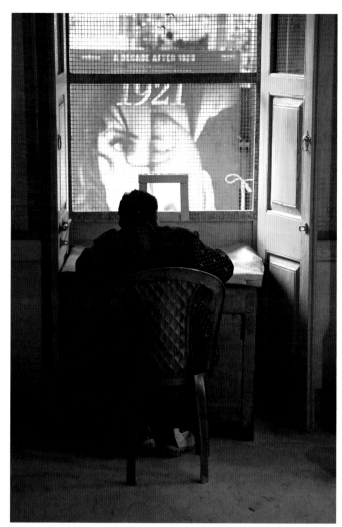

Fresno, California – USA – Azteca – 2011

Kolkata – India – Star – 2018

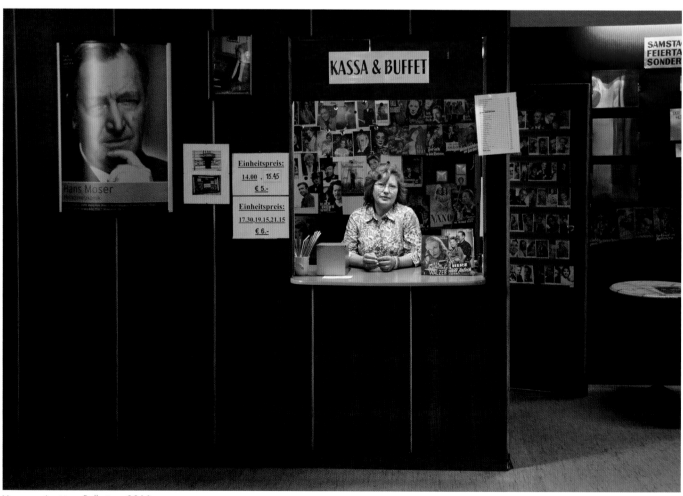

Vienna – Austria – Bellaria – 2011

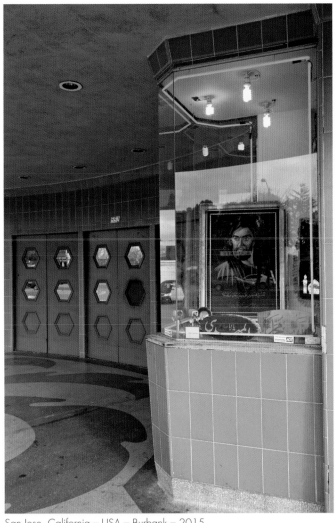

San Jose, California – USA – Burbank – 2015

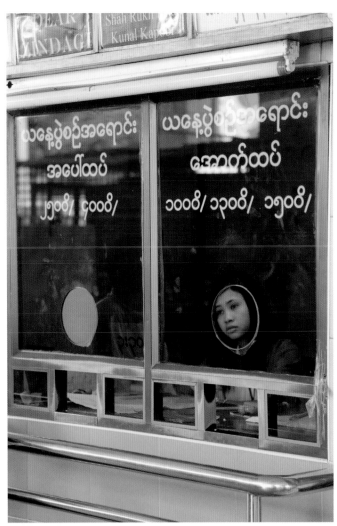

Yangon – Myanmar – Thwin – 2016

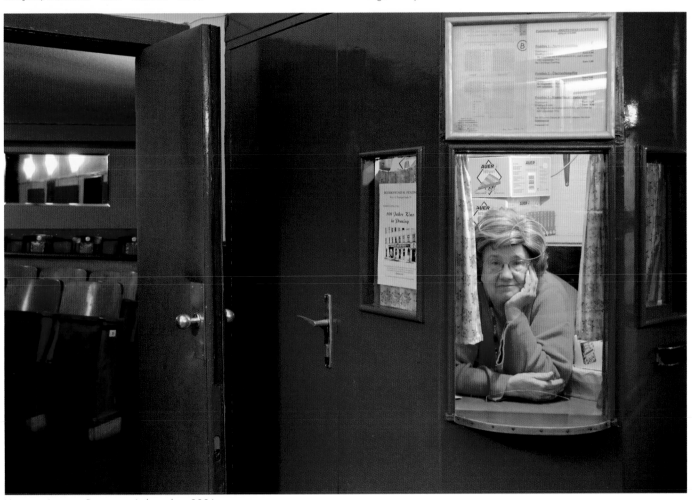

Vienna – Austria – Breitenseer Lichtspiele – 2006

Odessa, Texas – USA – Ector – 2011

Saint Eloy les Mines – France – Rex – 2011

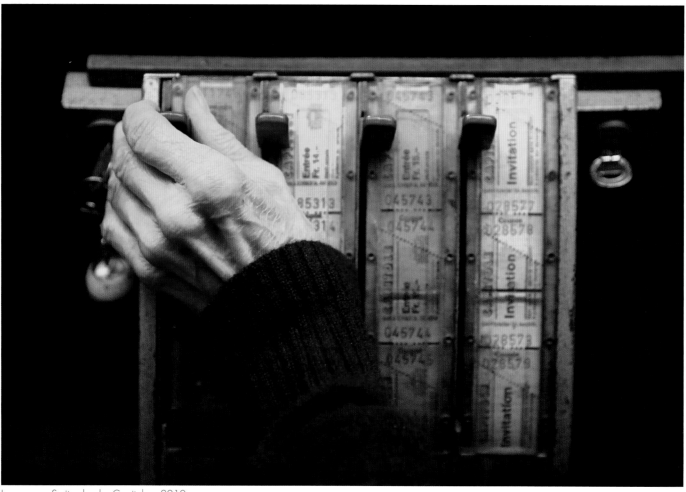

Lausanne – Switzerland – Capitole – 2010

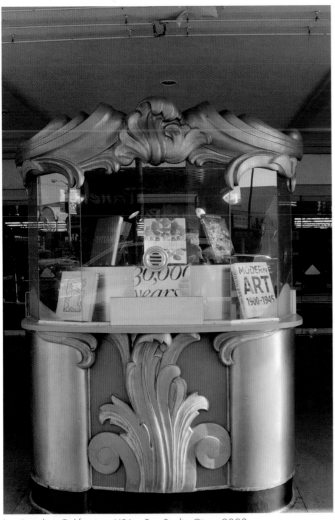

Los Angeles, California – USA – Fox Studio City – 2008

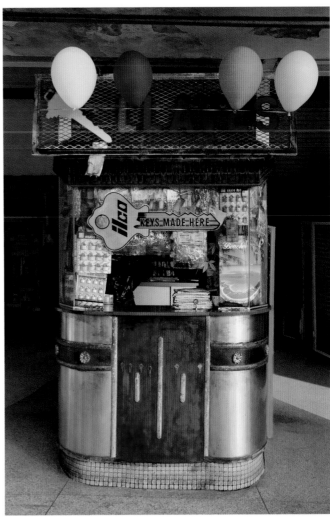

Los Angeles, California – USA – Westlake – 2010

Los Angeles, California – USA – Loyola – 2008

Fresno, California – USA – Crest – 2015

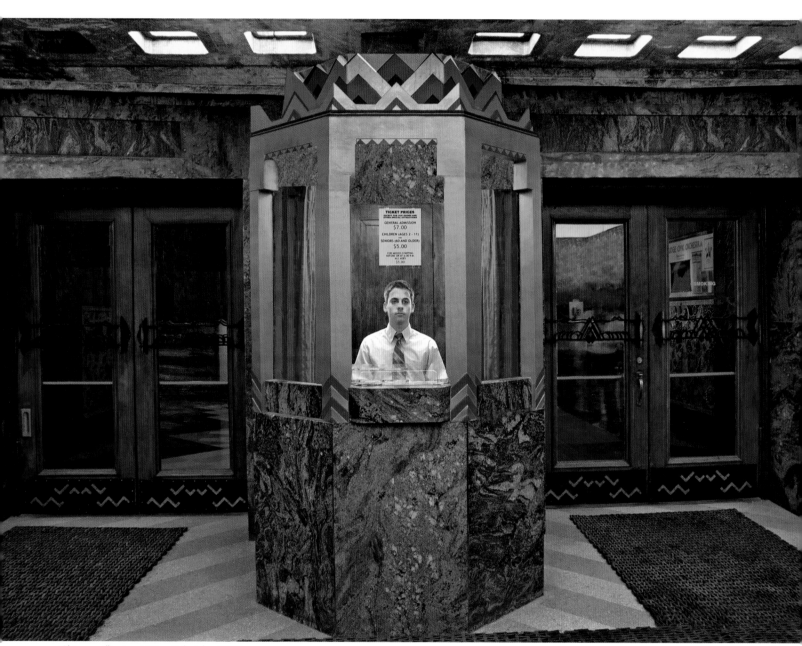

Chicago, Illinois – USA – Pickwick – 2008

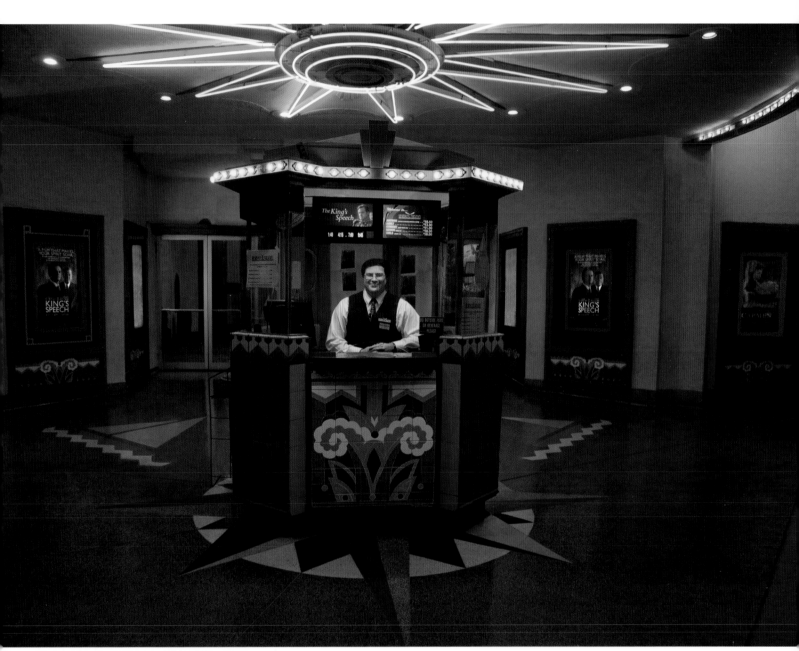

Newport Beach, California – USA – Lido – 2011

Lucknow – India – Mehra – 2017

Bankura – India – Chitra Mandir – 2017

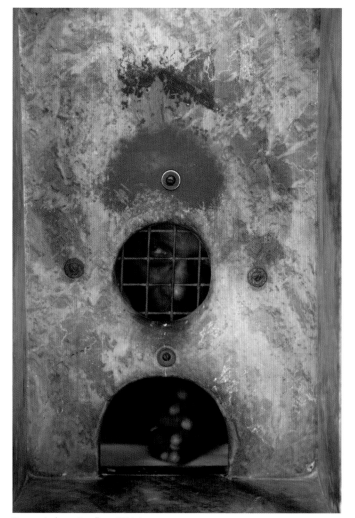

Pune – India – Apollo – 2014

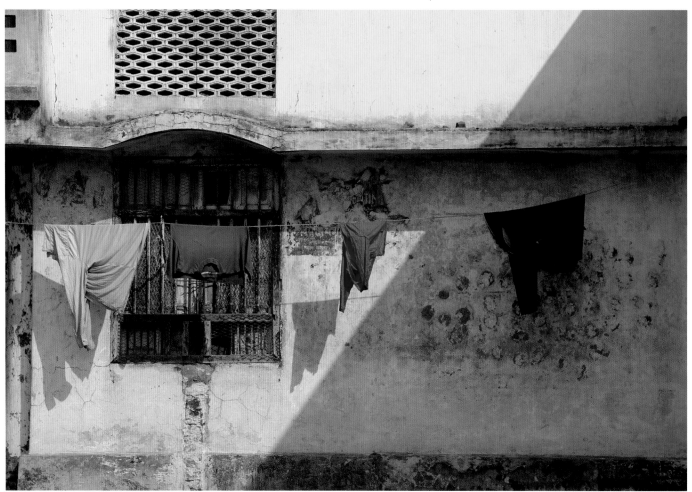

Bankura – India – Kusum – 2017

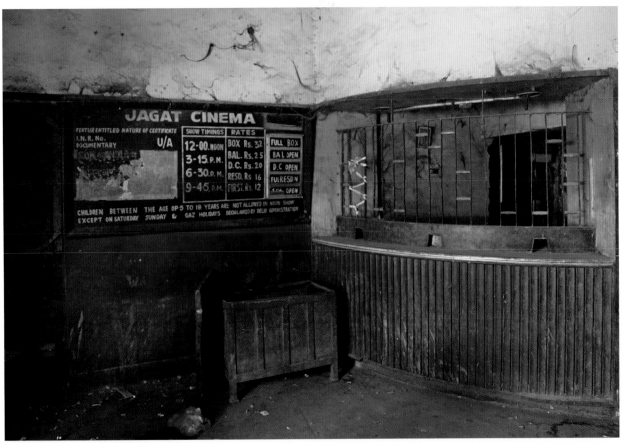

Delhi – India – Jagat – 2012

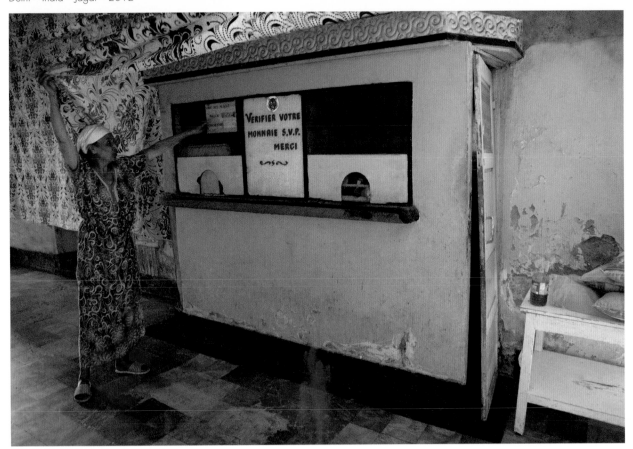

Oran – Algeria – Mogador – 2018

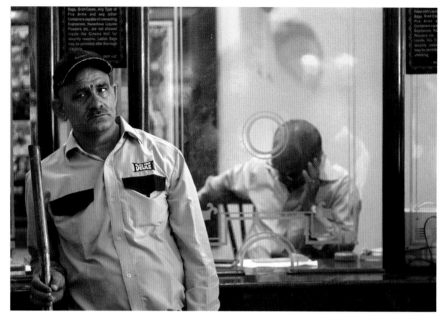
Delhi – India – Delite – 2012

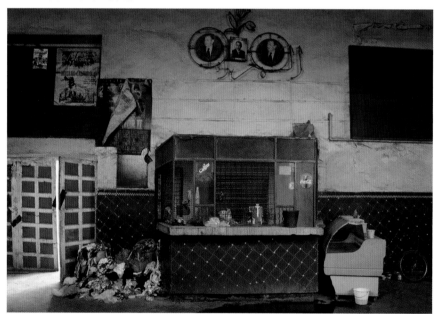
Marrakesh – Morocco – Hamra – 2009

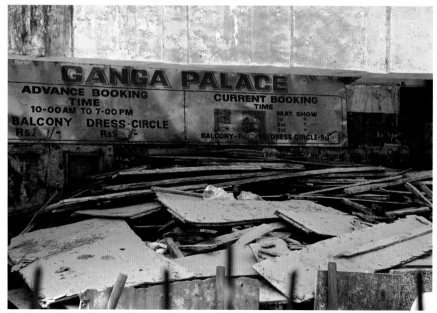
Mumbai – India – Ganga Palace – 2012

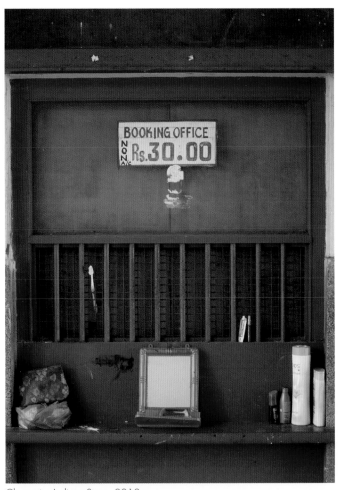

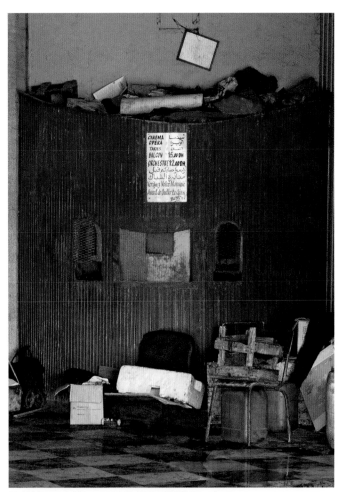

Chennai – India – Star – 2012

Casablanca – Morocco – Opéra – 2009

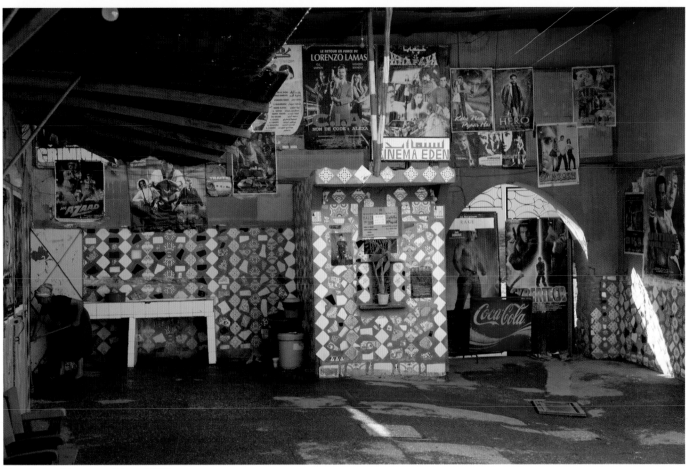

Marrakesh – Morocco – Eden – 2009

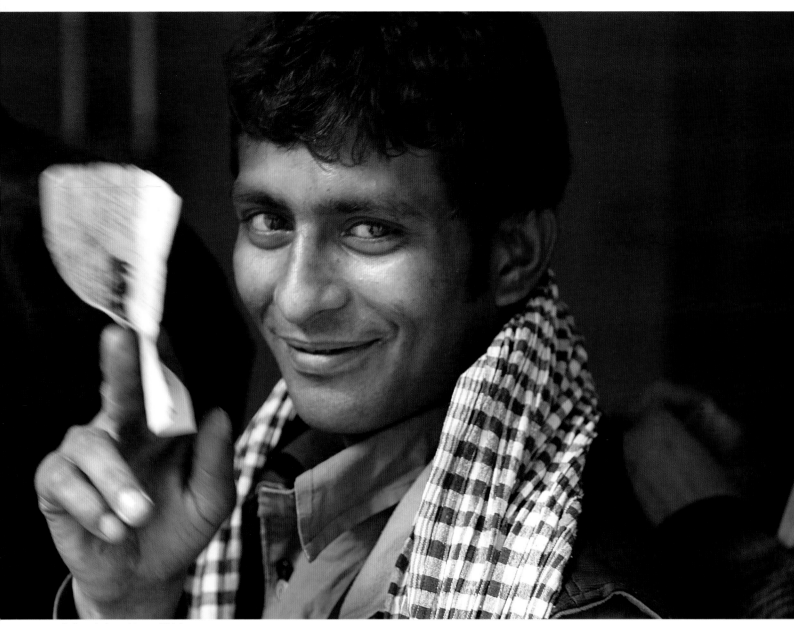

Delhi – India – Moti – 2016

Right page:
Ajmer – India – Plaza – 2016

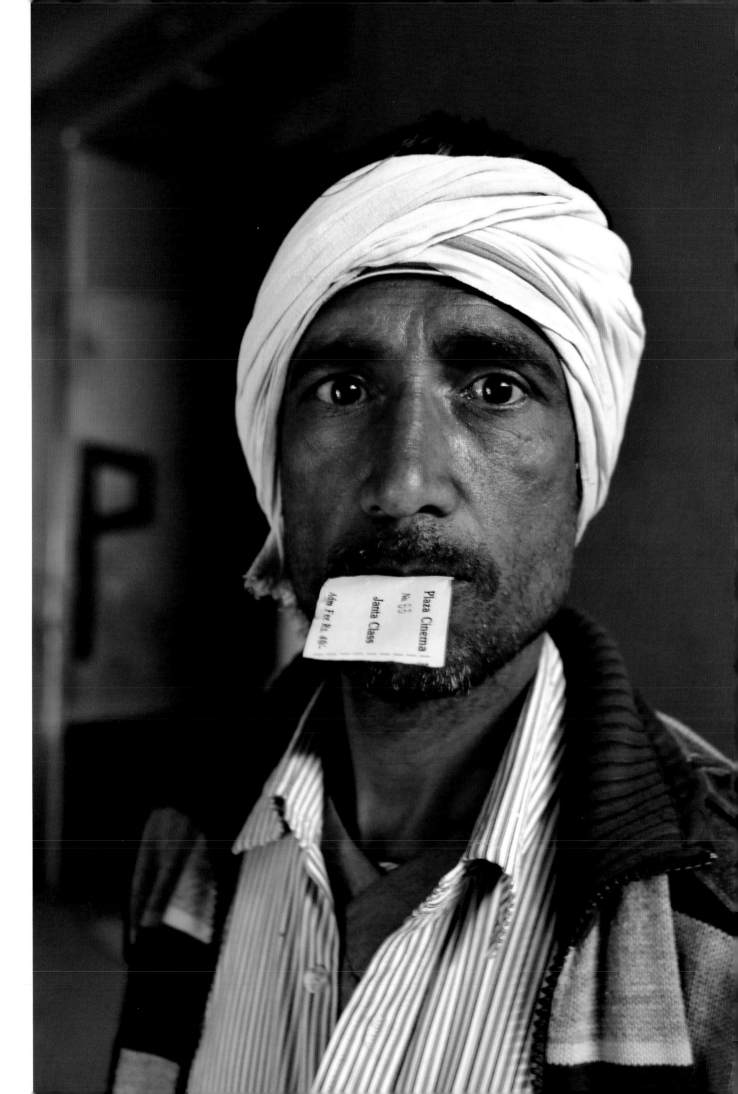

Ambala – India – Nigar – 2014

Ambala – India – Nigar – 2014

Pune – India – Alka – 2014

Mumbai – India – Super Plaza – 2013

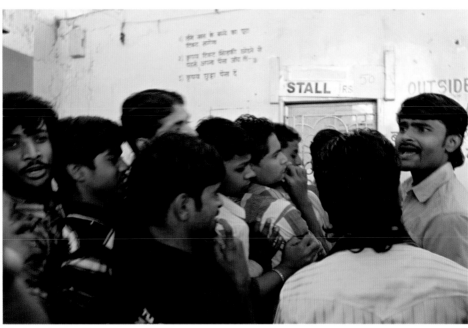

Mumbai – India – Super Plaza – 2013

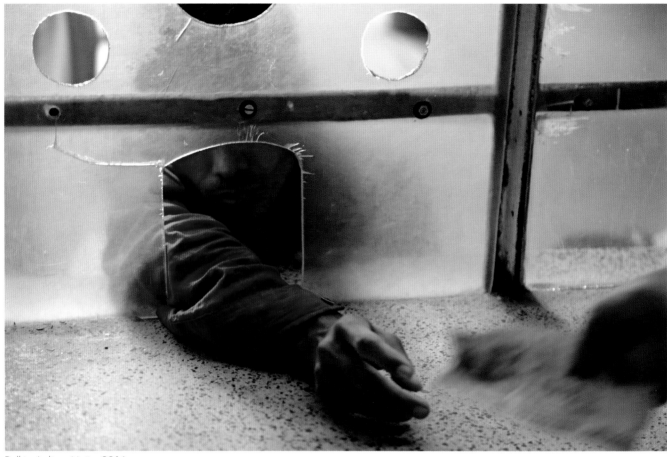

Delhi – India – Moti – 2016

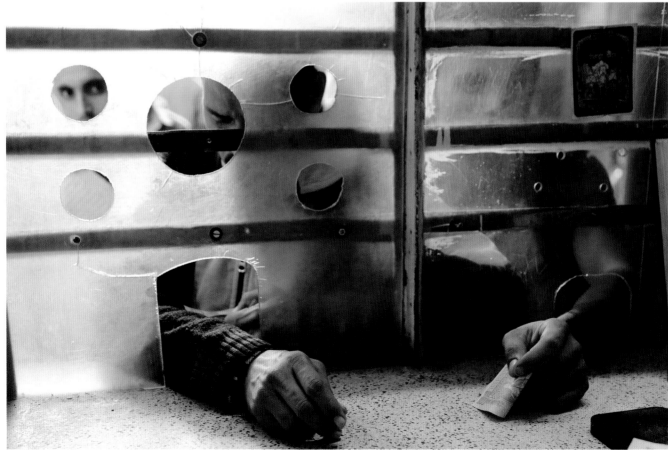

Delhi – India – Moti – 2016

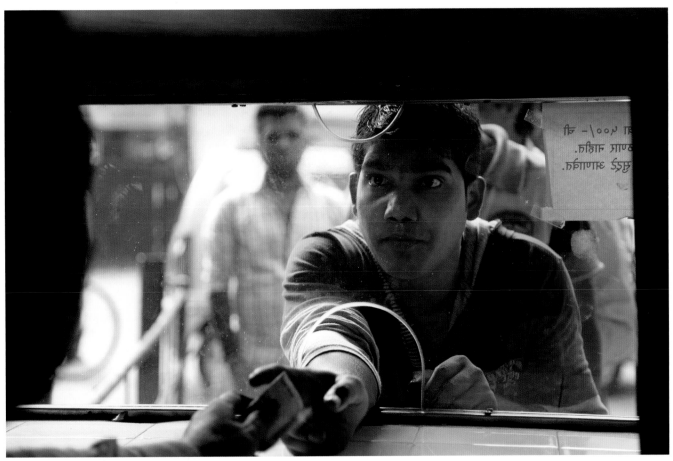

Pune – India – Vijay Chitra – 2014

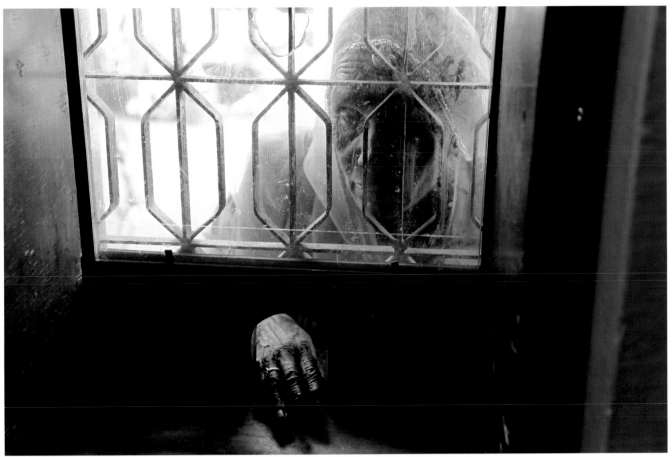

Bilara – India – Laxmi – 2016

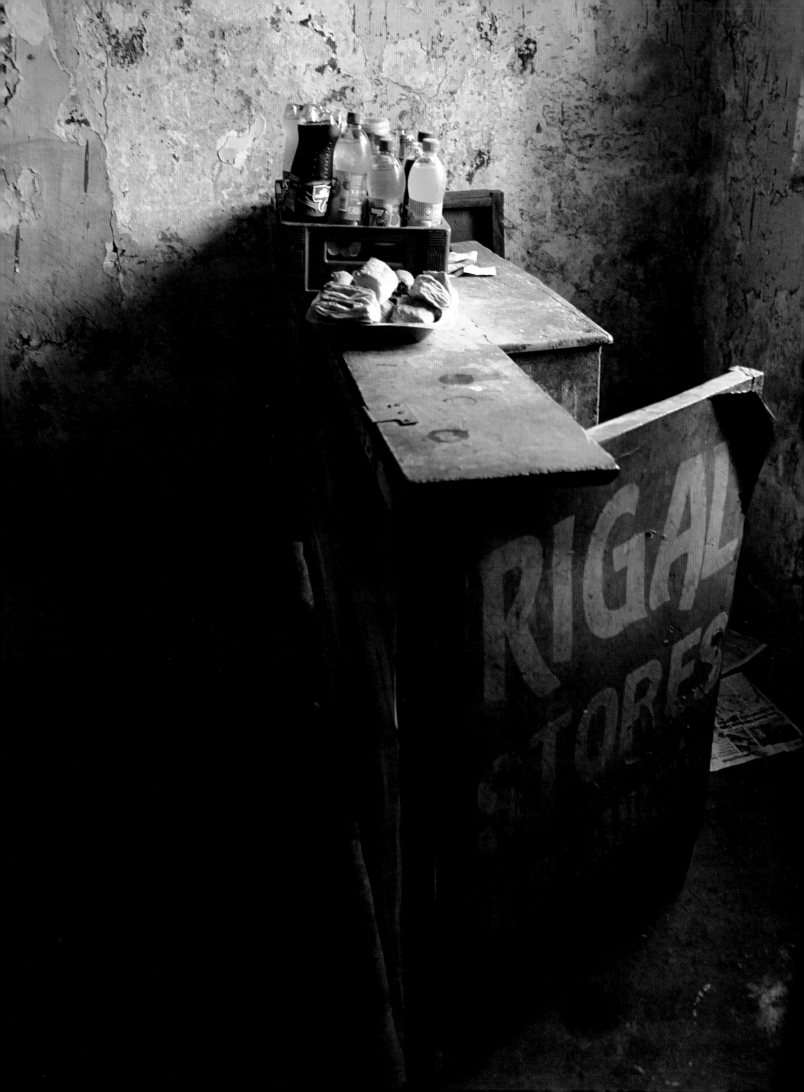

During the intermission, an usherette with her tray of delights would call out, promoting her wares as she was jostled by people making a beeline for the toilets, or smokers heading for the foyer, their habit ignited by cigarette adverts emblazoned on the screen. There are no longer any intervals. Films have become longer and longer. Yet in India, the traditional refreshment stall still thrives; customers surge towards it, trampling on others' feet, shamelessly jumping the queue. What is the point of a film if you can't eat and drink while you watch?

Lausanne – Switzerland – The lady of the Capitole – 2010

Kolkata – India – Elite – 2010

Kolkata – India – Elite – 2010

Kolkata – India – Elite – 2010

Kolkata – India – Elite – 2010

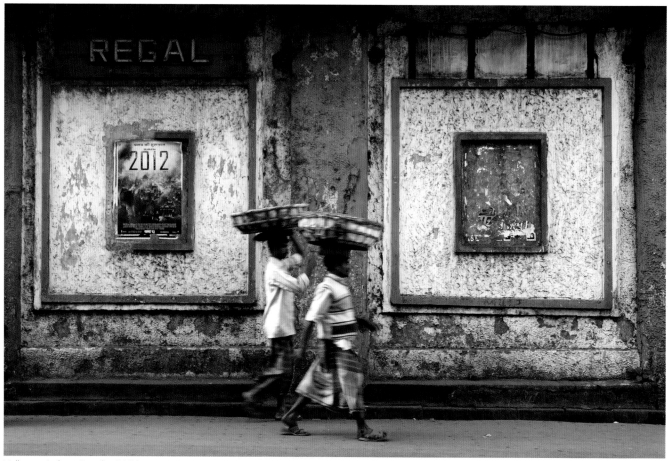

Kolkata – India – Regal – 2012

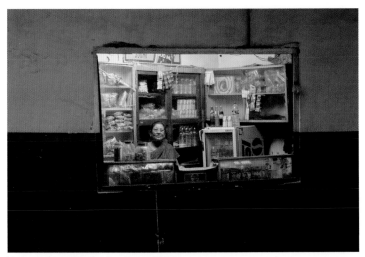

Kathmandu – Nepal – Ranjana – 2006

Bangalore – India – Uma – 2016

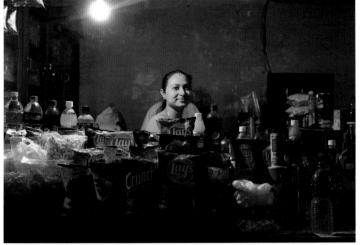

Jaipur – India – Paras – 2014

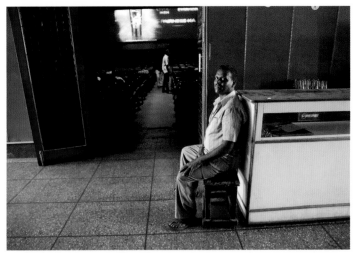

Bangalore – India – Menaka – 2016

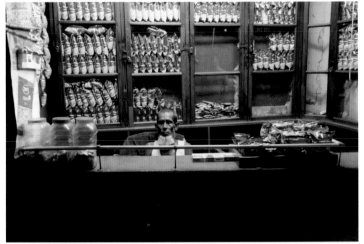

Dacca – Bangladesh – Manussi – 2012

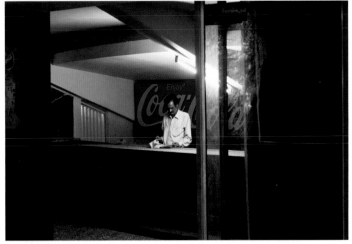

Bangalore – India – Sangeet – 2013

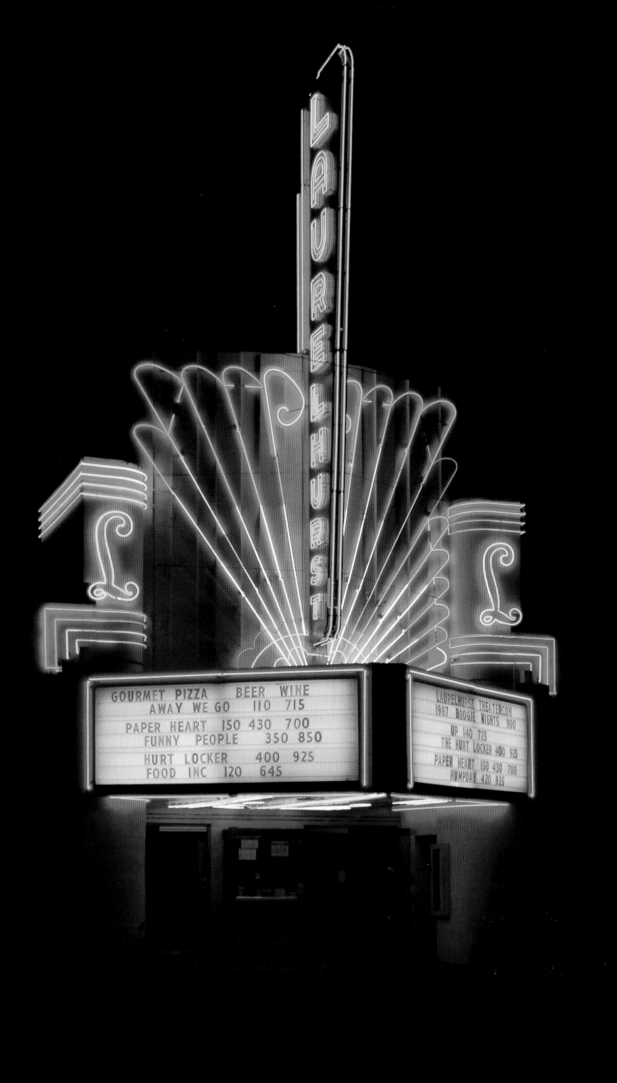

GOURMET PIZZA BEER WINE
AWAY WE GO 110 715
PAPER HEART 150 430 700
FUNNY PEOPLE 350 850
HURT LOCKER 400 925
FOOD INC 120 645

LAURELHURST THEATERCOM
1997 BOOGIE NIGHTS 900
UP 140 725
THE HURT LOCKER 400 925
PAPER HEART 150 430 700
HUMPDAY 420 935

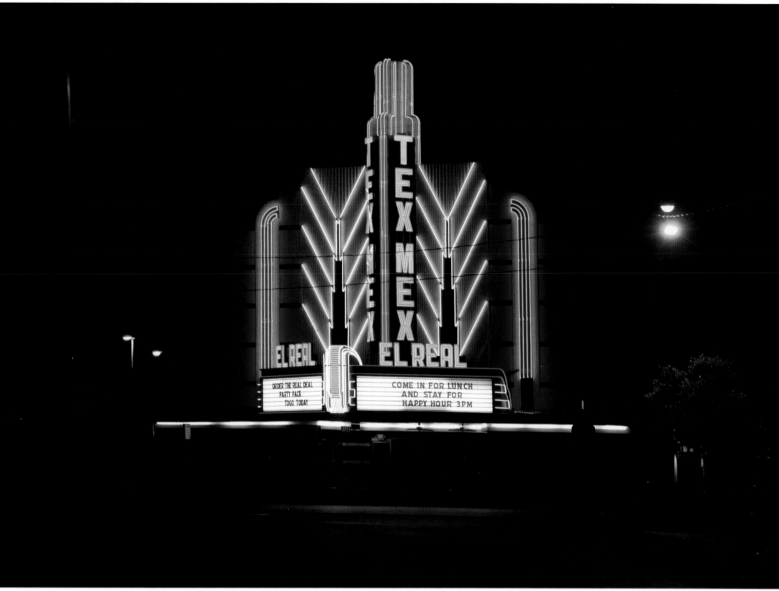

Houston, Texas – USA – Tower – 2011

Since the 1920s, cinemas have used their gaudy frontages to attract attention. Vivid neon colours and shifting patterns can have a powerful effect on human behaviour. Without realising it, people are drawn towards the source of the mesmerising illuminations and a promise of delicious surprises.

Although the commercial use of neon spread quickly, it was only the picture palace frontages that exploited the full potential of its art. Many are truly great works, created by now forgotten artists. Such works are still frequently encountered in Sweden and the United States, where they perfectly embody the magnificence of the cinema's golden age.

Left page:
Portland, Oregon – USA – Laurelhurst – 2009

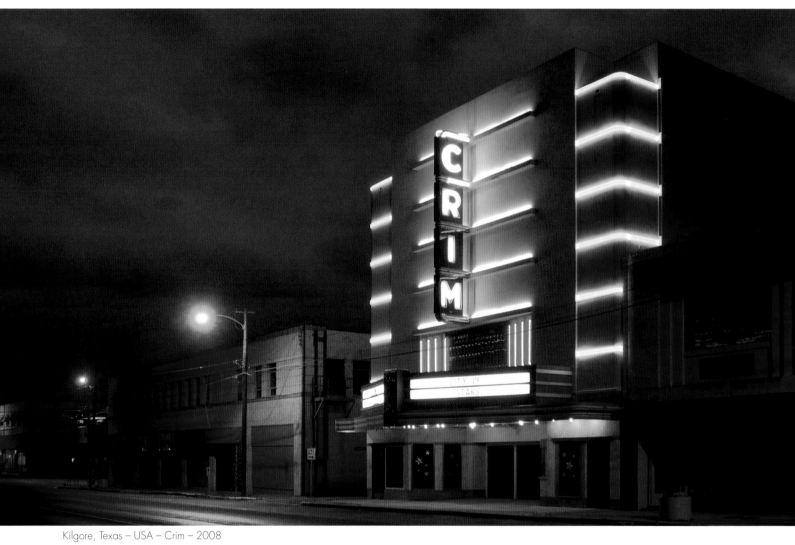

Kilgore, Texas – USA – Crim – 2008

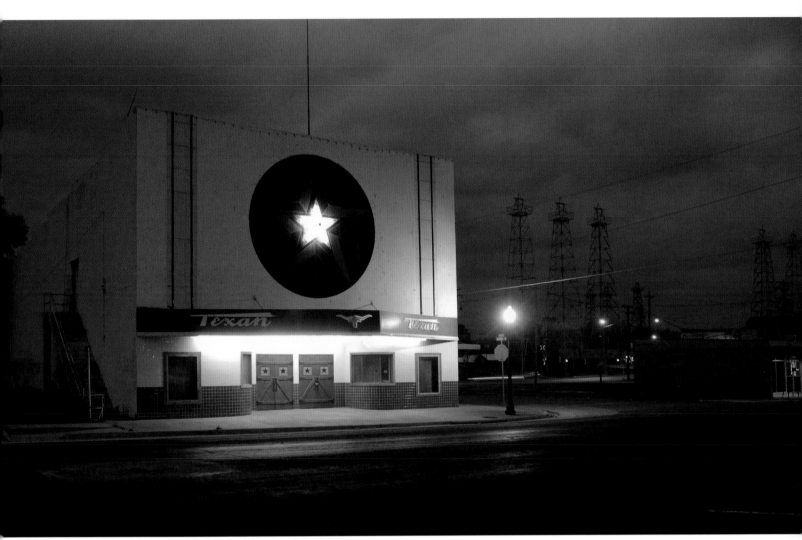

Kilgore, Texas – USA – Texan – 2008

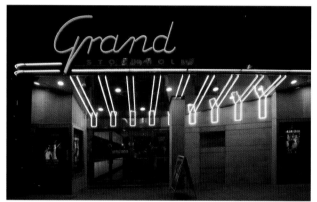

Stockholm – Sweden – Grand – 2014

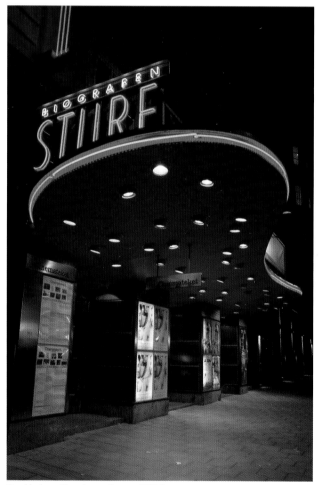

Stockholm – Sweden – Sture – 2008

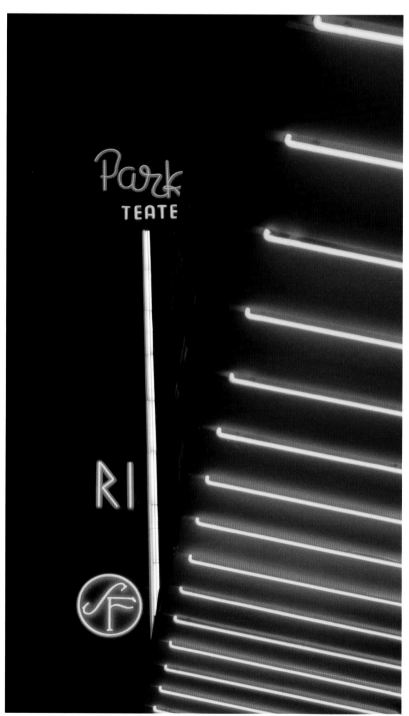

Stockholm – Sweden – Park – 2014

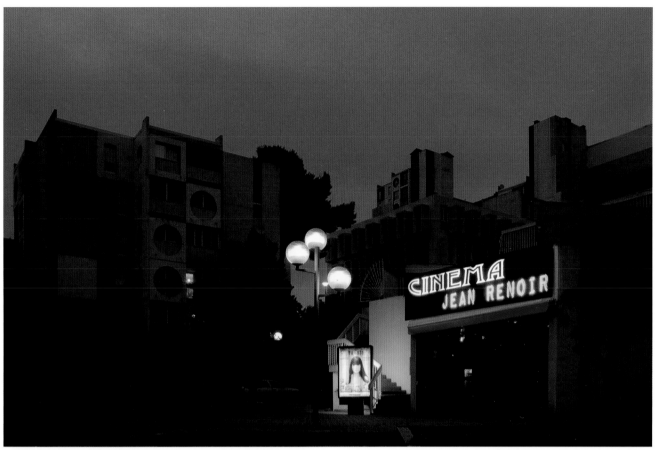

Martigues – France – Jean Renoir – 2009

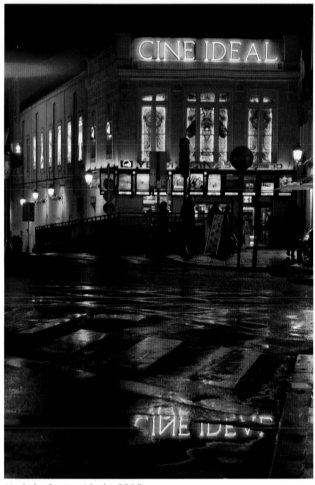

Madrid – Spain – Ideal – 2012

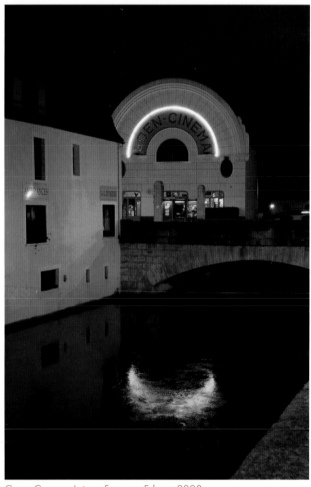

Cosne-Cours-sur-Loire – France – Eden – 2008

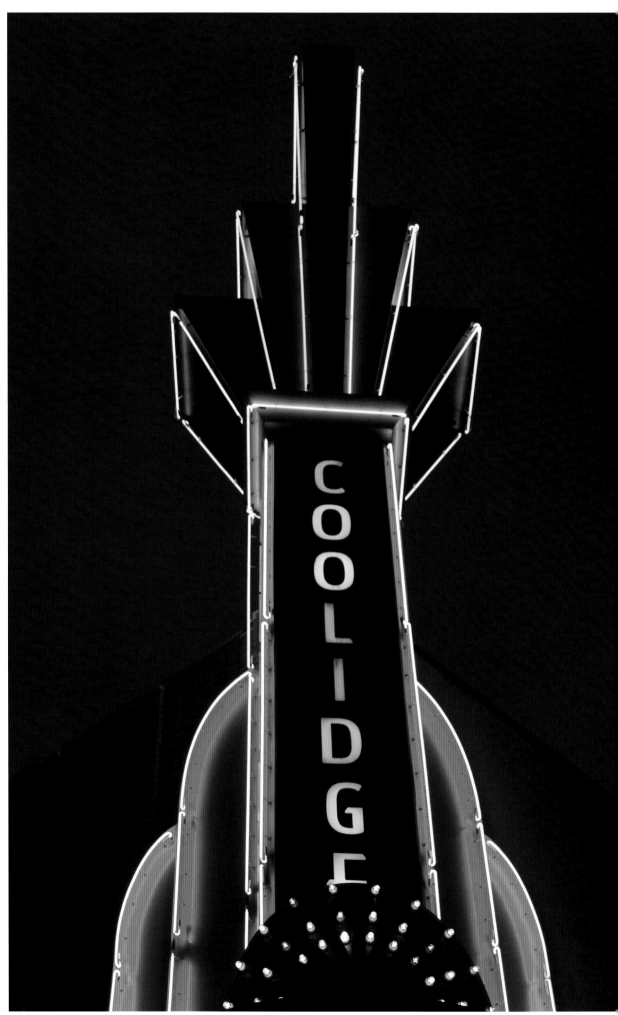

Brookline, Massachusetts – USA – Coolidge Corner – 2011

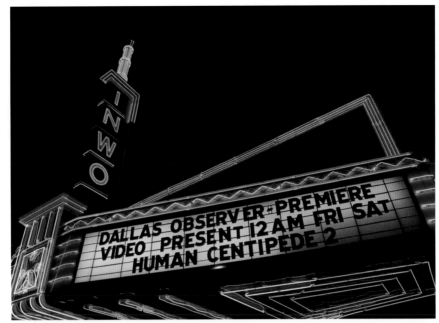

Dallas, Texas – USA – Inwood – 2011

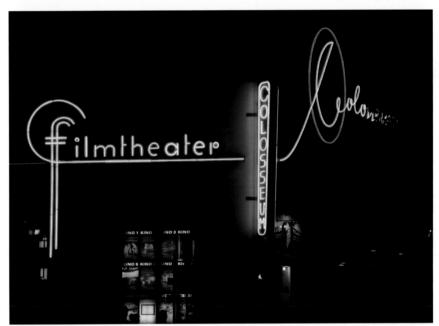

Berlin – Germany – Colosseum – 2013

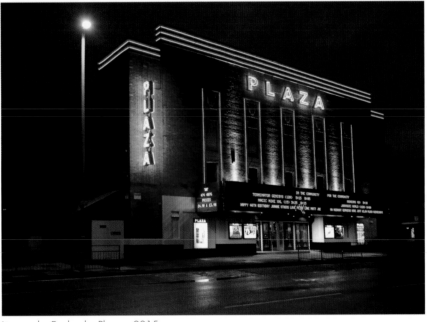

Liverpool – England – Plaza – 2015

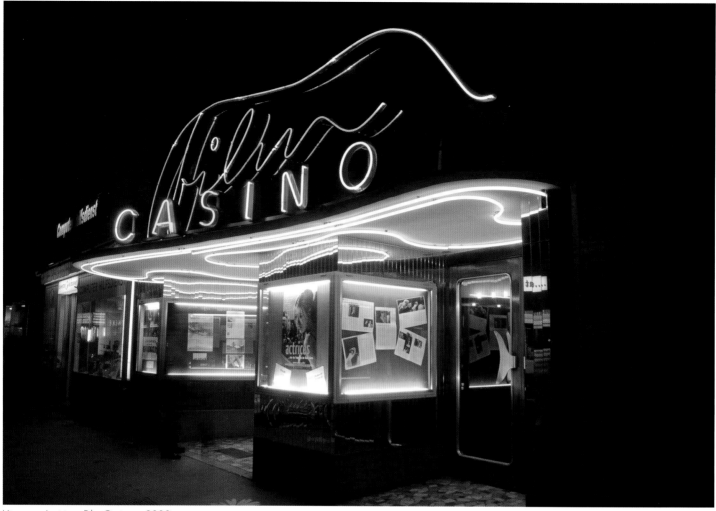

Vienna – Austria – Film Casino – 2008

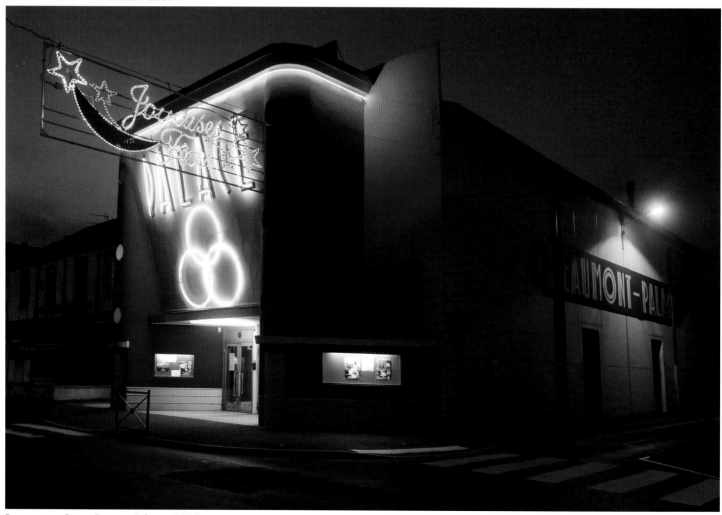

Beaumont-sur-Oise – France – Palace – 2015

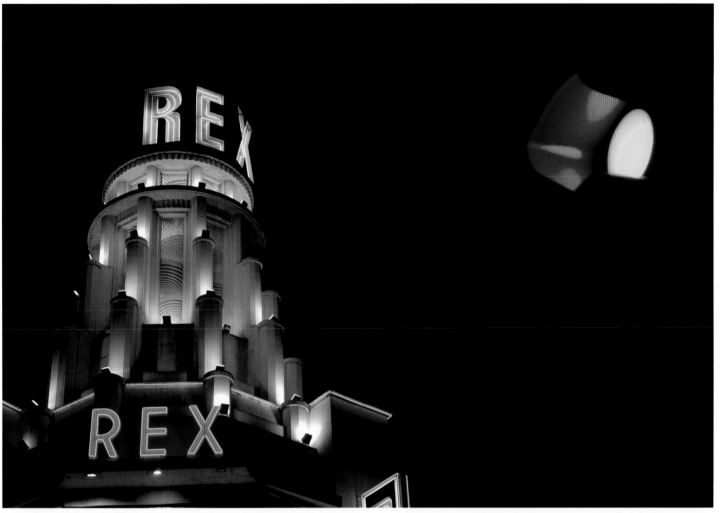

Paris – France – Rex – 2008

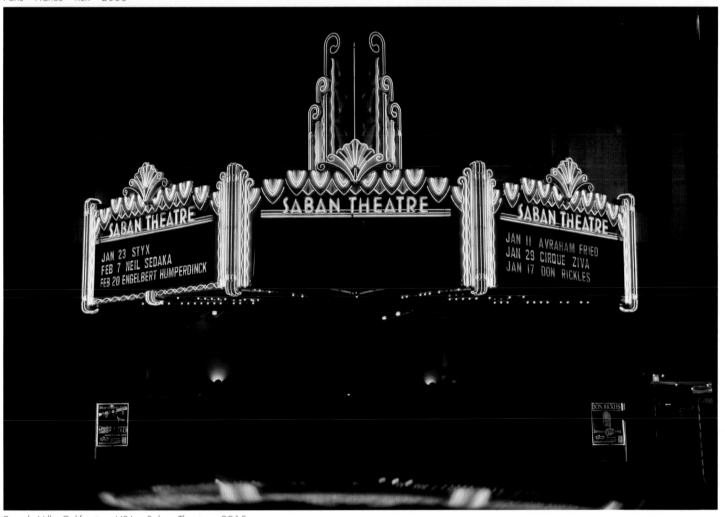

Beverly Hills, California – USA – Saban Theatre – 2015

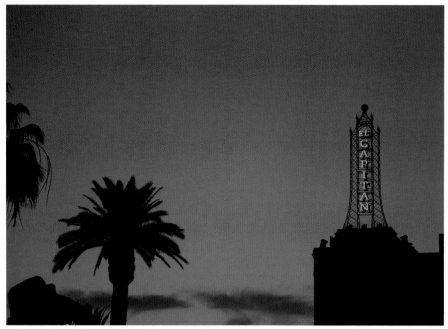

Hollywood – California, USA – El Capitan – 2015

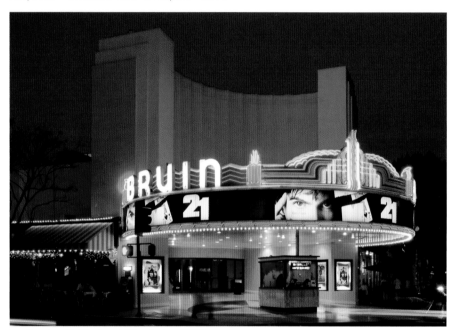

Los Angeles, California – USA – Bruin – 2008

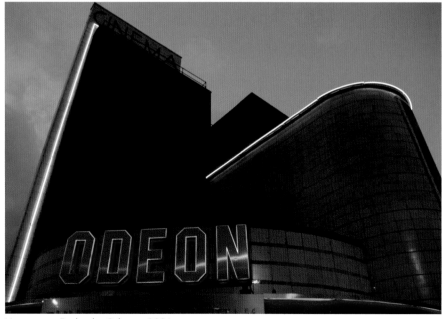

Harrogate – England – Odeon – 2006

Right page:
Detroit, Michigan – USA –
Fox – 2010

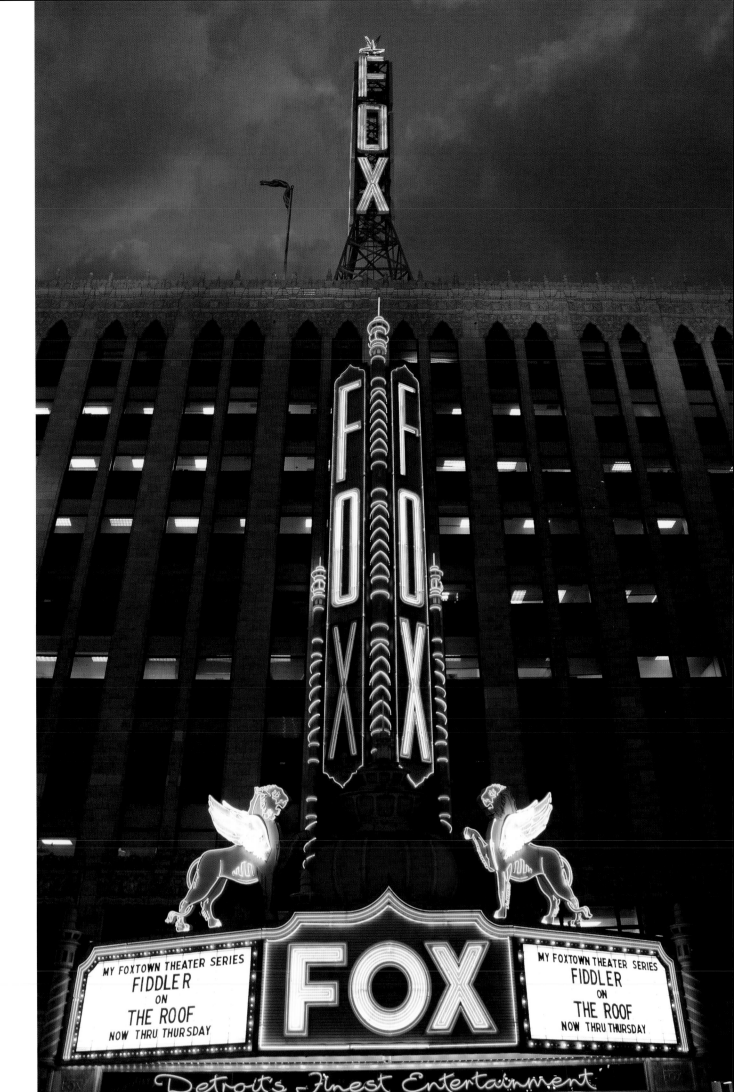

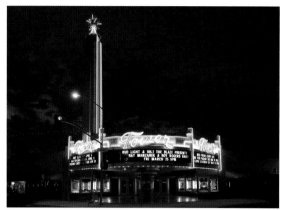

Fresno, California – USA – Tower – 2011

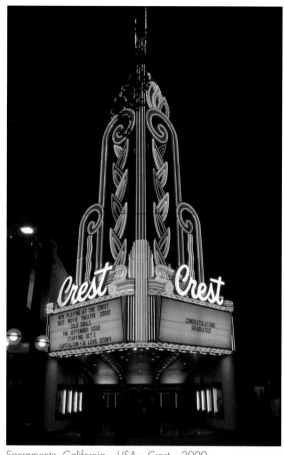

Sacramento, California – USA – Crest – 2009

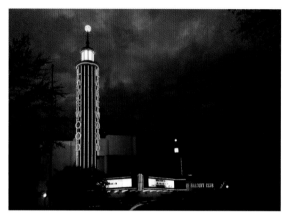

Dallas, Texas – USA – Lakewood – 2011

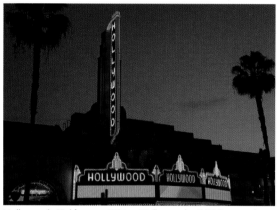

Hollywood, California – USA – Hollywood – 2015

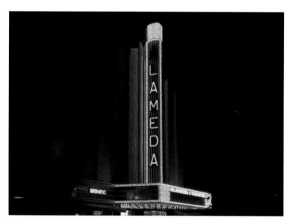

Alameda, California – USA – Alameda – 2015

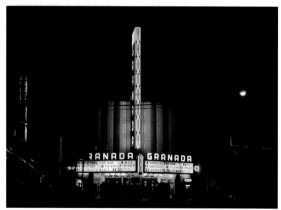

Dallas, Texas – USA – Granada – 2011

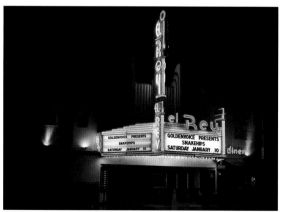

Los Angeles, California – USA – Fox La Brea – 2015

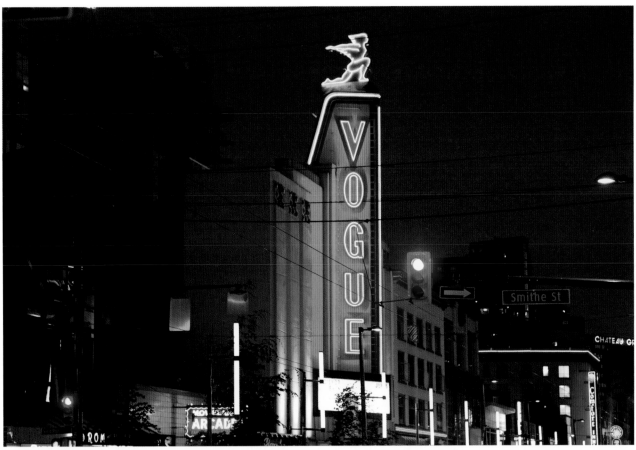

Vancouver – Canada – Vogue – 2014

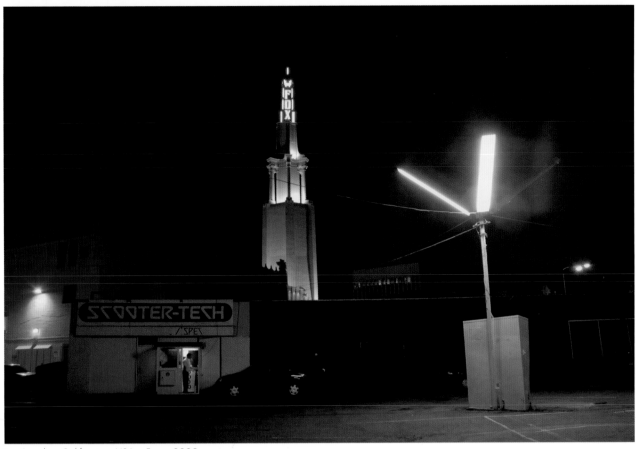

Los Angeles, California – USA – Fox – 2008

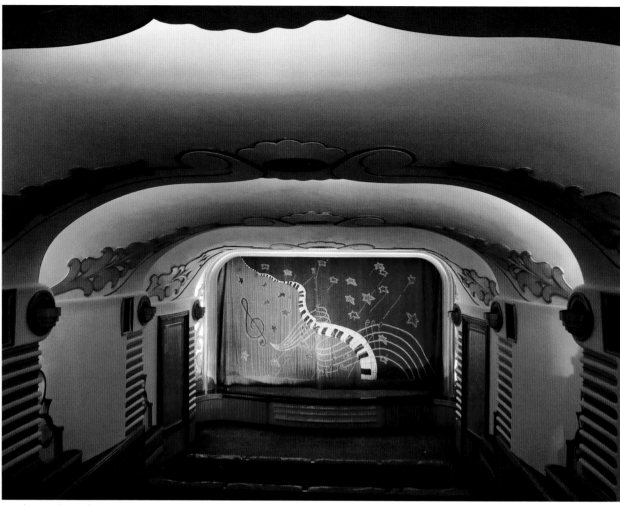

Mumbai – India – Liberty – 2012

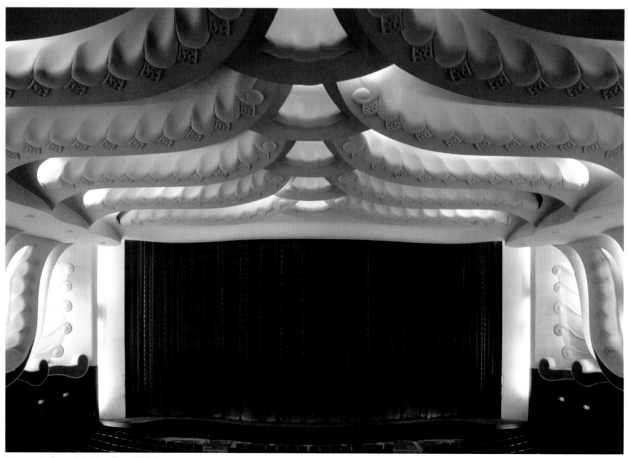

Jaipur – India – Raj Mandir – 2014

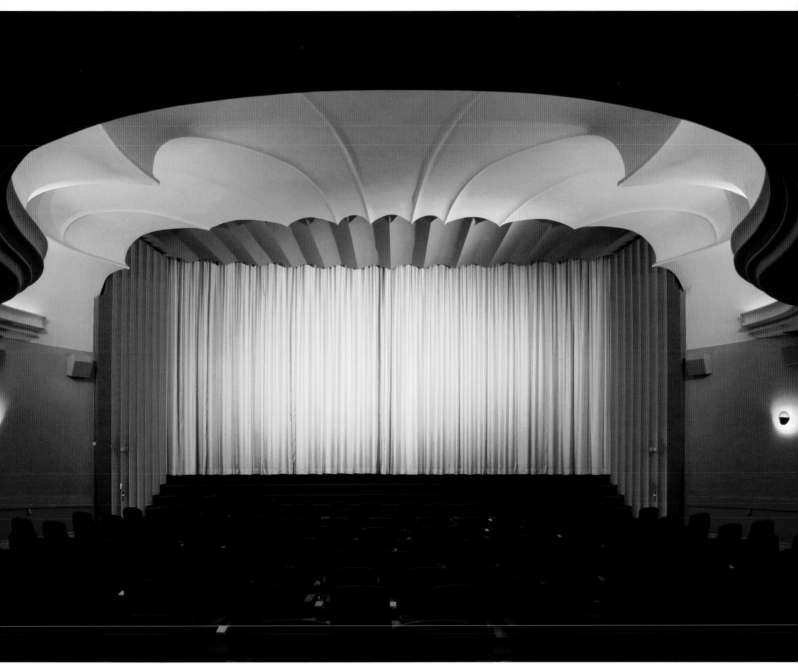

Berlin – Germany – Astor – 2013

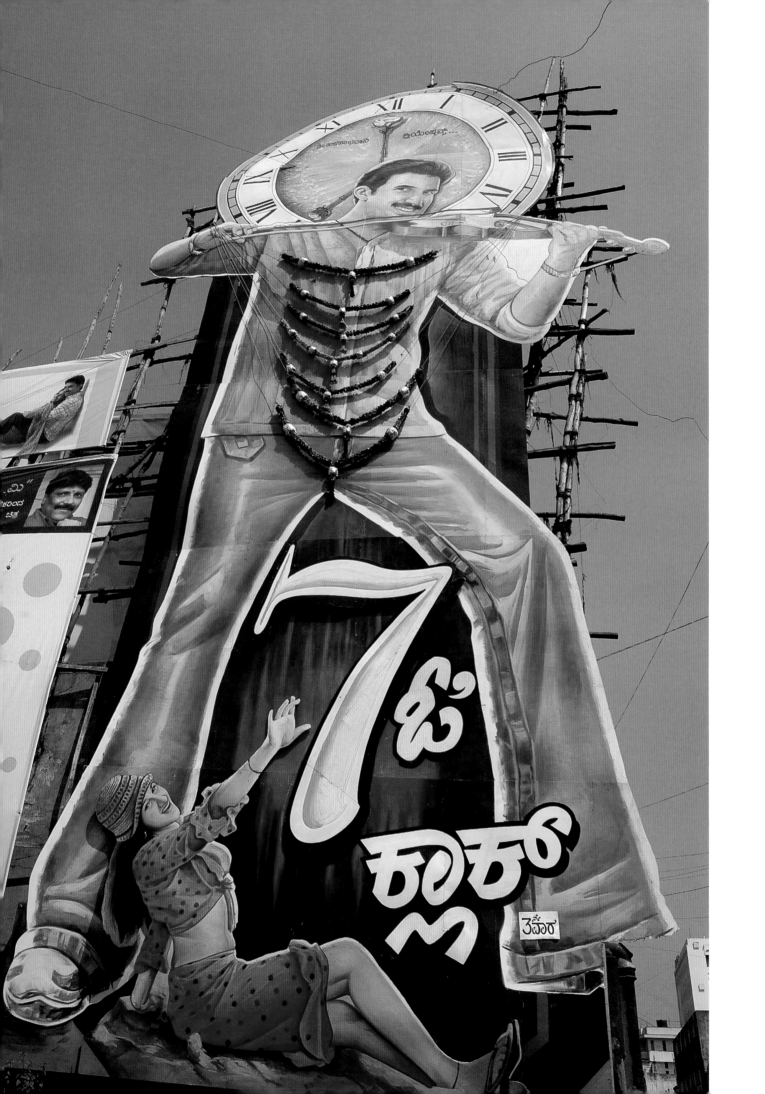

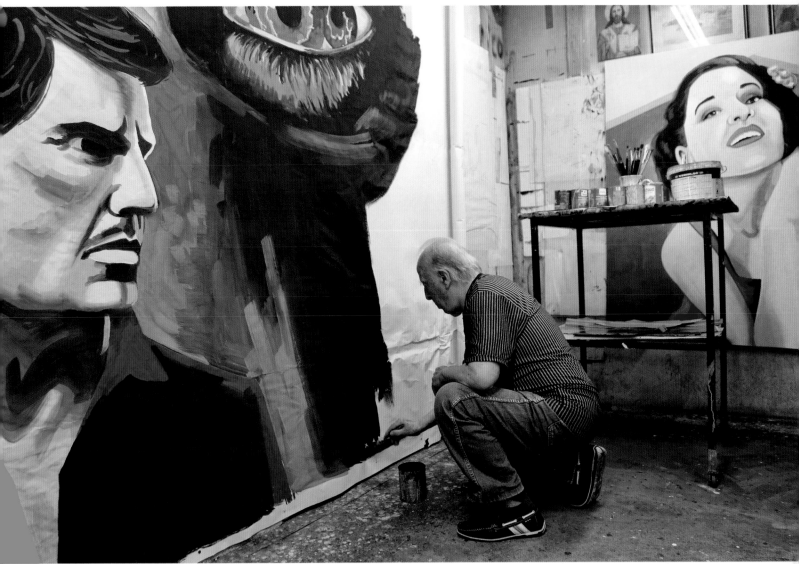

Athens – Greece – Vasilis Dimitriou – 2017

82-year-old Vassilis Dimitriou is Europe's last poster artist. Until recently, every Wednesday he would decorate the entrance to the Athinaion cinema in Athens with his hand-painted film posters. Now, due to illness, he only does it sporadically, and Virginia Axioti continues his work. Cinema director Kostas Giannopoulos is keen to retain the tradition. He has never forgotten looking out of his window across from the cinema, watching the workmen as every week they put up enormous hand-painted hoardings depicting femmes fatale in all their sensuality, and how they troubled his sleep as an adolescent.

In Bangalore, Matthanna Chinnapa, the last painter in a long and popular tradition, already seems to belong to a distant era. Change has come about so quickly in India. He looks nostalgically at his hoardings and continues painting in his meticulous manner, hoping his brushstrokes might slow down the passage of time so that he can carry on this tradition that is now his and his alone.

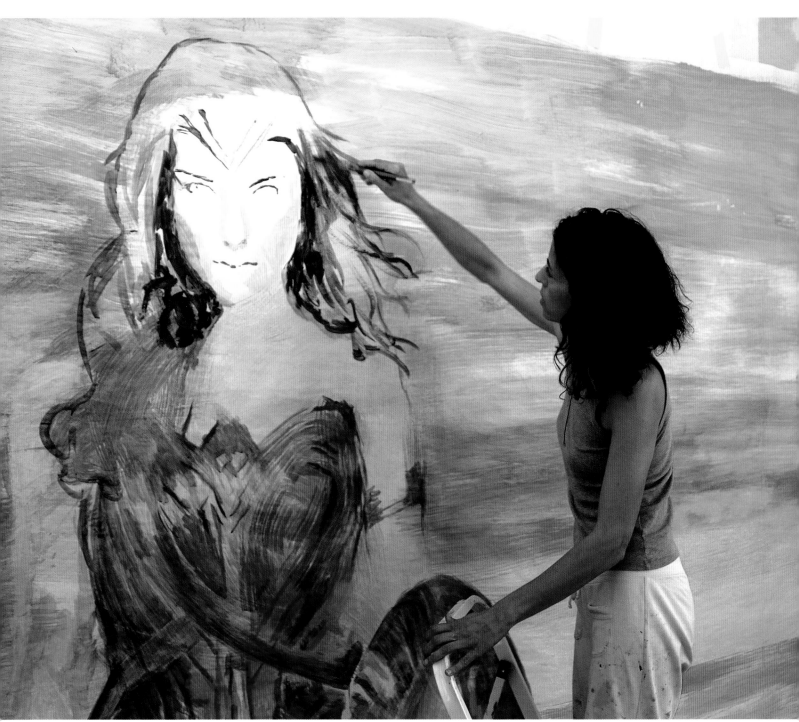

Athens – Greece – Virginia Axioti – 2017

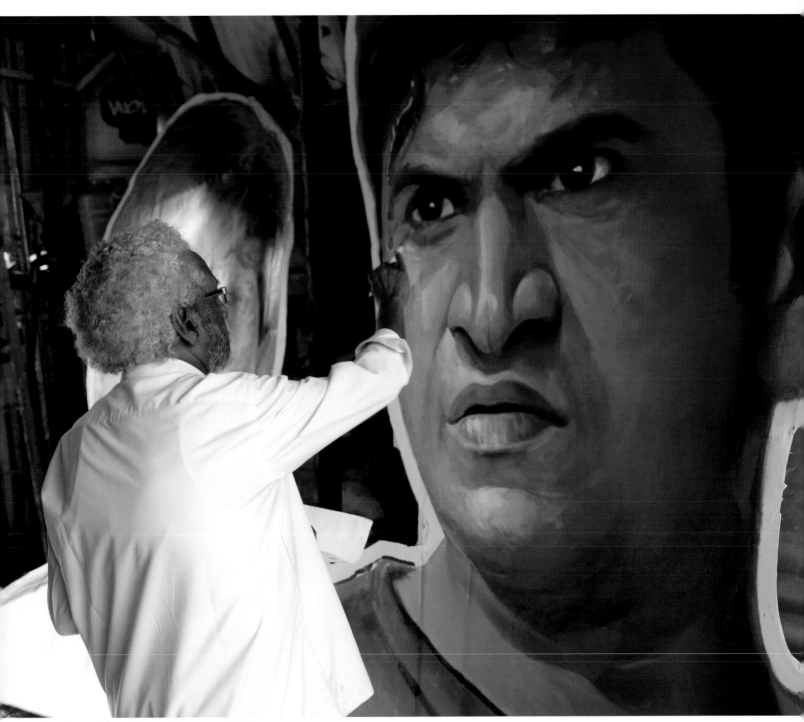

Bangalore – India – Mutanna Chinnappa – 2016

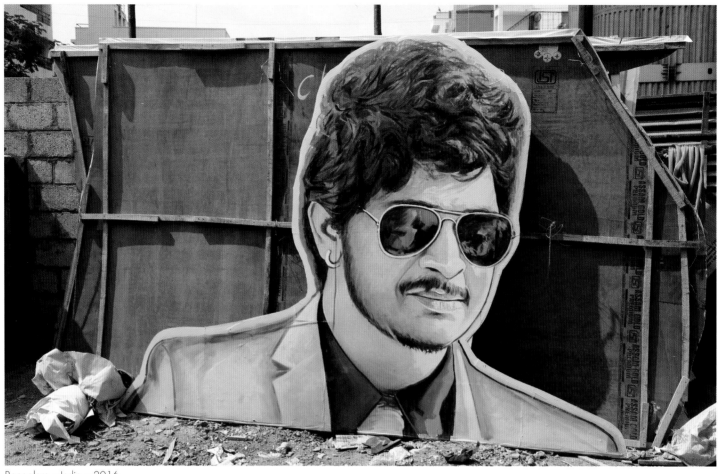

Bangalore – India – 2016

Bangalore – India – 2016

Right page:
Bangalore – India – 2016

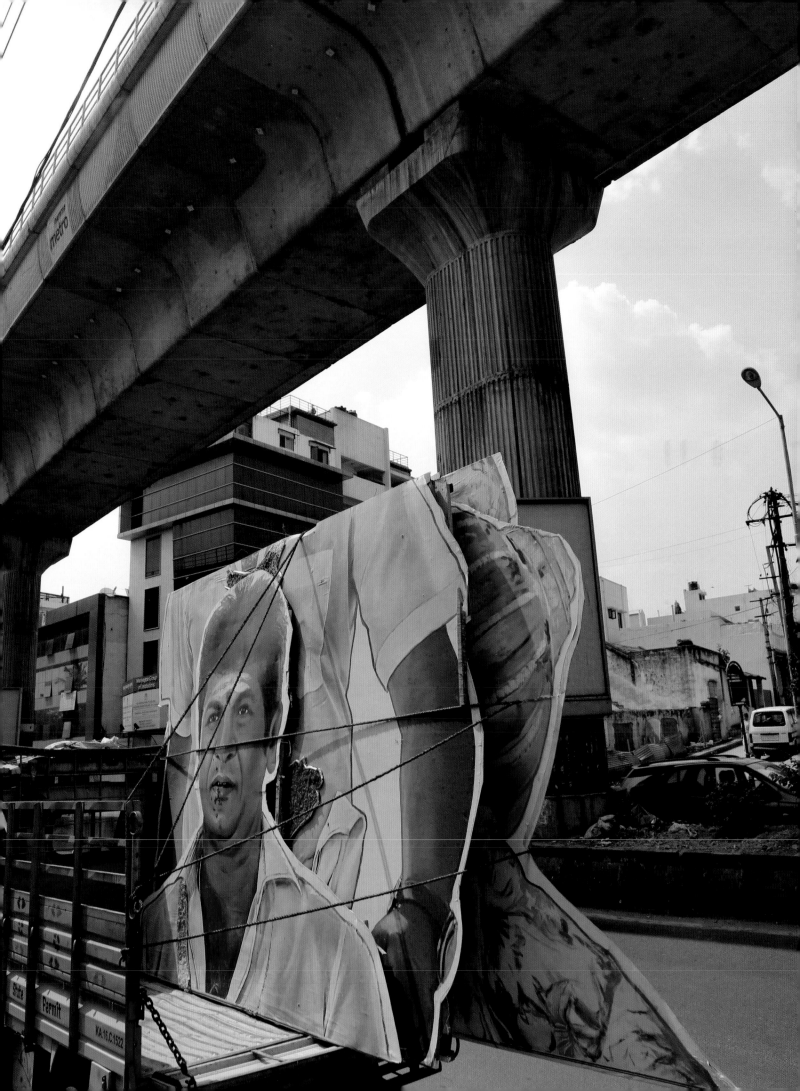

Jhunjhunu – India – Prabhat – 2016

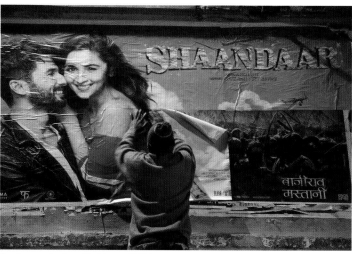

Jhunjhunu – India – Prabhat – 2016

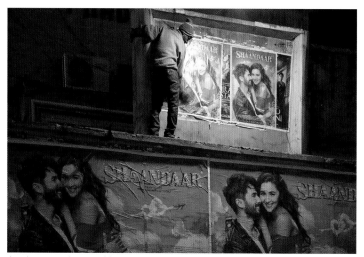

Jhunjhunu – India – Prabhat – 2016

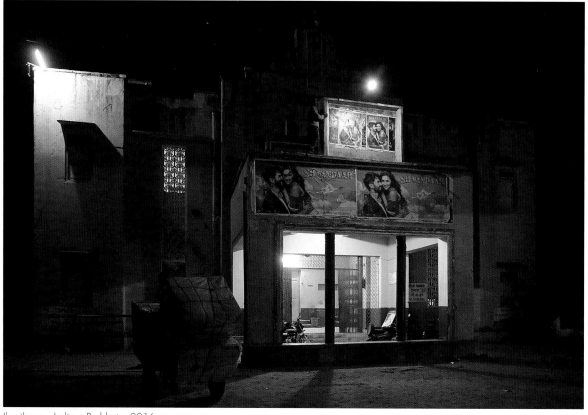

192 Jhunjhunu – India – Prabhat – 2016

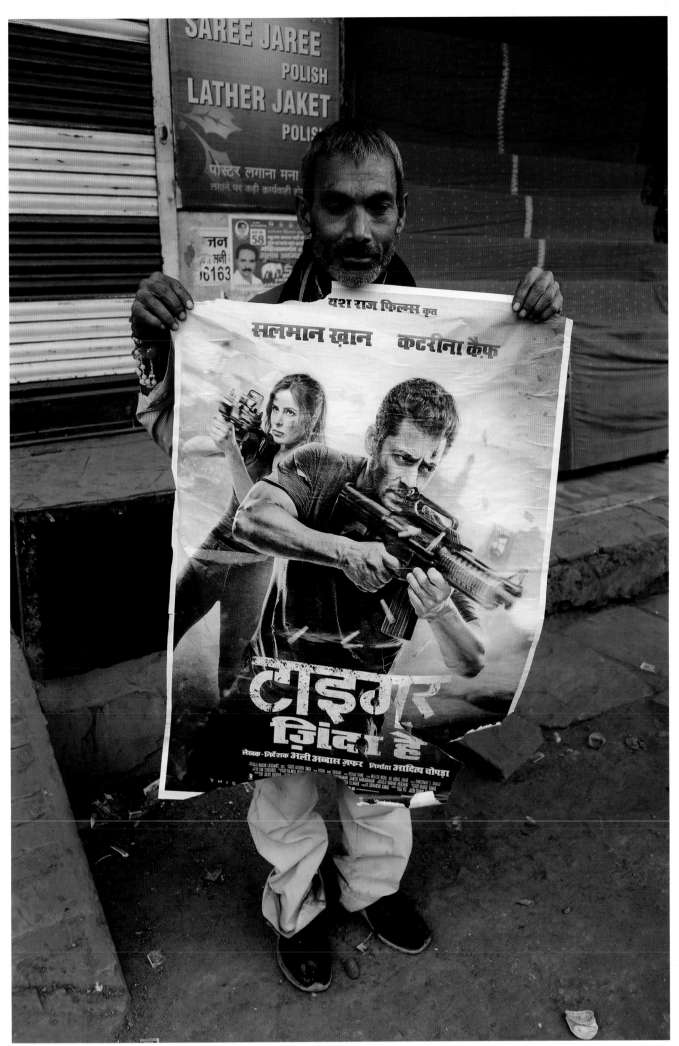

Allahabad – India – 2017

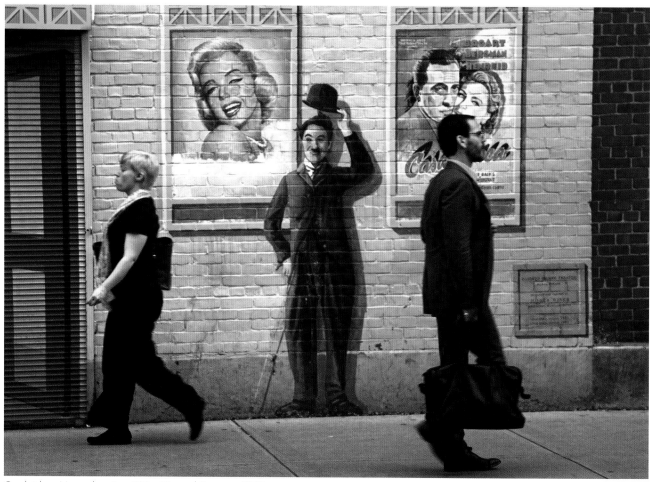

Cambridge, Massachusetts – USA – Harvard Square – 2011

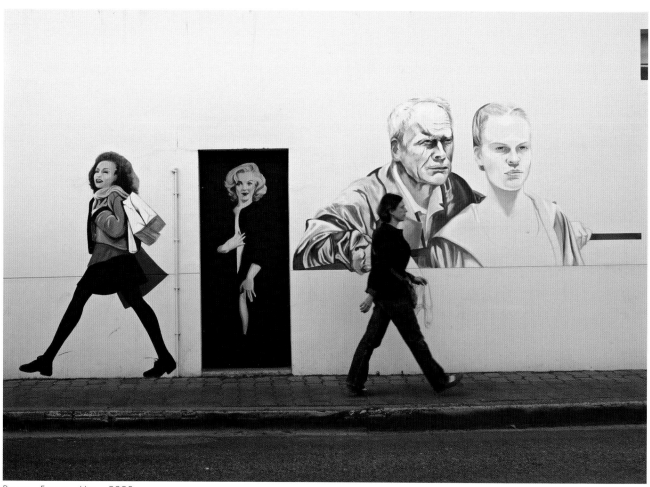

Bazas – France – Vog – 2008

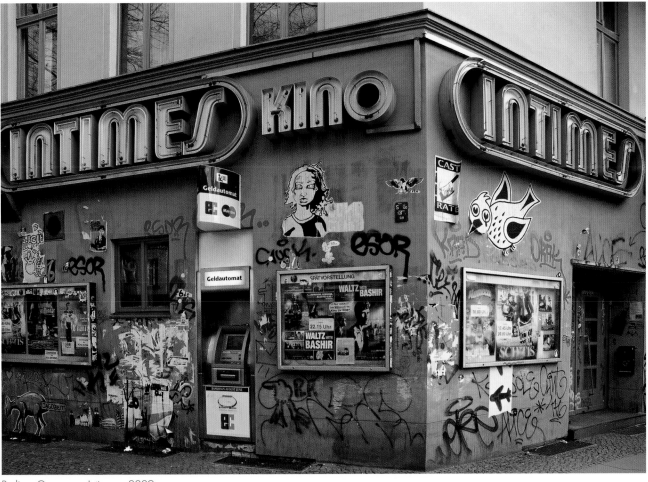

Berlin – Germany – Intimes – 2009

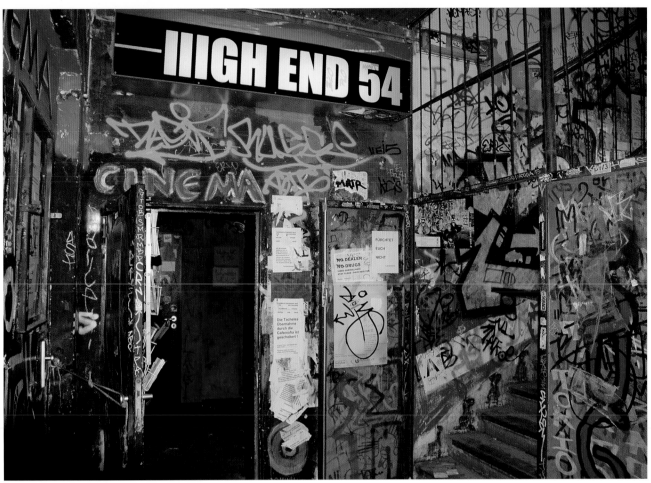

Berlin – Germany – High End 54 (demolished) – 2006

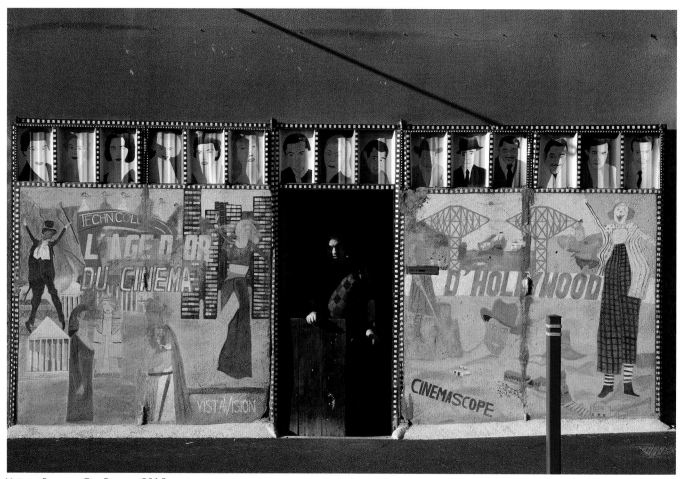

Viviez – France – Guy Brunet – 2015

Guy Brunet lives in a former butchers shop, which he rarely leaves. Inside, at least for now, he has stopped time. Now in his eighth decade, what lights up the life of this man of the 1960s are movies from the Golden Age of Hollywood. In his own style he repaints classic cinema posters, creating works that depict an array of characters: actors, directors, musicians. He acts out their parts in front of his own camera, applying his own interpretation to each one. He is a true star!

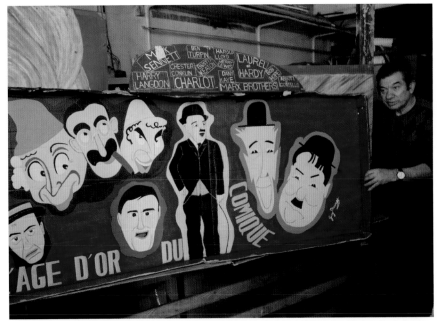

Viviez – France – Guy Brunet – 2015

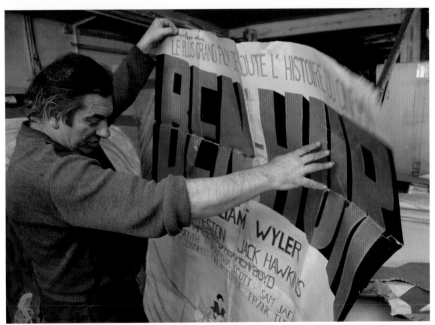

Viviez – France – Guy Brunet – 2015

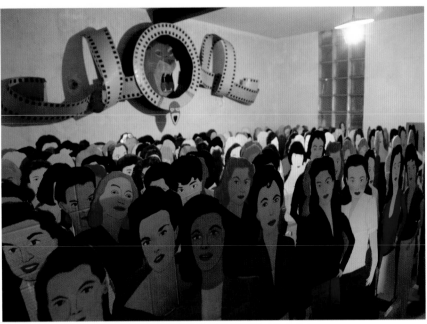

Viviez – France – Guy Brunet – 2015

197

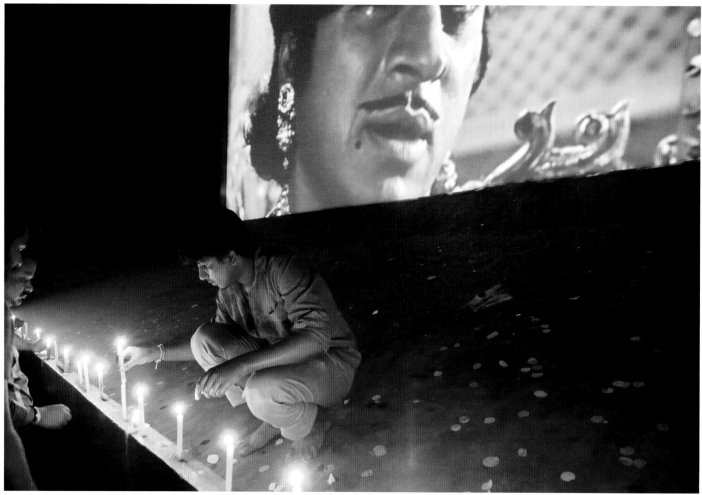

Bangalore – India – Remembering Raaj Kumar – 2016

Raaj Kumar is the embodiment of the mythical Indian film star. After he passed away in 1996, his funeral was attended by two million people. Through his films he conveyed the very essence of a hero, while in real life he was equal to the roles he played. No extravagance, no cigarettes, no alcohol; Raaj Kumar was a man made perfect by cinema, in much the same way as Hollywood in its day shamelessly embellished the lives of its stars. Audiences were electrified by Kumar's performances, almost going out of their minds as they watched. The public was in denial over his death – it marked the beginning of his immortality. Like the stars of Hollywood, he was worshipped as a god.

Right page:
Bangalore – India – Remembering Raaj Kumar – 2016

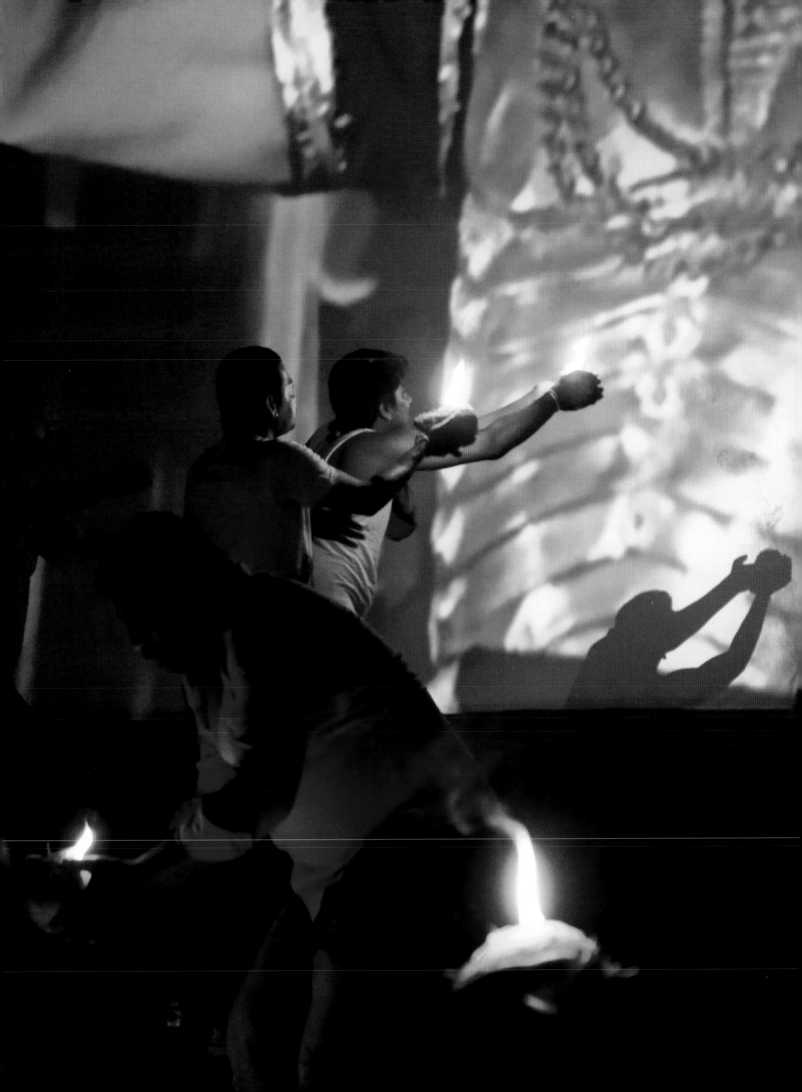

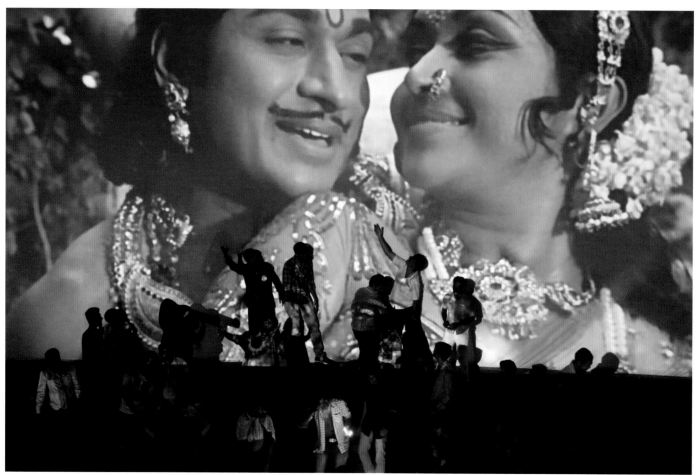

Bangalore – India – Remembering Raaj Kumar – 2016

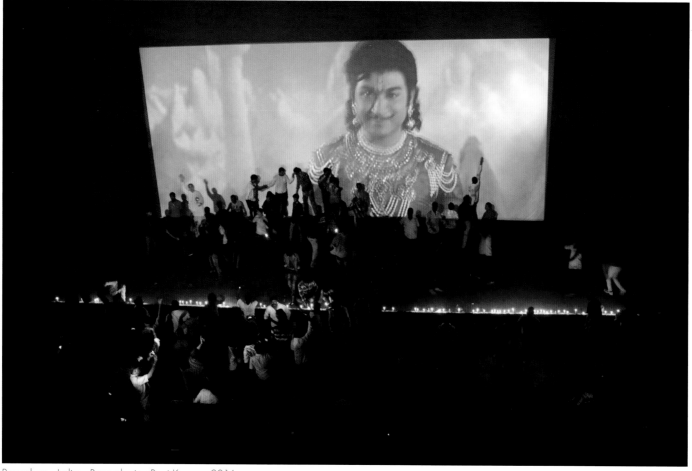

Bangalore – India – Remembering Raaj Kumar – 2016

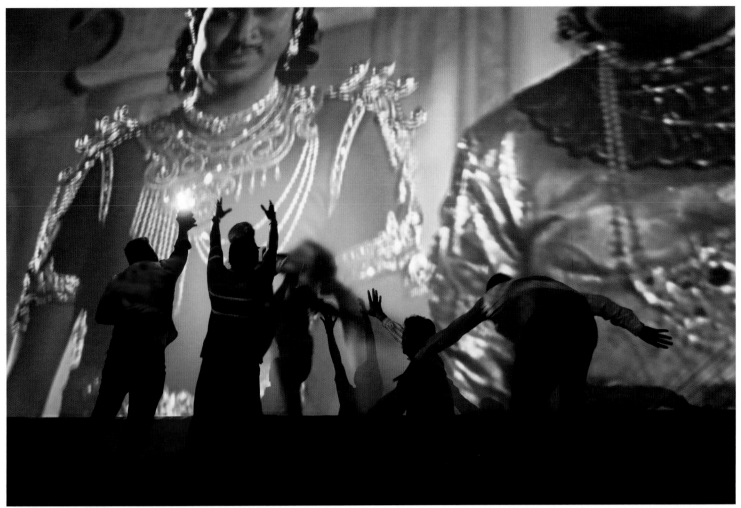

Bangalore – India – Remembering Raaj Kumar – 2016

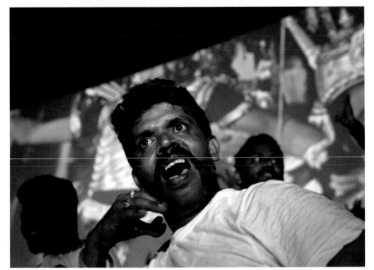

Bangalore – India – Remembering Raaj Kumar – 2016

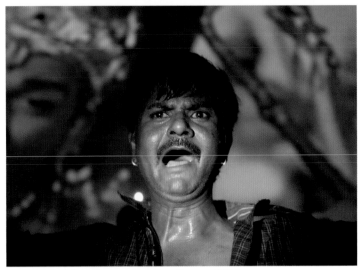

Bangalore – India – Remembering Raaj Kumar – 2016

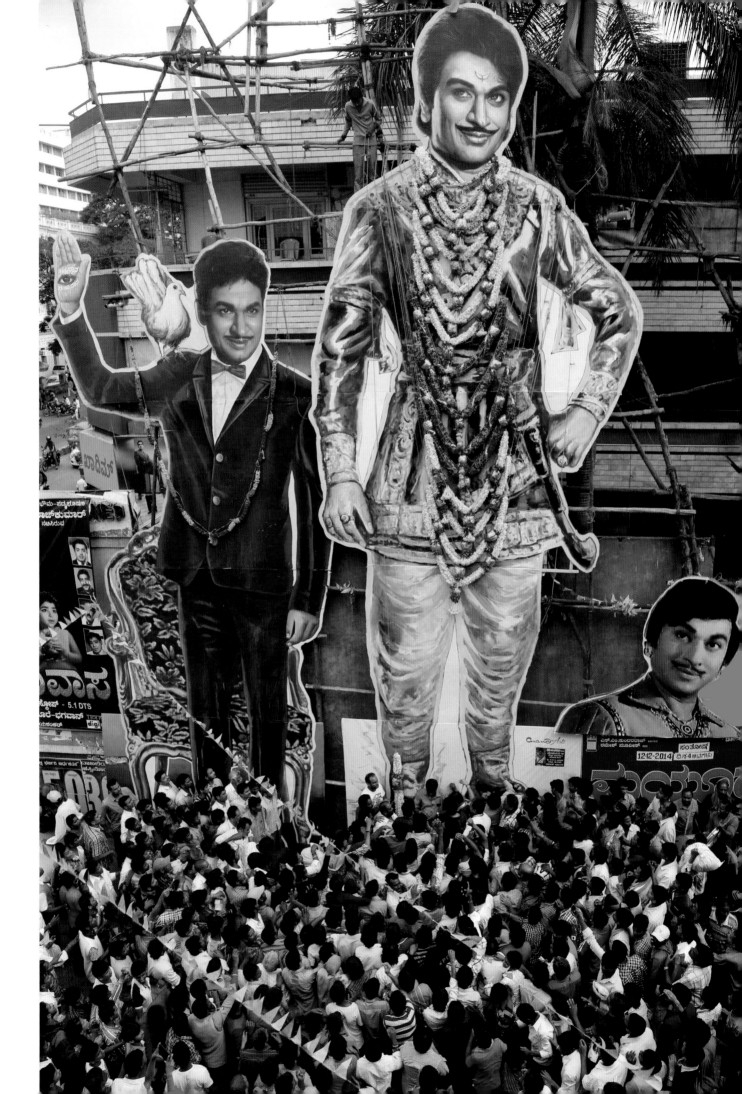

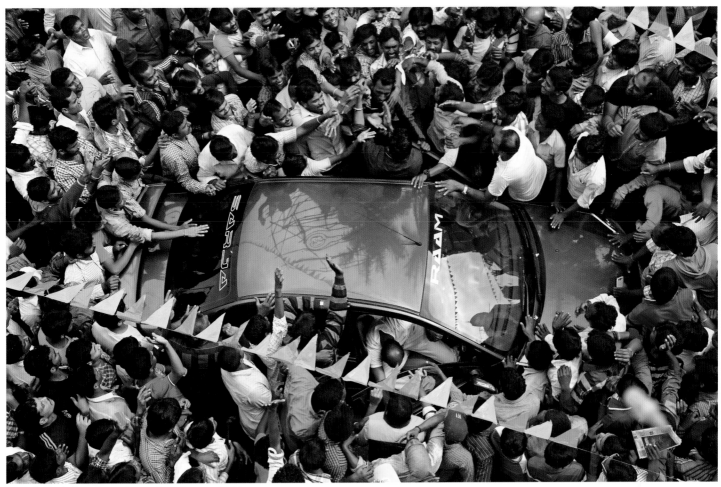

Bangalore – India – Remembering Raaj Kumar – 2016

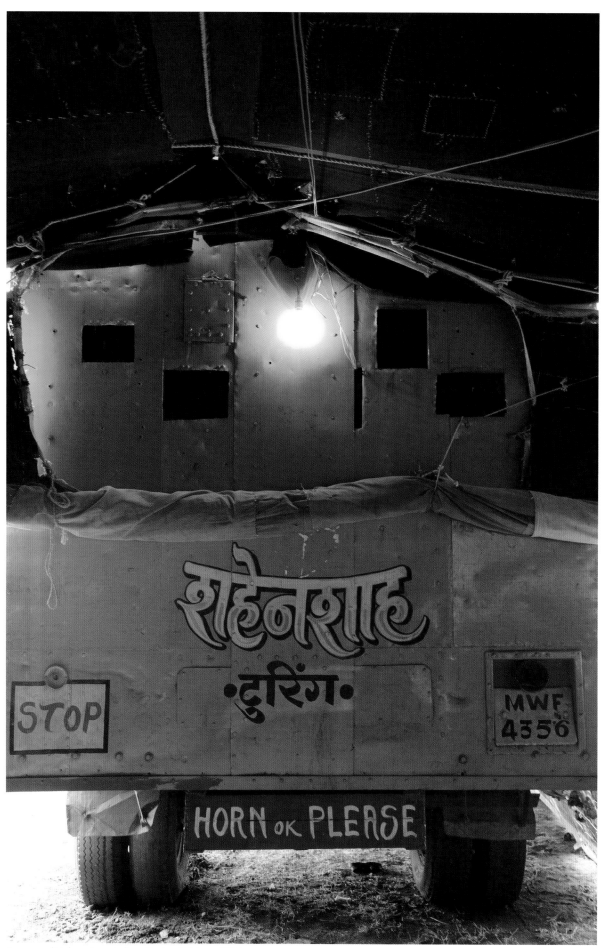

Puseagon/Maharastra – India – Touring Talkies – 2014

Off the beaten track in the heart of Maharashtra State in India, there are a few people who can be seen travelling around in their old lorries, pitching tents in the middle of nowhere. Television – that wily predator – has even reached these remote parts, stealing their audiences, which get smaller each time they hit the road. These people understand full well that interest in films has dwindled massively. Movies are no longer the stuff that dreams are made of. Maybe it's time to try a new venture.

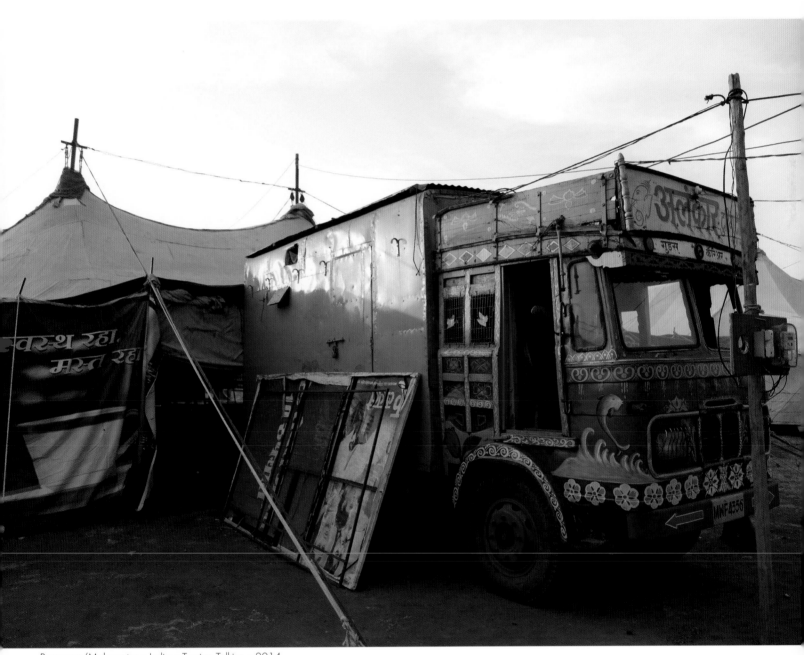

Puseagon/Maharastra – India – Touring Talkies – 2014

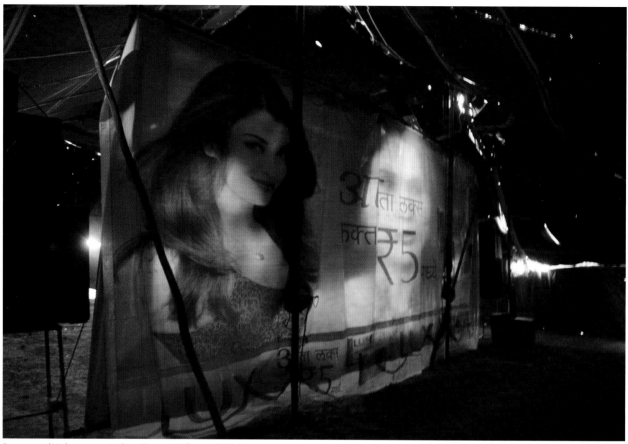

Puseagon/Maharastra – India – Touring Talkies – 2014

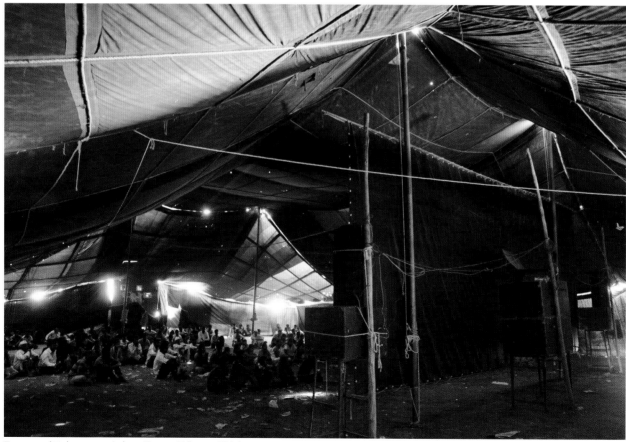

Puseagon/Maharastra – India – Touring Talkies – 2014

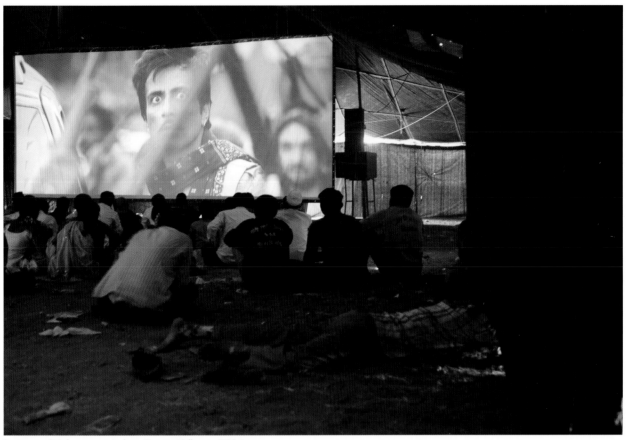

Puseagon/Maharastra – India – Touring Talkies – 2014

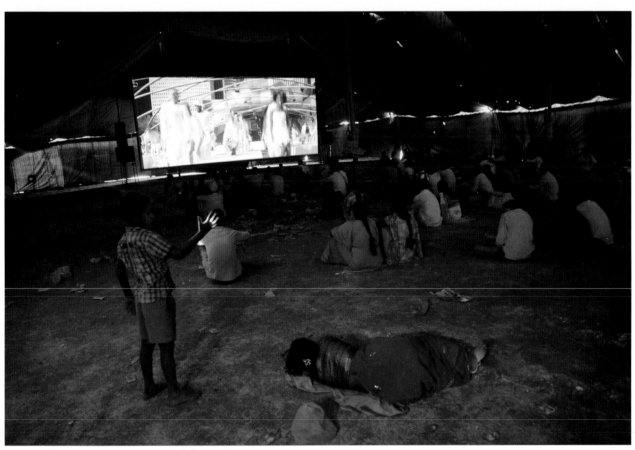

Puseagon/Maharastra – India – Touring Talkies – 2014

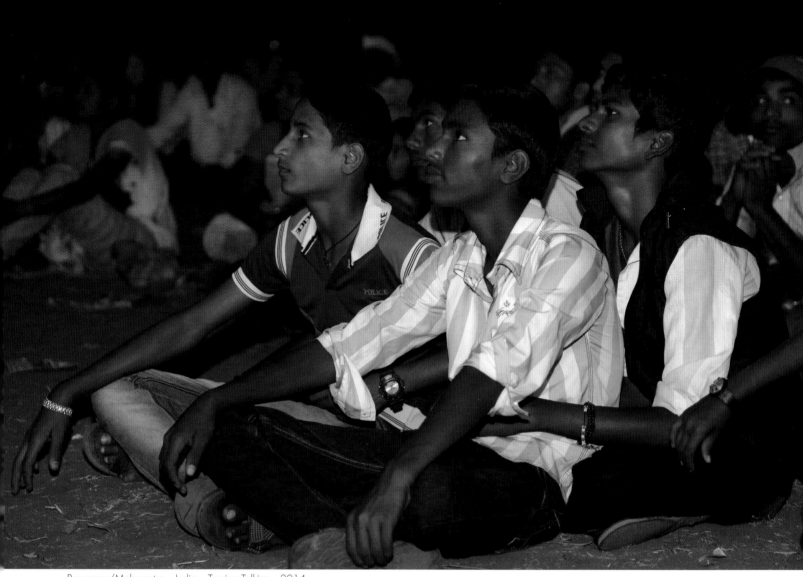

Puseagon/Maharastra – India – Touring Talkies – 2014

Right page, bottom photo:
Puseagon/Maharastra – India – Touring Talkies – 2014

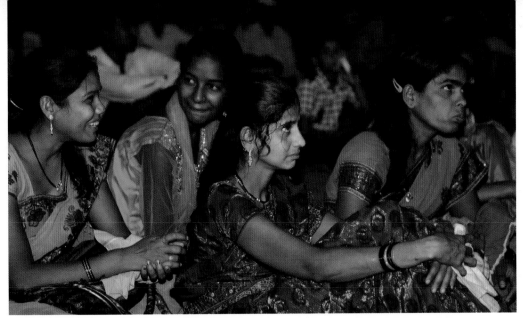

Puseagon/Maharastra – India – Touring Talkies – 2014

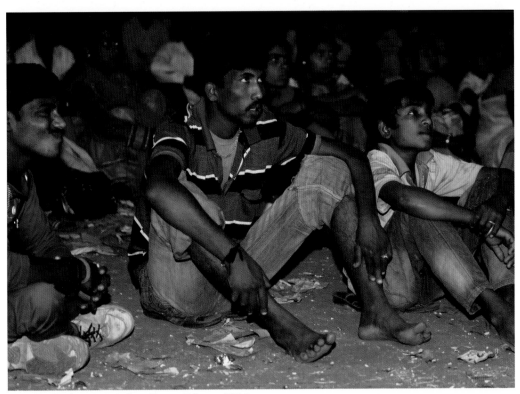

Puseagon/Maharastra – India – Touring Talkies – 2014

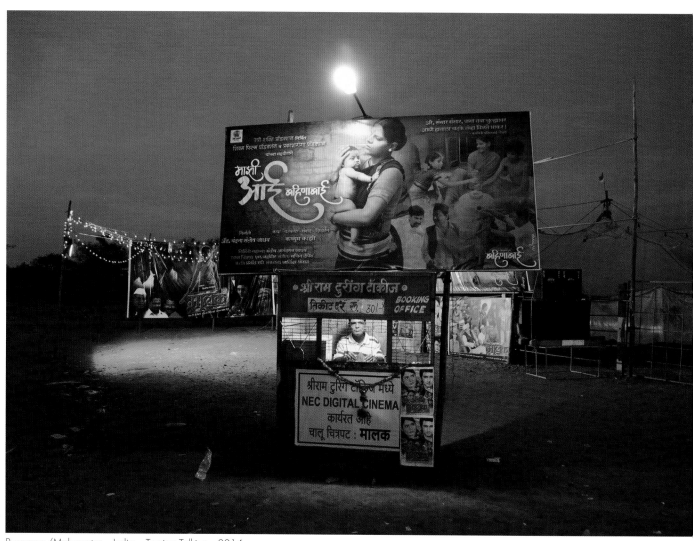

Puseagon/Maharastra – India – Touring Talkies – 2014

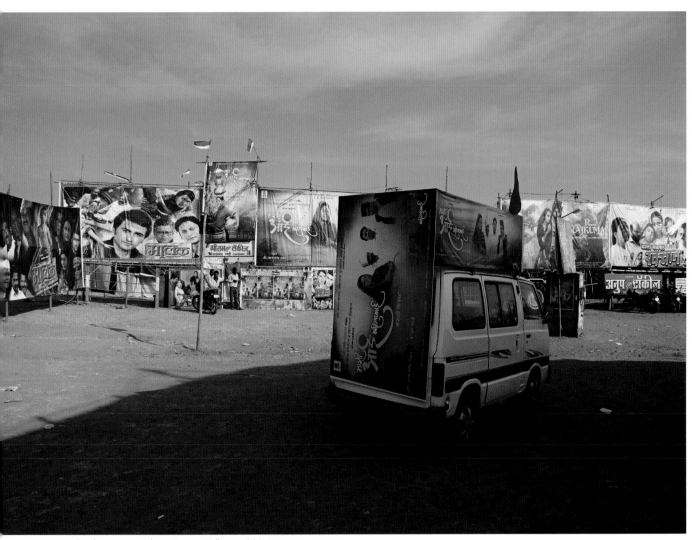

Puseagon/Maharastra – India – Touring Talkies – 2014

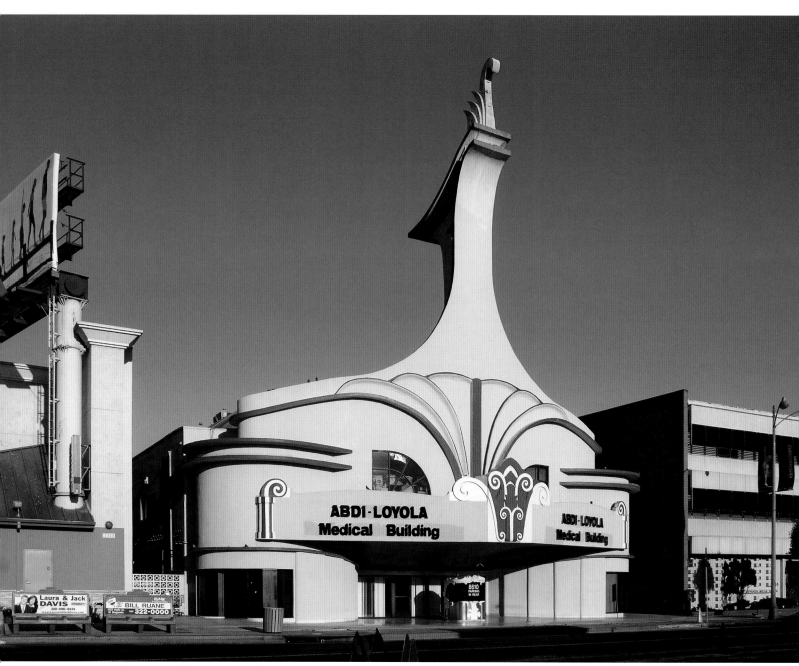

Los Angeles, California – USA – Loyola – 2007

What does the future hold? Some alternative uses

The dream factory is running out of steam; audiences are abandoning theatres as other temptations come their way and they embrace new lifestyles. As visits to the cinema decrease and revenues fall, theatres sometimes survive by sacrificing their huge and often very beautiful spaces, carving them up to create complexes that usually lack architectural character.

However, that same lack of character can sometimes be an advantage. Property developers are often on the lookout for old city centre picture houses struggling for survival; they can be bought and transformed into businesses that will yield guaranteed profits. Changing the use of old cinemas is a trend that began 40 years ago; it is a strange paradox that the trend continues today, when movie production is higher than ever.

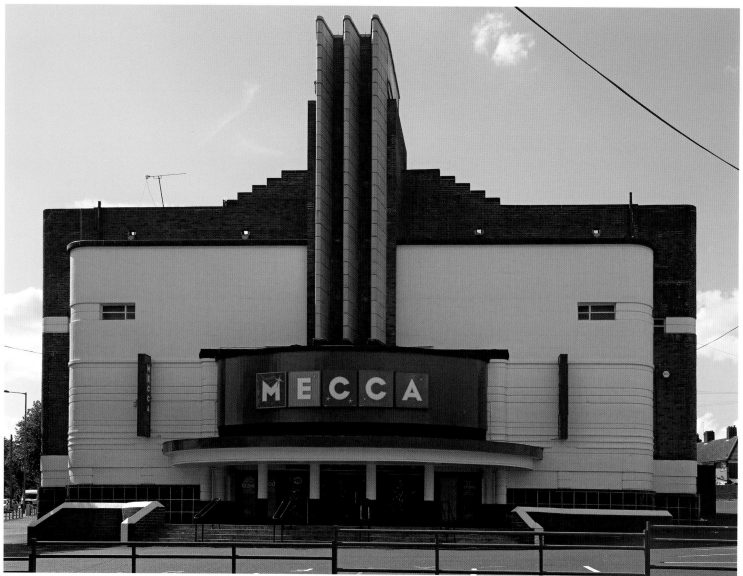

Birmingham – England – Odeon – 2015

In England, some of the most luxurious old cinema buildings still hint at the apprehension that visitors used to experience on entering, though the excitement is somewhat diminished because many of them have been converted into bingo halls. These properties, which have retained the fine décor of their interiors, have become a favourite with organisers of the highly popular game. However, although they often enjoy protection as listed buildings, these bingo halls are in turn being deserted, since bingo is now mainly played online. And as the players disperse they take with them the conviviality once found in a cinema audience.

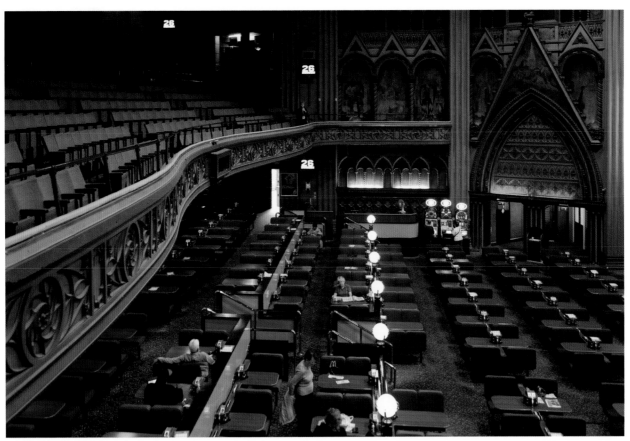

London – England – Granada Tooting – 2013

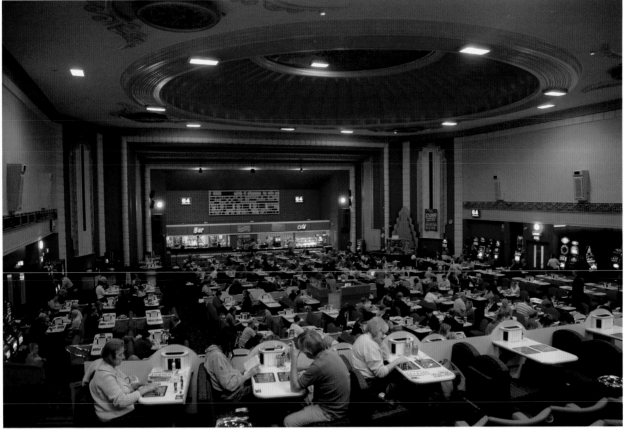

Exeter – England – Gaumont – 2006

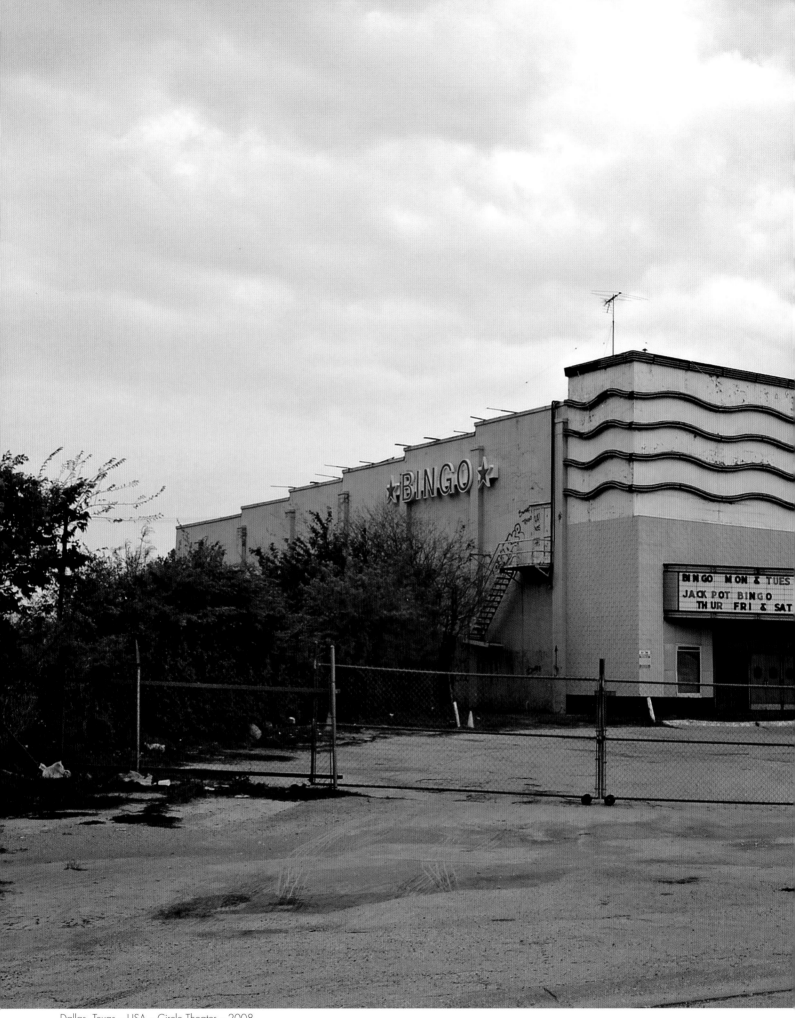

Dallas, Texas – USA – Circle Theater – 2008

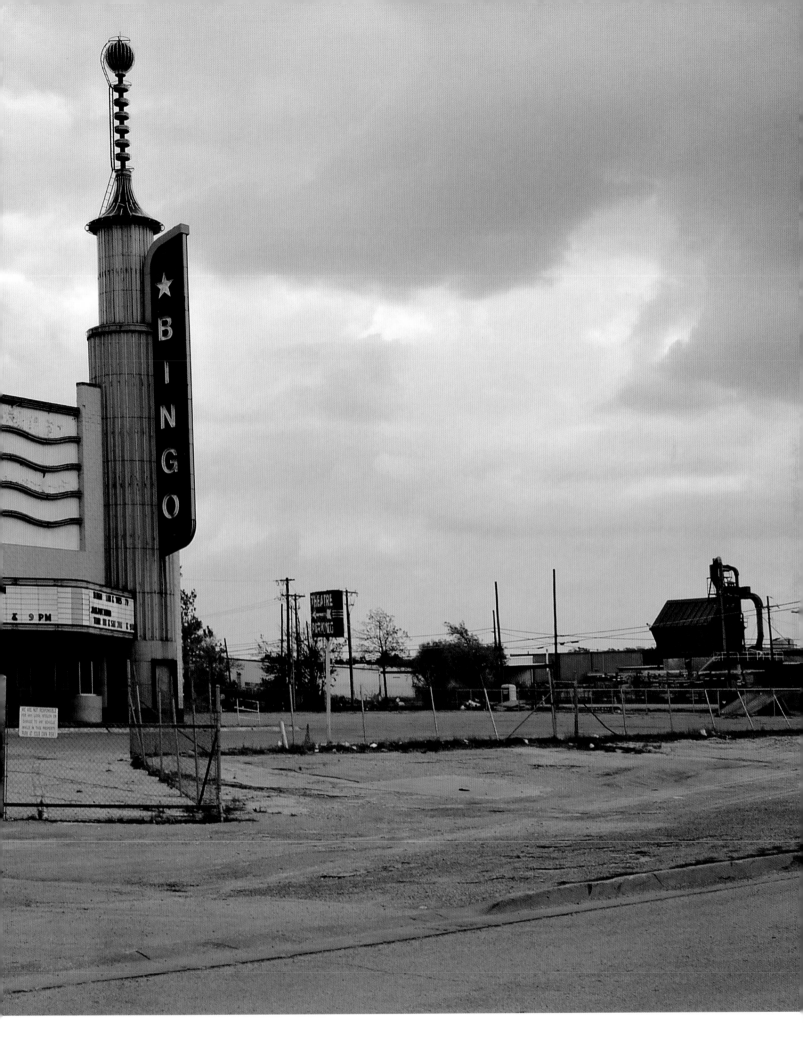

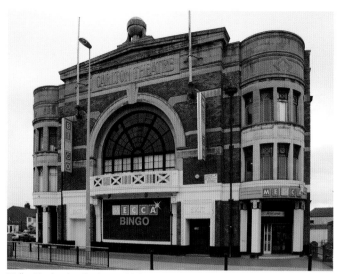

Hull – England – Carlton – 2006

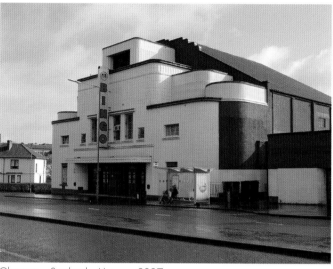

Glasgow – Scotland – Vogue – 2007

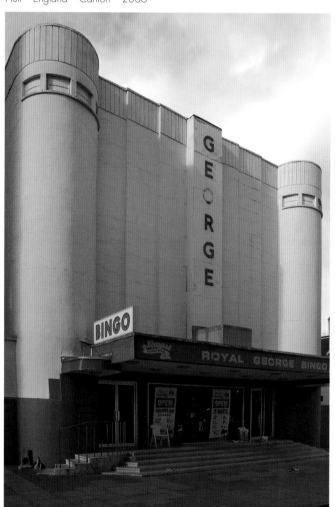

Edinburgh – Scotland – George – 2007

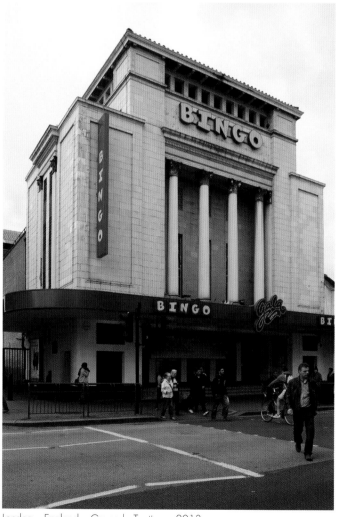

London – England – Granada Tooting – 2013

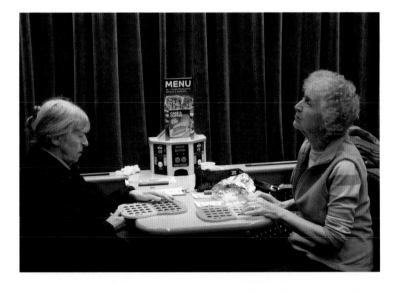
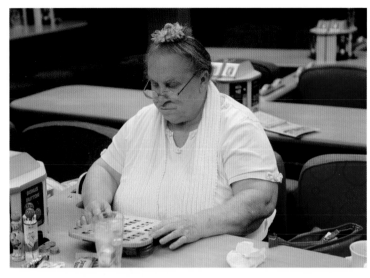

Atmosphere in a bingo hall

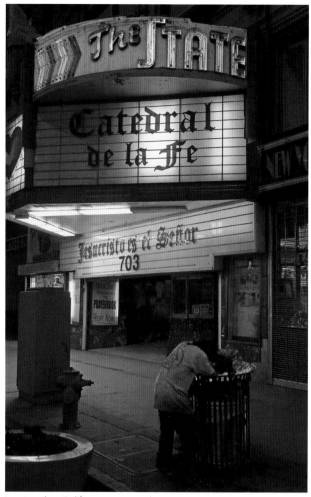

Los Angeles, California – USA – The State – 2008

In the United States, many cinemas (over 500 to date) are being transformed for use as churches. In most cases the main architectural elements have been preserved. So the cross replaces the name of the movie theatre: goodbye Georgia, hello Jesus. The people acquiring these theatres make full use of the vast interior space to hold ever-increasing numbers of believers. Cinema audiences are replaced by congregations, but the devotion continues unabated.

In France, the process is reversed. The worship of film is supplanting that of religion, and cinemas are occupying former churches. Goodbye Jesus, hello Gaumont!

Right page:
Los Angeles, California – USA – The State – 2008

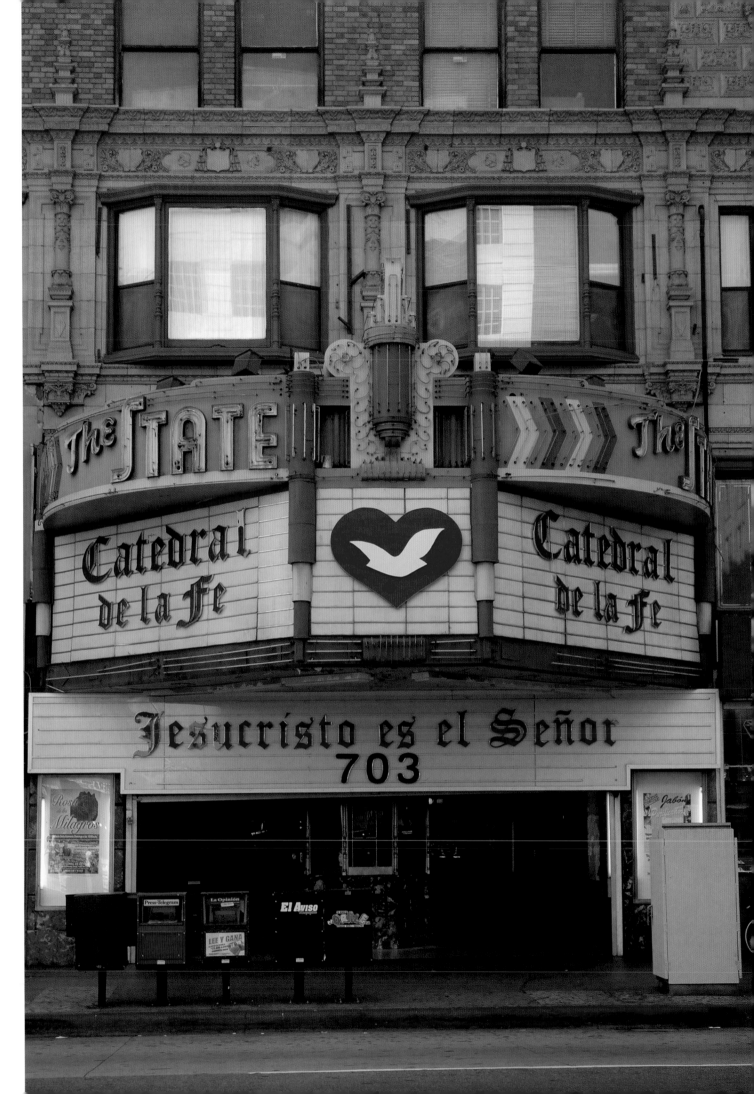

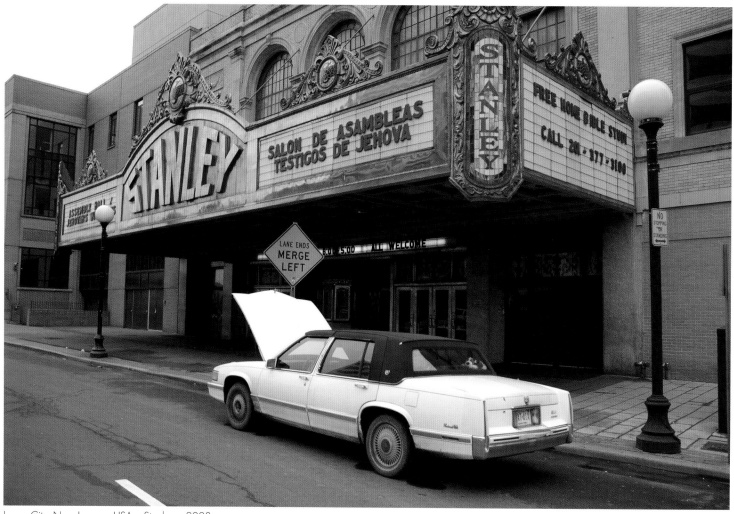

Jersey City, New Jersey – USA – Stanley – 2008

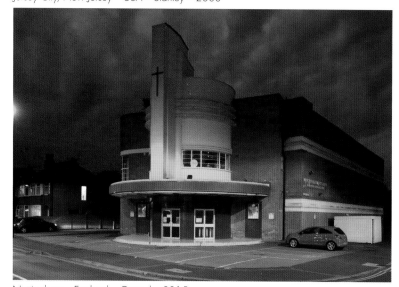

Nottingham – England – Capitol – 2015

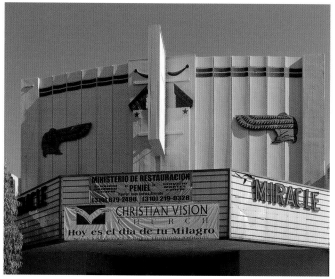

Inglewood, California – USA – Ritz – 2008

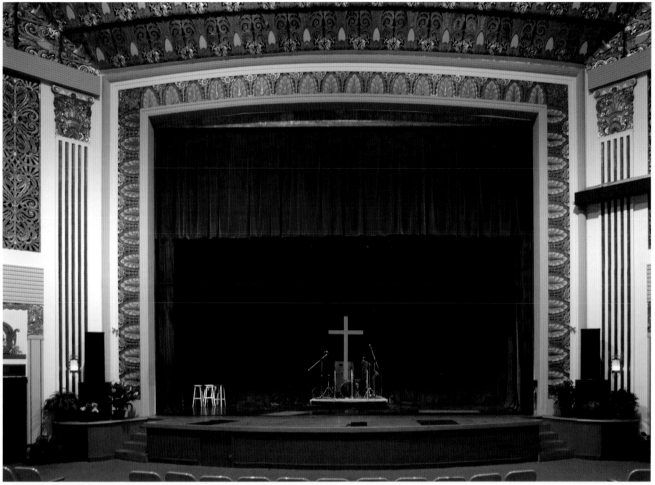

Montreal – Canada – Le Château – 2014

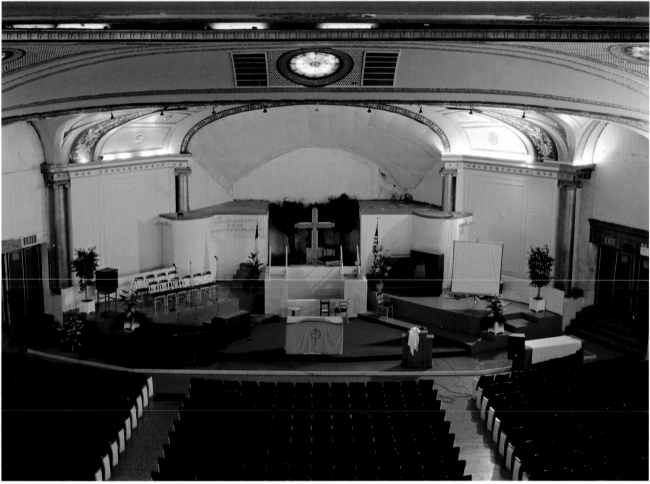

New York, New York – USA – Brooklyn Loew's – 2011

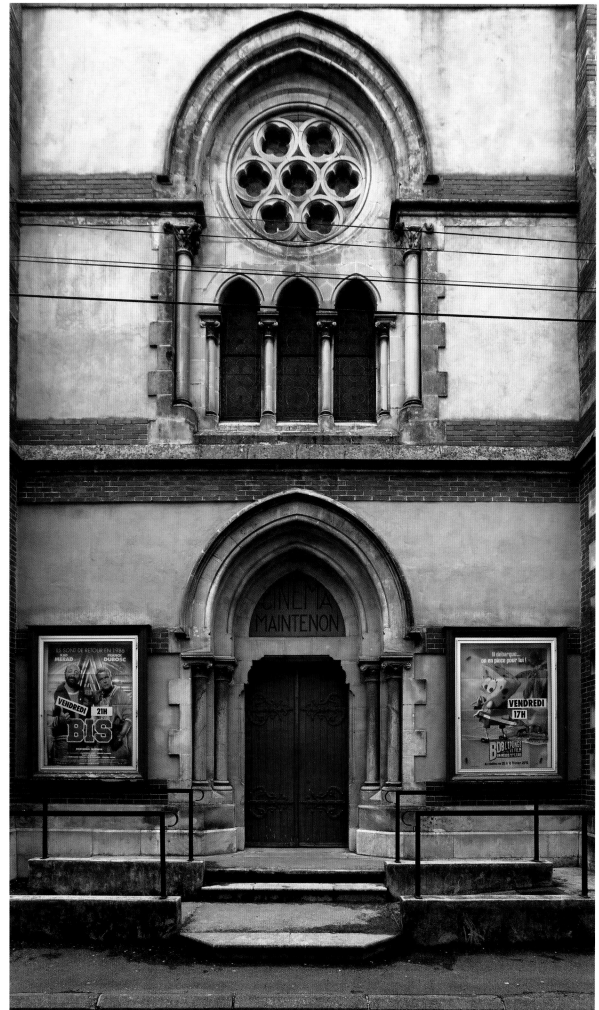

Bagnères-de-Bigorre – France – Maintenon – 2015

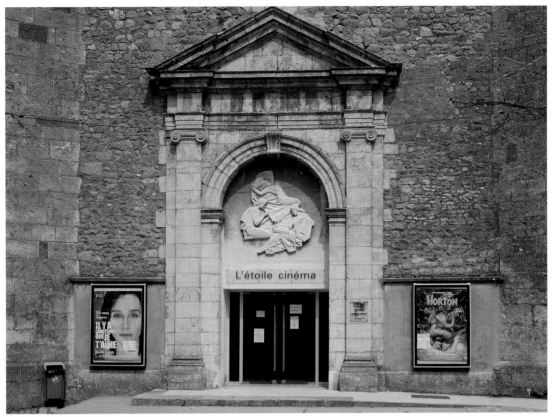

Saulieu – France – L'étoile – 2008

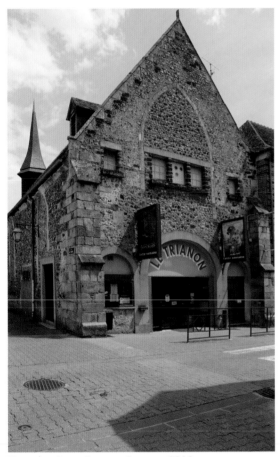

Verneuil-sur-Avre – France – Trianon – 2018

Poligny – France – unknown (no longer in use) – 2007

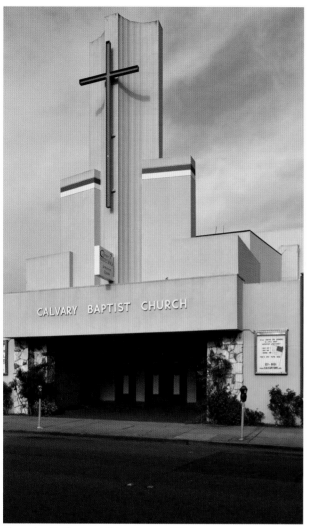

Alameda, California – USA – Vogue – 2015

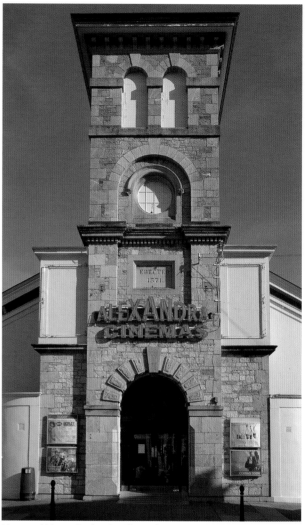

Newton Abbot – England – Alexandra – 2006

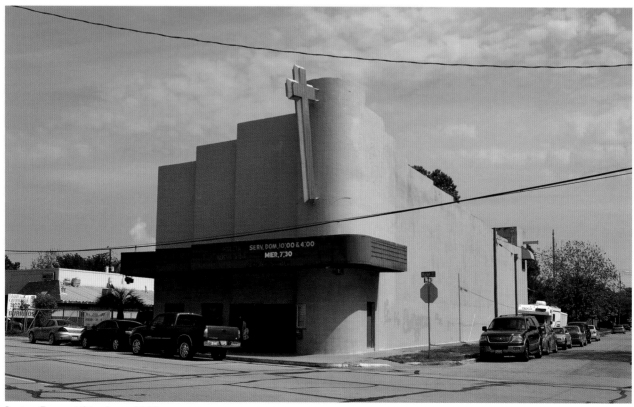

Bayton, Texas – USA – Bay – 2008

226

Right page:
Los Angeles, California – USA – Meralta – 2008

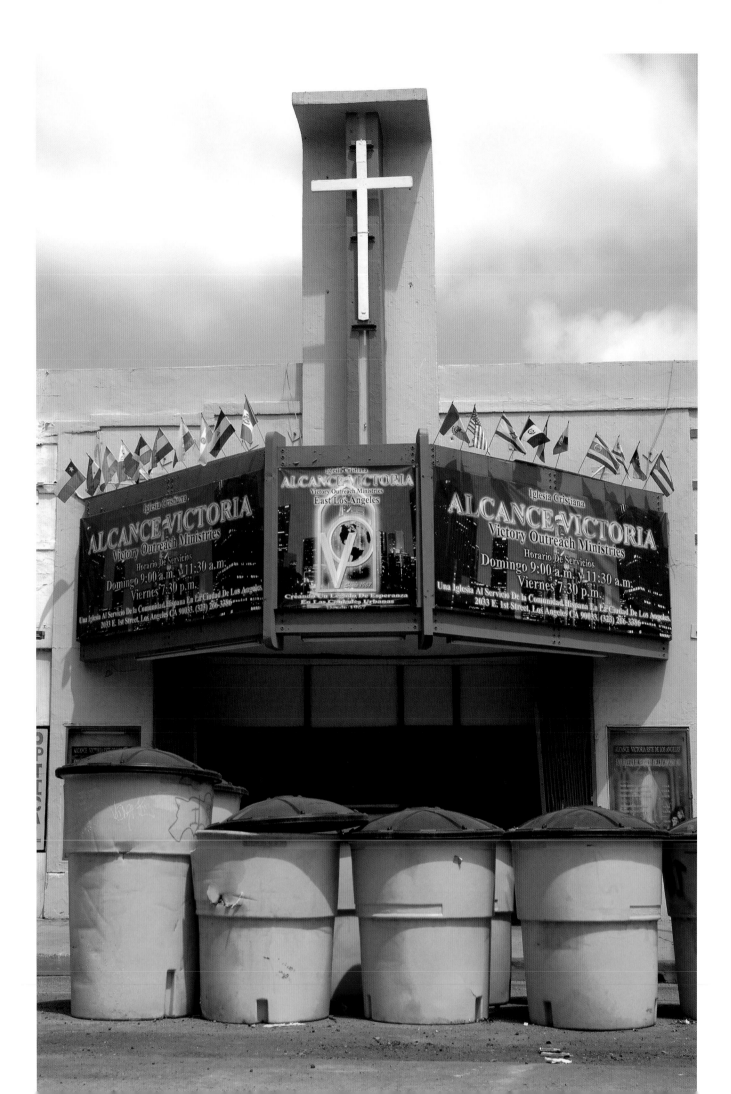

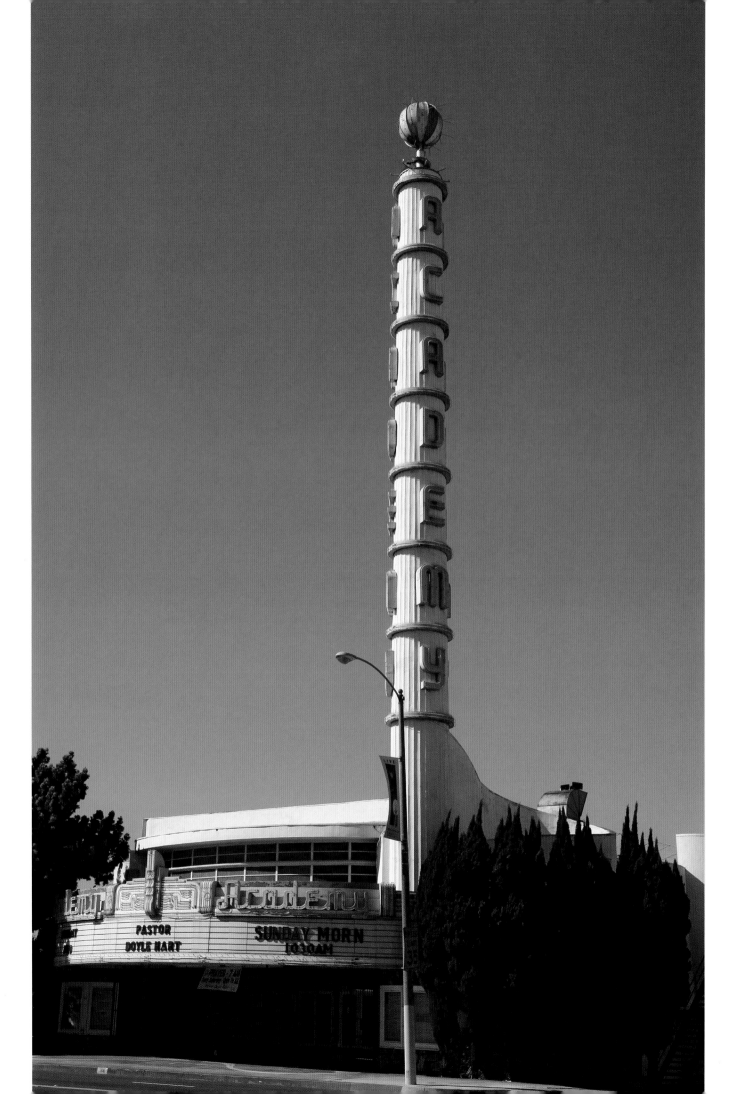

PASTOR
DOYLE HART

SUNDAY MORN
10:30AM

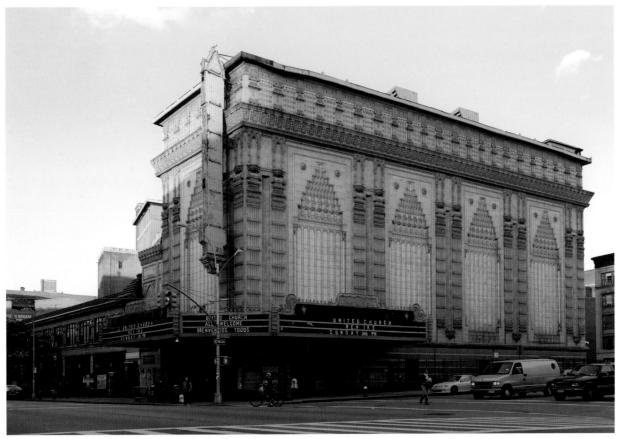

New York, New York – USA – Loew's 175 Street Theatre – 2011

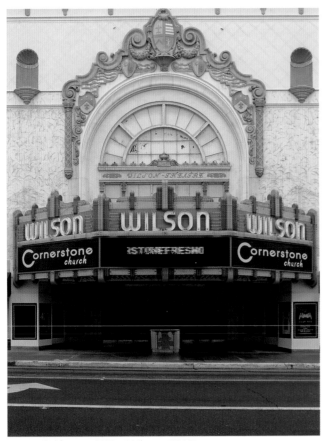

Fresno, California – USA – Wilson – 2015

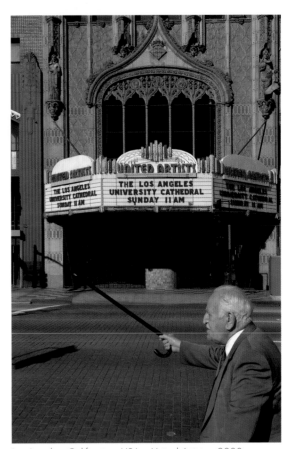

Los Angeles, California – USA – United Artists – 2008

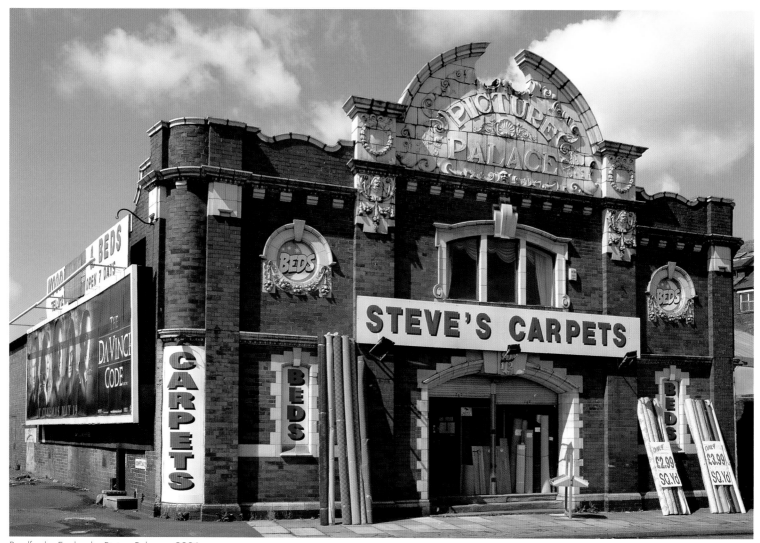

Bradford – England – Picture Palace – 2006

But some conversions are more prosaic. New owners create temples of consumerism that have only one element in common with the movie shows of old: a desire to be profitable. Bookshops, second-hand stores, restaurants, sports halls and even car parks: the glorious past witnessed by the walls that surround customers as they go about their business seems eons away, and may soon be forgotten entirely.

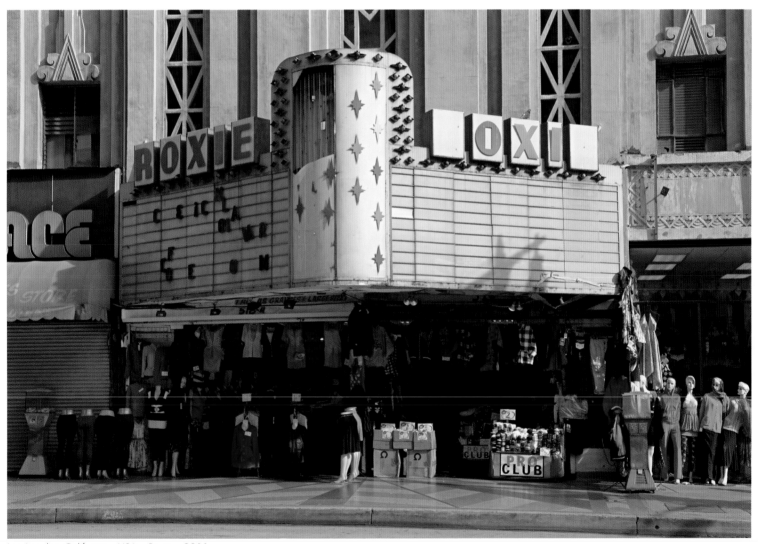

Los Angeles, California – USA – Roxie – 2011

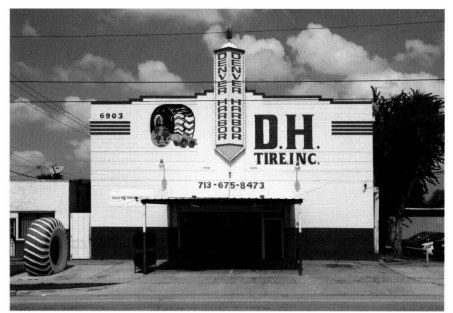

Houston, Texas – USA – Globe – 2011

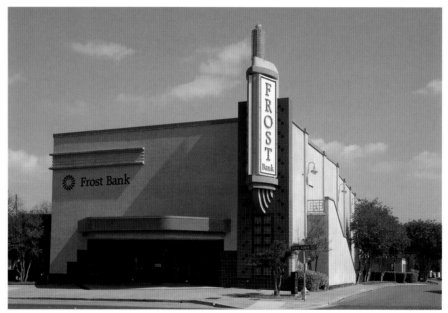

Fort Worth, Texas – USA – Bowie – 2008

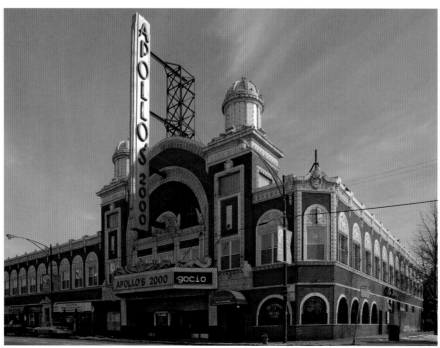

Chicago, Illinois – USA – Apollo – 2008

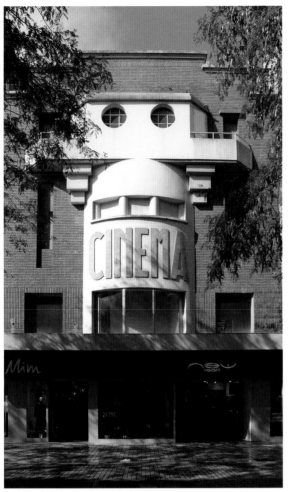

Amiens – France – Gaumont Picardie – 2012

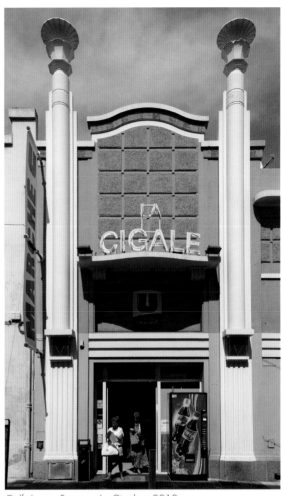

Golfe-Juan – France – La Cigale – 2010

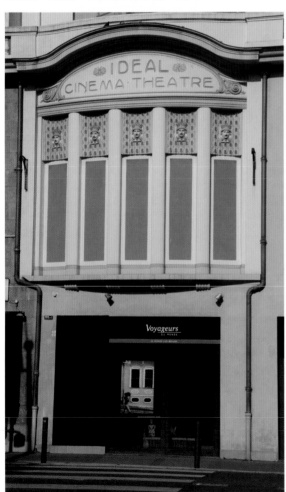

Nice – France – Ideal – 2010

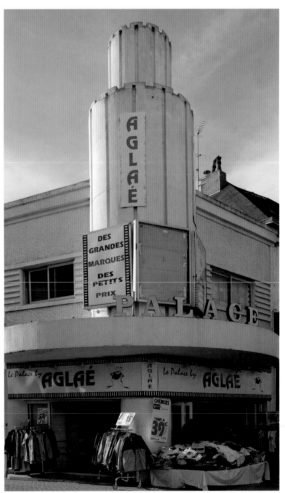

La Baule – France – Palace – 2006

233

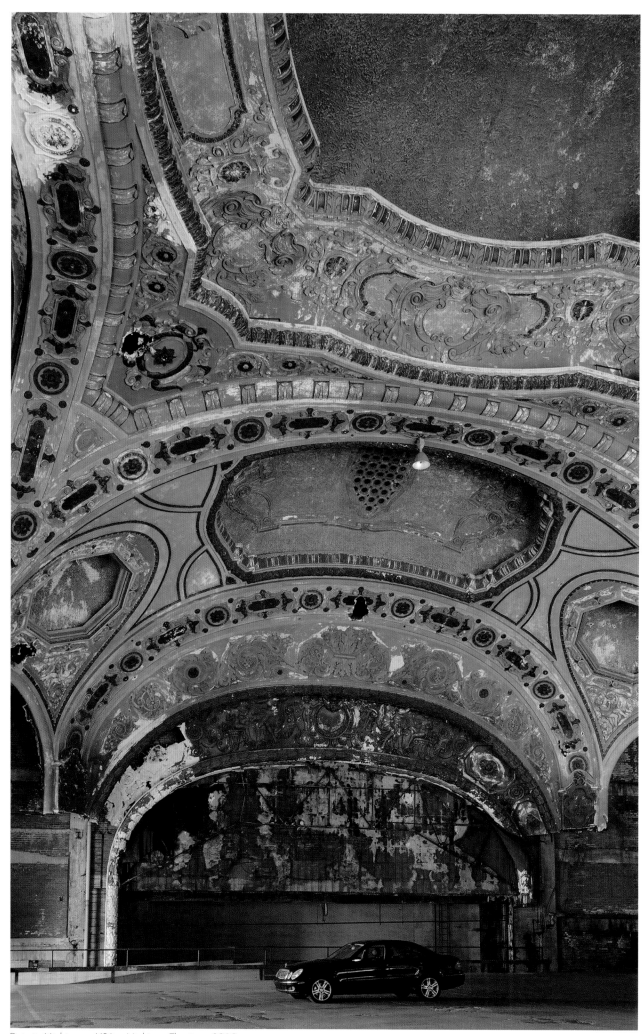

Detroit, Michigan – USA – Michigan Theater – 2010

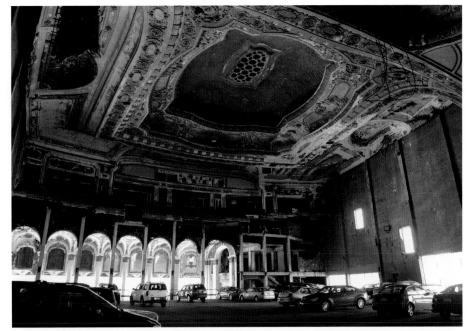

Detroit, Michigan – USA – Michigan Theater – 2010

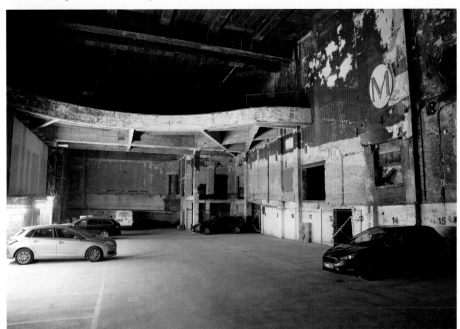

Brussels – Belgium – Marivaux – 2017

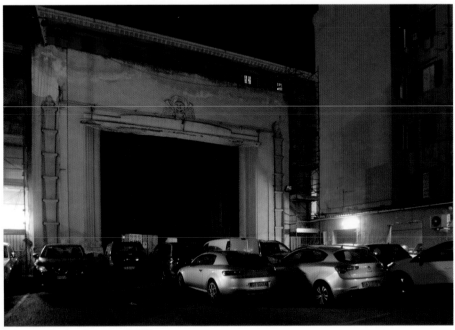

Palermo – Sicily – Trianon – 2017

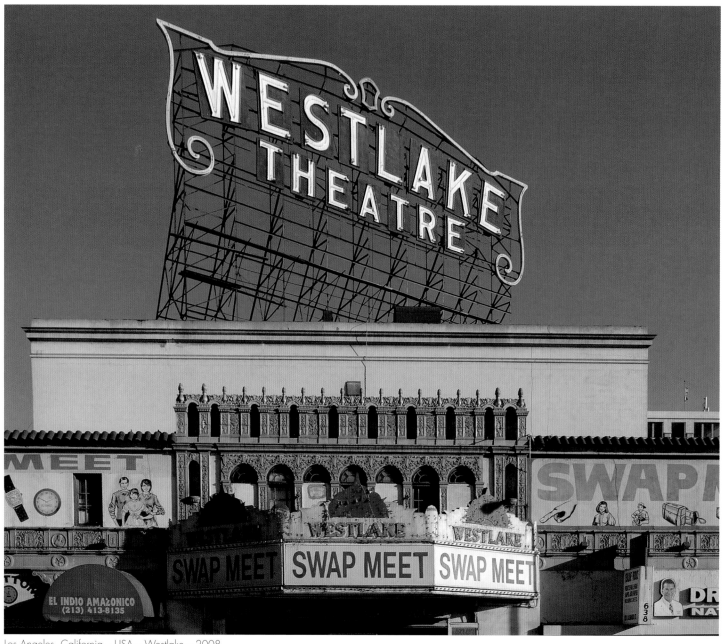

Los Angeles, California – USA – Westlake – 2008

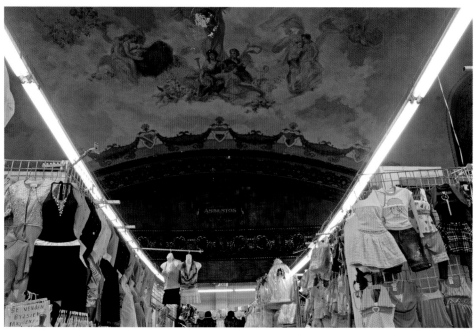

Los Angeles, California – USA – Westlake – 2008

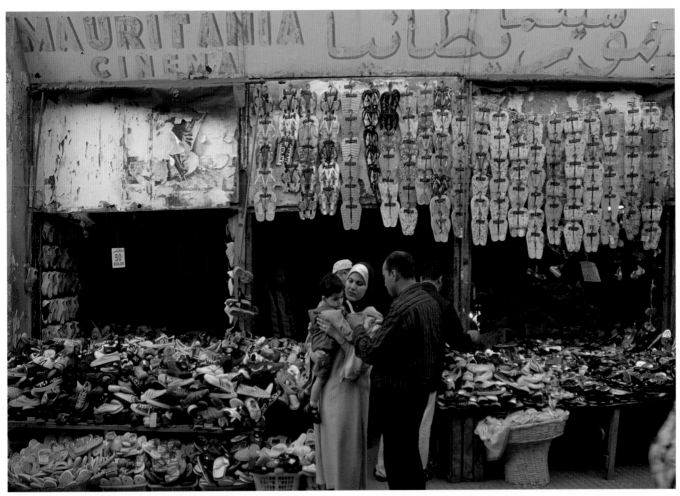

Rabat – Morocco – Mauritania (demolished) – 2009

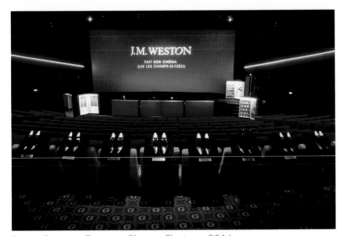

Paris – France – Gaumont Champs Elysées – 2016

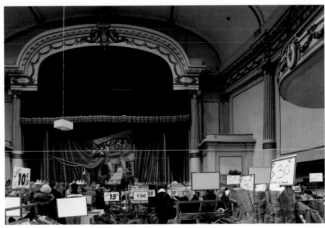

Paris – France – Barbès Palace – 2010

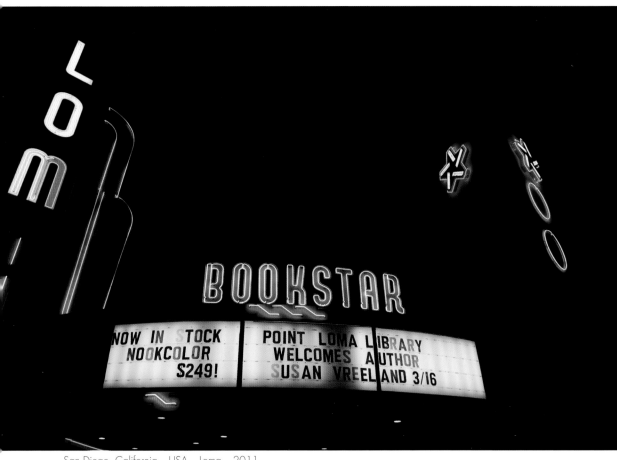

San Diego, California – USA – Loma – 2011

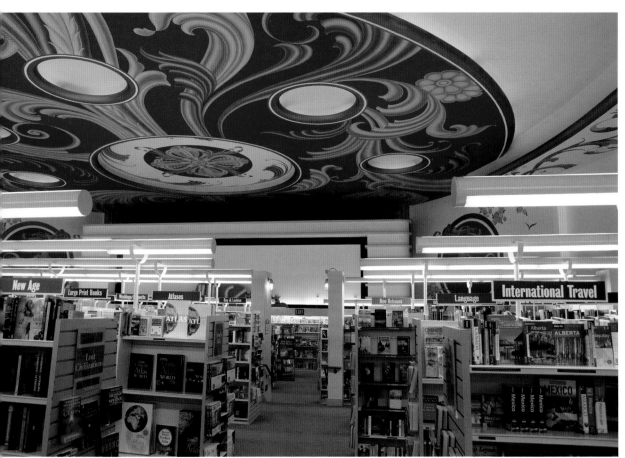

San Diego, California – USA – Loma – 2011

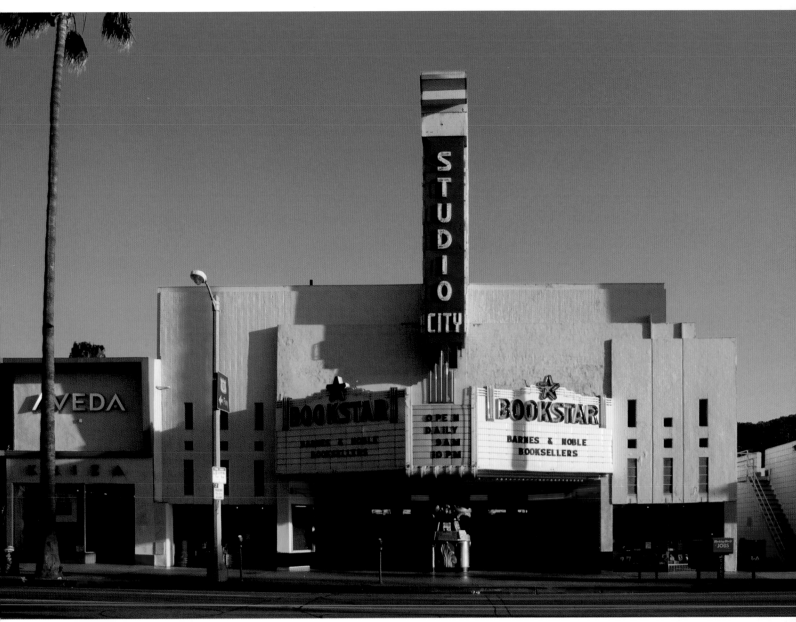

Los Angeles, California – USA – Studio City – 2008

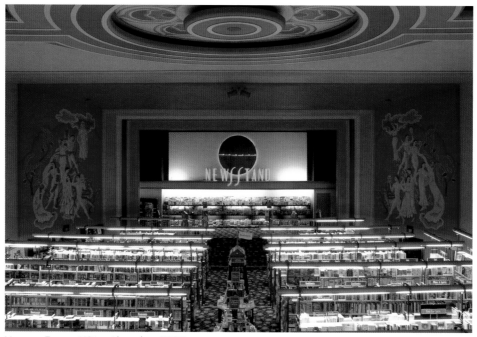

Houston, Texas – USA – Alemeda – 2008

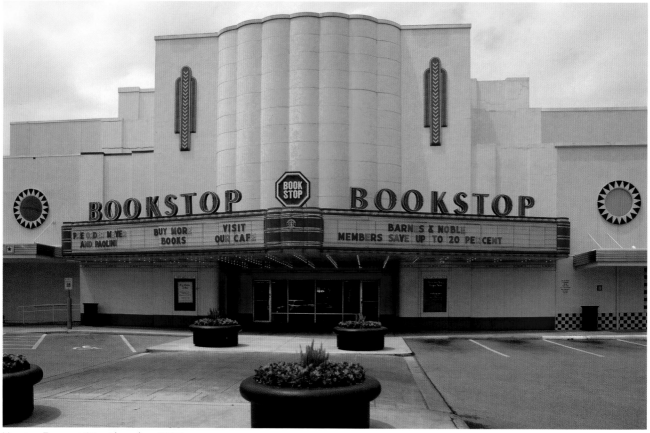

Houston, Texas – USA – Alemeda – 2008

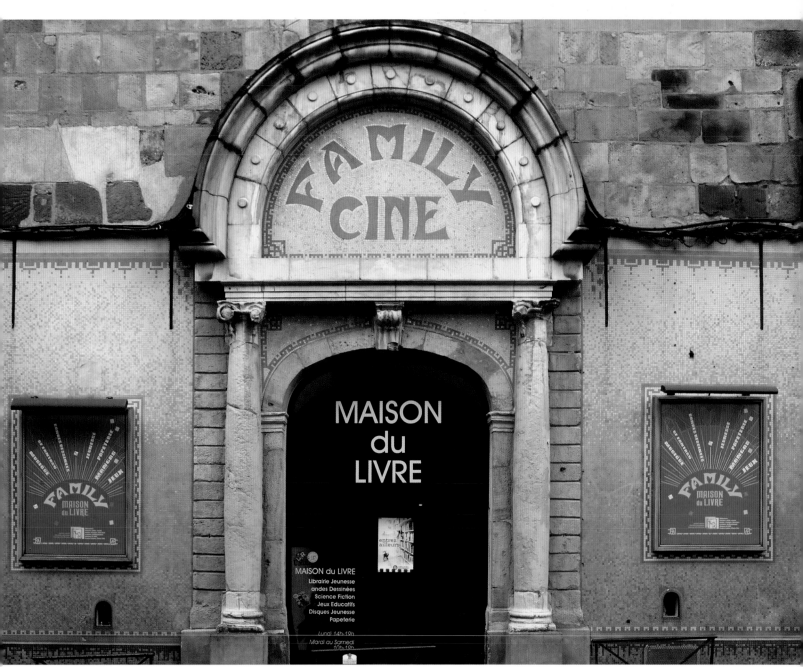

Rodez – France – Family – 2015

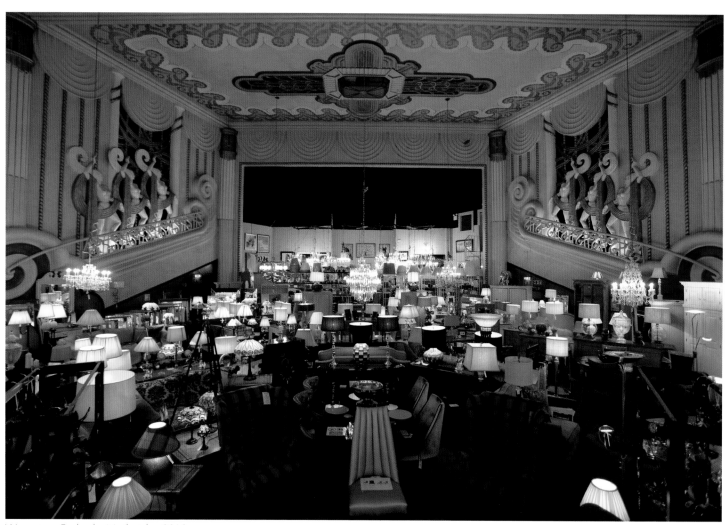

Worcester – England – Northwick – 2018

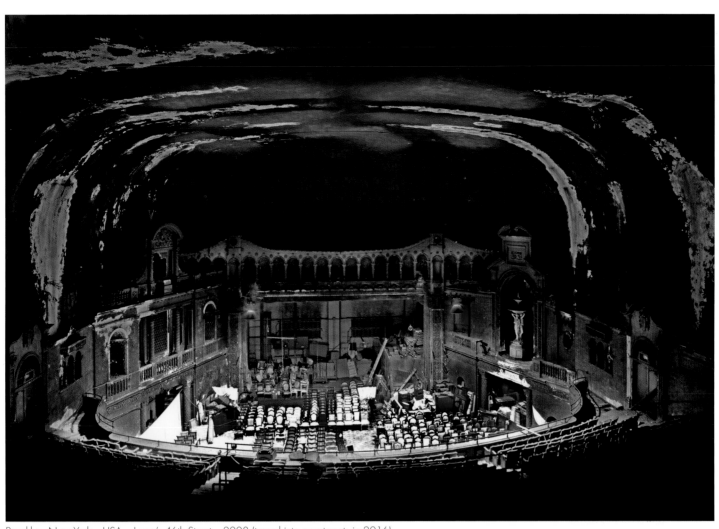

Brooklyn, New York – USA – Loew's 46th Street – 2008 (turned into apartments in 2016)

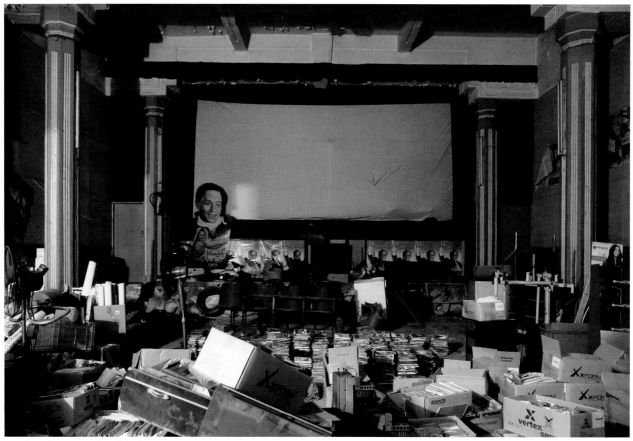

Tripoli – Lebanon – Lido – 2018

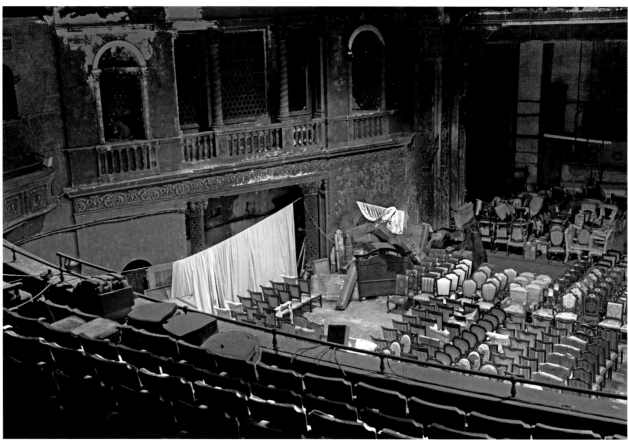

Brooklyn, New York – USA – Loew's 46th Street – 2008 (turned into apartments in 2016)

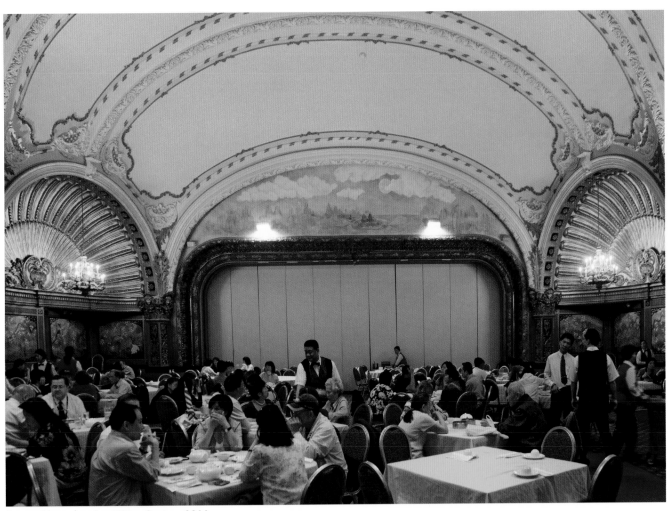

Boston, Massachusetts – USA – Center – 2011

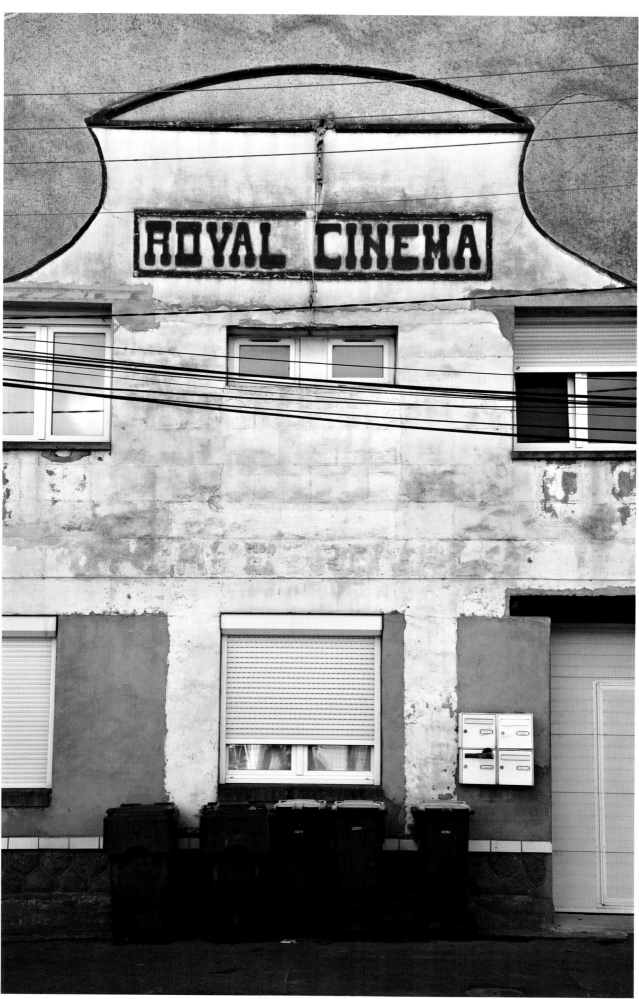

Liévain – France – Royal – 2012

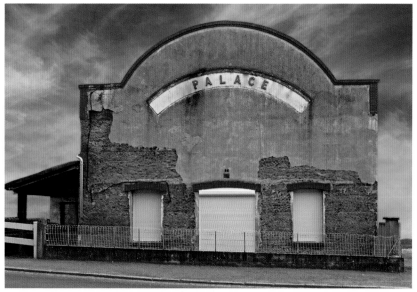

Montceau-les-Mines – France – Palace – 2014

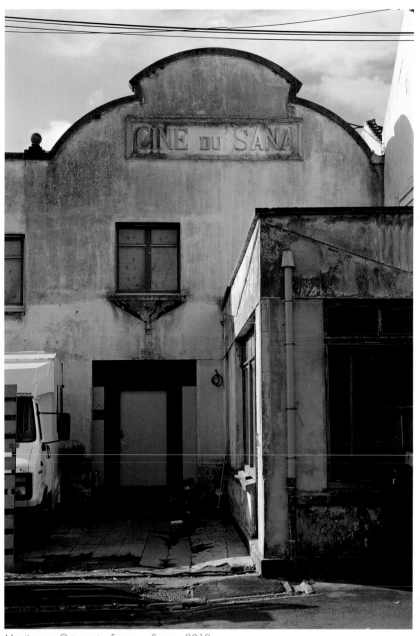

Montigny-en-Ostrevent – France – Sana – 2012

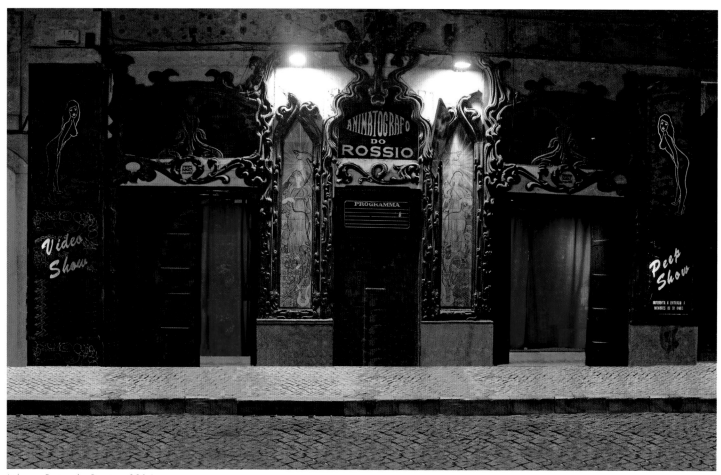

Lisbon – Portugal – Rossio – 2014

In their fight for survival, some cinemas resorted to showing Kung Fu movies. These would

be followed by Indian films, albeit with a musical soundtrack guaranteed to be out of sync.

Last of all, before their inevitable closure, they would screen blurred pornography that was

over in the blink of an eye, sometimes offering two screenings for the price of one ticket.

But with almost universal access to the Internet, who still frequents these establishments?

Perhaps forward-looking film lovers convinced that the future of cinema is in X-rated epics.

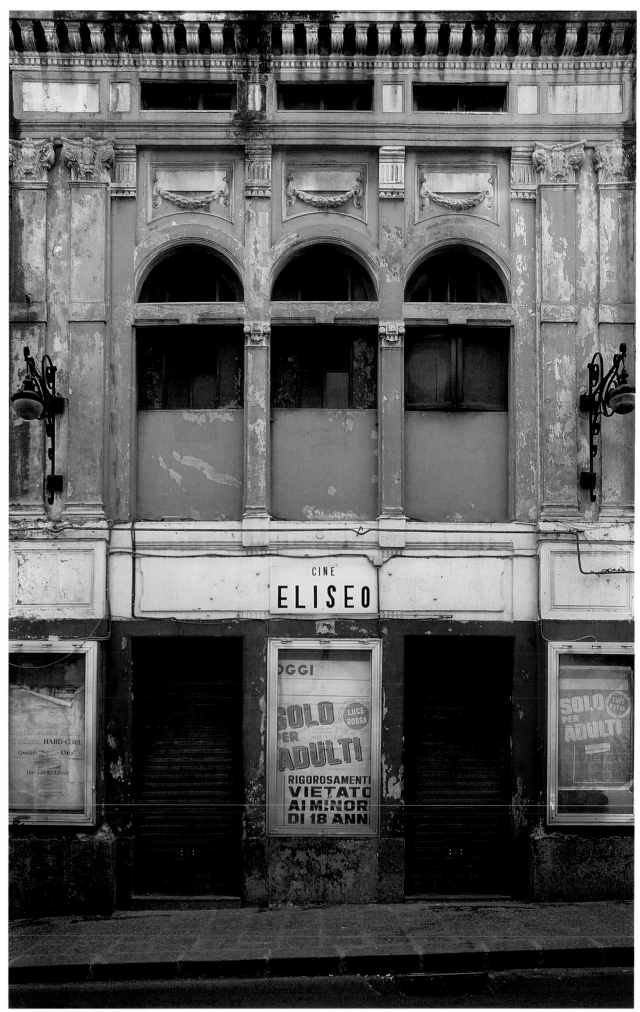

Catania – Sicily – Eliseo – 2009

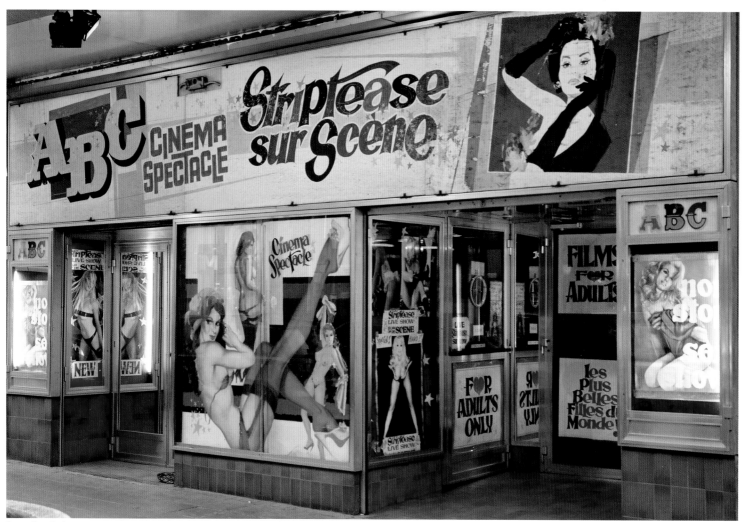

Brussels – Belgium – ABC – 2009

Right page, bottom photo:
Zurich – Switzerland – Roland – 2010

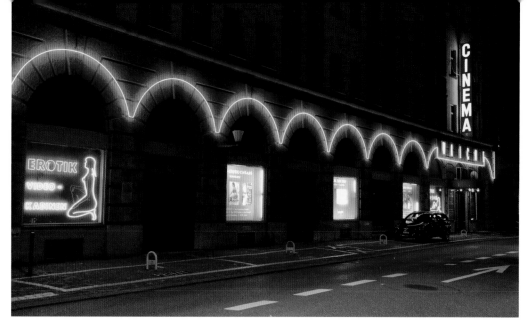

Zurich – Switzerland – Walche – 2010

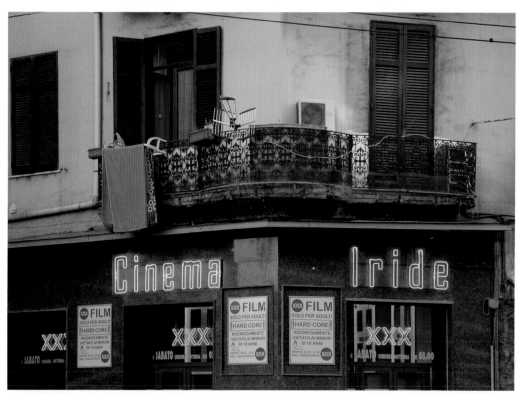

Naples – Italy – Iride – 2009

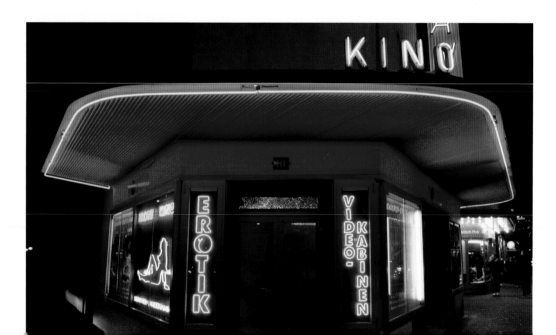

Vienna – Austria – Fortuna – 2006

Madrid – Spain – Cinema X – 2009

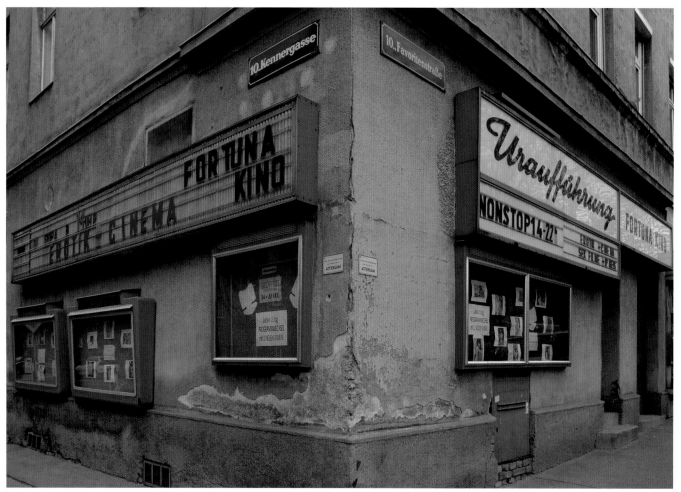

Vienna – Austria – Fortuna – 2006

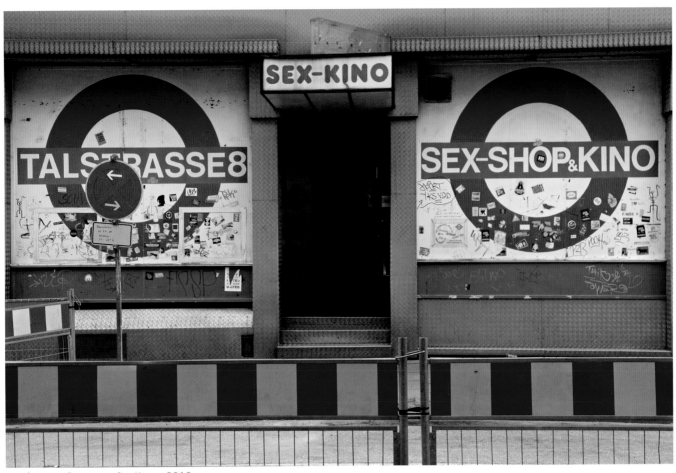

Hamburg – Germany – Sex Kino – 2010

In order to prevent the doors of a cinema locking forever, the only solution for some people is to move in, despite the collapsed roof, water damage, and generally impoverished circumstances. Stairs leading to a balcony can still create the illusion of affluence. Somehow, life seems less painful if spread over two floors, as it is for families like those in Oran or Havana.

In Montpellier and Rome, rebellion tends to be cultural in nature. Allowing a cinema to slowly die is not acceptable; the space needs to be opened up for the purpose of creative expression — a demand widely shared among young people who are convinced the authorities will never take action against them.

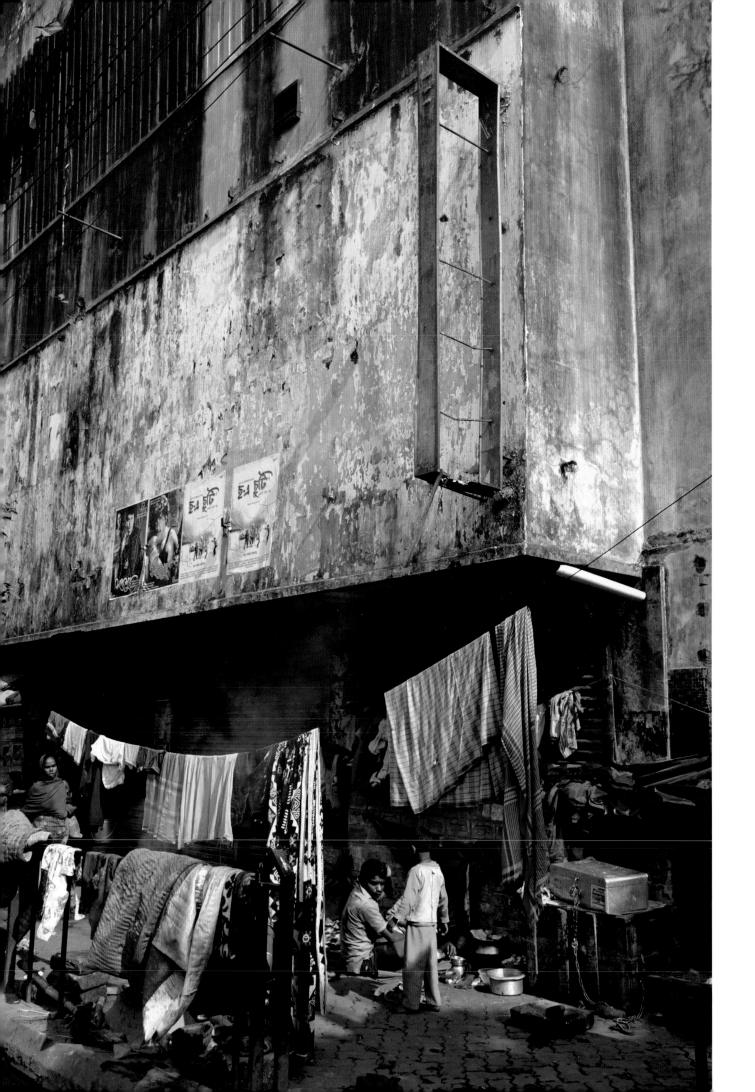

Rome – Italy – Volturno – 2013

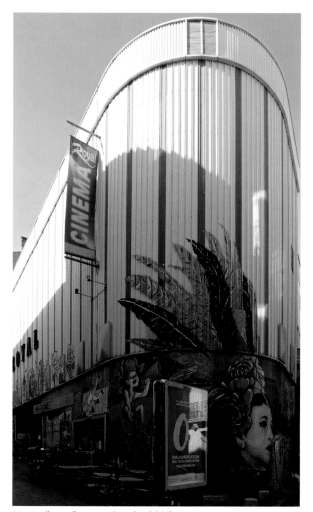

Montpellier – France – Royal – 2017

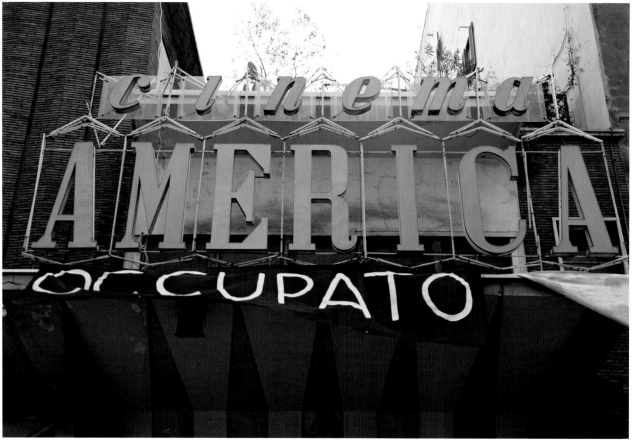

Rome – Italy – America – 2013

Right page, bottom photo:
Rome – Italy – Volturno – 2013

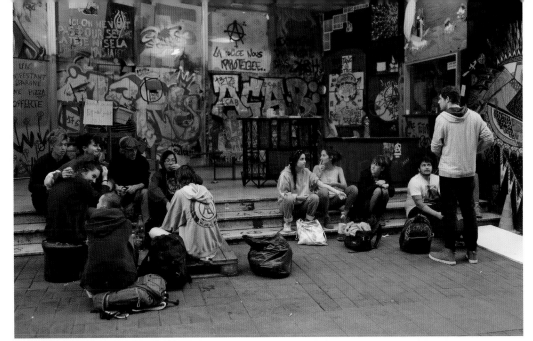

Montpellier – France – Royal – 2017

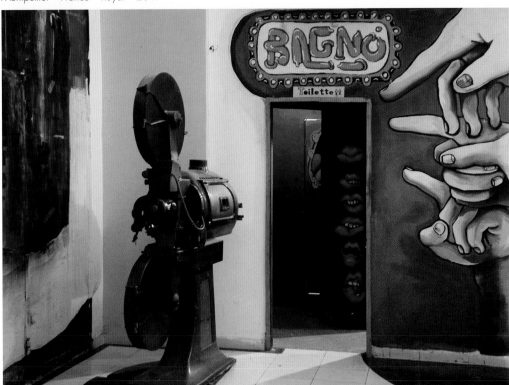

Rome – Italy – Volturno – 2013

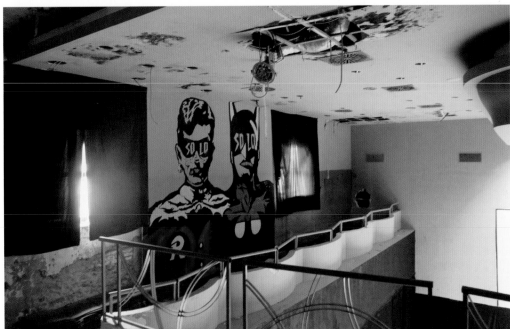

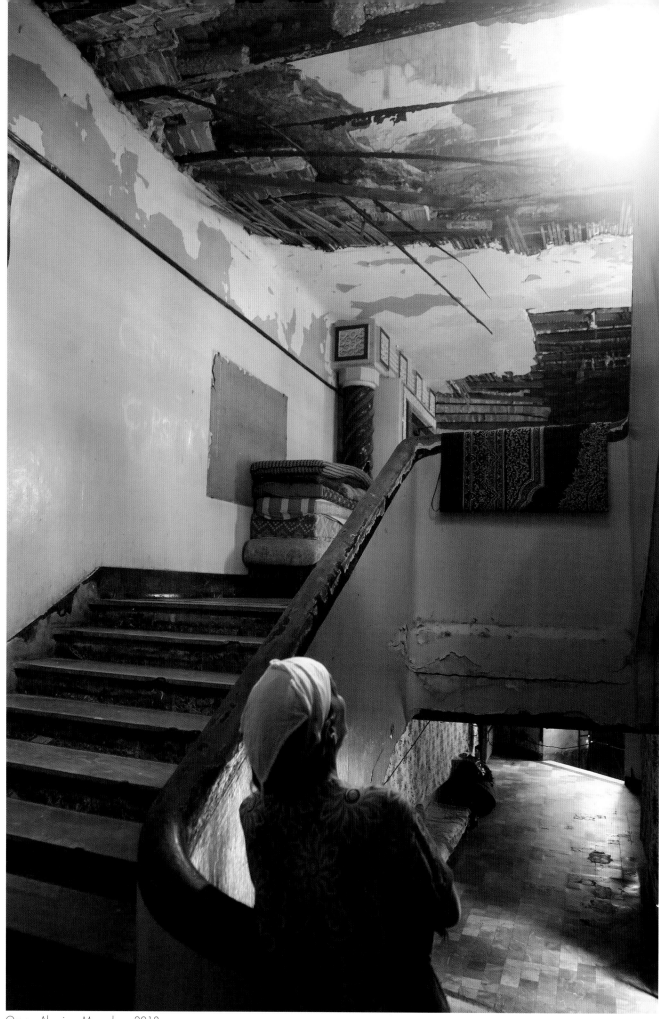

Oran – Algeria – Mogador – 2018

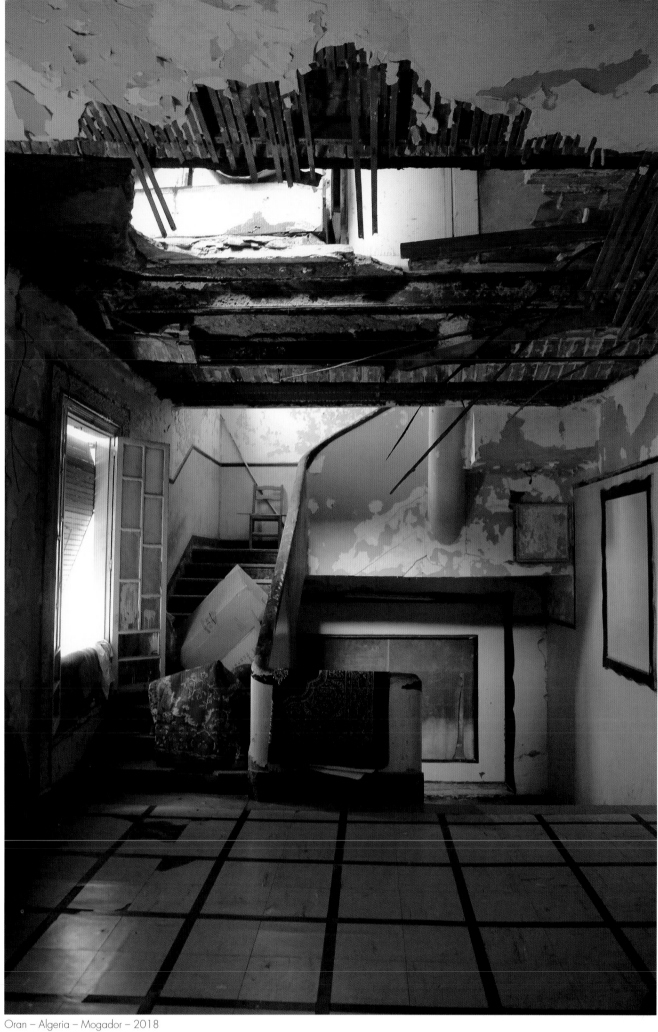

Oran – Algeria – Mogador – 2018

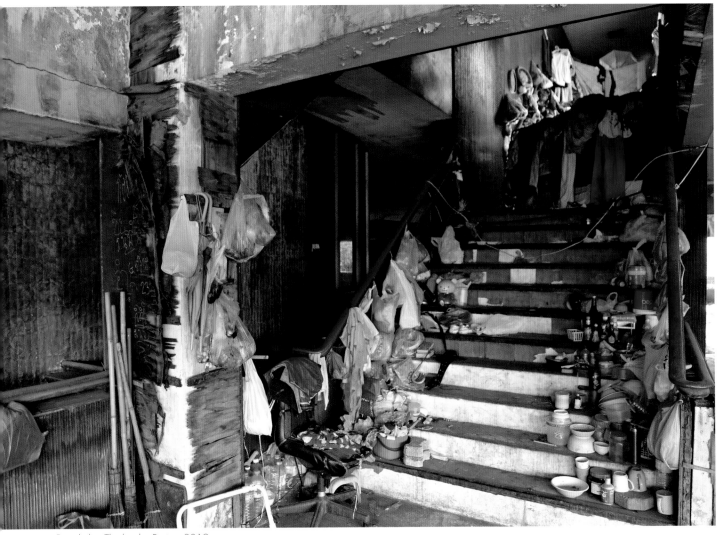

Bangkok – Thailand – Paris – 2019

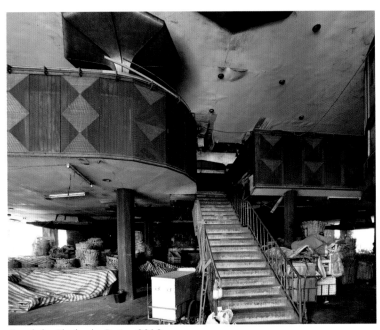

Bangkok – Thailand – Paris – 2019

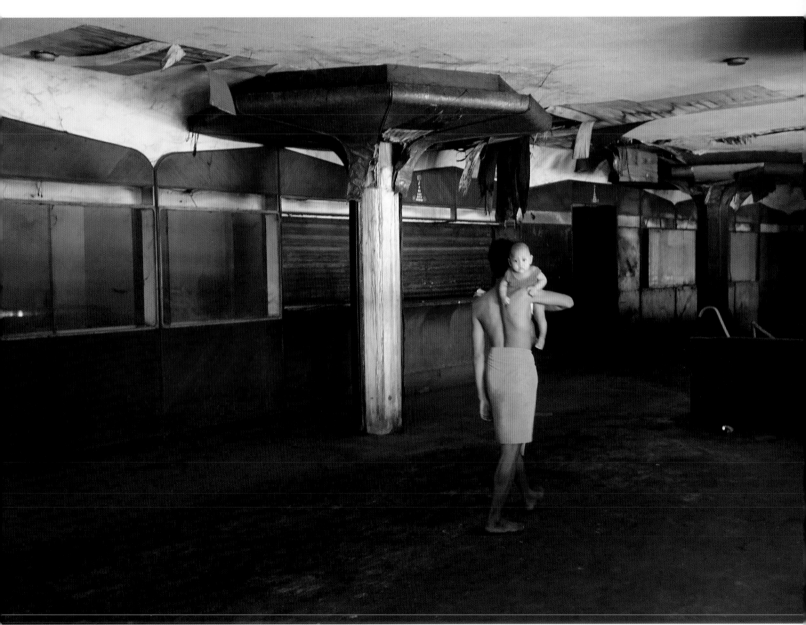

Bangkok – Thailand – Paris – 2019

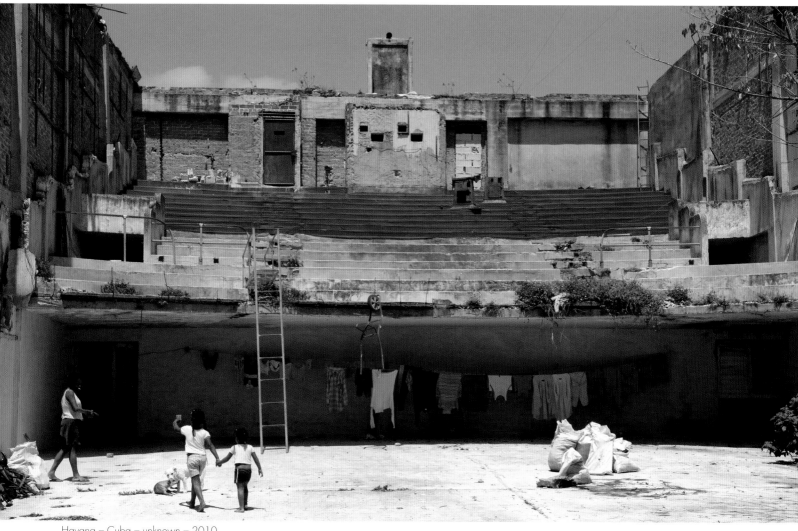

Havana – Cuba – unknown – 2010

Before the 1959 revolution in Cuba, Havana was home to 135 cinemas – possibly the densest concentration in the world in relation to the size of its population. Apartment buildings, hotels and extravagant casinos were built in the 1930s, all controlled by the American mafia, who catered to every desire of its American clientele. At the same time, cinemas proliferated. It is a strange fact that, even though these movie theatres are still there, they can sometimes be difficult to spot. If you look carefully, clues can be found on the outside of some buildings. But inside, the seats are beyond repair and the screens are torn.

Some theatres are now abuzz with people happily pursuing their varied activities: classes in dance, boxing or conjuring. The dream lives on but with a slightly different twist. Other theatres have been adopted for a less benign purpose; they have become refuges for families condemned to living on the street after losing their homes.

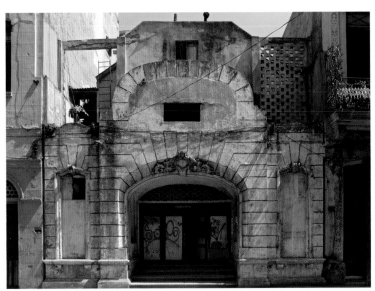

Havana – Cuba – Neptuno – 2010

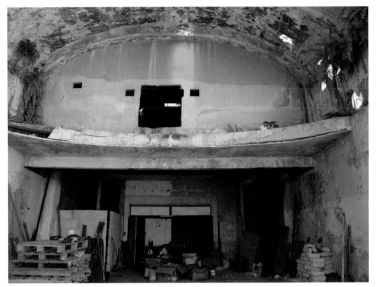

Havana – Cuba – Neptuno – 2010

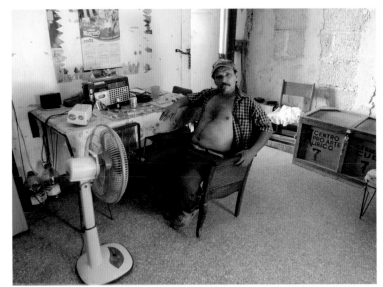

Havana – Cuba – Neptuno – 2010

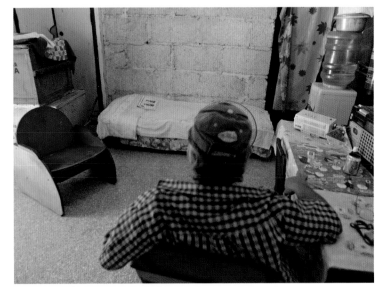

Havana – Cuba – Neptuno – 2010

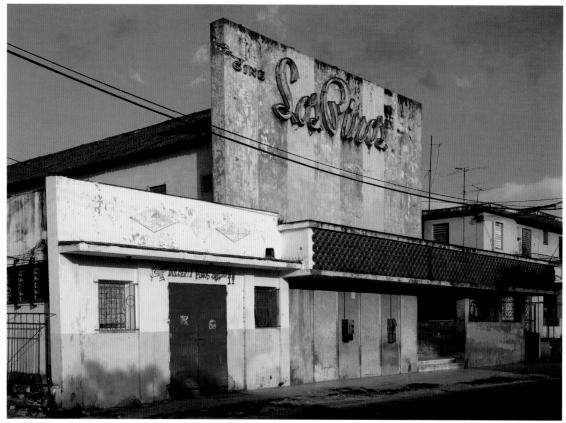

Havana – Cuba – Los Pinos – 2013

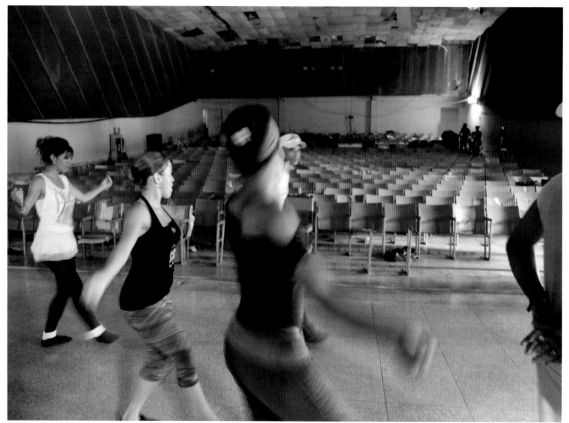

Havana – Cuba – Los Pinos – 2013

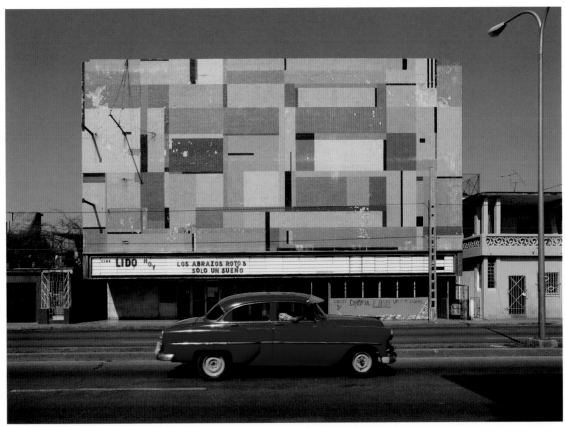

Havana – Cuba – Lido – 2013

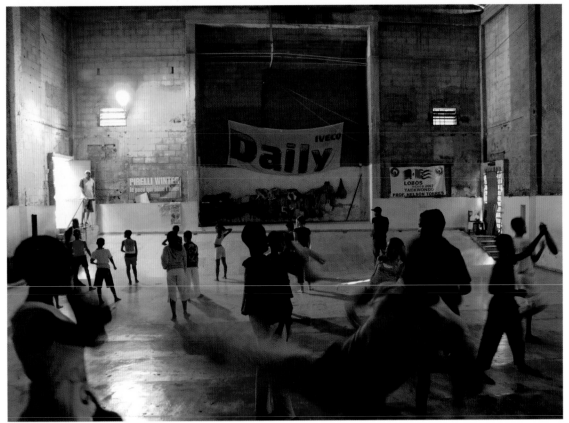

Havana – Cuba – Lido – 2013

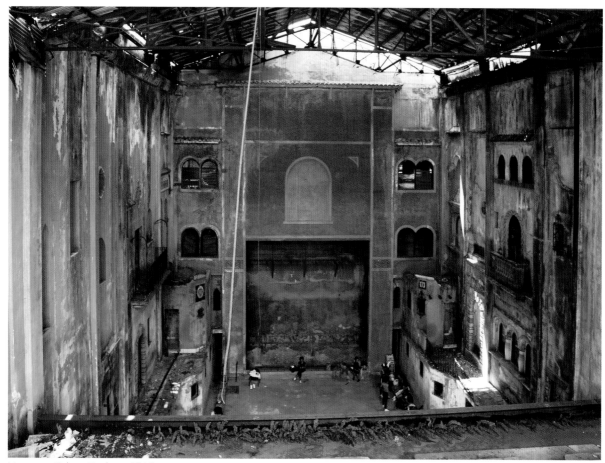

Havana – Cuba – Verdun – 2013

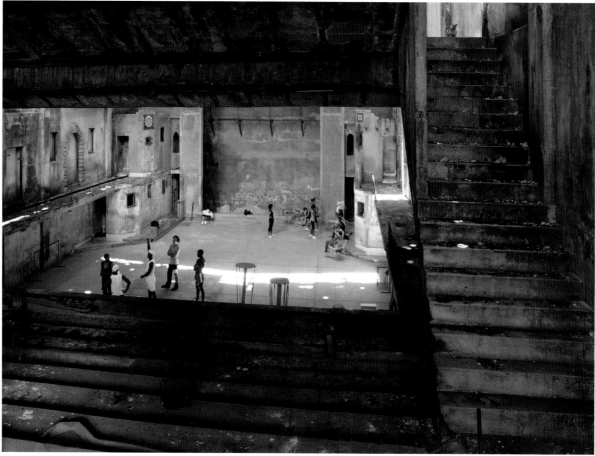

Havana – Cuba – Verdun – 2013

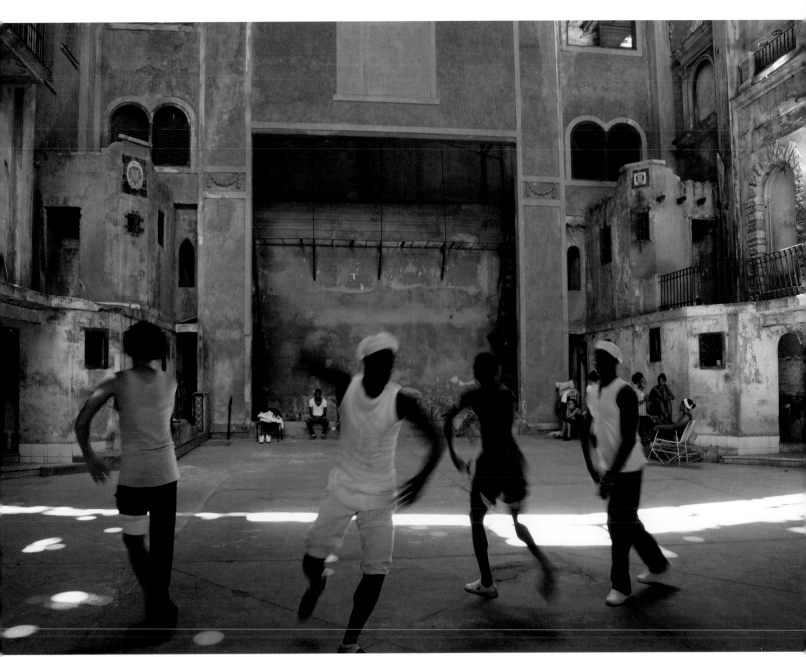

Havana – Cuba – Verdun – 2013

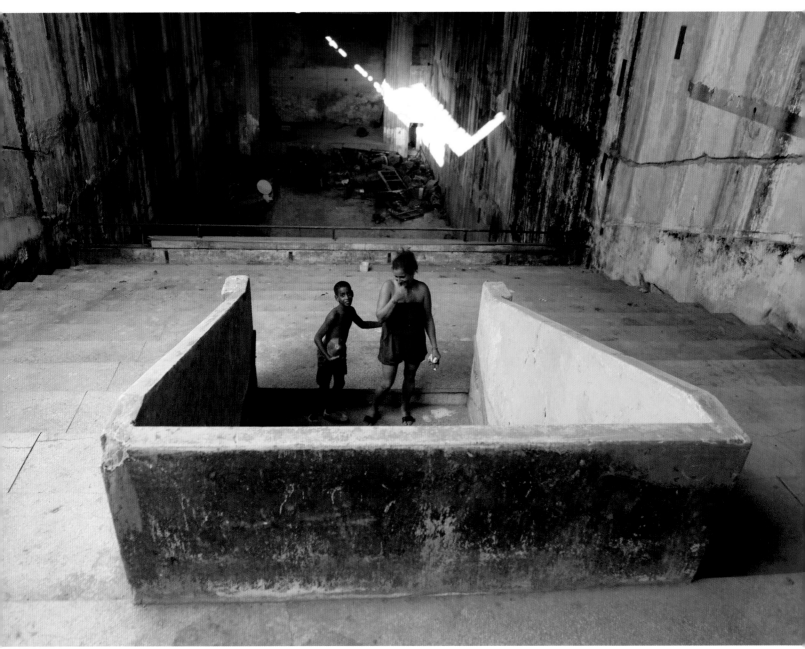

Havana – Cuba – Palace – 2013

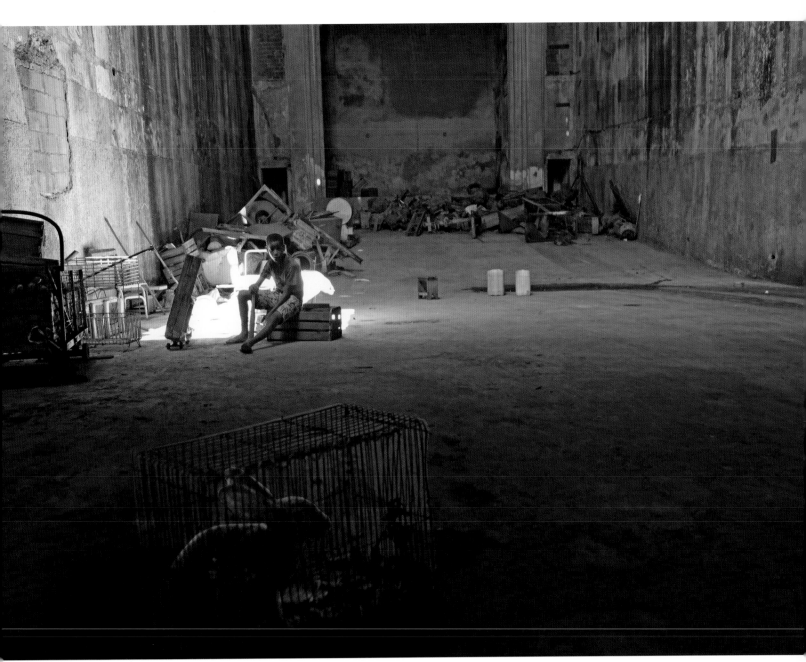

Havana – Cuba – Palace – 2013

When the function of a movie theatre changes, it can be fun to play 'spot the difference' between the original and the redesigned façade. Some are unrecognisable, while others still show outward signs of their earlier activities. But without exception, all of these buildings have had little choice but to cede to the whims of their new owner.

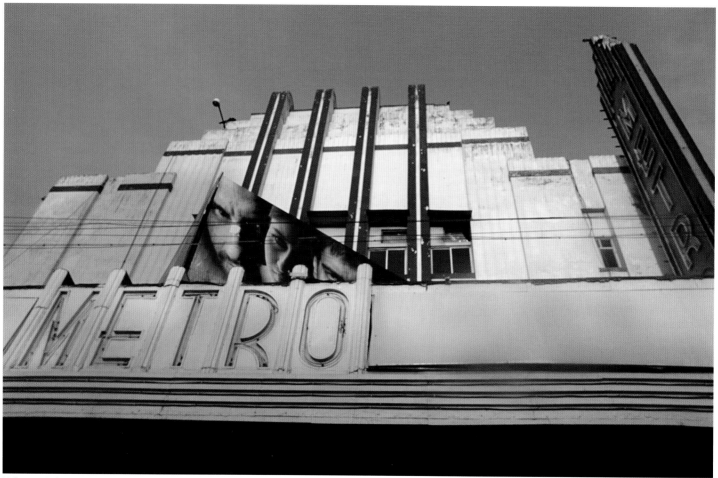

Kolkata – India – Metro – 2006

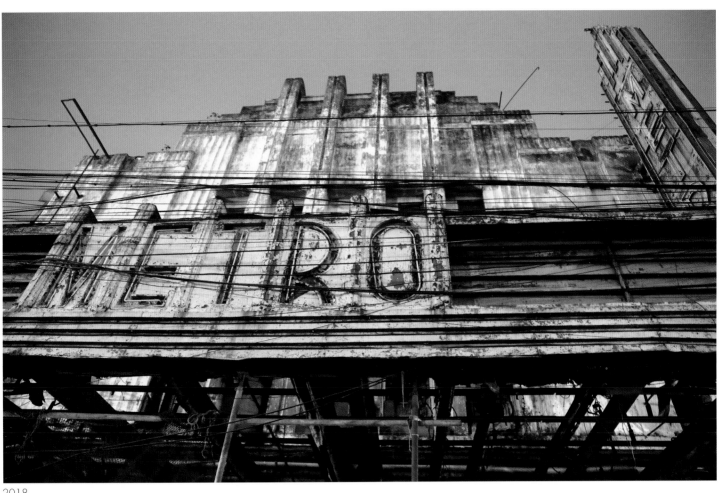

2018

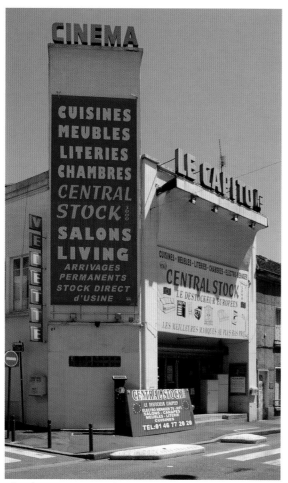

Villejuif – France – Capitole – 2007

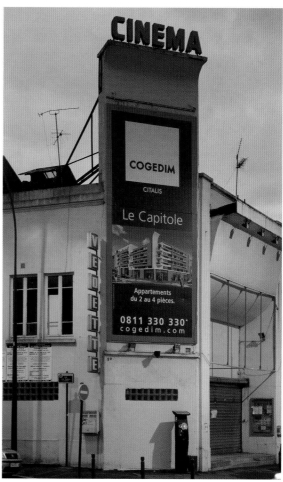

2008 (real estate program)

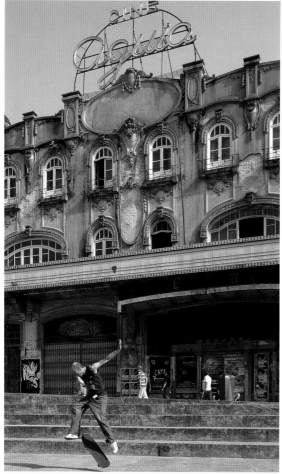

Porto – Portugal – Aguia – 2008

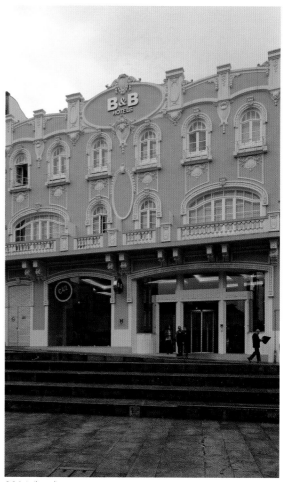

2016 (hotel)

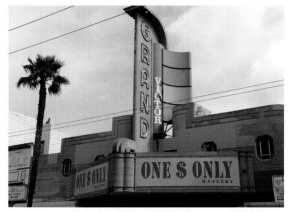

San Francisco – California, USA – Grand – 2011 (store)

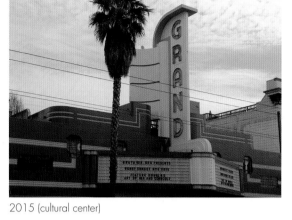

2015 (cultural center)

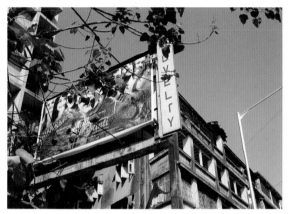

Mumbai – India – Novelty – 2006

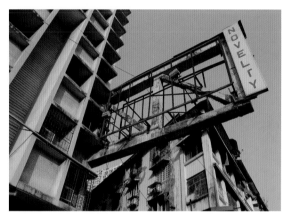

2013

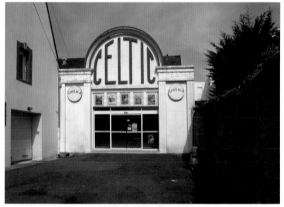

Concarneau – France – Celtic – 2006

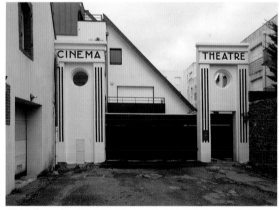

2012 (house)

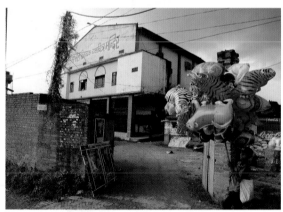

Bhaktapur – Nepal – Nawa Durga – 2011

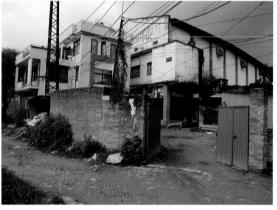

2015 (abandoned behind a building)

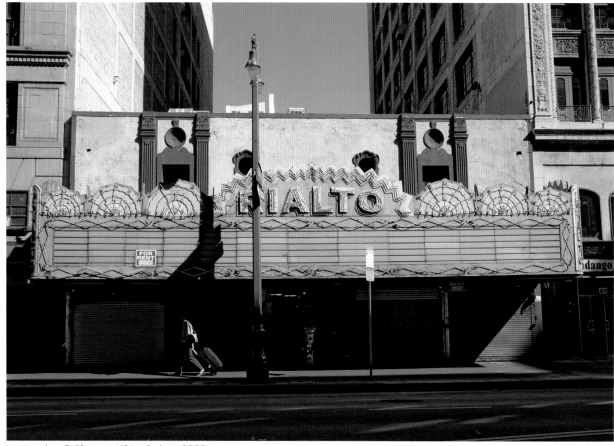

Los Angeles, California – USA – Rialto – 2008

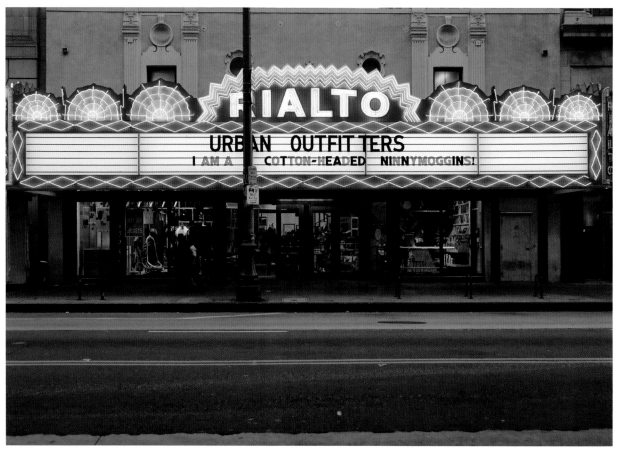

2015 (clothing store)

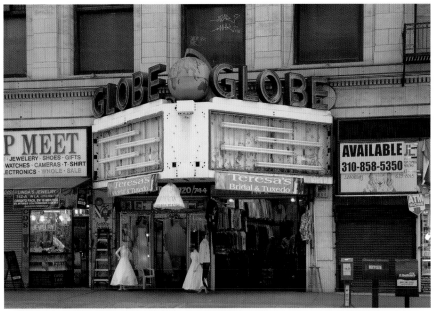

Los Angeles, California – USA – Globe – 2008 (store)

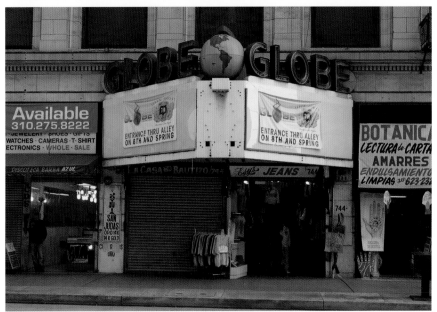

2011 (store)

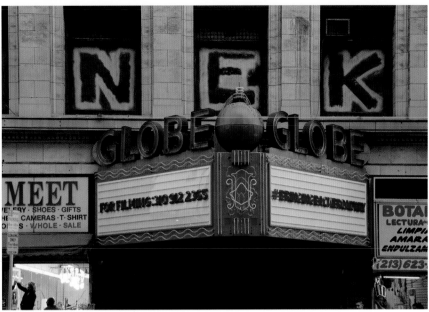

2015 (for rent)

Geneva – Switzerland – Hollywood – 2007

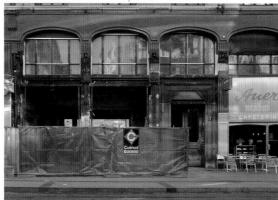

2008

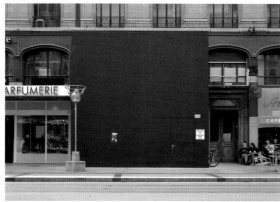

2008

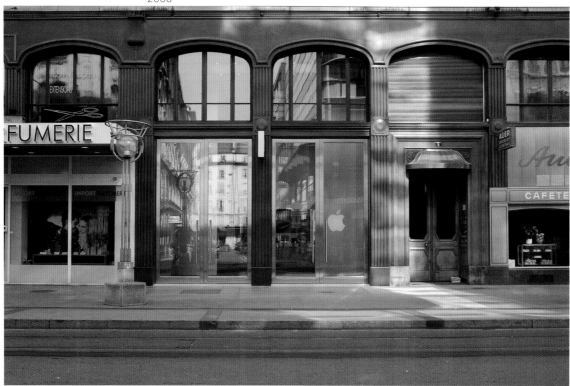

2010 (multimedia store)

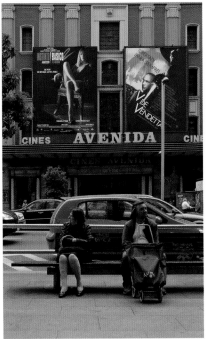

2006

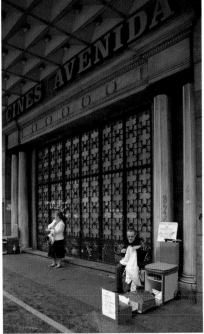

2006

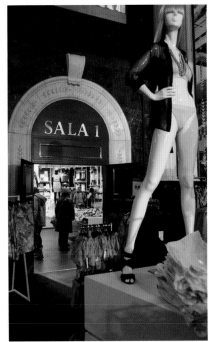

2012

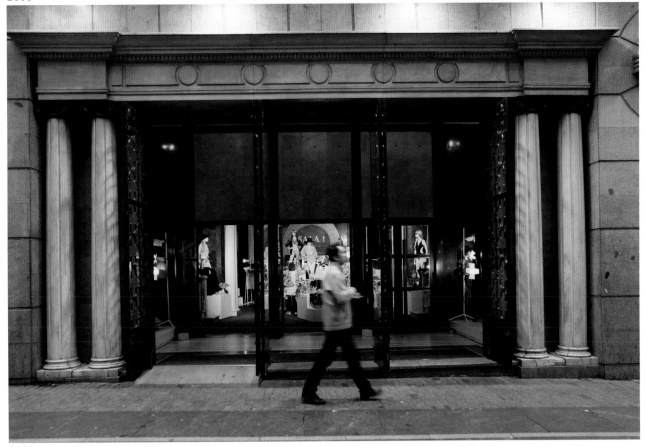

2012

In great numbers people crowd into the former Avenida de Madrid cinema, built in 1928, and since 2009, a branch of H&M. In great numbers they pore over clothes before rushing upstairs to try them on, without realising that this staircase once led into a majestic film theatre with 1,453 seats. In great numbers they fail to look up and notice the magnificent chandeliers. And in great numbers they see nothing but cheap clothes inside this carcass of a cinema where filmgoers were once a precious commodity.

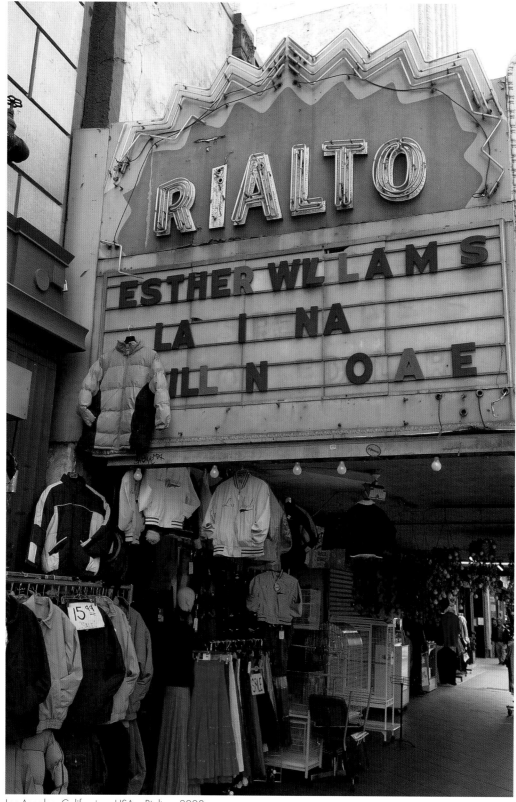

Los Angeles, California – USA – Rialto – 2008

Former swimming champion Esther Williams was nicknamed the Hollywood Mermaid, a title

that defined her career in the 1940s; she starred in numerous musical comedies that invariably

involved synchronised swimming. In 2006 her name still appeared on the canopy of the Rialto

cinema in Los Angeles, not far from several pairs of trousers.

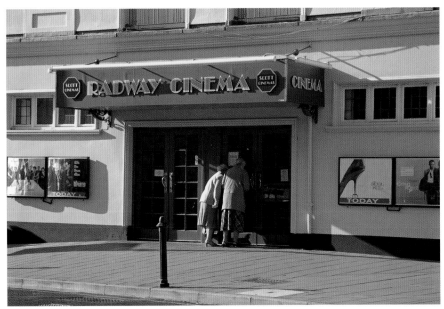

Sidmouth – England – Radway – 2006

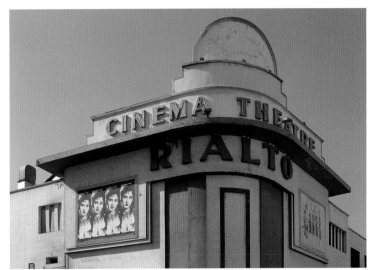

Casablanca – Morocco – Rialto – 2015

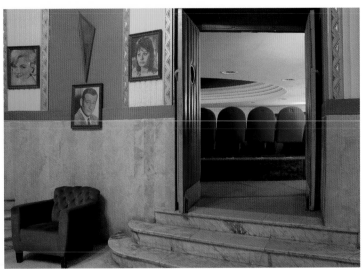

Casablanca – Morocco – Rialto – 2015

Casablanca – Morocco – Rialto – 2015

In 2015, Fred Astaire keeps dancing with Ginger Rodgers at Casablanca's Rialto.

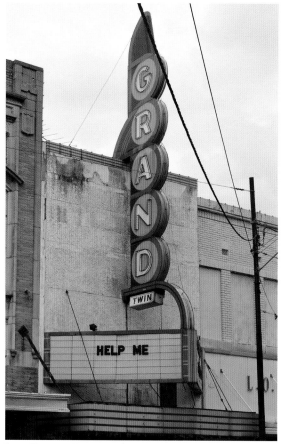

Paris, Texas – USA – Grand – 2008

Glasgow – Scotland – Odeon – 2007

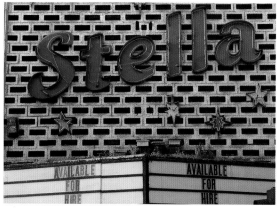

Dublin – Irland – Stella – 2006

Kolkata – India – Alochaya – 2010

Beeville, Texas – USA – Rialto – 2011

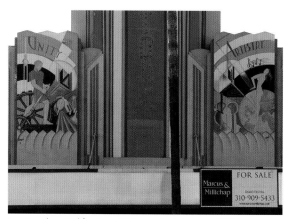

Los Angeles, California – USA – United Artists – 2006

Bangkok – Thailand – Paris – 2019

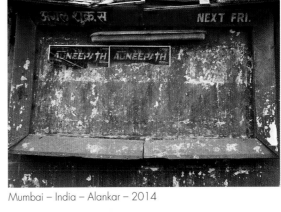

Mumbai – India – Alankar – 2014

Casablanca – Morocco – Opéra – 2009

Marrakesh – Morocco – Hamra – 2015

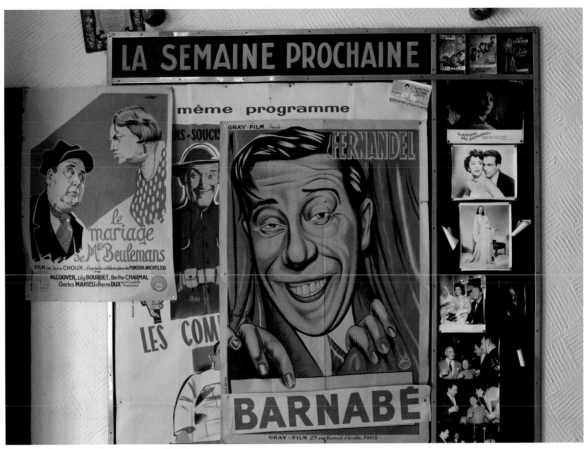

Saint-Eloy-les-Mines – France – Rex – 2011

New York, New York – USA – Commodore – 2005

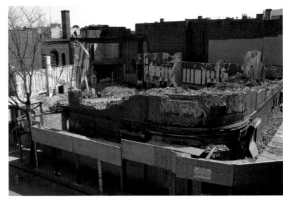

New York, New York – USA – Commodore – 2007

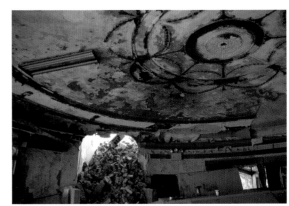

New York, New York – USA – Commodore – 2007

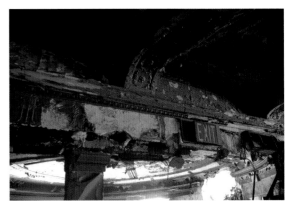

New York, New York – USA – Commodore – 2007

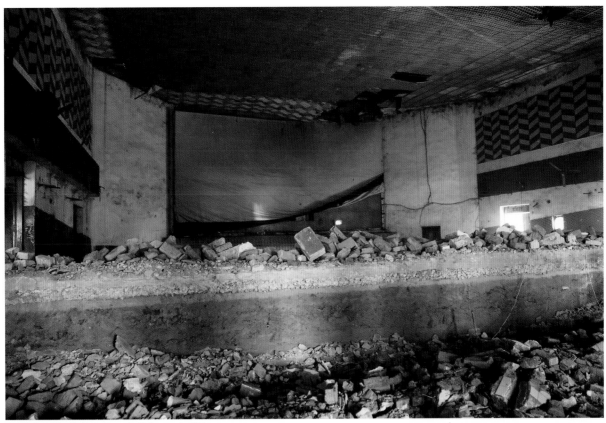

Mughalsarai – India – Kamala Talkies – 2017

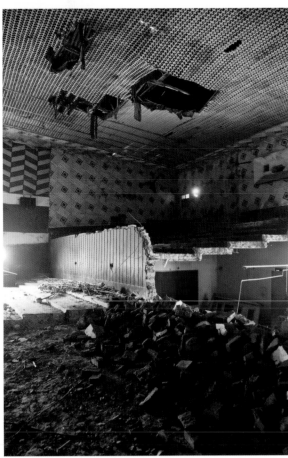

Mughalsarai – India – Kamala Talkies – 2017

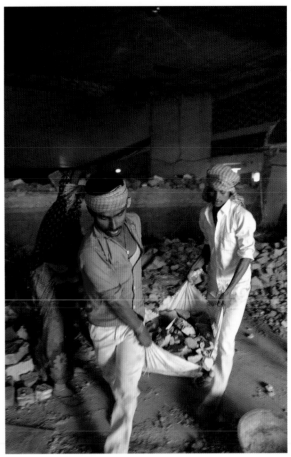

Mughalsarai – India – Kamala Talkies – 2017

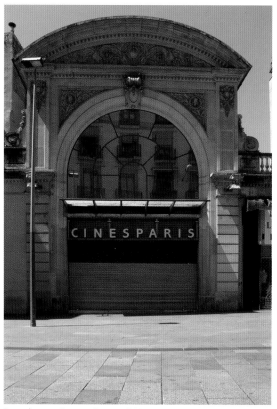

Barcelona – Spain – Paris – 2006

It is late afternoon in Barcelona. A pedestrian area in front of the Paris cinema. The weather is fine. The following morning the sky is still blue but the cinema has vanished. Passers by look stunned. They simply cannot believe their eyes. Heavy plant operators are finishing the job. Two years later, Zara opens up on the ruins of the cinema. The sky is cloudy.

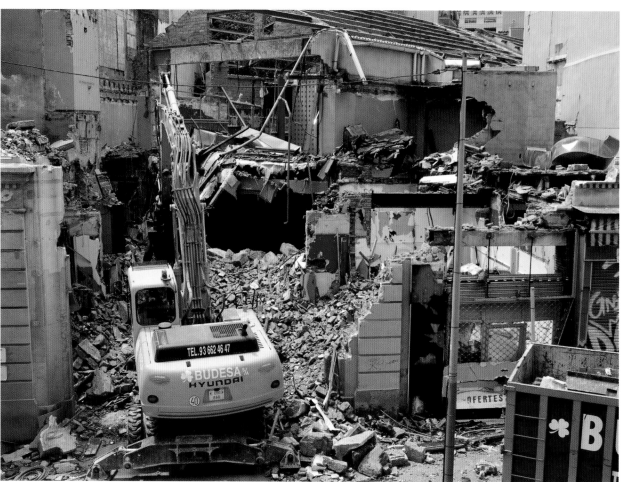

Barcelona – Spain – Paris – 2007

Barcelona – Spain – Paris – 2007

Barcelona – Spain – Paris – 2007

Barcelona – Spain – Paris – 2007

Barcelona – Spain – Paris – 2007

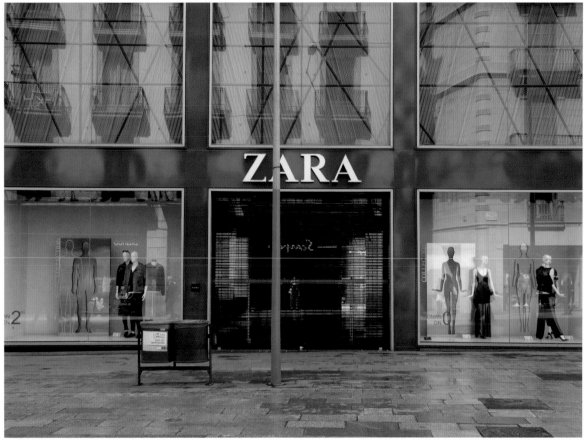

Barcelona – Spain – Paris – 2012

Newark, New Jersey – USA – RKO Proctor's – 2010